BERTOIA

FOR HARRY

BERTOIA

THE
METALWORKER

BEVERLY H. TWITCHELL

INTRODUCTION

A tragic 1970 plane crash brought Harry Bertoia to Marshall University in Huntington, West Virginia, with a commission to create a memorial to all those who had died. A new student center was being designed by architect Keith Dean, who recommended that Bertoia be considered for the commission to sculpt a memorial at the site of the new building. Bertoia's design of a bronze fountain received the commission because of the work's quality and the thoroughness of his presentation, but his enthusiasm, sincerity, and natural charm were also advantages. Bertoia designed the sculpture's organic forms to suggest growth and life; they would be animated by the play of the water's movement and its sound. Later, he admitted that he had always wanted to design a memorial. It is an especially challenging type of monument because of its association with death, but it is also part of a long and important tradition in the history of art. He believed that the youthful population of a university offered a fascinating opportunity for creating a memorial, because it must honor and remember the dead while also stressing life. No morbid centerpiece belonged on a campus full of young people. From the large, enclosing forms low in the sculpture, the fountain swells and rises to lift viewers' eyes toward the sky. Some thought it resembled a tulip; others, a chalice. Bertoia found the speculation mildly interesting but thought such associations had more significance for viewers than for him: his concern was the expressive power of its abstract shapes.

Water rises from the center of the *Marshall University Memorial Fountain* to flow over its interior and outer forms, falling into the pool where it stands, then recycling and rising again. Light plays over the moving water with reflections in constant flux. The water murmurs and splashes, speaking of continuity, of death and new life. In subsequent years Bertoia delighted in seeing newspaper photos of baptisms at the fountain, and of dogs and babies splashing in its pool. It had earned a role in the community.

P. 220

55

Born in a tiny village in northern Italy, Bertoia understood that for thousands of years fountains have been centers of daily life in small towns and urban neighborhoods. Sources of water for residents, they were also gathering places where friends and neighbors chatted, joked, and gossiped while filling containers with water to take home. Fountains are still centers of activity as well as landmarks, whether in unpaved villages or magnificent urban piazzas. Likewise, the *Memorial Fountain*, installed and dedicated in the fall of 1972, became a focal point on campus, a meeting place. Its sounds are refreshing on hot days, and its spray tickles the face and sparkles in the hair when there is a breeze.

The *Memorial Fountain* was ultimately what started me on the path to writing this book, for I arrived at the university in August 1972 to begin a career teaching art history. Bertoia's 1954 *Screen* for Manufacturer's Trust Company, at 510 Fifth Avenue in New York, had dazzled me when I saw it in a slide in an undergraduate course on American architecture. The sculpture warms and enlivens the space designed by the architect Gordon Bunshaft of Skidmore, Owings and Merrill. The screen's beauty, the wit and variety of its details, and its practical way of separating the teller cages from the more private aspects of banking were wonderful. The notion that a large Bertoia sculpture would become part of my daily life pleased me greatly. The next spring, a colleague and I invited Bertoia to address our classes.

P. 159

119

On April 4, 1973, Bertoia spoke to a group of students and faculty members about his work, explaining how nearly every piece he made resulted from ideas generated by those before it. He saw this as an evolutionary process consistent with his claim that his art and his view of life were based in nature. He joked easily while he spoke, clearly an affable, energetic, unassuming, and warm man. Instead of discussing his work at length, he showed a 1965 film made by Clifford West, a friend since they were both at the Cranbrook Academy of Art and the best man at his wedding. That film, *Harry Bertoia's Sculpture*, opens on the back of a Bertoia "bird" chair from which he rises to light his pipe with the eight-inch-long (20.3 cm) blue flame of a welding torch, an idea the artist himself surely had suggested and found amusing. The small, irregular bowl of his pipe was proof that he

P. 125

24

had done this often. West filmed metal screens and organic bronzes from many views, exposing unanticipated elements, but his film also included Bertoia's sculptures that chime, ring, and make other sounds. West filmed these sounding pieces so beautifully that even experiencing them vicariously was vivid and wonderful. In footage in the barn where Bertoia arranged and experimented with the pieces he thought most successful, he can be seen moving from one sculpture to another, leaning down to touch some only a few inches tall, reaching above his head to caress tall ones or grip them together forcibly; he played these works made of groups of vertical rods by moving some gently at their tips, by strumming others just above the floor, and by pushing many gently from opposite sides so they meet to sound gently rather than really collide. He played pieces singly and in groups, sustaining some sounds to interact audibly, and he struck a few deep, rich tones on gongs suspended from rafters. The film records a great variety of sounds, some crisp and brief, others prolonged, building and waning gradually while higher or lower tones entered. Having never encountered anything like this, we were mesmerized and delighted.

Afterward Bertoia took questions in a lively conversation with his audience. A professor of piano somewhat belligerently claimed the sculptures did not make music. Smiling, Bertoia calmly replied that he "did not claim it was music, but sounds you may find interesting or pleasing." The moment was memorable because of both its content and the way that the artist politely and honestly defused the confrontation. Later, at a party in his honor, Bertoia and I talked at length. He invited me to visit him in Pennsylvania after school was out. It would be the first of my many visits to Bertoia's workshop, home, and barn over the next seven years. He and his vivacious wife, Brigitta, and I became close friends. We talked at meals, on long walks, in the car, and after dinner in the barn or living room. We discussed subjects ranging from art to current events, books, and all sorts of ideas. Conversations took their own course, from serious to frivolous and humorous. My visits always stimulated me aesthetically and intellectually.

Bertoia was often quite philosophical, consistent with his gentle approach to life. As a toddler in a small farming community when World War I ended and a teenager during the Great Depression, he had developed no desire for luxuries and never seemed to complain. He was generous: he gave of himself, he gave money he thought would be well spent, and he gave his work to people he liked and who he knew would appreciate it. Over the years I only once saw him be less than pleasant. He took on no airs, liked everyone and was courteous, often a bit formal. Despite humble beginnings, he was very sophisticated and refined. A perfectionist, Bertoia was always positive in outlook, with an intense drive to work, to produce, to push his art as far as possible. He loved working. Despite this seriousness, he had a whimsical streak and sense of humor that flavored his work and daily life. His inventiveness was not merely evident in his art but also in how he approached it: making tools, improvising processes, and contriving terms for thinking and speaking about them. Those terms will be used here because they are clear, useful, and his.

Bertoia was personally humble but proud of his art; it was, he thought, significant work. He worked six and a half days most weeks in his workshop, and after every long day he retreated to his barn, experimenting with the sounds he produced or making the monotypes he called simply his "graphics" or "drawings." His energy resulted in part from his habit of napping after dinner, allowing him to work until well after midnight. Visiting there for a guest who took no such rests was both exhausting and exhilarating.

I came to love Harry and Brigitta Bertoia and was privileged to have their affection and trust. Although we were from different generations and backgrounds, Harry and I worked well together, selecting pieces for two solo exhibitions of his art that I curated, one in Allentown, Pennsylvania, in 1975 and another at Marshall University two years later. We usually agreed on which examples to choose from a group of works, but when we differed, each of us would explain why she or he had picked a particular piece; the

stronger argument quickly and easily settled the matter. By then I knew him well and felt little need to be deferential, so I could defend my views frankly. It was amicable and even fun. The process also revealed a great deal about what he thought and how he made aesthetic decisions. He was happy with our selections and how we reached them. Over the years, we interacted in many ways, usually as colleagues and friends, although on occasion he was paternal or took the role of mentor. Sometimes he asked me to critique his work or evaluate and compare pieces in a group. This was natural, easy, and relaxed, an interesting intellectual exchange.

Bertoia's forms and techniques ranged widely between the 1930s and his death late in 1978, reflecting the speed of change in society during that period. Some artists adopt a style and stick to it. Others invent new forms and methods as new opportunities arrive, as did Bertoia. Having some knowledge of Bertoia's beliefs is essential to understanding how his work absorbed and adapted ideas from the Bauhaus, Constructivism, Surrealism, and Vitalism, even how his work can appear simultaneously Minimalist and spiritual. Bertoia's art exemplifies to an unusual degree the tenets of Modernism outlined by Walter Gropius. In 1920, only two years after the end of World War I, Gropius infused Modernism with tremendous idealism: the promise that good design can improve life. In the hands of lesser architects and artists over the span of fifty years, Modernism too often dwindled into sterile, empty, effete forms. Beginning in the late 1970s, the Postmodernist counterattack pointed out flaws in late Modernism but also fell into some superficial decorativeness while shoving aside more inventive and meaningful works like Bertoia's. The pendulum has swung back.

Bertoia approached the world with a critical eye and mind as well as with joy. He had an unquenchable desire to work, a drive to evolve his art as far as possible, but he also relished laughter, good conversation, and the occasional glass of *vino*. He was full of new ideas, warmth, and wisdom as well as humor. Many now know him only through his work, but even that often inspires fondness not only of the art but also of Bertoia himself. The power of his works and the consistency between the art and the artist give rise to affection and admiration.

AUTHOR'S NOTE

Writing about Harry Bertoia's work is complicated above all because he did not sign or assign titles to his art, although once in a while he deviated from that principle. Especially under pressure from a museum or collector, he sometimes would give a work a name. James Abbott McNeill Whistler famously insisted that a work of art must "stand alone," or exist essentially on its own, never depending on a story or sentiment or factors outside the work. He insisted that it must meet purely artistic criteria, aesthetic ones. Bertoia had a similar if not identical idea: he wanted viewers to respond directly to the work, uninfluenced by titles or an artist's reputation. He was sending his work out into the world unencumbered, to stand on its own merits, encouraging viewers to think and perhaps feel as a result of what they experienced.

Unfortunately, the absence of titles and signatures potentially raises questions about the authenticity of individual works. Since Bertoia was active relatively recently, the history of individual works can usually be traced back to him, with photographs and his extensive records establishing the authorship and dates of many pieces. Further, connoisseurship, or close examination of style, form, technique, and materials, usually exposes the increasing number of fakes—it has long been the case in the art world that when work becomes valuable, fakes and forgeries may appear. Much more difficult, especially in writing, is distinguishing individual authentic works, because of his habit of working in series, executing a group of pieces that vary only slightly in detail or proportions in order for him to examine the effects of subtle differences. This makes pointing out the distinctions between untitled works and analyzing specific examples very difficult.

Thankfully, photographs help enormously. Unfortunately, Bertoia's early life and work are not well documented, and only in the late 1950s does chronology become more certain and do documents become more plentiful.

Discussing Bertoia's sounding pieces involves yet another degree of difficulty, because experiencing these works is a sensory experience—auditory, visual, and sometimes more physical still, when the sound vibrations affect your core. One advantage of having waited forty years to write this is that technology now makes it much more possible for readers to experience the sounds of the sculptures, if only vicariously, through digital video and audio recordings.

Another advantage of having waited so long to write this book is that if affection for Bertoia and his work might compromise my objectivity, the passing of four decades has affected my perspective, and the access to Bertoia, his wife, workshop and barn, as well as the insights I gained compensate for any bias I have. My photographs and notes, as well as his letters to me, are essential information, and now papers, interviews, and other documents have become available to enlarge the wealth of data. Although I am retired from academe, my approach nevertheless needs to be traditional. Tracing the development of Bertoia's art is essential to explaining it: because his work evolved, it really needs to be presented chronologically. Discussing the context in which works developed is also important and will largely consist in the art and ideas influencing Bertoia, although some pertinent biographical and world events must also enter the discussion.

Bertoia's chairs for Knoll have been consistently popular since their introduction in 1952. By 1978, when Bertoia died, however, Modernist ideas were being challenged, then rejected, by Postmodernists. The beauty, spirituality, and sincerity of his work struck some as naive while others wondered about the value of kinetics and acoustics in sculpture. For two decades Bertoia's work was shown infrequently, but it began reappearing in exhibitions and at auction increasingly from about 2000. His art was so individual that it left little visible influence on the work of artists other than imitators, but it has been a valuable example for those who admire that Bertoia consistently worked in multiple media, and respect his fine craftsmanship, his aesthetic, and his integrity. Recent aficionados of electronic and ambient music now consider Bertoia's Sonambient recordings important antecedents of and inspiration for their own works. Great interest in what is now called "Mid-Century Modernism" has brought Bertoia's works to the public in important exhibitions and brought it wide acclaim.

"The sky is very blue in San Lorenzo. . . . The earth itself is an inspiration to art," Harry Bertoia explained when he was in his late fifties. He had enjoyed a rather idyllic, rural Italian childhood in the tiny agricultural village of San Lorenzo d'Arzène, in Friuli, which Bertoia described as "somewhere between the Alps and Venice."[1] (It is about 50 miles/80.5 km northwest of Venice.) With the given name Arri Bertoia, he had been born in the early spring of 1915, during World War I, at a time when a village childhood likely was more similar to one a hundred years earlier than to childhood there today. Electricity and automobiles existed in cities but not in a village of between 350 and 500 people. San Lorenzo's size and location determined much of the character of life there; people farmed on a small scale, tending some livestock, growing corn, and cultivating their vineyards to produce wine.

P. 19

The memories of Ave Bertoia de Paoli (1920–2012), Harry's sister, are the main source of information about those early years, though she was elderly when the younger generation of her family interviewed her.[2] She remembered spending time with her brothers outdoors when she was small and that her oldest brother, Oreste (1908–1971), played "nicely" with her. Students at the village school used a single textbook for all subjects for their entire four years of classes. Harry's artistic ability was evident very early, and for some months when he was fourteen or fifteen, he rode his bicycle to Casarsa, about a mile away, to attend evening drawing classes. After a short while his teacher told Harry there was nothing more he could teach him, so the boy stopped going, but these classes may well have stirred his desire for further study in art. Ave implied that because of Harry's talent, he was responsible for fewer farm chores than she. She proudly remembered that his skilled drawings were so widely known that brides would ask him to make floral designs for them to embroider on their linens.[3] In a 1972 interview, Bertoia recalled that as a child he liked building "little houses, playgrounds, constructions that were possible with what little was available." But when he was a child, "Strangely enough, the world was prescribed by the ability to bicycle for a day and I think I was able to cover a radius of about 25 miles/40.2 km. So I didn't know any of Italy beyond that point prior to coming to the United States."[4]

In San Lorenzo he is still referred to as "Arieto," a diminutive of the name "Arri" on the baptismal records in the chapel registry. His father, Giuseppe, who had by then immigrated to Canada for work, called him Harry. Harry, Oreste, and his sister lived with their mother, Maria, and their father when he was home. A hand-tinted black-and-white photo of the three children survives in the oval format popular early in the twentieth century. Careful observation shows that the neckties and Oreste's tie pin were painted on when the picture was hand tinted, as most probably was the embroidery on Ave's dress. It is clear that life was hard for the Bertoias and their neighbors. An agricultural depression was so severe that many men worked abroad to earn a living, including Harry's father, who did farm work in Argentina, Canada, perhaps even in the United States. Italy had undergone many decades of turmoil that included unification as a country before World War I began, contributing to its economic problems.

P. 19

Surrounded by relatives, the family worked in the vineyards and cornfields and kept a few animals, but drought so reduced production that farming was not a viable livelihood, and northern Italy endured a long agricultural depression. For entertainment there was lively conversation and reminiscences of his uncles' travels, and Harry's father and four uncles sang, accompanying themselves on string instruments and the accordion. Family lore maintains that Giuseppe's father was first "violin cellist" at La Fenice, the opera house in Venice. Music was always important to family life as entertainment and relaxation. Oreste dreamed of becoming a professional musician, playing various instruments all his life and even composing music.

For both Ave and Harry, the most memorable event of their childhood was the arrival in town of gypsies. The itinerant life and colorful wagons of the Romanies fascinated the children despite adults' usual wariness of gypsies.

What most fascinated Harry, however, was the tinkers who made and repaired metal implements, beating tools, pots, and pans into shape and polishing them.

Well after having completed his studies at local schools, fourteen-year-old Harry was intrigued when he heard of the Venice Biennale and the Accademia di Belle Arti there. He told his mother that he wanted to study in Venice. She then wrote to her husband, who was working in Canada at the time. In a process that must have seemed interminable to Harry, Giuseppe returned to San Lorenzo and offered his son the choice of studying in Venice or going to Detroit to live with his brother, Oreste, who worked in a Ford Motor plant. Giuseppe had worked in Detroit before the Wall Street Crash and spoke glowingly of the city. He was considering bringing his entire family there, but his wife was unwilling to make so great a change in middle age.[5] Guiseppe gave his son three days to decide his fate. They sailed to America in 1930, which must have been quite an adventure for the boy, who was listed on the ship manifest as "Arri" and "student," while Giuseppe appeared as "labourer." They first entered Canada, because Giuseppe was by then a Canadian citizen, and Harry soon joined Oreste in Detroit.[6]

It is impossible today to imagine the shock of going from San Lorenzo to Detroit in 1930. The sheer size of the city, its traffic, noise, electricity, and plumbing all must have been dizzying. Bertoia admitted many years later that his vague imaginings of America and his father's glowing reports of Detroit contrasted greatly with the disappointing reality of the city during the Great Depression. He especially remembered the worries of the unemployed: "Their concern was contagious." He also, at least looking back, thought that "strangely enough, the abundance of time was creating a direction, so to speak, whereby young people as well as artists were finding ways to keep active."[7] Getting work was so difficult that his father went back to Canada, and Oreste insisted that Harry's options would be better if he went to school. They rented a room from an Italian family that first year, which must have made daily life easier and helped Harry's transition to his new circumstances.

Detroit was one of many American cities that had a "Little Italy," an enclave of Italians who lived near each other, helping each other while remitting some of their income to relatives who had not come. There were many Italian organizations in Detroit, and they drew members from Windsor in Ontario, Canada, as well as from the US side of the Detroit River. Detroit had an Italian Chamber of Commerce and a prominent patriotic organization, the Order of the Sons of Italy, as well as professional, social, and charitable organizations to help the sick, orphaned, and widowed. In addition to their overt purposes, members of these groups helped each other in many ways, raising money for scholarships and often serving in the roles extended family members would have had in Italy.[8]

Bertoia rarely spoke about his transition to America, other than admitting that learning English in an Americanization program was difficult. Despite his Italian rhythms, accent, and gestures, he came to speak and write articulate and often eloquent English. At sixteen he entered the Detroit public schools, where he was placed in classes with much younger students because of the weakness of his earlier education. After attending Cleveland Elementary School, he was extremely fortunate in 1935 to attend Cass Technical High School. It was renowned for its offerings in areas such as engineering, and its art program included courses more typical of a college. Like many older students, Bertoia never lacked either motivation or discipline. He always remembered two teachers there, Miss Davis and Miss Louise Greene, head of the art department, who recognized and encouraged the gifts of their new student. Cass Tech provided Bertoia with experience in jewelry and printmaking, opportunities that are still rare before university, and he may also have taken some engineering or mechanical drawing courses. He went on Saturday mornings to classes at the Detroit Institute of Art. After graduating from Cass Tech in 1936 at age twenty-one, he spent a year on scholarship at the School of the Detroit Society of Arts and Crafts.

Greene had advised Bertoia to apply in 1936 for entry and financial assistance there. Expecting to become a painter, he studied with Sarkis Sarkisian and John Carroll while continuing to do some work in jewelry.

It is disappointing but not surprising that little material survives from the Bertoias' childhood in Italy or the years in Detroit when Harry and Oreste were on their own. They brought few possessions with them from Italy and would have kept little from these early years. As a result of the lack of records and documents, it is impossible to date his earliest extant works with great certainty. A few realistic drawings, including one from a photograph of a young sister who died before meeting her brother, have surfaced and attest to his early ability to render forms accurately. A still life that Bertoia painted in the late 1930s, perhaps even as a student at the Detroit Society of Arts and Crafts, is an untitled still life of a bowl of fruit on a table. A painting in oil on canvas, it shows the strong influence of Paul Cézanne in its subject, its asymmetry, the exaggerated folds of the tablecloth, and the modeling of the fruit. Bertoia used light and shadow to convey the apples and oranges' volume and density. This accomplished painting emphasizes the physicality of its subject. It is in every respect a painting by a sculptor. Bertoia had clearly learned important lessons from Cézanne's work and in the process was also paying tribute to this artist he admired.

Greene reasserted herself in her former student's life by urging him to apply to the distinguished Cranbrook Academy of Art in nearby Bloomfield Hills. Bertoia had never heard of the school. The farmland that was Bloomfield Hills at the turn of the century, by 1920 was becoming a community of estates. Its wealthy suburban setting could hardly have differed more socially, economically, or visually from the poor and crowded neighborhood where the Bertoia brothers lived in Detroit. "Miss Greene," as Bertoia always referred to her, even drove him, a box of his jewelry and a sheaf of his drawings in hand, to his interview with Eliel Saarinen. Saarinen was so impressed with Bertoia and his work that he accepted him then and there.[9] Bertoia's future would evolve from Cranbrook. There he learned about Modernist ideas. There too he made friendships that would remain important for the rest of his life, for Cranbrook associates would determine the commissions that opened his mature career. It was also at Cranbrook that he met his future wife.

Decades later, any mention of Italy brought a special smile to Bertoia's face, but he only returned there once, in 1957, on a fellowship from the Graham Foundation for Advanced Studies in the Fine Arts. He needed to experience Italy's artistic patrimony first hand, as that trip allowed, and he was thrilled and fascinated to see the art of Italy that he had known only from books. He spent some time in San Lorenzo, visiting family and friends, but would never return. Bertoia hated to leave his work for more than a few days, he explained. Like many who have had two countries, he often felt Italian when in the United States and, on his return to Italy, likely found himself to be very American. Importantly, however, belonging to the Italian tradition of several millennia of art and also being part of American Modernism were both essential to Bertoia's sense of himself and his work. He always remained very Italian and simultaneously very American, having become comfortable in the dual existence that allowed him to love the old country and his new one. He was especially grateful for the opportunities the new country provided. The Italian countryside, where he played, did farm chores, explored nature, and grew, was essential to determining the person and artist he became. That landscape of his childhood shaped his love of the natural world and would be the basis of his art. He would come to appreciate that nature was not simply his surroundings but something of which we are all a part.

Between the World Wars, a confluence of ideas concerning what was and is important in art emerged. Modernism was an absolute break with the Victorian past. The principles most Modernists upheld gradually meshed into a loose, broad consensus that overrode differences between styles

and movements. Under this umbrella of ideas, individual Modernists molded their own aesthetics, each omitting some ideas or principles and adding others, emphasizing what seemed right. Over time most artists' views naturally shifted in response to events, new work, and new ideas.

Modernism's strength and influence depended in part on the fact that it is more than a style in art. Modernism is a set of beliefs based on the insistence that the use of reason makes it possible to improve the human condition. Based on belief in progress, Modernism is inherently optimistic. It raised the importance of science and mathematics and established them as standards for measuring achievement in many other areas. A perhaps curious result of these ideas is that the history of art and the development of individual artists came to be understood as resulting from evolution, much as abstraction, a search for essences that artists often reached gradually, in stages, was an evolutionary process and an indication of Modernism. Many considered abstraction "inevitable."[10]

In 1930, when Bertoia arrived in America, Regionalism was the predominant style in art. The United States was emerging from the political isolationism reflected in the realist paintings of Regionalists like Thomas Hart Benton, John Steuart Curry, and Grant Wood. Regionalists rendered ordinary, rural Midwestern life using conservative techniques, styles, and compositions that go back to the Italian Renaissance. A great chasm separated these conservatives from the Modernists, who dismissed Regionalism as irrelevant, provincial, and xenophobic. The vast conservative and uninformed public considered Modernism incomprehensible, elitist, and foreign. Nevertheless, Modernism began gaining a foothold in East Coast cities and on college campuses and from there moved into other urban centers.

Two of the most influential and enduring forces of American Modernism have been New York's Museum of Modern Art (MoMA), founded in 1929, and the Museum of Non-Objective Painting (later renamed the Solomon R. Guggenheim Museum), which opened the following decade. These museums became bulwarks of Modernism through their exhibitions and catalogs, as well as through reviews in the growing number of art magazines that spread the Modernist dogma. Both these institutions were significant in Bertoia's early career. Museum of Non-Objective Painting cofounder Hilla Rebay would buy his works for the museum and offer him encouragement, beginning in 1943, and MoMA would exhibit his works before he was thirty.

The critic Clement Greenberg and the first director and curator of MoMA, Alfred H. Barr, Jr., presented Modernism in art as an evolution beginning with Impressionism and continuing after Post-Impressionism. Between 1925 and 1935, Modernist art split into two branches, one formal, the other expressive. Formalism, which emphasized composition or form, relied on analysis and thus the intellect, so it quickly became the dominant branch of Modernism. The expressive trend was considered secondary largely because it emphasized feeling, both sensory and emotional. While formalism was explained as a progression from Cézanne to Henri Matisse and Cubism, then to the Bauhaus and Constructivism, the expressive branch of Modernism had developed from Paul Gauguin and Vincent van Gogh. Its less rigidly preordained course proceeded from Post-Impressionism to Edvard Munch, Odilon Redon, and then Dada and Surrealism. This rigid oversimplification of Modernism is now under question and new insights are emerging.

Both the formal and expressive directions in Modernism were essential for Bertoia's art, and he worked to merge those two tendencies so often considered polar opposites. Bertoia's ultimate concern was to express the power and majesty of the life force in nature, but to do so, he had to develop a suitable visual language. He believed that his expressive aims required him to understand the theories and intentions of important twentieth-century art movements, so he could adapt some ideas from the recent past to use for his own purposes. He proceeded with seriousness and intensity that likely resulted in part from wanting to make up for the time lost in his transition to the United States. As a result, he adopted his central ideas and

methods surprisingly early and incorporated them rapidly in his work. The diversity of the sources from which he drew, as will be seen, confirms his wide and careful study as he progressed toward forming his own aesthetic. His sources, perhaps paradoxically, reveal how his work is both thoroughly Modernist and original.

In the Midwest in the late 1930s, Harry Bertoia was making work that was contrary to the ideas and standards accepted there, but he persisted nevertheless, knowing that he needed and wanted to work abstractly, nonobjectively. His intellect, knowledge of Modernism, and firmly held beliefs about nature led him to that conclusion. The ideas he wanted to express were abstract and, therefore, so must be his forms. He sought to reduce ideas and forms to their essences in order to suggest the vital spirit in nature. Rather remarkably, this student at the Cranbrook Academy of Art arrived at a set of ideas that would guide his work for four decades.

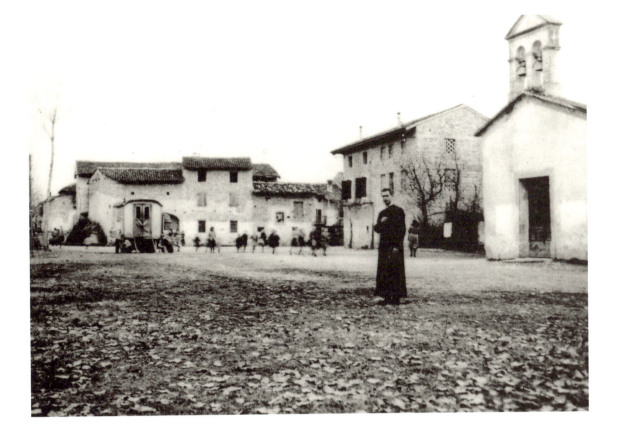

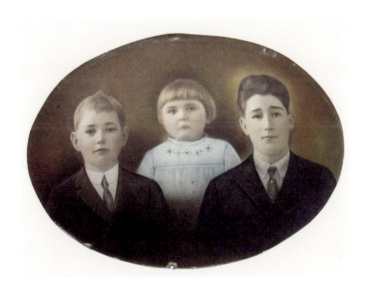

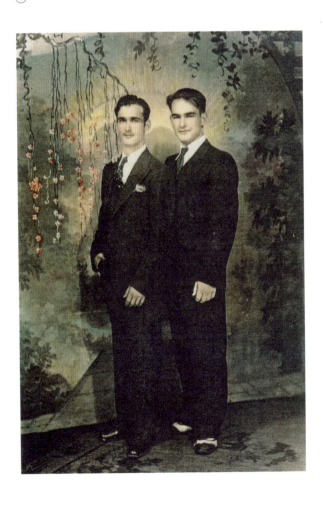

1 Piazza of San Lorenzo with a gypsy caravan to the left, 1950 or earlier.
2 Harry, Ave, and Oreste Bertoia, hand-tinted black-and-white photo, c. 1923.
3 Portrait of Oreste Bertoia (left) and Harry Bertoia (right), Detroit, early 1930s.

2

> . . . Cranbrook, surely more than any other institution, has a right to
> think of itself as synonymous with contemporary American design;
> the work of its students and faculty did more than that of any other
> place to focus international attention on design work being done
> on this side of the Atlantic.
> —Paul Goldberger

Harry Bertoia's future, both personal and professional, took its course
as a result of his years studying and working at the Cranbrook Academy of
Art from 1937–43. The preceding few years had prepared him well for the
idealism as well as the artistic freedom the school provided and, entering
at age twenty-two, he was focused, highly disciplined, and ready to absorb
everything possible.

"A perfect storm of manufacturing money, ample space and robust industry
created one of Modernism's most fertile and important outposts in and
around Detroit."[1] By the late 1930s the automobile industry was bringing
Modernism to a growing and prosperous Detroit area. Developments in the
automotive industry stimulated new and important design in other fields,
particularly in architecture and interiors. Eliel Saarinen and his son, Eero,
were hired to develop a plan for central Detroit; Skidmore, Owings and
Merrill developed the Ford Motor Company headquarters nearby in
Dearborn; and Marcel Breuer produced St. Francis de Sales Catholic Church
in North Shores, Michigan. Other noteworthy Modernist buildings were by
Ludwig Mies van der Rohe, Minoru Yamasaki, Frank Lloyd Wright, Charles
Eames, and George Nelson.

The new offices and homes needed furnishings, and western Michigan,
with its plentiful timber and waterways for transportation, had become
a center of early mass-produced wood furniture after the Civil War. The
bureaucratic infrastructure needed to win World War II was so vast that it
increased the demand for desks, file cabinets, and desk chairs. One result
was that the Metal Office Furniture Company (later renamed Steelcase)
brought out the first furniture with interchangeable parts. Then the
post-war building boom created desire for new furnishings to suit the new
architecture. In addition to Herman Miller, companies that met these needs
included Widdicomb, Baker, Calvin, and other furniture manufacturers
prominent at the time. Some of these companies were employing prominent
designers like George Nelson, Charles and Ray Eames, George Nakashima,
and Isamu Noguchi.[2] Detroit and the state of Michigan itself made essential,
often overlooked, contributions to the development of Modernism
in America.

Cranbrook was in some respects a universe away from Detroit. It reflected
a uniquely American tradition of utopian communities such as Amana, Iowa,
New Harmony, Indiana; Oneida, New York; and the Shaker villages along
the East Coast and west to Ohio and Kentucky. Those nineteenth-century
attempts at perfection rested on religious ideals, in contrast with Cranbrook,
which was an artistic and educational community. Like the religious
settlements, Cranbrook enjoyed a bucolic setting of several hundred acres
in Bloomfield Hills, 25 miles (40.2 km) from urban Detroit. Farmland at the
turn of the century, Bloomfield Hills was becoming a cluster of estates by
1920, and the Cranbrook educational community was an asset there. Harry
Bertoia must have been astonished when he first saw the rolling terrain,
wooded areas, and orderly arrangement of buildings designed to take
advantage of views to reflecting pools and sculptures. It was definitely
not Detroit.

Cranbrook's founder, George Booth, named the campus after his father's
birthplace in Kent, England, where the Cranbrook Colony of artists had
been established in the mid-nineteenth century. In Michigan, the all-girls
Kingswood School Cranbrook, like most subsequent structures on the
Cranbrook campus, was designed by Eliel Saarinen, the architect who Booth
had hired to plan the campus and all programs in art. Saarinen and George
and Ellen Scripps Booth shaped a vision of both Cranbrook's spirit and its

P. 44

11

physical campus as an artistic and intellectual community. Its hills, woods, and lake offered much needed escape from its intense, creative atmosphere, inviting moments of relaxation and fresh air for students like Bertoia.

George Booth admired the English Arts and Crafts movement that William Morris had begun in the mid-nineteenth century and that lasted well into the Art Nouveau period, peaking from 1880 to 1910. Initially inspired by the applied arts of the Middle Ages, the early phase of the Arts and Crafts movement was devoted to excellence in design and hand craftsmanship in all things for interiors. Morris was drawn to a romanticized ideal of a medieval community of artists creating works of all kinds that harmonized. By the 1880s, Morris and his associates, recognizing practical necessity, had incorporated some mechanization. The Weimar School of Arts and Crafts, reinvented as the Bauhaus in the hands of Walter Gropius, was also under the spell of communitarian ideas and, in the face of financial pressures about 1925, similarly turned to machines, designing items for industrial production. The Booths sought to merge the ideals of the Arts and Crafts movement with the best of the American Academy in Rome and the collaborative work they saw among American architects there. They dreamed of opening a school to foster such interaction. A few years later Booth opened a School of Arts and Crafts at Cranbrook.

Soon Saarinen would merge his own vision with that of the Booths. The Booths and Saarinen officially founded the Cranbrook Academy of Art in 1932. The Cranbrook Art Museum opened in 1942, with the library, dorms, a dining room, and houses following. Saarinen was the president as well as the designer of the art programs and architect of most buildings. The Academy of Art was (and remains) the most important aspect of Cranbrook. It was small and so selective that the student body included only thirty-five students in Bertoia's time, although it is now a graduate school of about 150 students.[3]

Saarinen was part of Finland's Arts and Crafts movement at the time when it was absorbing Art Nouveau influences. Like William Morris, he was so attracted by the ideal of designing everything for domestic life and making it all harmonize that his Cranbrook house became the perfect example of "early Cranbrook style." The contents of the home were designed and handmade by all the Saarinens and created for specific places in the house. While the principles underlying the designs remained the same, the style shifted with the times, so the dining room is neither Arts and Crafts nor Art Nouveau in style, but instead quite clearly Art Deco.

The home's harmony between furniture and architecture updates Robert Adam's designs for great eighteenth-century British country houses. Such consistent interaction of many arts in one space was key to Saarinen's ideal. Saarinen's influence on Cranbrook, however, was more "modernizing" than truly Modernist, for his approach was conceptually closer to that of William Morris than the Bauhaus. Cranbrook has sometimes been dubbed the "American Bauhaus," but it was too conservative for that to be accurate. Some of the greatest modern architects, such as Saarinen, Wright, and Gropius, saw all the arts as subservient to architecture. Their point of view implied that the purpose of painting and sculpture, not to mention textiles and metalwork, was to decorate buildings rather than to exist as significant expressions in their own right. But Gropius was not entirely consistent in his ideas. When he was thinking in his role as Bauhaus director, he wrote, lectured, and encouraged a curriculum based on the idea that all the arts are equally important. This revolutionary view contradicted the notion of a hierarchy in art entrenched for centuries that was based on the intellectual content of particular types of work. Thus art that taught lessons based on the Bible or history was the most important, and, as a corollary—with the exception of architecture—the more useful, the less worthy of esteem it was. This generally applied to crafts. Gropius insisted that aesthetics should determine how successful art is, not its medium or category. Saarinen and Gropius, like George Booth, were also enchanted by Morris's ideal of

communal life, and it endured at the academy. The ideal of community infused Cranbrook through shared meals, as well as an active campus social life, including dances, costume parties, and cooperative artistic projects. While architects' offices depend on teamwork because of the complexity of designing buildings and architecture's reliance on specialties like engineering, artists generally work alone. Cranbrook's group approach to solving design problems was unusual and would influence the artists who studied there and strengthen the bonds they formed.

Before Bertoia arrived at the Academy of Art, some people at Cranbrook had noticed him when he was at the School of Detroit Society of Arts and Crafts. Having received a letter of admittance, he was invited by Loja Saarinen, the director's wife, to show her some "suggestions for a ring she wished to have made," which reflects something of the intimacy of the early Cranbrook years.[4] Students and faculty all knew each other and interacted extensively, which the flexibility inherent in having no curriculum or degrees encouraged. Students worked independently, conferring with the faculty on their own initiative, sharing their work and ideas with each other in what now might be called a "learning community." The architecture critic Paul Goldberger described the Cranbrook Academy of Art's uniqueness: "It is part artists' colony, part school, part museum and part design laboratory" that never let students "be bound by the narrow lines separating various design disciplines."[5] They interacted in many situations, social as well as educational, which increased their opportunities to learn from each other.

"Cranbrook," Bertoia remembered, "did not have a specific program, all classes were rather open, could be freely attended or abandoned pretty much at will." He mentioned having attended some of Wallace Mitchell's drawing classes. Financial difficulties had led to closure of the Metals Shop in 1933. In 1938, Bertoia's second year at Cranbrook, Saarinen asked Bertoia if he was "interested in starting a metal craft class" and Bertoia said, "this appealed to me very much because I saw some tools that were there and when I see tools I want to get busy with them."[6] As the Metal Craftsman, he taught full-time and produced his own work.

Despite ideals and theory, architecture dominated the art academy, and Saarinen assigned the fine arts to as subsidiary a position as that of crafts. Eliel Saarinen's notion of the hierarchy of arts disciplines was directly reflected in the salaries of their "directors": Saarinen allotted himself an $8,000 annual salary, while the sculptor Carl Milles earned $5,400, the painter Zoltan Sepeshy $3,000, and Loja Saarinen, his wife and instructor of textiles, received only $900.[7]

Architecture students worked together in teams, often with Saarinen on his projects, and photographs show Bertoia had a role in them. He was naturally interested in studying structure—whether of plants, buildings, or sculptures—and he may have taken one or more engineering courses at Cass Tech. It is clear that the enduring interest in and understanding of architecture that Bertoia gained at Cranbrook would contribute greatly to his success in designing and winning sculpture commissions. Eliel Saarinen's professional reputation attracted students who became esteemed designers and architects, including his own son, Eero (who had earned his architecture degree at Yale before returning to Cranbrook), Charles Eames, Harry Weese, and Ralph Rapson. Inclusion in this architectural circle taught Bertoia to think like an architect. An especially important result was his ability to envision space from floor plans, elevations, and other architectural drawings, a significant advantage when designing sculptures for particular spaces and buildings yet to be constructed.[8] Cranbrook's faculty was predominantly European and male. One of the few female students was Florence Schust (who later married Hans Knoll), an orphaned student at the Kingswood School, whose early interest in architecture led her to Eliel Saarinen and then Cranbrook Academy. She would be welcomed into the Saarinen family, going with them on family vacations to Finland, and Eero became like a brother to her.[9] Putting great effort into major national competitions was an effective

P. 47 8

strategy that Eliel Saarinen and his son used for advancing Cranbrook's reputation and for preparing students for their own professional lives. Eero Saarinen and Eames are believed to have first collaborated in the design of a modern exhibition system for the 1939 Faculty Show at Cranbrook.[10] The 1940 Museum of Modern Art (MoMA) competition Organic Design in Home Furnishings was one of the most important competitions on which Cranbrook students and faculty members collaborated. They designed chairs whose fluid shapes were their visibly "organic" characteristics, but their biomorphism resulted more from the aim of suiting the human body than from simply wanting their style to conform to the competition's title.

P. 46

Perhaps the most prominent commission for which Cranbrook architects competed was for the art museum to be affiliated with the Smithsonian Institute in Washington, D.C. Eliel Saarinen led the work on the project and plan at least in part because entry was limited to professionals, although students could assist. It was a major victory for Modernism that a modern design was specified.

The Smithsonian Gallery of Art (now the National Gallery of Art) design prepared at Cranbrook was ostensibly the work of the firm of Saarinen and Swanson, led by Eliel Saarinen and his son-in-law, Robert Swanson, but like many Cranbrook undertakings, it resulted from a highly collaborative process. Chris Chamales, Rapson, and Eero Saarinen did the competition drawings, and a Detroit cabinetmaker produced a mahogany model, which had to be veneered with a thin layer of marble in order to meet the requirements. Students made metal trees to suggest landscaping, and a sculpture of Pegasus for the center of another pool. Casting all of the miniature sculptures and fabricating "silver railings and window muntins set into Plexiglas," as well as other metalwork, were Bertoia's responsibilities. He and Milles melted nickels and dimes to obtain the silver.[11]

They won the 1939 competition, but the building was postponed because of the war. When the project again became a priority in 1945 as the National Gallery of Art, the former Secretary of the Treasury, Andrew Mellon, who was responsible for raising much of the cost of the building and donated the first important collection to the museum, selected John Russell Pope to design the building in a simplified neoclassical style "suitable" to the National Mall. The updated neoclassical design chosen was anti-Modernist but reflected a postwar desire for the stability, order, and permanence that classical forms convey. Winning the competition and then losing the job must have been a galling and horrible disappointment for those at Cranbrook.

The leader of Cranbrook's second generation of artists was Eero Saarinen, who practiced architecture (often with his father), taught at Cranbrook, and designed furniture. Charles Eames had been a practicing though not terribly successful architect in St. Louis when he came to Cranbrook in 1938. In the 1940 Organic Design in Home Furnishings competition, he collaborated with Saarinen, and they won a first prize for a molded plywood chair as well as another prize for modular furniture. Ray Kaiser had provided the drawings for the chair, and Don Albinson and Bertoia made the model. Their different areas of expertise made the group a good team, and as Rapson recalled in a 1982 interview, "Saarinen had lots of ideas about various chair forms but little idea then of construction methods; Eames, on the other hand, had a great interest in technology and detailing."[12] By stretching upholstery and foam rubber over bent plywood, they could give chairs entirely new forms, surpassing the complexity of Alvar Aalto's and Marcel Breuer's plywood molding of the 1920s and 1930s, although mass production was not then technically feasible.[13] These revolutionary designs are most significant, however, because they spawned virtually all the chairs that Saarinen and Eames would design separately, and this common source helps explain the similarities in some of their later chairs.

P. 47

Working across the hall, Bertoia was devising a chair of his own, his first. Using sheet plywood for each side of the chair established the structure and

P. 49

defined its silhouette. These two pieces of plywood provide the chair's base and legs while also framing the seat and back. After drilling carefully spaced holes near the front edge of each plywood piece, Bertoia inserted wooden dowels that join the plywood of the frames and support the sitter. A thicker dowel serves as a stringer, reinforcing the top, and is repeated at the base of the chair. The transition from vertical back to nearly horizontal seat provides a pleasing and rather unexpected continuity. This appears less comfortable than Bertoia's later chairs, although its dependence on linear elements prefigures the metal chairs to come.

Schust, who remained "Shu" to friends even after marrying Hans Knoll, became friendly with Bertoia and knew of his work on chairs at Cranbrook. She studied at the Architectural Association School of Architecture in London but left because of the war. Then she studied with Mies van der Rohe at the Institute of Design in Chicago, returning often to Bloomfield Hills and the academy, which was in many respects her home. It seemed natural for her to invite Bertoia in 1950 to join Knoll Associates,[14] the company she and her husband, Hans, owned, where she was head of design. Bertoia always remembered the time in his student days when he saw her for the first time, reclining on a green sofa in the Saarinen home.

Like his father, Eero Saarinen often designed furniture. After about 1940 he generally used his own furniture designs, produced by Knoll, in effect rejecting the Arts and Crafts tradition that his father had so long upheld and instead working as an industrial designer. Eero had learned a great deal from Eliel, including how to solve design problems by thinking, as Eliel said, of "the next largest thing. If the problem is an ashtray, then the way it related to the table will influence its design. If the problem is a chair, then its solution must be found in the way it relates to the room."[15] Bertoia learned from these words that he would have heard from both Saarinens.

In September 1940, a young German woman, Brigitta Valentiner, was admitted to Cranbrook through her father's connections. When German politics had gone from unpleasant to dangerous, Edsel Ford had invited her father, the art historian Wilhelm Valentiner, to become director of the Detroit Institute of Arts and live at his Grosse Pointe estate. Valentiner and his young wife, Caecelia, had traveled extensively when he was a well-known art adviser to important collectors in Europe and the United States, as well as a connoisseur specializing in Rembrandt and his circle. Wilhelm Valentiner was also a prescient collector, amassing prints and paintings by German Expressionists, especially works by members of Die Brücke and Der Blaue Reiter. As a scholar of the Renaissance and Baroque who had a real taste for Modernism, Valentiner was exceptional. He was unusual in his interest in young living artists and unique in collecting so far out of his expertise, much less in buying the Expressionist pictures that Hitler despised and made the focus of the 1937 *Degenerate Art* exhibition. Collecting this work was aesthetically and politically risky, even dangerous. The Valentiners moved from the smart suburbs into Detroit, where they lived in the director's home attached to the museum.

As the only child of peripatetic parents, Brigitta had often been left with nannies or relatives and at a Swiss boarding school. This intelligent girl who experienced a less-than-happy childhood became a resourceful, energetic, and lively woman, fluent in three languages and very widely read. Brigitta was completely unlike other Cranbrook students: she had little sense of direction and no compelling interest or real talent in art. She remembered making two small pieces in Maija Grotell's ceramics studio that she decorated with images inspired by Paul Klee prints she had discovered in her mother's books. Her painting classes with Mitchell and sculpture with Marshall Fredericks were better experiences than her weaving class with Marianne Strengell, where she accidentally cut the textile on her loom in half. Soon she focused on Bertoia and their courtship.[16] Her parents were delighted by the prospect of an artist as son-in-law, and Bertoia rather idolized her father. He and Wilhelm Valentiner, whom he would come to call "Papi," became very close. They talked at great length, often about art and

P. 48

Modernism, and the older man encouraged Bertoia in his work. Over the years Valentiner would speak to dealers and friends, encouraging them to buy Bertoia's work. Brigitta and Harry were married on May 10, 1943, with Cranbrook student Clifford West as best man and Brigitta's parents in attendance. Valentiner would be an important adviser to the young artist early in his career. Various accounts credit Valentiner and his wife separately for introducing Bertoia and his work to the New York gallerist Karl Nierendorf.

17

P. 51

Bertoia said he "did a little bit of painting" at Cranbrook when he studied with Mitchell, but "it was going in a direction where it never quite satisfied me because of the lack of spatial dimension." *Mountain Landscape*, a watercolor that is especially unusual in being both signed and dated by the artist, is a good indication of both how and what Bertoia was painting at Cranbrook. The straight lines result in a geometric character that is stylistically between the work of Paul Cézanne in the 1870s and 1880s and proto-Cubism a few years before 1910. Bertoia's forms and their contrasts of warm and cool, light and dark, were quite successful efforts at making the mountains solid and volumetric and defining many layers in space. This work is more abstract and emphatic than the Cézannesque still life. But painting's reliance on illusion "wasn't quite what I was seeking," he explained, and he increasingly turned to work in three dimensions.[17]

4

P. 46

At least in part as a result of his growing dissatisfaction with painting, Bertoia increasingly turned to Milles, the prominent Cranbrook sculptor. Bertoia greatly admired Milles, whose figurative bronzes, including the *Orpheus Fountain*, are landmarks on the Cranbrook campus. Bertoia and Milles talked often, and Bertoia remembered their discussions as thought-provoking and instructive. While he liked and admired Milles, Bertoia never took a class from him; his affection and respect for Milles kept him from explaining his reasons, and the conservativism of Milles's art is one likely explanation. Milles's works now seem much closer to the works of Auguste Rodin than to those of Constantin Brâncuși. Bertoia acknowledged having learned a great deal from Eliel Saarinen and especially liked and admired his son, Eero, with whom he worked on commissions in the 1950s. Grotell, who had come from Finland like the Saarinens, had taught ceramics in New York and New Jersey before coming to Cranbrook, where she was head of her department from 1938 to 1966. Grotell and Mitchell, who had earned a master's degree at Columbia University after studying at Cranbrook, taught drawing and painting at Cranbrook and were more receptive to nonobjective art than most of their colleagues. Grotell and Mitchell would be more supportive of Bertoia's work than others and were sympathetic to his views. Mitchell was one of three American-born members of Cranbrook's faculty; Bertoia settled into Cranbrook quite easily, perhaps in part because being European was not unusual there.

Cranbrook offered other important types of artistic and intellectual stimulation in its extensive library holdings, a wise early investment in the students' education. Even in Bertoia's time, it was a repository for great numbers of influential art books and periodicals. Journals are especially important in contemporary art, because they contain announcements and reviews of exhibitions that reach the public much faster than books: even in the 1920s, announcements and reviews of gallery and museum exhibitions appeared a few months after the shows opened, so serious artists could read about and see photos of works that were in distant places. It is not hard to imagine the young Bertoia pouring over this wide array of illustrated journals, especially since he read numerous periodicals on many subjects later in his life.

Additionally, famous artists and architects came to campus, including Wright and, on one occasion, Gropius and László Moholy-Nagy, who came together from Chicago. Bertoia recalled that once he happened to sit across from Gropius at lunch. "True to [Gropius's] nature, he didn't lose any time but popped a very important question. He said, 'What can you do with objects in space?' Well, of course I did not have an answer, and I probably

am still working on it, but it was a relevant question then, and it's really, as one sees it now, . . . at the core of the Bauhaus mentality."[18] Visiting artists helped keep Bertoia and others at Cranbrook in touch with trends and ideas in the United States and Europe. Bertoia clearly knew about the Bauhaus when Gropius and Moholy-Nagy visited campus, and he would have read about the works of Wassily Kandinsky, Paul Klee, and others and discussed them with Valentiner as well as his friends. Shu was studying with Mies van der Rohe at the Institute of Design in Chicago, colloquially known as the "Chicago Bauhaus" or "New Bauhaus," which Moholy-Nagy had founded after fleeing Germany. Mies, the last director of the Bauhaus in Dessau, left for Chicago and Moholy-Nagy in 1933 opened the Chicago Bauhaus. Richard Schultz, an industrial designer who would later work with Bertoia, studied at the Institute of Design, as Moholy-Nagy's Chicago Bauhaus had become, and noted the value of the Bauhaus foundation course, which "taught the Bauhaus concept of creativity" and depended on seeing projects as problems to be solved.

JEWELRY AND HOLLOWWARE

Bertoia had a solid enough foundation in jewelry making techniques to teach when he assumed the position of Metal Craftsman in 1939. He soon learned to use the equipment at Cranbrook, allowing him to make larger objects, usually functional ones, which he enjoyed. It allowed him to increase his skills, which always pleased him, and expanded the range of items he could make. Bertoia noted that he was delighted with the tools he found in the Metals Shop. He discussed his early work in that position with characteristic modesty:

> This was really the beginning of the metalwork at Cranbrook. Well, it was more the beginning for me; I'd done very little of it at Cass when I was confined to jewelry, but at Cranbrook they had larger tools. . . . Oh, [what I did was] of no great value from any point of view. What it amounted to were pots and pans, some useful tableware, trays, and beer mugs. . . . But it was the beginning of an acquaintance period with metal and as such had value.[19]

The jewelry course introduced techniques like casting, forging, and chasing that were completely foreign to the students. Always logical and systematic, he explained metalworking techniques while he demonstrated them to the students. This was a much more efficient way to introduce materials and processes than individual instruction. When he finished demonstrating, he often gave students the pieces they had watched being created.

P. 50

While Bertoia's working methods were influenced by the Saarinens, they also reflected those of the Bauhaus, and they influenced his approach to teaching, including his approaching any project as a search for the best solution to a problem. This involved analyzing materials, processes, and design together with the function of the intended project. The studies or models that resulted would be compared and analyzed, often resulting in a synthesis of the best aspects of the studies. Refinement came next, often involving many steps. This emphasis on problems and their solutions determined that he would use some traditional methods as well as many techniques he invented in making his jewelry and sculpture.

Several decades later, Bertoia would classify his sculpture according to the processes he had used to make it. It is an approach that applies equally well to his jewelry and may have been an outgrowth of his teaching. There are a few early, traditionally cast pieces made by the lost wax method. Other processes he used were modeling or shaping works by directly manipulating the hot metal, and constructing jewelry out of wire. In addition, he constructed hollowware from sheet metal. He experimented with working bronze on a lathe, for example, and made a small number of other works using unusual or combined techniques, most of which he produced after leaving Cranbrook.

Few of Bertoia's cast works still exist. He made at least two conventional rings set with single stones, one for his brother Oreste's wife, and one he made in about 1942 for his future mother-in-law, reusing a stone she already owned. Its clean lines make it classic and timeless, but small quadrilaterals enliven it and the shank adds to its subtlety and modernity. Caecelia Valentiner's ring and two others Bertoia cast are consistent with his later work primarily in their fine craftsmanship. They were made using the lost wax technique of casting, a centuries-old technique that begins with modeling a wax version of the desired item, then encasing it in plaster. Heat is used to melt the wax, which runs out of channels made in the mold. Pouring molten metal, usually silver or gold, into the mold fills the cavity left by the wax. When the metal is cool, the plaster can be chipped away to reveal a metal object in the shape and with the character of the wax model.

A Modernist ring he made while demonstrating this process in class is unusual. The cast silver piece has a sculptural front resulting from Bertoia having carved wax into pronounced raised and recessed areas that thoroughly synthesize organic and geometric traits. He then made a mold from the wax form and demonstrated lost wax casting, giving the ring to a member of the class when he was finished. Sixty years later the woman who had received the demonstration piece learned that she and Bertoia's daughter, Celia, lived in the same town. She gave Celia the ring.

At Cranbrook Bertoia also cast several other Modernist rings as well as simpler wedding bands; Eames asked him to make one for his bride, Ray, and he made another for the wife of Edmund Bacon, the architect and Philadelphia city planner. He also cast a study for his own wedding ring, using aluminum, likely recycled, because of the difficulty of obtaining silver during the war. The slight curve of the sides made a better fit between fingers and the slit at one corner is similar to the more rounded version he made for Ray in 1941.[20]

Bertoia rarely if ever cast materials after he left Cranbrook, because he believed in "truth to materials," the principle advocated by the Russian Constructivist Vladimir Tatlin that every material has a nature or essence that should be respected and used expressively. Marble, for example, should not be carved and polished to look like human flesh but should be worked in ways that reflect its structure and strength. Only a few years into his tenure at Cranbrook, the idea of "respecting the integrity of materials," another way of expressing this idea, led Bertoia to reject casting metal, because an object that has been cast reflects the pliable original from which the mold was made and conceals the nature of the material itself. Bertoia preferred to work more directly and make works that brought out the nature of his materials.

Given free rein in Cranbrook's metals department, Bertoia put the facility and equipment to extensive use, experimenting with processes and making many pieces of jewelry in only a few years. These works always resulted from the intersection of materials and processes with Russian Constructivism, Vitalism from France and England, and his own design sense and ingenuity.

Modeling is the shaping of soft, pliable materials like wax and clay by gouging, pushing, pulling, and rolling them. It is often used to make the original from which a mold for casting is made, but it can also have other uses. Bertoia modeled molten silver, forming it without a mold. He shaped the hot silver with improvised tools, using whatever was at hand as long as it would not melt. He even squirted and sprayed water to push silver into fluid shapes and create texture. This method is virtually unprecedented, in part because of its potential danger. It suited Bertoia because it preserved much of the volume achievable in lost wax casting while letting him work the metal directly. It reveals the liquid state of silver, in which it was worked very directly in free-form, highly organic, modeled silver pieces. The shapes of this vaguely human brooch have more in common with abstract Surrealism than with human anatomy but clearly express the nature of the silver when it was molten.

P. 54

Bertoia made directly modeled pieces soon after taking over the Metals Shop. The resulting pieces combined two Modernist tendencies begun in the 1920s that were still current in the 1940s: abstract Surrealism and Vitalism. Molten silver's liquidity encouraged using the vitalist forms that always appealed to Bertoia. But these methods and shapes are also consistent with his preference for methods that allowed him to work directly and show respect for the integrity of materials, as had Brâncuşi and Kazimir Malevich. These ideas remained consistent and important in Bertoia's mature work.

For decades brooches have been popular, because they can be worn on many types of clothing. From an artist's point of view, they are small, frontal sculptures that demand none of the anatomical compromises or varieties of sizes required by necklaces, rings, and bracelets. A pin traditionally has a decorative front or face and, hinged out of view on the back, a pin bar or stick can open and penetrate clothing before being secured in a concealed clasp. Commercial findings like clasps and pin bars were available, but Bertoia, like Alexander Calder, made most of his own and integrated them into the works.

In the 1940s and 1950s, mass-produced pins often represented natural forms, although there also were some geometric brooches. Leaves and flowers, shells, seahorses, and fish frequented the lapels and shoulders of women's dresses and jackets. Most pins ranged from 1 to 3 inches (2.5 to 7.6 cm) in size in part because jewelry must suit the clothing it is worn with, and many fabrics cannot support the weight of heavy pins. Period photographs document the unusual shapes Bertoia achieved in rows of brooches and pendants that he made before 1943, when obtaining metal became extremely difficult because of the war. Some of these forms are rather geometric, but most are highly organic and vitalist. They are quite unlike most jewelry from about 1940 and remain unusual. While he also made necklaces, pendants, earrings, and bracelets, Bertoia made more brooches or pins than any other form of jewelry.

P. 52

18 19

Having mastered the major traditional techniques of jewelry making before going to Cranbrook, Bertoia now had both the skills and opportunity to work as he chose. A large percentage of his jewelry is constructed of wire, which he found creatively promising and marketable. At Cranbrook he devised innovative ways of connecting elements that led him to new forms.

P. 54

23

One unusual type of jewelry Bertoia constructed of wire must have been inspired by spiderwebs. His brooches of this type all differ but are structured similarly of wires that extend in several directions from a core and have sewing thread wrapped around them as they stretch from one wire to the next, making an orderly web of transparent planes of thread that reach almost to the wires' tips. In one such brooch, a small piece of matte aluminum is tied at the center of the brooch's foundation by a silver wire. Extending from under the brooch, a longer wire stretches beyond the sides of the web to serve as the stick that bends back to form a hook and clasp the end of the pin bar. Bertoia flaunted this functional element rather than concealing it, as is conventional. It increases both the size and presence of the piece. Combining the bar and clasp and leaving them visible, Bertoia made the spiderweb more abstract, distancing it from the natural world and making it an inventive and unorthodox Constructivist brooch. Years later, walking and observing the woods near his home, he would remark about his admiration for the strong and delicate spiderwebs, especially when sunlight caught dew on their strands.

Bertoia probably experimented first with thread as practice for using silver wire. The number of surviving threaded pieces suggests that he liked using the thread, with its fineness and color, and liked placing it in an unexpected context. Pieces including thread range widely in color, but he often preferred unusual colors like dark purplish-brown. Including so cheap and ordinary a material as thread in jewelry likely appealed to him as a small act of rebellion as well.

A pendant with a foundation of silver wires is a substantial example of the silver webs. Bertoia carved a lozenge of ebony, then set it with small, irregular bosses, or a drops, of silver. The ebony-and-silver lozenge is the focal point of the work. Layered in space, its elements produce a sculptural effect as well as contrasts of light and dark, reflectivity, texture, shape, and mass. The tips of the wires are flattened into elongated ovals. Their eccentric surfaces catch light from many angles, much as the wire's irregularities do. They also reveal the difficulty of pulling wire straight, unlike thread. These imperfections are consistent with the rest of the piece, because their effect is organic. At nearly 6 inches (15.2 cm) long, this brooch is dramatic. At least twice the size of most pendants, it exemplifies Bertoia's penchant for making large jewelry and seems to suggest that even at Cranbrook he wanted to work on a big scale. However, he also made pins resembling this pendant's central element but lacking spiderwebs. A related, slightly more refined, pendant uses thinner wires and has a silver, modeled center that includes a black bead that appears to be made of plastic. (He used plastic beads in some other pieces as well.) It is large, approximately 6¼ inches (15.9 cm) long, and is very striking and bold.

Bertoia's wire constructions include many other types of brooches, but they often evolved from a form called the bar pin that was popular in the Victorian period. Structured around a metal bar, generally quite narrow, a bar pin was usually worn horizontally at the throat, spanning the gap between the points of a collar. At the end of one Modernist bar pin is a modeled, organic form with four hammered wire "fingers" soldered to it. A small boss of silver projects between two fingers, adding dimension, contrast, and variety to the brooch. Turning the pin over, however, reveals that the boss is more than decorative: it is the head of a rivet that extends as a short wire emerging on the back, curving down and serving as the clasp. The bar itself is a wire hammered and pierced near its left end to accommodate another rivet that enters and exits the pin like a sewn stitch, then bends back toward the large end of the pin as the stick. The two small, three-dimensional elements on this rather minimalist brooch are at once functional and decorative. In pieces of Bertoia's Constructivist jewelry, like this pin, he cleverly integrated the findings into the design, making them simultaneously functional and decorative. Ingenious and economical problem solving is evident in much of his work and has a great deal in common with the Modernist taste for revealing structural materials in buildings while also assigning them an aesthetic role. The structure of this seemingly unprepossessing bar pin became the basis of many of Bertoia's brooches.

Kitty Baldwin Weese became an important collector of Bertoia jewelry. She had multiple ties to Cranbrook: her brother, Benjamin Baldwin, worked on the Smithsonian Gallery of Art (now the National Gallery of Art) design project with Bertoia while on an architecture fellowship at Cranbrook, and the man she married, the architect Harry Weese, was also a fellow there who would become her brother's business partner. Bertoia gave her a wonderful brooch that has a structure descended from, but more elaborate than, that of the pin with the "fingers." The bar is hammered at one end, where the stick is hinged to the bar by passing through a small hole and descending through an adjacent one. The other end of the stick passes behind the brooch to curl into a hook to catch the bar. Most of the pin is one long hammered wire scribbling back and forth to pierce the cylindrical spine repeatedly in a controlled and lazy path that widens, then narrows.

Its simplicity is elegant, with a natural and fluid movement. The small functional wires at each end of the bar contrast with the longer, flat lines and reveal their function on the front of the brooch. Bertoia made a variety of pins constructed in this way, as well as at least one ring and a bracelet. In many of these works, the elements piercing the central stem are shaped like barbells, their rounded ends preventing them from slipping out and also adding a bit of weight that encouraged them to be mobile. These small elements shift in position as the wearer moves.

Bertoia experimented with adding movable parts to wire constructions, as on a pendant from about 1940 that belonged to Kitty Baldwin Weese. He constructed these pieces without soldering, using only cold processes to connect pieces by having the ends of some wires support others. This entailed hammering a wire flat, widening it, then piercing it to make a small hole. Inserting another wire through the hole, he could then attach it permanently by hammering its tip so it widened and could not slip through the hole. The hammered ends of wires spread and curved a bit, gracefully supporting other wires. Punching an opening at the end of a wire and inserting another allowed Bertoia to join the parts of many works. He had arrived at a simple, straightforward technique that required no special equipment, one he could even do at the kitchen table. This humble technique also introduced motion.

Two bent and flattened wires, the small one attached to the larger, hold five hammered drops that curve and flare at the sides of Weese's pendant. Alternate ones are threaded with a bone bead, introducing other shapes, colors, and materials. Like the tips of the upper wires, those that hang have tips hammered into organic shapes that retain the beads and finish the drops. Pendants always move when worn, but this one, 4½ inches (11.4 cm) long, would be full of motion. Even in 1940 Bertoia was experimenting with the potential for motion in his work.

Bertoia is renowned for the kinetic sound sculptures that were his focus in his last years, but his interest in mobile elements began with jewelry. Even in the 1940s, Bertoia's work was thought to have elements in addition to kinetics in common with those of Calder. Bertoia had been selling his jewelry and hollowware, including serving dishes and trays, at crafts shows in the region, such as the Detroit Artists Market, where he began showing in 1938. In 1940 Karl Nierendorf assembled an exhibition of Modernist jewelry in his New York gallery that included works by Bertoia and Calder. The two artists had arrived independently at new and often parallel ideas about jewelry techniques, materials, and functions. Their Modernism lay in reliance on the aesthetic effect of design and construction, not precious materials. As a result of this enormous change of emphasis in jewelry, they are often called the founders of the modern studio jewelry movement, when they actually were its predecessors rather than members. It was soon after World War II that American modern studio jewelry[21] emerged with the work of Art Smith, Margaret de Patta, Ronald Hayes Pearson, John Prip, and others. It was part of the larger modern studio crafts movement. Their bold organic forms, Constructivist abstractions, and combinations of metals appeared on wearers at readings of Beat poetry, and folk music and jazz performances, as well as exhibitions of Abstract Expressionist painting. Bertoia's producing such work in the Midwest before 1940 is remarkable. Perhaps just as surprising is that women in Bloomfield Hills and Detroit were buying and wearing his jewelry.

Jewelers are often reluctant to make earrings, because producing two that match often requires making three or more. While earrings sell well, sometimes they are hardly worth the effort it takes to make them. When he was at Cranbrook, Bertoia clearly was not well-informed about findings for earrings that allow them to stay in place, much less be comfortable. Pierced ears were not as popular or even acceptable in the American middle class as they were in Europe, so he devised ways of making earrings that were alternatives to the screwbacks coming into widespread use. The result was that he designed an attractive and inventive wire spiral that could be pressed against the back of the ear to keep the earring in place. The clusters of four hammered, bent, and slightly creased wires form the leaves of these earrings. They were riveted together by the wire that forms the spiral fixture behind the ear.[22] They would move slightly when worn, creating flickering reflections. It is likely that at the time Bertoia sold them for ten or twenty dollars, and they were rarely worn because their backs were fragile and may not have kept them firmly in place. Because such earrings were inexpensive and difficult to wear securely, it is likely that few of those that were made have survived—Bertoia silver earrings are rare.

P. 57

30

31 P. 58

He made an exuberant wishbone design, one of a number of such pieces, using some recycled materials, suggesting that it was from 1942, when metal was quite difficult to obtain. One stem is repurposed, bearing the stamp ".999," which usually indicates the purity of the silver, and the copper stems of the earrings have some indecipherable lettering stamped on them as well. Five hammered wires pierce the stem, forming a variation on the wishbone form by passing through the stem and turning down. The stem has more patina than the leaves, giving it a coppery color. The use of small commercial "jump" rings facilitated adding new handmade ear wires.

34 P. 59

In a rare extant pencil study of jewelry, Bertoia explored highly sculptural shapes. Such volumetric forms would require modeling, casting, or carving, like with the ebony piece centered in the silver web pendant, which he was increasingly reluctant to do. These pieces typically have wires connecting segments, a motif he was then exploring. Familiar forms appear within the deeply pierced spaces in the center of the lower row of the drawing, and their interior forms resemble the ebony and silver sections of extant brooches constructed of wires. The masses in the drawing have characteristics of both geometry and organicism, which is typical of shapes in much abstract Surrealist painting and sculpture of the era.

Brass is inexpensive and flexible, with appealing color. Bertoia used it extensively beginning about 1940 and also near the end of the decade in California. The directness of cutting and hammering brass wires and sheets and fabricating them cold, without soldering, must have been a delight. Applying only a little force to an industrial wire with a hammer could produce biomorphic or organic shapes. Chance sometimes entered into the process. Bertoia almost certainly sketched ideas for some pieces, perhaps even drawing directly on the brass before working it, and he could vary surfaces, chasing them to create small indentations that caused multiple reflections. Such surface details have to be complete before sculpting the sheet metal, to avoid distortion. Bertoia's love of direct techniques also determined the characteristics of a remarkable forged and riveted brass brooch from a Rhode Island collection. Bertoia shaped the leaves or petals, cutting and bending them slightly, then inserting rivets to align and retain them. This construction lets the thin, flexible brass elements move with increased freedom. Bertoia varied the three-dimensionality of individual leaves, creasing some lengthwise along the center so their sides slope down, while others are slightly domed.

33 P. 58

Strikingly fluid and energetic, the brooch's abstract forms suggest the motion of a real, living form, giving it biomorphism without a specific biological reference. Its substantial size—6 inches (15.2 cm) wide—would occupy half the distance between a woman's shoulders. (Bertoia made a smaller version in gold for his fiancé, perhaps reducing its size because of the cost of materials, but he must have realized so large a piece would be too much for a petite woman like her.) He seems to have been unaware that oversized jewelry is difficult to wear. Twenty years after receiving a pair of brooches similar to this one, Pipsan Saarinen, Eero's sister, had a royal-blue evening dress designed and made to accommodate a pair of large Bertoia brooches related to this one in design and also made at Cranbrook.[23]

Bertoia had no interest in making anything resembling the typical jewelry store merchandise. He wanted to avoid jewelry's usual social connotations and expand its artistic possibilities. He frequently used unusual materials in an effort to make a new kind of jewelry based on good, inventive design and brought out the inherent beauty of lesser, nonprecious materials. It was the combination of these factors that led to comparisons between Bertoia's work and Calder's even in Bertoia's early Cranbrook years. These two artists independently produced oversized pieces in brass with fastenings integrated into their designs.

Calder had studied engineering to escape becoming the third generation of sculptors in his family. Soon discontented with his job, he left for Paris. In the 1920s he was fortunate to find himself in the company of artists of the

Parisian avant-garde and charmed them at parties by pulling brass wire and little trinkets out of his pockets and forming them on the spot into wonderful toys and jewelry. Because Calder never studied jewelry making but instead worked instinctively and spontaneously, his necklaces, pins, and earrings were usually fabricated cold, without solder, in brass wire and sheet. His grandson, Alexander S. C. Rower, observed that Calder "did not differentiate between artistic formality and the grace of functionality," and so he exposed the fasteners in his jewelry as freely as did Bertoia. Often inspired by non-Western jewelry, he adopted motifs eclectically, especially from disparate African tribes, and he often wired bits of colored glass and ceramic shards to his brass pieces. Rower noted that his grandfather's "at once primitive and refined" jewelry reveals "the eccentricities of his hand expressing subtle tactile qualities."[24]

After the exhibition at the Nierendorf Gallery in New York, Bertoia's and Calder's works again appeared with those of others in 1947 at Alexander Girard Gallery in Grosse Pointe, Michigan. Their works seemed more similar than they actually were, because they both relied heavily on brass wire and sheet when other jewelers were mostly using silver. Bertoia's silversmithing skills were a great advantage, providing him with a full repertoire of techniques to use, adapt, or reject. His jewelry initially appears deceptively simple but is always finely crafted and meticulous, in contrast to Calder's impulsiveness. There is nothing primitive about it. Whereas Bertoia smoothed the edges of forms, Calder might leave them jagged, proof of having worked quickly. These differences in their works resulted from conscious decisions: they are aesthetic in nature rather than matters of quality. Calder and some of his works have been described as rather childlike and innocent. The focused and often intense Bertoia at times could also achieve a childlike freedom and playfulness in his art, but it is informed rather than innocent. Importantly, these two Modernists who would become known for their large-scale metal sculptures both wanted to escape the economic and social connotations of traditional jewelry and instead make wearable art. Ironically, their jewelry, intentionally designed to avoid the pretentions of gems, now sells for tens of thousands of dollars.

A 1940 Nierendorf Gallery exhibition of Bertoia's metalwork was his first solo show.[25] From 1938 to 1943, Bertoia exhibited at a flourishing crafts fair, the Detroit Artists Market, selling jewelry and hollowware in brass and pewter, and also at a small shop in Bloomfield Hills. For a Faculty Show at Cranbrook in about 1942, he exhibited a group of hollowware pieces, tea caddies, pitchers, even a platter with repoussé divisions to separate foods, demonstrating that he had studied the conventions of formal meals before giving traditional vessels clean and sensuous Modernist forms. His work "can be divided into two categories: beautifully imagined and completed metal ware and playful jewelry, which was often improvised on the bench." While no preparatory drawings survive for the larger silver pieces, Bertoia "often made maquettes in baser metals to test the feel and clarify details before the final version was turned out in silver."[26] (Bertoia was expanding his repertoire of techniques, including spinning a bronze vase on a lathe into a form both bold and elegant in its simplicity. Its shape and reflections are so pleasing that no added decoration is necessary. Its Modernism is based on truth to materials and processes.)

The most complex of Bertoia's large Cranbrook metalwork pieces were sterling silver tea and coffee services with creamers and sugars. Their wonderfully Moderne designs are great American examples of the Art Deco style as it grew increasingly streamlined in the 1940s. Bertoia mastered the geometry as well as both the angle and increasingly mechanistic style of these sophisticated pieces for use and display on buffets. The *Coffee and Tea Service* in the Cranbrook Art Museum has the clean planes, crisp edges, and swept curves of the era. The vessels are full and round in front to hold and balance their contents while being poured. The long curves of their sides meet at a straight plane in back below cherrywood handles arched to match the curve in the metal below. Because it holds something so physically different, the sugar suggests but varies the form of the other

P. 60 35

P. 47 7

P. 61 37

pieces to curve at both sides and open widely to admit a sugar spoon. The synthesis of geometry and organicism in the shapes here is a real departure from the strict geometry of Eliel Saarinen's designs for silver.[27] Wooden handles and finials protect hands from the heat of the beverages, and the warmth and texture of the cherrywood contrast pleasingly with the sheen of perfect silver planes. Bertoia clearly knew not only that silver's conductivity makes it unsuitable for handles but also that wood has been used since well before Paul Revere. In a tea service at the Detroit Institute of Arts, he paired Moderne shapes with the new material acrylic, creating a wonderful combination of smooth, reflective surfaces and interpreting familiar objects in a Constructivist manner. Bertoia's concern for function led him to insulate the coffee and tea pots by creating an air space between the sheets of silver to slow heat loss. There are only a few Bertoia coffee or tea services, reflecting their creation when the Great Depression was increasingly becoming a memory in wealthy Bloomfield Hills and such luxury items were more desired.

36 P. 61

32 P. 58

A highly unusual piece Bertoia likely produced not long before the Metals Shop was closed because of the scarcity of materials is a brooch made of a cast and tapered bronze bar with silver wire loops. The subtle twist of the bar is typical of Bertoia's attention to detail and his refusal to let an element be as expected. Wrapping and draping the silver from the elegantly shaped bronze encouraged the silver loops to be sculptural, alternately drooping from the front and rear of their horizontal support.

GRAPHICS

Bertoia made much of his entire jewelry output at Cranbrook, although he would return to making jewelry between 1948 and 1954 and make a few pieces from 1975 to 1977 that differ considerably from earlier works. In the late 1930s and early 1940s, he was dividing his days between working with architects, teaching, and working in metals. At night, however, he worked in solitude in Cranbrook's basement print shop. His graphics were a private record of ideas, a kind of pictorial journal that would be the source of many works in other media. As he developed new images, he also experimented with a variety of printmaking processes.

Years later, if pressed, he would discuss his two-dimensional works in terms of technique, but he usually tended to call all his works on paper, whether drawings or monotypes or mixed media works, simply "graphics" or "drawings." Like Russian Constructivists, he left his works untitled, wanting viewers to look and respond rather than rely on titles to tell them what to think. The great majority of his over three thousand graphics were monotypes, or unique printed images, but he began printmaking more traditionally, with woodcuts, including a small, quite realistic self-portrait. His intellectual grasp of design was solid, and his techniques had developed in step with his knowledge and analytical skill, as is especially evident in a pair of abstracted, complicated woodcuts he made in small editions, unnumbered, in 1941. They are significant for two reasons: they are considerably more sophisticated than the two woodcuts that preceded them, and they are the only overtly Italian subjects in his vast oeuvre. They were ambitious undertakings that demonstrate a mastery of both composition and style. These farm scenes draw upon memories of life in San Lorenzo. Identical in size and with boldly contrasting light and dark, a pair of prints, *Winemakers* and *Corn Harvest*[28], uses four rows (or registers) of active figures that are separated by narrow black bands. Many people in *Winemakers* bend and lift, picking and loading grapes into baskets, while others are sitting on a cart or stand crushing fruit in a huge vat, creating strong contrasts between active and more restful sections of the image. Narratives of biblical, historical, and genre scenes since the Middle Ages have relied on registers to organize images, especially those depicting sequences of actions, and Bertoia used this pictorial convention to relate the agricultural processes so familiar in San Lorenzo. He often violated the border separating registers with a wheel, the vat, or human feet, but

38 39 PP. 62–63

the division remains sufficiently consistent to organize the action. The figures are angular and linear, in a few cases white against black, reversing the predominantly dark figures against lighter backgrounds. They are stylized, geometric forms that contrast strongly with the black background. Details like the fine pattern of the baskets, of vats holding grapes, of wheels, barrels, and clothes vary the scale of lines and enrich the page. This abstracted depiction emphasizes the physicality of the work and the strength and energy of the farmworkers. They are abstracted rather than distorted expressionistically.

Corn Harvest (1941) shows the other main farming activity of a northern Italian late summer, as Bertoia remembered from his childhood. Everyone steps, lifts, or bends forcefully. This is a notably dark print, but the figures, the plays of line versus shape, and the textures are all consistent with those in *Winemakers*. However, they comprise a more adventurous and abstract composition. While the harvest unfolds in the conventional registers, some of the framing lines defining sections not only are at strong diagonals but also are fully integrated into the scene. So at lower left, the top of a fence both describes the setting and at the same time frames people eating lunch and those shucking corn below; some are silhouetted against the texture of ears of corn. At the center a bold, black diagonal line defines where a man is emptying ears of corn into a huge container at an angle, forming a diagonal. Every inch of these prints stresses the physical intensity of farming, which Bertoia would have remembered from experience. Entirely absent from this depiction of the artist's childhood are both social statement and sentiment. They are much more abstract and complex than his two earlier woodcuts, one a self-portrait and the other a boy reading in bed. As such, the two farm scenes show Bertoia's rapidly evolving ideas and skills. Their forms and decorative patterns are in many respects related to the early Art Deco style of Cranbrook, especially the works of Eliel Saarinen, most of which lack the rounded, volumetric, and machined forms and sense of speed of mature Art Deco.

P. 63

Working with images carved into wood has many limitations. The carving itself is tedious, encourages great detail, and invites errors that often require starting again. The fact that each print was the same as the ones before and after it displeased Bertoia: many years later he observed that he had "got tired [of woodcuts] because one print after another came out identical. I said 'Oh this won't do.' I got the notion that if I cut that block of wood in many parts then I could change the parts and there would be something new coming out. So that really happened and I was delighted. I said, 'Oh, this is fun!'"[29] He invented a new method of printing pictures, making unique printed images, or monotypes, in which techniques often were mixed.

His art had made tremendous leaps from the Cézannesque works of the late 1930s to the wood-block prints, which, in turn, would be the progenitors of works for decades to come. Soon Bertoia started working more freely on prints, placing his paper on the glass palette that he had inked with a brayer (a smooth roller usually 3 to 5 inches [7.6 to 12.7 cm] wide), and shortly after 1941 his work became more akin to the imagery of abstract Surrealism. Like the Dadaists, he had already begun to welcome chance in his artmaking processes, and now he increasingly embraced it. The use of chance had also become standard Surrealist procedure, incorporated into the movement's cult of dreams, Freudian ideas, and use of organic or biomorphic imagery. Automatic drawing was a Surrealist attempt to draw subconsciously, an extreme form of doodling. Bertoia worked quickly to take advantage of spontaneity—"happy accident"—especially in the 1940s, perhaps approaching Surrealist "automatism." He stressed that working fast on his graphics was important since the ink dried, and "I had to be speedy because I wanted to be ahead of my thought. If I could only stay within my inner self and work fast so that reason and awareness would not come in yet, that would be fine."[30] The imagery of Joan Miró, André Masson, and even Yves Tanguy interested him because it was open to multiple readings. For Bertoia, examples of such artists' pictures encouraged him

to follow his own ideas rather than to imitate them. As they were also doing, he began making swaths of color, opaque and transparent, and placing forms and lines within, behind, and in front of them.

Working in that Cranbrook basement at night, Bertoia evolved a way of printmaking that suited him so well that he used it for the rest of his life: inking a surface with a brayer, then placing a piece of paper on top of the ink and working from the back of the paper, blindly. By applying pressure with his hands, a stylus, or improvised tools, he transferred ink to the paper. Sometimes after removing the paper, he would place another sheet on the glass and print again, working from the back without reinking. This second print retained a "shadow" or "ghost" of the first one, as well as the lines, shapes, and colors he had just added. Bertoia would sometimes also draw on a print or even add collage, creating new layers of forms, textures, and greater depth. This method requires only a step or two but leaves open the possibility of adding to the work after lifting the paper from the glass. Technically, the results are monotypes, but some mix media, especially with the addition of painted and collaged elements. His method allowed great freedom and encouraged working non-objectively, as he wanted to do. Having demonstrated that he could work traditionally, he set off in his own direction. He was an unusually independent artist, an inventor and educated autodidact.

Late in 1941, A. Everett "Chick" Austin, Jr., the audacious, at times unconventional director of the Wadsworth Atheneum Museum of Art in Hartford, Connecticut, bough twenty-four monotypes from the young artist. No correspondence about this sale is in the Bertoia archive, and the museum's documentation only amounts to one delighted and grateful letter from Bertoia. On Cranbrook's Art Deco letterhead, Bertoia wrote on January 16, 1942, of his "deep satisfaction in learning . . . that one set of color prints was purchased by your museum. This is an honor and a rare priviledge [sic] distinguished by being the first concrete sign of encouragement in the continuation of that type of work." He could "vaguely remember" that each print cost two dollars and the set was "about thirty prints." Selling monotypes to Austin seems to have struck Bertoia as his first real sign of success as an artist.

The set of monotypes Austin bought is from *Synchromy #5*, Bertoia's fifth in the series of "Synchromies." Each piece explored one color mixed to modulate it in a wide range of intensities, values, and temperatures. Bertoia used the word "Synchromy" in reference to the term's musical connotations and as a nod to Stanton MacDonald-Wright and Morgan Russell, who had applied the word to their color studies in 1912. They named their style Synchronism, and it included the first American avant-garde works to receive international attention. Like other early abstractionists, they had justified their art by claiming their works were analogous to musical compositions. They varied the intensity and value of colors to create relationships among forms and illusions of depth, and also to suggest moods, all without recognizable imagery.

Bertoia's use of "Synchromy" is complicated because he did numerous series and called each "Synchromies." Use of any sort of title reflects the pressure Bertoia felt to give titles to works, which he strongly disliked doing, preferring to leave everything untitled. He chose so abstract a word as "Synchromy" in part because the works were about abstract visual relationships. He was willing to call a large group of pictures Synchromies, creating them in series, including the series *Synchromy in Blue* and the *Synchromy No. 5* series.

40 41 42 43 PP. 64–65 The Wadsworth's works generally use colors ranging from low-intensity or dull violet to red and red-brown, a palette that already reveals Bertoia's taste for unusual, subtle mixtures of colors. He often rubbed his palm or fist over the paper surface, letting the ink produce a granular texture, and allowing him to easily increase or decrease pressure and the amount of ink he was putting down. Lighter and darker areas suggest distinct planes in

space, reinforced by straight, black lines, likely applied from the front after printing. Occupying the fields of color in one monotype, is floating, geometric life. Some shapes seem anchored in place by vertical lines, others catch attention and send the eye moving around the surface, giving the work an emotional impact with a lighthearted, Surrealist taint. In another, bold slashes cross at many angles. The stillness and muted tones of others in the *Synchromy, No. 5* series give way to quick, aggressive movement and intense colors. The sense of speed and force from the lines and color make this a rare expressionist work by Bertoia. The enormous range of style and expression in these early, very experimental works shows he was learning how to achieve new effects and a great variety of compositions.

P. 65 42

P. 65 43

In 1942 Bertoia devised a more immediate and flexible way of working and never returned to making woodcuts. Using a brayer, he applied oil paint to a sheet of heavy paper. Like the palettes on which many painters arrange their colors, he set out areas of different colors of paint on a sheet of glass and dipped blocks of wood, instead of brushes, into the colors before stamping them onto the paper. He may at times even have printed from pieces of textured metal.

Sometimes his handling of the blocks emphasized textures that introduced interesting patterns into a work. At other times he emphasized the blocks' edges, creating short, sharp lines, then blurred the outlines of nearby blocks with a brush. He left evidence everywhere of how he had worked to create rich surfaces and interesting plays of space, color, and texture, adding some of these effects in paint with various tools. These nonobjective works were a great deal more avant-garde than most art at Cranbrook at that time, as Bertoia was aware. Today they confound curators and catalogers only because they straddle the line between painting and printmaking. Brigitta Bertoia often called them "wood-block paintings" rather than monotypes, an unusual but accurate description. Soon Bertoia abandoned oil paint for the backgrounds and relied almost solely on printer's ink for both the first layer of colors and the imagery. Working this way held great interest for him. He recalled beginning these works in 1942 and was still using the technique in 1948. He would at times replace square and quadrilateral blocks with ones shaped like bricks, long and rectangular, that gave greater variety in composition. Using blocks allowed him such freedom and spontaneity that the "movable forms with their innate flexibility . . . allowed him to pursue problems of motion and continuity," a process he compared to Gutenberg's movable type.[31]

Bertoia's work would continue to use the wood blocks, then make reference to the "wood-block paintings," for many years. He made small and large ones, varied their palettes greatly, and eventually took them into the third dimension. An example that has a very different effect than the monotypes previously discussed, largely because of its coloration, is in The Phillips Collection in Washington, D.C., a collection in a private home that has become a museum. It is one of fifty-three monotypes that Phillips exhibited as a solo show in the summer of 1945. The show was another significant achievement in Bertoia's early career.

Phillips bought five monotypes from its Bertoia exhibition. One of the smaller examples has a surface that seems to shift in space because of the contrasts of colors that range from fairly intense to quite dull and from relatively light to very dark. Despite the prevalence of orange, the work seems somber rather than lively or even harsh. Across much of the right portion of the monotype, fine lines spider across the surface for no reason other than to enrich the image playfully. They introduce a more random and organic character to prevent the blocks from creating a checkerboard effect. Additionally, these rather Surrealist lines add a layer in the space depicted. This is an early example of his "wood-block" prints. It is one of the examples where he added elements like line in paint, resulting in these works sometimes being called "wood-block paintings." Bertoia printed from wood blocks though most of the 1940s, yet no two works are identical. How Bertoia could create complex images without looking at what he was

P. 67 45

working on is only partly explicable. When he drew with a pencil or pen, he concentrated for some seconds, deciding quite precisely what to put on the paper, even when preparing to draw on a paper napkin to illustrate a lunchtime discussion in a restaurant. Then he moved his hand over the paper as if rehearsing and composing the image before bringing it into existence. After making several passes in the air, he would put his hand and pencil (or when it became available in the 1970s, a felt-tipped pen, an implement he loved) on paper to produce an image. His mental previsioning of the image and practicing of how and where to bring it into reality were essential to the sureness of the results. He explained that "drawing on the back side of the page did not permit clear visibility, a great advantage, for it necessitates inner vision to take over the function of the eye."[32] He had trained his mind to envision a work before beginning it. In rare instances he did preparatory sketches before making a monoprint, however, and must have destroyed most of them. If something unplanned but fortuitous happened, he was happy to improvise and incorporate it, or, if it was a real mistake, he would start again on clean paper.

Another work, *Untitled (Monoprint No. 44)*, also in the Phillips Collection is a very significant transition from the wood-block paintings to freer, more organic works. Over the imprints of the wood blocks, Bertoia smudged the ink and blurred forms. On top of those shapes he produced two dominant semicircles, one in light colors, the other inverted and darker. The edges and precise repetition of the semicircles indicate that they were printed, not drawn or painted. He reused the semicircular piece of wood, printing it on at least one other monotype of the period. He was, at least for a while, widening the range of his imagery.

Cranbrook's Modernism focused on applied arts like architecture and metalwork. Eliel Saarinen and many faculty members believed that traditional painting, printmaking, and sculpture were subsidiary. However, since Saarinen preferred using textiles to decorate walls, pictorial art was of little concern to him, so he left the painting program more independent than closely scrutinized.[33] Bertoia's solitary, almost secretive nocturnal printmaking at Cranbrook certainly reflected his preference for working without interruption, but it may have resulted in part from a desire for privacy, because nonobjective art was very much against the grain there. Even the works of Klee, exhibited in 1940 at the Detroit Institute of Arts, were not well received by the public or press. Bertoia knew that his work was more avant-garde than was liked at Cranbrook, where he was "almost alone among instructors" in his enthusiasm for non-representational art. Finally, in 1940, he showed some of his monotypes first to Saarinen, who told him to stick to metalwork, and then to Milles, who even "slammed the door on him." He did find support and encouragement, however. Soon after arriving at Cranbrook, Bertoia had studied painting with Mitchell, whose work in the 1940s was growing increasingly geometric and abstract while Bertoia's was also developing. He and Grotell, who taught ceramics, found Bertoia's monotypes so promising that they encouraged him to send some to Hilla Rebay for her opinion.[34] He did, with wonderful results.

After Bertoia sent a group of prints to Museum of Non-Objective Painting co-founder Hilla Rebay, she quickly sent him a telegram saying they had arrived and asking what he was charging for them. Ten dollars each, he answered, a significant increase from the two dollars he had asked from the Wadsworth Atheneum Museum of Art. On February 17, 1943, her first letter to Bertoia praised the works he had sent. For the next three years, Bertoia would send Rebay monotypes when she requested them for shows, as she frequently did. She represented herself to him as an art talent scout and impresario, experienced at discovering and promoting the works of promising young artists.

Baroness Hildegard "Hilla" Anna Augusta Elisabeth Rebay von Ehrenwiesen was one of the women who had a monumental role in the history of Modernist art. A painter from Stuttgart, Germany, she was hired by the wife of Solomon R. Guggenheim to paint a portrait of him in about 1927 despite

being primarily a painter of nonobjective works. As he posed in her studio, she explained her nonfigurative pictures on the studio walls and the European abstraction of the time, calling it "nonobjective." It "reached for the spiritual realm," she said.[35] In 1937 she wrote, "Non-Objectivity will be the religion of the future. Very soon the nations on earth will turn to it in thought and feeling and develop such intuitive powers which lead them to harmony."[36] Guggenheim had been a collector of Old Master paintings, but Rebay became his adviser, encouraging him to amass increasing numbers of contemporary, nonrepresentational paintings. By 1939 Rebay was the founding director and curator of the Museum of Non-Objective Painting, opened in a Manhattan town house that Guggenheim rented to display his collection. The opening of the museum was a sensory experience offering Bach and Beethoven for the ears, incense for the nose, and Kandinsky, Klee, and others for the eyes. *New York Times* art critic Aline Louchheim (who would marry Eero Saarinen) later described the museum as "an esoteric occult place in which a mystic language was spoken."[37] Amid rumors that Guggenheim and Rebay were linked romantically, she became the most prominent supporter of fully abstract art in the country and the impetus behind some the most avant-garde exhibitions in the United States in the 1940s. Her enthusiasm for the work of the Russian painter Kandinsky was avid, likely because he produced important nonobjective work and because he, like Rebay, was interested in theosophist ideas. Kandinsky's *Concerning the Spiritual in Art* was central to her beliefs and to her encouraging Bertoia to make his work both nonobjective and spiritual. Her exact meaning, of what she wrote, however, was often unclear.

On March 3, 1943, Rebay wrote to Bertoia, mixing praise and criticism. She complimented his works, especially the ones in color, but she cautioned him against using lines as decorative repetitions, for "every line must have its own life and own rhythm." Tantalizingly, she proclaimed, "I am sure we will soon make a special exhibition of your work."[38]

Rebay wrote again the following week, saying that Guggenheim "liked your work very much and he feels like myself that it would be of interest to acquire your color prints and some of the drawings." While promising to show as much of his work as possible, she also chided him, saying that she

> will have to eliminate those which are too repititious [sic] and decorative. Avoid to succumb to the charm of texture as you sometimes do; as charm is accidental. Rigidly force yourself once in a while to clarify your themes and the space-balance of their in-between, also different possibilities of their inter-relationships. Seek crystal clearness. You will find it most beneficial in increasing your message and spiritual power.

Receiving so much criticism must have been difficult, but Bertoia saw the opportunity ahead and so was characteristically tactful. On June 8 he wrote that he had sent five large drawings, three smaller ones, and "one synchromy composed of ten prints" that he described as "charming, gay almost playful." He added that "the sequence of ten prints, has arisen considerable enthusiasm by those who already saw it," and he encouraged them to be exhibited as a series, in numerical order. Of the largest drawings, he said, "From their minutest part to their oneness, they are vibrating and alive." He added, "In these drawings I came closest graphically [to] clearly recording the realm I am now exploring."

Rebay replied on June 14 that she was especially pleased with the work in color she had just received, adding that she had "already arranged the exhibition because we had to give the titles to the printer ten days ahead of time for the catalogue. I chose the titles to give each of the works some differentiation, although I do not believe in titles, but it is entirely impossible to handle hundreds of pictures without the possibility of designating them." This is rather important because it reflects that Gropius's idea of the equality of media was not accepted.

When Rebay asked for the names of works despite his reluctance to provide them, she crossed an unspoken art world ethical line by inventing titles for his works. Her insistence prodded Bertoia to verbalize his intentions when he answered her four days later:

> One thing I am after in my work is to carry further the essence of an ever changing pattern, when I succeed it will be close to some kind of mobile painting, hence the idea of sets or sequences. In other words the birth and growth of an idea taking place in time space that could not be achieved in one single picture. The name synchromy sounds ambitious, yet inadequate—the putting together of color. There is more than just color that has to be organized. However, to call, for example, "Synchromy in Blue" or "Synchromy No. 12," referring to the set of ten prints I last sent you is as descriptive a title as any, but will the public accept it as the name "nylon" has been accepted? . . .
>
> The total price of the set of ten "Synchromy in Blue" is $225.[39]

The nonobjective monotypes of the *Synchromy* series are generally colorful, although the most dramatic are black and white, or nearly so. Their experimental nature is evident in their great diversity: there are purely geometric ones, organic ones, and examples that combine both biomorphic and geometric forms. They are consistently moderate in scale, usually less than 1 foot (30 cm) in any direction. (Artists' experiments are often small to save materials and money.)

Rebay, who so admired the mystical aspects of paintings by Kandinsky, encouraged Bertoia to work in a vein consistent with her idea of art as "an initiation to the mystical mission of spiritual realities, this is the message of non-objective painting."[40] Bertoia's later works would contain some spiritual content, but that is not really attributable to Rebay's influence, because his own inclination and his wife's influence certainly would have affected him more strongly. Furthermore, his early work seems more in line with Kandinsky's and Klee's interest in abstraction in art as a parallel to music. Both amateur musicians who played together as Bauhaus faculty members, Kandinsky and Klee had each written about parallels between music and pictures. Classical music was especially important to Bertoia all his life, and he remarked upon general parallels between music and his 1940s pictures like the *Synchromy* series.

One small Cranbrook work from about 1942–43 is a monotype in a private collection. Perhaps from the *Synchromy in Blue* series, it has an irregular line separating the dark upper section from the rest of the picture, as if there were a high horizon and a dark sky. The dark upper area results from many layers of thinly printed colors that create delicate strips of tones built up almost like a painter's glazes. The majority of the surface is a rapid gradation from dark Prussian blue to blue-green and on through slowly modulated yellow-greens. Much of the upper register is occupied by a dark blue semicircle, placed off-center and tipped at an angle. It is printed from the same curved block of wood that Bertoia used twice in a previously discussed monoprint in the Phillips Collection, *Untitled (Monoprint No. 44)*. This monoprint is not only closely related to a slightly later work, but also shows that Bertoia was beginning to move from the wood blocks to other forms and imagery.

Rebay's taste for color was at the expense of appreciation for works in black and white. Color has spatial as well as emotional and decorative effects, which can distract from the subtlety of monochromatic compositions. Rebay appreciated Bertoia's black-and-white monotypes less than the polychromatic ones, despite their complexity. A black-and-white *Synchromy* monotype demonstrates the spatial and compositional complexity Bertoia could achieve in these early works. With sharp forms coming from three places, this nearly square piece is full of motion. The range from dark to light is both great and nuanced, and all those strata in space suggest that Bertoia removed the paper, put more ink in an area of the glass, and

P. 68

replaced the paper to transfer the ink, repeating this process multiple times. Beyond the technical achievement, however, Bertoia imbued this print with a sense of mystery, of the inexplicable. Could this be the spirituality Rebay encouraged Bertoia to add to his work?

While the size and shape of a work are usually an artist's choice, format influences a work's outcome, since it influences the internal relationships that are its composition. For most of his career, Bertoia preferred working on elongated sheets of paper, so the square *Synchromy #387* was an experiment in a format he did not perpetuate. This monotype is relatively small, less than 15 inches (38.1 cm) on each side. Its range from near white to velvety blacks is rich and interesting, with forms and patterns emerging from the dark textures and lines in the middle tones. Nevertheless, a bit of light shines forward from behind the large central semicircles. Tipping them so their straight edges are diagonals implies motion. These dark, heavy forms seem to float, perhaps buoyed by the sharp, upward-pointing shapes or the dense murkiness. Fine, intersecting gold lines add interest and enigma.

A larger and quite different example from the *Synchromy* series, *Untitled (#47a)* shows that Bertoia's mind was simultaneously on jewelry and prints. P. 69 47 Against soft-edged brown arcs made by sweeping the side of his hand across the paper, mottled patterns of grays extend toward most corners. The image has many layers, textures, and small white elements, ghosts of the print before it. On top of all that, Bertoia made groups of fluid lines that meet at bold dots near the sides of the paper. With its constant motion and its density, the image creates a dreamlike incomprehensibility reminiscent of works of abstract Surrealism. The long lines swaying across its surface are closely linked to a vertical brooch included in the 2015 Cranbrook exhibition *Bent, Cast & Forged: The Jewelry of Harry Bertoia*.

The design of this vertical brooch appears to have been extracted from the middle ground of the monotype, for it omits all the monotype's closest and most distant lines and shapes. Instead, it retains only the curving horizontals lifted from the dense monotype. Turned vertically, the long curves are visually stronger. Surprisingly, these elongated silver wires are also more calligraphic than the printed lines, despite having been hammered. Linking the bold wires with fine, quirky ones stabilizes the brooch and adds a touch of whimsy. It is possible that these two works were contemporaries and the discrepancy in their dates reflects their having been studied apart. But Bertoia liked to return to his graphics later, sometimes mining them for ideas, so it is also possible that he returned to the monotype a few years later and revived this motif in silver. In 1942–43, when the monotype was likely made, the war made obtaining metal difficult, and Bertoia was transferred from metalwork to become instructor of printmaking at Cranbrook. The shortage of metal explains why he made so little jewelry in his last two years at Cranbrook and resorted to making the study for his own wedding ring in aluminum that likely was recycled.

It was probably in 1943 at Cranbrook that Bertoia constructed a wooden framework allowing him to arrange small rectangles of paper in space. This P. 69 48 three-dimensional outgrowth of the wood-block prints is an experiment in light and space. Bertoia took it to California when he and Brigitta drove there late that summer and, in 1950, he would move it when they relocated to Pennsylvania; this transporting suggests its great importance to him. When he wanted to develop the ideas in a piece further, he would keep the work, frequently placing it prominently so he saw it often, stimulating his thinking. Eventually it might lead to more fully developed work. Squares of paper, suspended on fishing line from screw eyes fill the wooden frame with planes floating in layers in space. Light and shadow vary the appearance of the white paper squares, making them range widely in value at the same time as they cast similarly varied shadows. Stemming from early monotypes, this relatively modest piece was the germ of the multiplane constructions that would be so important to his early 1950s work. It is a pivotal work in Bertoia's artistic development.

After Bertoia left Cranbrook in the late summer of 1943, he continued to correspond intermittently with Rebay, and he sent her works as late as 1946. On October 26, 1943, Rebay testily wrote that some of his former students had visited and been "criticizing our hanging of your prints, as not in the right succession" because she had not installed them in the way the artist intended. Recommending that he study the "continued motion" of Oskar Fischinger's films if he wanted to work in series, she admitted her preference for painting's "depth and restful majesty." Bertoia could not have been pleased, but he tactfully avoided mentioning it when he wrote on December 12, 1943, complying with the museum's request that he send a biography.

Then on February 26, 1944, he wrote to Rebay, who had requested that he send more work. He said he had checked his records and found that none of the work he had sent her "was ever returned and that not all was purchased by the Museum of Non-Objective Painting. [I'd] like to know what happened to the many prints and drawings not accounted for, and what has been done with them. Please inform me, otherwise I shall not be able to send you any of the new work I have just finished." She had been ill, she replied.

As months of letters turned into years of corresponding, however, it became increasingly clear that Rebay and her staff were inefficient, inaccurate in accounting for works, slow in paying for purchases, and unreliable about returning pieces no longer on display. Especially at first, it must have been intimidating for Bertoia to correspond with the "Baronness Rebay," always addressing her by the title typed below the signature on her letters. As he became increasingly sure of himself and his work, however, he asserted himself respectfully and pleasantly but nonetheless firmly in requesting his due. In the future, Rebay would request work from Bertoia and write hoping they could meet, but he followed up on neither request. He was moving on. The ideas and people who had been central to his time at the Cranbrook Academy of Art would continue to shape his work and life.

After their wedding, Harry and Brigitta Bertoia lived in an apartment in nearby Birmingham, Michigan, while Harry continued teaching and working at Cranbrook during the summer. Brigitta gave piano lessons, read, painted, and adjusted to housewifery. Two years earlier Charles and Ray Eames had left Michigan for Los Angeles, where they were refining molded plywood technology and went into the business of making prototypes for the military and daily life. In the summer of 1943, Charles invited Harry Bertoia to join the Eames Office. With the $300 Rebay had paid for monotypes and the proceeds from selling jewelry and other prints, Brigitta and Harry got into his old green Chevrolet and headed west on Route 66. World War II was raging when the Italian artist and his German bride set off on their all-American journey.

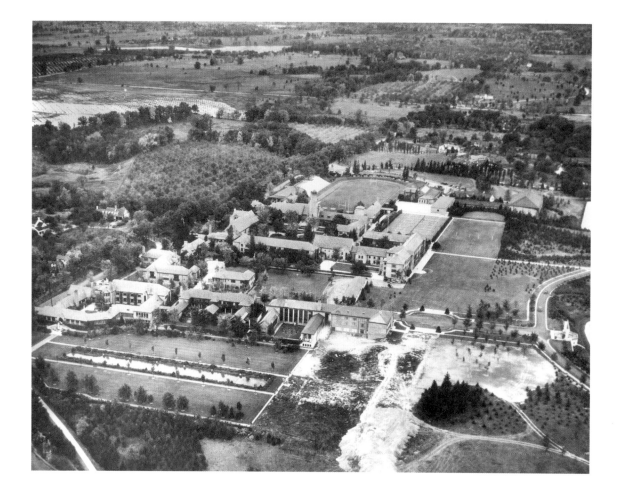

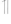

1 Aerial view of Cranbrook Educational Community, Bloomfield Hills, Michigan, c. 1936. The Academy of Art
 is at the lower right.
2 Eliel Saarinen (Architect, 1873–1950). Dining Room, Saarinen House, 1930; photographed after restoration
 in the early 1990s.
3 Eliel Saarinen (Architect, 1873–1950). Living Room, Saarinen House, 1930; photographed after restoration
 in the early 1990s.

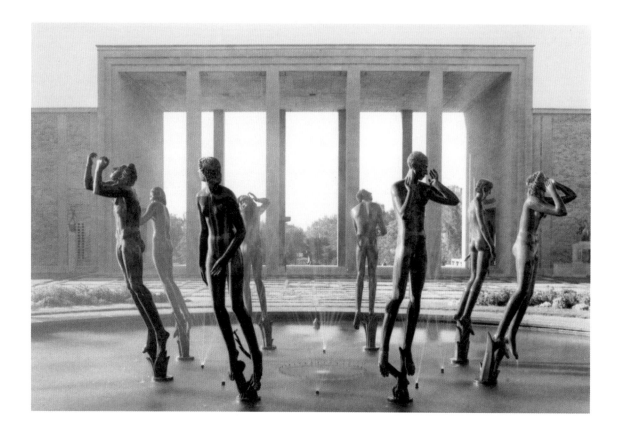

4 Carl Milles (1875–1955), *Orpheus Fountain*, 1937, in front of the Cranbrook Art Museum and Library by Eliel Saarinen.
5 Eero Saarinen (1910–1961) and Charles Eames (1907–1978). Chairs and Storage Unit, 1939–41.
6 Benjamin Baldwin, Harry Bertoia, and Eliel Saarinen with the model of the Smithsonian Gallery of Art in 1939.
7 Charles Eames holding a spun bronze vase by Bertoia, c. 1939, with others looking on.
8 Harry Bertoia, Marjorie Cast, Charles Eames, and Benjamin Baldwin at Cranbrook, looking at a project, 1938.

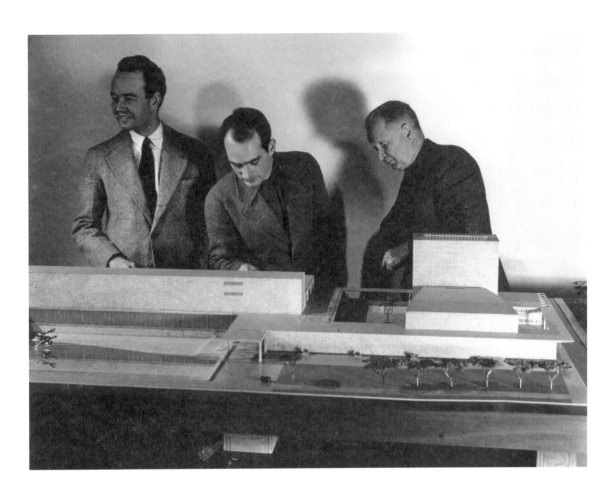

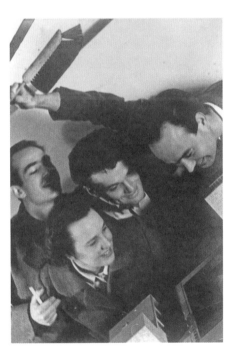

10

11

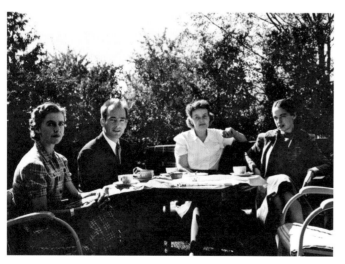

9

12

13

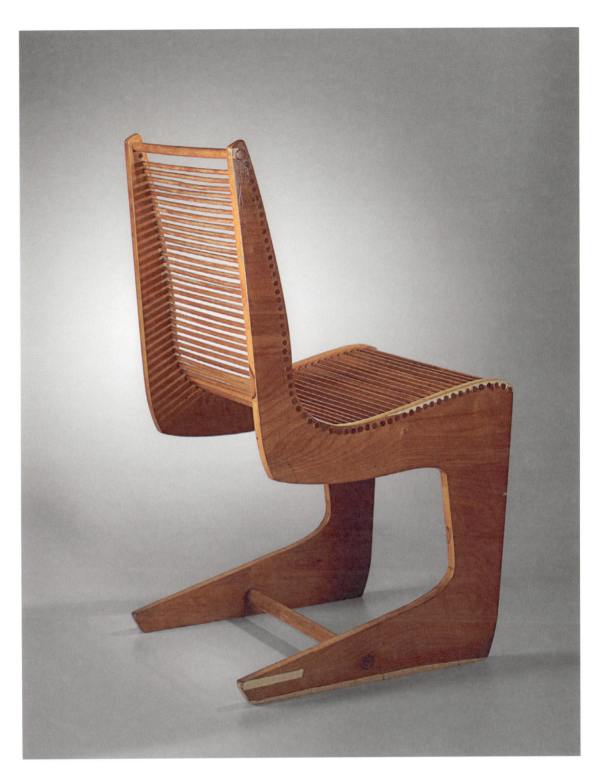

14

9 Harry and Brigitta Bertoia at a Saarinen tea, 1944.
10 Harry Bertoia (far right) and Brigitta Valentiner (middle) with an unidentified student (left), March 1942, at a "Come as a Song"
 party at Cranbrook Academy of Art.
11 Students dancing at a Halloween Party, Cranbrook Academy of Art, October 1939.
 Harry Bertoia is on the far right in the plaid shirt
12 Faculty Breakfast, Cranbrook Academy of Art, September 1939. From left to right: Brigitta (Valentiner) Bertoia, Harry Bertoia,
 Maija Grotell and Jill Mitchell.
13 Architecture Students, Cranbrook Academy of Art. November 1939. From left to right: Edward Elliott, Victor King Thompson,
 Ted Luderowski, Harry Bertoia, Lawrence Lackey, James Berkey, and Vito Girone.
14 Prototype chair, c. 1939. Birch plywood and dowel rods. 33½ x 18 x 33½ in. (85.1 x 45.7 x 85.1 cm).

115

116

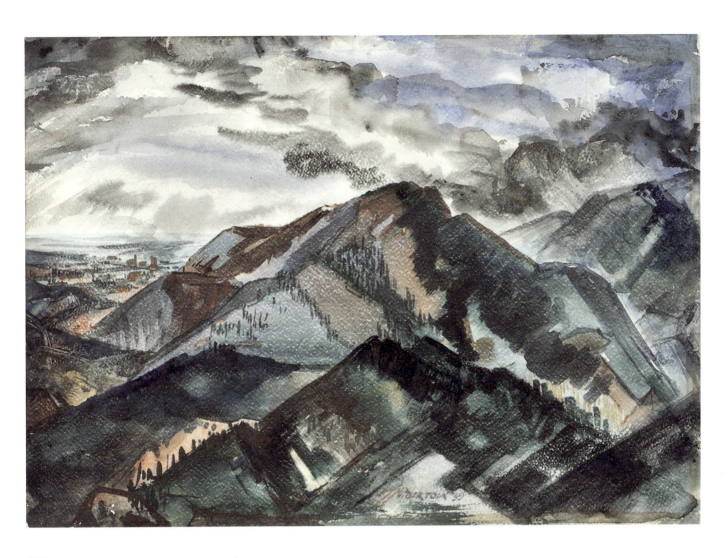

17

15 Joe Munroe portrait of Harry Bertoia in July 1942.
16 Harry Bertoia demonstrating techniques using a torch for a student, c. 1939.
17 *Mountain Landscape*, dated and signed "H. Bertoia, 1939," lower corner. Watercolor on paper.
 10 x 13⅞ in. (25.4 x 35.3 cm) framed.

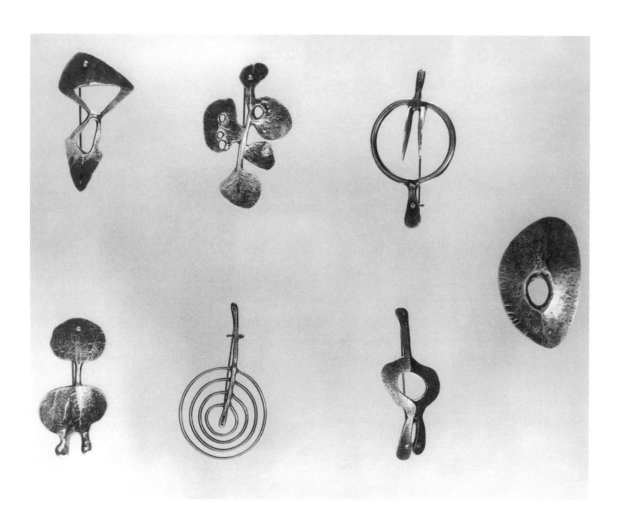

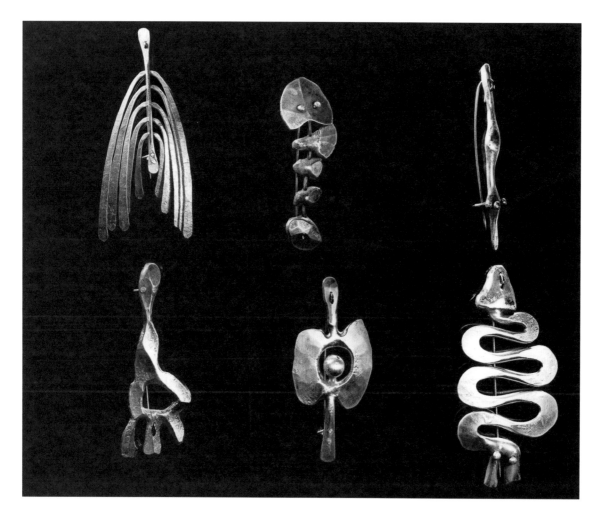

CRANBROOK 1937–43

18 Photograph showing silver jewelry Bertoia made at Cranbrook Academy of Art, 1938–42.
19 Photograph showing silver jewelry Bertoia made at Cranbrook Academy of Art, 1938–42.
20 *Untitled* (ring) c.1940. Silver, ebony, and ivory. 1 x ¾ x ¼ inch (2.5 cm x 2 cm x 6 mm).
21 *Untitled* (ring with kinetic elements) c.1940. Silver. ¾ x ¾ x ½ inch (2 x 2 x 1.3 cm).

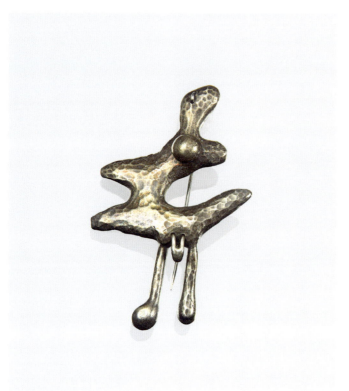

22

23

24

25

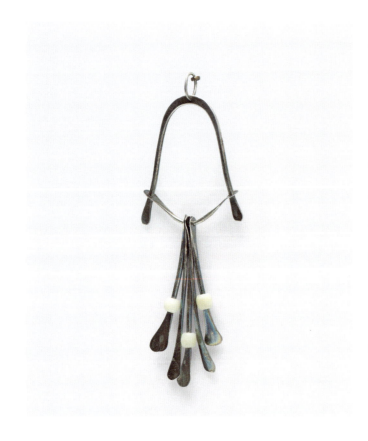

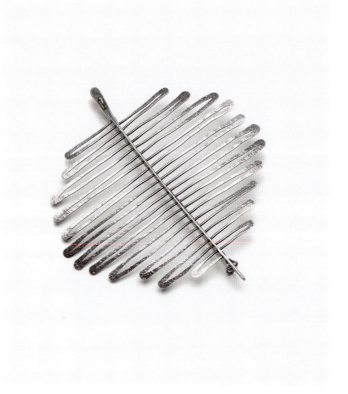

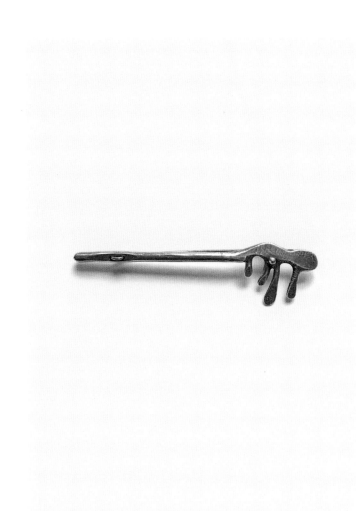

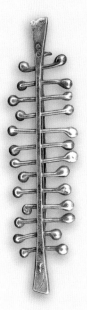

26

27

22 *Untitled* (brooch), c. 1940. Sterling silver, 1½ x 2¼ x ½ in. (3.8 x 5.7 x 1.3 cm).
23 *Untitled* (brooch), c. 1940. Sterling silver, aluminum, and thread. 2¼ x 3½ x ½ in. (5.7 x 8.9 x 1.3 cm).
24 *Untitled* (pendant), c. 1940. Silver with bone beads. 4½ x 1½ x ¼ in. (11.4 cm x 3.8 cm x 6 mm).
25 *Untitled* (brooch), c. 1940. Silver. 3¼ x ¼ in. (8.3 cm x 6 mm).
26 *Untitled* (brooch or bar pin), c. 1940–42. Sterling silver. ⅞ x 3⅜ in. (2.3 x 8.4 cm).
27 *Untitled* (brooch), c. 1942. Silver. 3 x ⅞ in. (7.6 x 2.2 cm).

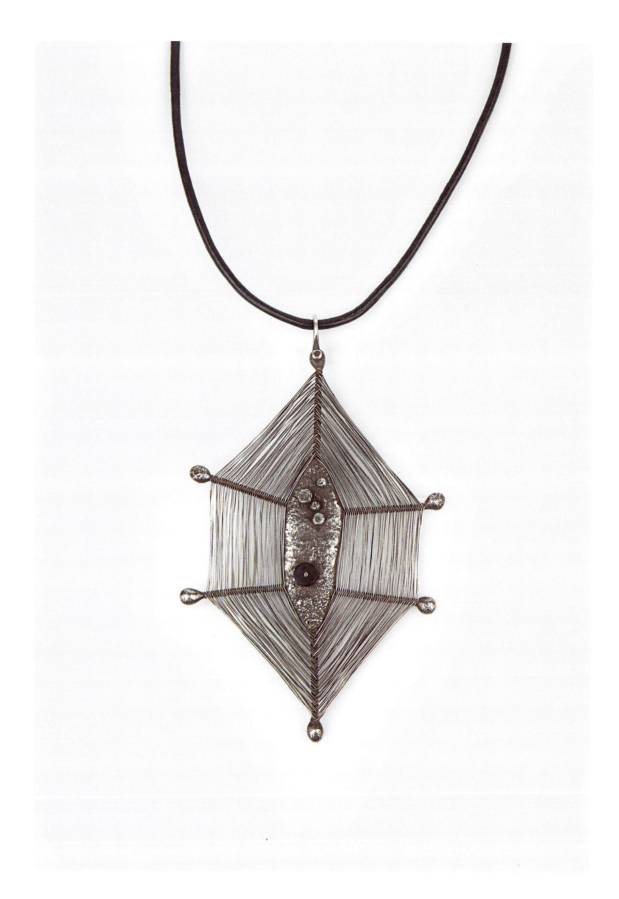

28 *Untitled* (pendant), c. 1940–42. Silver wire and black bead. 6¼ x 3⅞ in. (15.9 x 9.9 cm).
29 *Untitled* (kinetic bangle), c. 1940. Silver. Width: 1.6 in. (4.1 cm), circumference: 2¾ in. (7 cm).
30 *Untitled* (earrings), c. 1940. Silver. 1 x 1½ in. (2.5 x 3.8 cm).

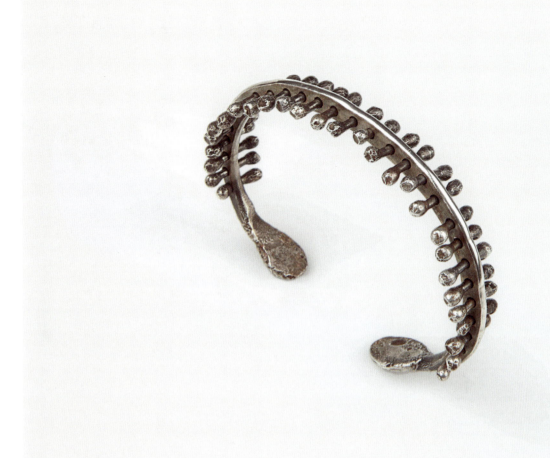

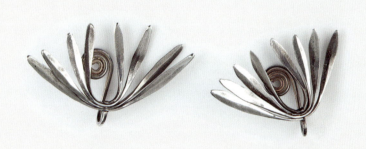

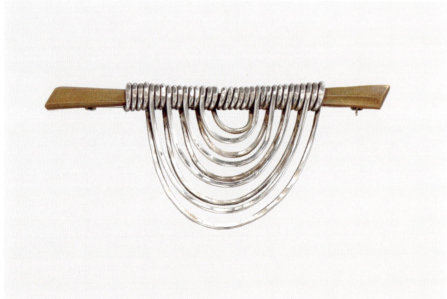

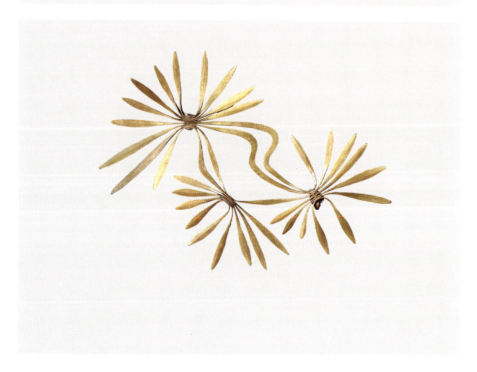

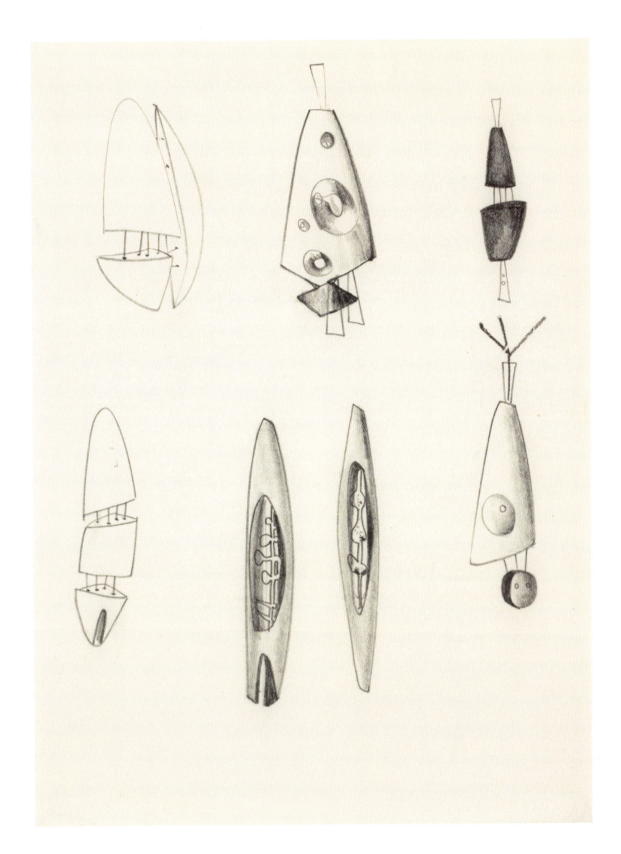

34

31 *Untitled* (earrings), c. 1942. Hammered silver wire, repurposed copper wire, and modern findings. 3½ x 1¾ in. (8.9 x 4.4 cm).
32 *Untitled* (brooch), c. 1940–42. Bronze with silver wire. 1⁷⁄₁₆ x 3 ⅜ in. (3.7 x 8.4 cm).
33 *Untitled* (brooch), c. 1942–43. Forged and riveted brass. 4½ x 6 x ¼ in. (11.4 x 15.2 x 0.6 cm).
34 *Untitled* (Jewelry Studies), c. 1940. Pencil on rice paper. 8½ x 11 in. (21.6 x 27.9 cm).

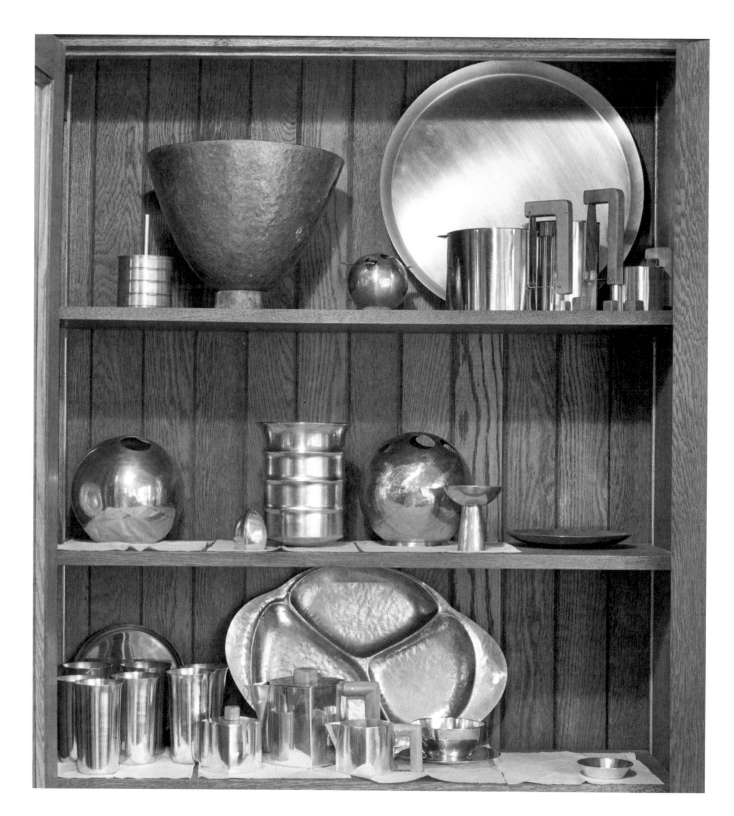

35

35 Display of Bertoia hollowware at Cranbrook, c. 1942.
36 *Tea Service*, 1938–39. Silver and lucite. Teapot: 7¼ x 5⅝ x 4⅛ in. (18.4 x 14.2 x 10.4 cm); sugar bowl with
 cover: 2⅞ x 4¼ x 3¼ in. (7.4 x 10.8 x 8.3 cm); creamer: 2½ x 4¾ x 2⅞ in. (6.35 x 12.1 x 7.4 cm).
37 *Coffee and Tea Service*, c. 1940. Silver and cherrywood. Tray: 15½ in (39.4 cm); teapot: 6⅝ x 4 x 7¾ in.
 (16.8 x 10.2 x 19.7 cm) coffeepot: 8 x 3½ x 8 in. (20.3 x 8.9 x 20.3 cm); sugar bowl: 3⅛ in (7.9 cm);
 water pitcher: 8¾ x 3⅝ x 7½ in. (22.2 x 9.2 x 19.1 cm); creamer: 4½ x 2¾ x 5 in. (11.4 x 7 x 12.7 cm).

36

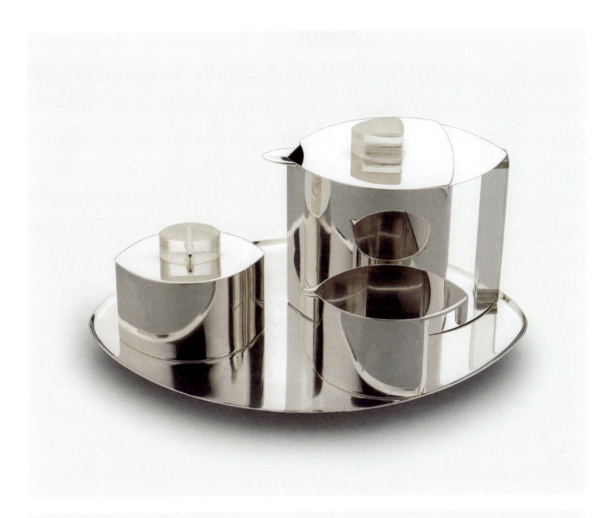

37

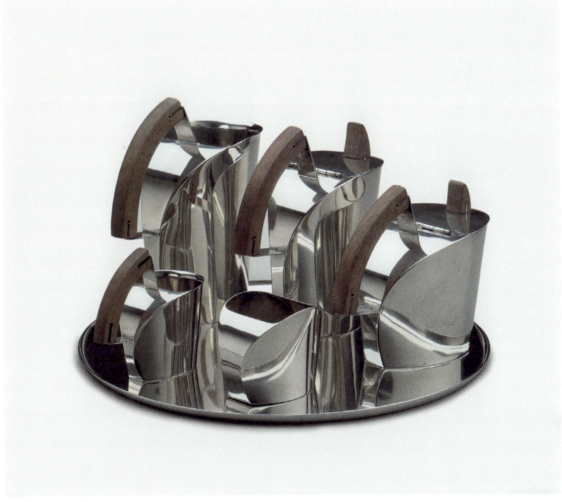

38

38 *Winemakers*, 1941. White line relief print, printed in black ink on laid paper. Image: 10½ x 8¼ in. (26.7 x 21 cm); plate: 14⅜ x 11½ in. (36.3 x 29.2 cm).

39 *Corn Harvest*, 1941. White line relief print or woodcut on paper. 10¼ x 8¼ in. (25.9 x 20.8 cm). Signed in the block "HB" and signed and dated in pencil lower right "Harry Bertoia."

40 *Synchromy #5*, c. 1941. Monoprint, ink on paper. 6⅞ x 9 in. (16.4 x 22.9 cm).
41 *Synchromy, No. 5*, c. 1941, Monoprint, ink on paper, 6⅞ x 9 in. (16.4 x 22.9 cm).

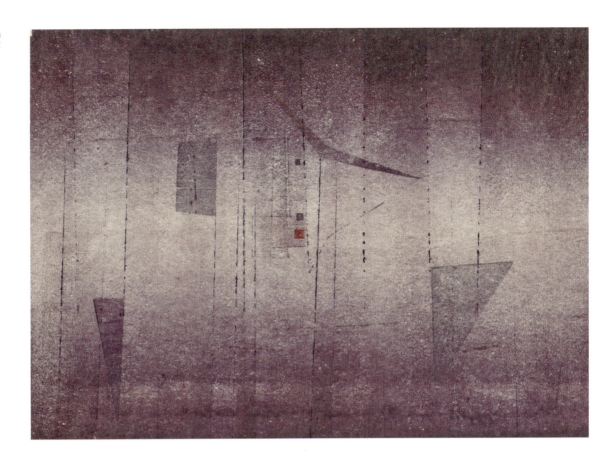

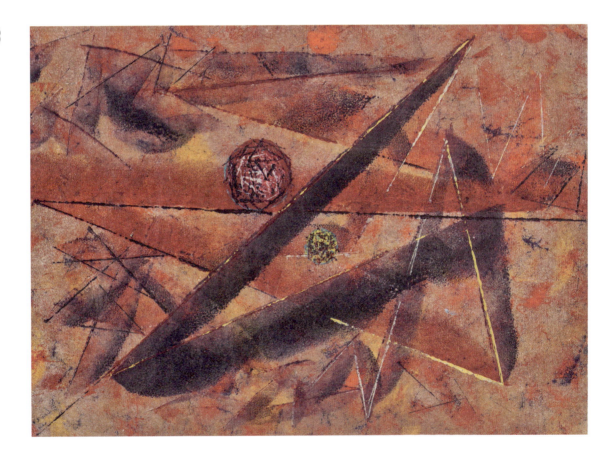

42 *Untitled*, c. 1941. Monotype, ink on paper, 6⁷⁄₁₆ x 9 in. (16.4 x 22.9 cm).
43 *Untitled*, c. 1941. Monotype, ink on paper. 6⁷⁄₁₆ x 9 in. (16.4 x 22.9 cm).

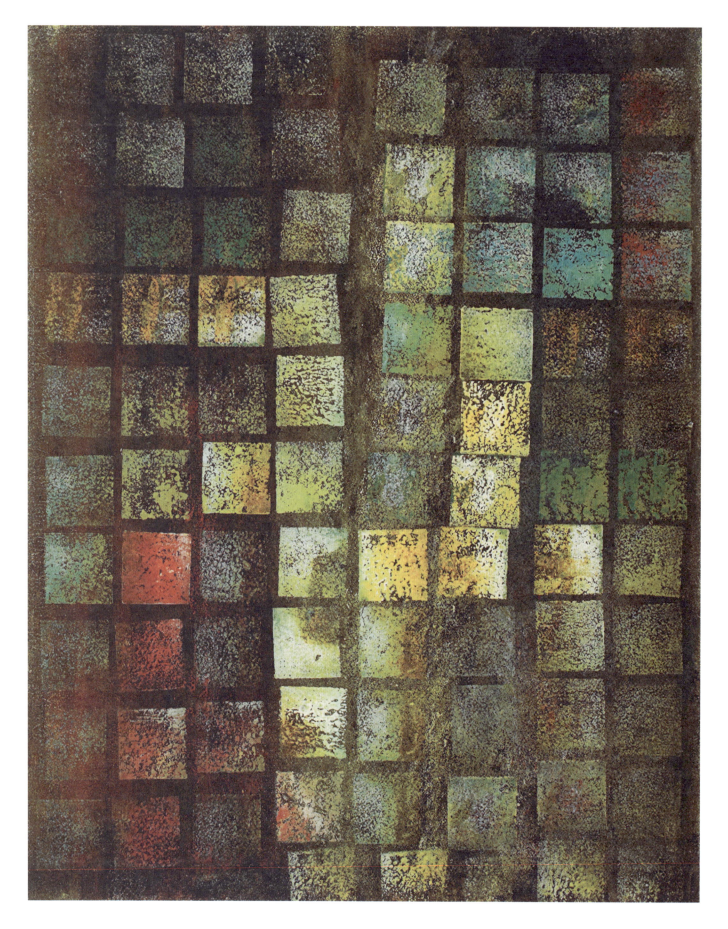

44

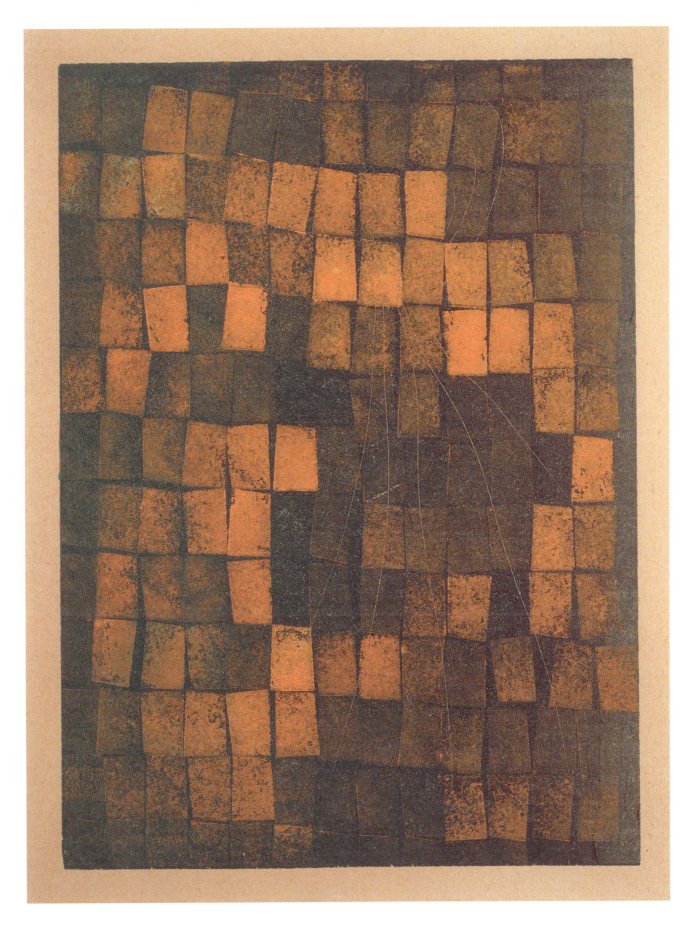

45

44 *Untitled* (monotype), c. 1942. Ink and oil on paper. 24½ x 19½ in. (62.2 x 49.5 cm).
45 *Untitled, Monoprint No. 26*, 1940–43. Ink on paper. 9½ x 7⅜ in. (24.1 x 18.5 cm).

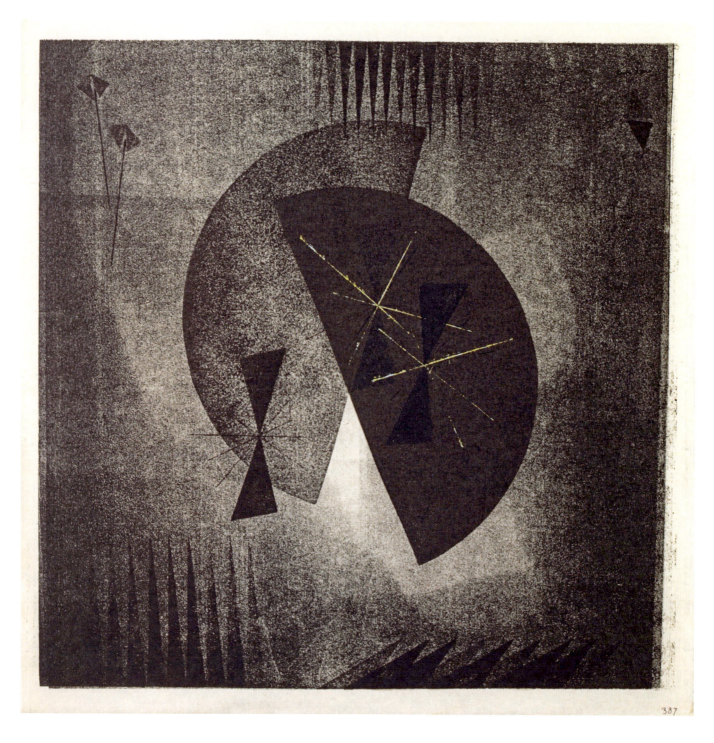

46

46 *Untitled (Synchromy Series #387)*, c. 1939–43. Monotype, ink on rice paper. 14½ x 14¼ in. (36.8 x 36.8 cm).
47 *Untitled (Synchromy Series #47a)*, c. 1939–43. Monotype, ink on rice paper. 18 x 24 in. (45.7 x 61 cm).
48 *Untitled* (Study in Light and Space), c. 1943. Paper, painted wood, fishing line, and hardware.
 Approximately 15 x 30 in. (38.1 cm x 76.2 cm).

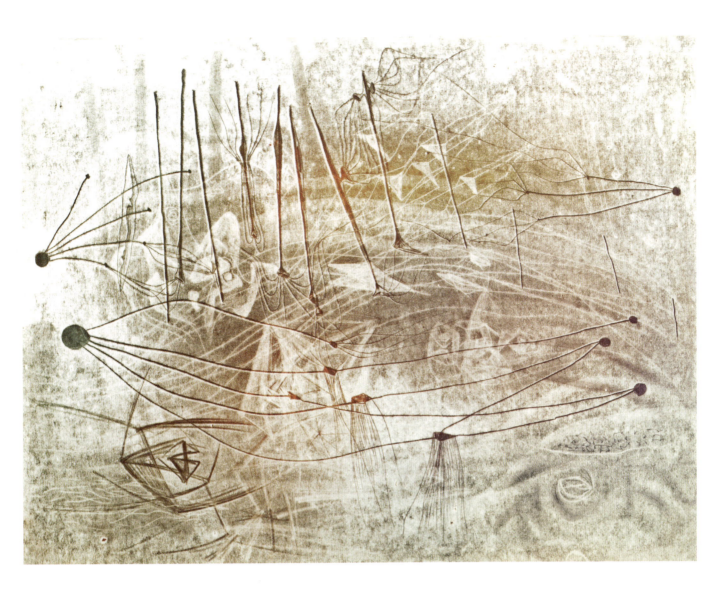

47

48

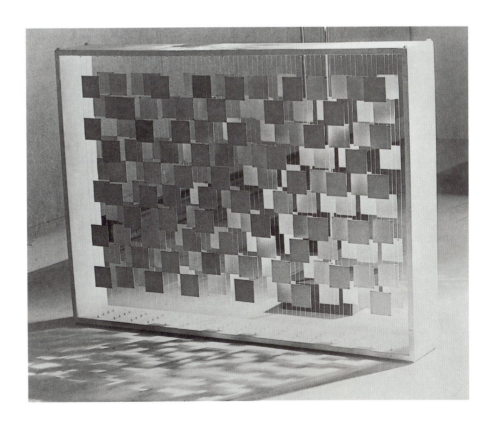

3

On the Pacific Coast there are fewer shackles on tradition. There is unslackening development of new thought. There is a decided willingness to take a chance on new ideas.
—Henry Dreyfuss

In the summer of 1943—the middle of the war for the United States, while combat dragged on in Europe—the newlywed Bertoias headed west from Michigan, using the extra gasoline rations allotted to those relocating for work, then followed legendary Route 66 from Chicago. Even then California was part of the American dream, the Golden State, upheld as an ideal destination in popular songs since the 1920s. Bertoia later recalled that he had been glad to leave behind the cold and wet of Michigan, and he and his wife were setting out as adults to make their way in the world.

The Bertoias' road trip included the natural wonders of the Painted Desert and the Petrified Forest in Arizona. It was almost noon when they arrived at the Grand Canyon and they naively began hiking to the bottom. "Most people," Brigitta wrote much later in her memoirs, "were already coming up or riding on donkey back. We had taken one little sandwich that fitted in Harry's pocket." Exhausted, hungry, thirsty, and grateful for the full moon lighting their way, they reached the top about nine o'clock.[1] Decades later, Brigitta explained in conversation that during—and even long after—the war they encountered some hostility as a German and an Italian in America. She even admitted that sometimes she claimed to be Swiss. Few knew of it, but when Bertoia faced a draft board in Michigan, his status had been "under question"; the army needed to clarify it before inducting him. Having arrived from Italy destined for Windsor, Canada, he had crossed the river into Detroit, entering the United States illegally.[2] Being offered a job by Charles Eames in war-related work was a legal alternative to military service.

Soon the couple reached Los Angeles. After a brief stay with a Cranbrook friend, they rented a room near Malibu with a view of the ocean, then a tiny apartment nearby. Brigitta made an effort to overcome the limitations of both food rationing and her culinary skills in order to feed them both. She passed the hours while Harry was at work with hobbies and walking on the beach. Her lively intelligence led her to question assumptions, and her unusual childhood encouraged individualism that flavored everything she did. The title of her autobiography, *The Adventure of Living*, is an accurate reflection of how she saw the world. Harry, perhaps as a result of his Italian upbringing and despite his profession, lived more conventionally, a traditional family man of the era, at work while his wife assumed the role of homemaker, and soon would take on most parenting duties as well.

In September 1943, Harry Bertoia and Herbert Matter, a Swiss photographer and graphic designer, went to work with Charles and Ray Eames and their associates in their newer, larger office in Venice, not far from their Santa Monica Boulevard office. The Eameses referred to it as the "design collaborative"; Bertoia later called it the "Eames menagerie."[3] It must have been a shock for Bertoia, because the friendliness and collegiality of Cranbrook had been replaced by the autocracy of Charlie Eames. Matter would have arrived without Bertoia's expectations, at least. Matter is best known for the large-format photomontages he had done in Zürich for travel companies and his work for Condé Nast publications like *Harper's Bazaar* and *Vogue,* and when he left the Eames Office three years later, he would become central to creating Knoll's public image, especially its image in print.

The arrival from Cranbrook of Charles and Ray Eames in California in the summer of 1941 was quite different from that of Harry and Brigitta Bertoia two years later. When the Eameses reached LA, John Entenza, editor and publisher of *California Arts & Architecture*, helped them rent a Westwood apartment designed by Richard Neutra. While Charles Eames worked as an architect at MGM studios, his wife, Ray, designed covers for Entenza's journal, which would subsequently drop the state's name from its title and expand its scope. In their spare bedroom they jerry-rigged a machine using two-by-fours, a heating element, and a mechanism to pump air into the

machine, forcing plywood into the shapes they determined, when it did not break.[4] Two things give plywood its strength: the layering of veneers (thin sheets of wood) at perpendiculars, taking advantage of the strength of the grain in two directions, and the glue that laminates this sandwich. The real difficulty in molding plywood is applying the right amount of pressure, bending but not breaking it.

5 P. 46

Charles Eames wanted to fulfill the promise of the chair that he and Eero Saarinen had produced in 1940 for MoMA's *Organic Design in Home Furnishings* exhibition in 1941. Eames and Saarinen had agreed that each could develop chairs from their joint starting point but, with jobs and geography separating them, they would work individually. (The starting point they shared explains the similarities in some of the works they later produced separately.) The Eameses were developing from the Organic chair, trying to solve the technological problems encountered in 1940. The real goal Charles Eames had set was to make a comfortable, pleasing, and affordable plywood chair that would benefit from mass production, rather than being compromised by it. Doing so meant using no expensive padding or upholstery. Plywood appeared to be the logical material.

California's population doubled in the 1920s, and new arrivals from the East Coast and Europe encouraged a tilt toward Modernism. In 1939, the San Francisco World's Fair was advertised using thoroughly European, Art Deco posters, for example. The aesthetic principles of European architects such as R. M. Schindler and Richard Neutra were from the Bauhaus, but the allure of the California climate and views led them to modify Northern European designs by opening up floor plans and flooding spaces with light that entered through walls of glass. The new California architecture encouraged a casual way of life. The press was captivated by this rejection of Edwardian formality, and feature articles in magazines and newspapers with full pages of colorful photographs further promoted the California Modern style. Contemporary furnishings were undeniably needed.[5]

California had a long history of Spanish colonial, then Mexican, Arts and Crafts. Too often at odds, the arts flourished alongside technology during its boom of the 1930s and 1940s. Various Modernist artists and craftspeople worked in California, including Glen Lukens, a potter who had the foresight to bridge the usual gulf between handmade and industrially produced objects, advocating that handmade objects were compatible with machine-made ones. This helped ensure that making objects by hand remained viable in an increasingly industrialized world. Many artists, including the silversmith Margaret de Patta, joined Lukens in producing work that middle-class consumers could afford.

The industrial designer Henry Dreyfuss, a pioneer of ergonomics, left New York in 1943 for the West Coast and soon observed that in California there was "a decided willingness to take a chance on new ideas." He believed that Southern California was destined to become the world's new design center."[6] One distinguishing characteristic of design in California, so different from the situation in New York and Chicago, was its interdisciplinary and collaborative environment. Architects and designers of furniture, graphics, and interiors interacted on projects with disregard for distinctions between them. Group dynamics fostered innovation.[7]

After Pearl Harbor, California's population again multiplied as the region became central to the American war effort. With combat in Europe winding down and fighting intensifying in the Pacific, ground troops trained on army posts up and down the coast, and important work at Naval and military air installations ramped up. Supporting these new developments were research organizations that brought in scientists, especially physicists, and specialists in various areas of both engineering and design. Advances in naval and aviation technologies were under exploration. New uses of molded plywood, fiberglass, and various metals being developed for the military soon led to ancillary civilian applications, especially in furniture.

The Eameses were thoroughly idealistic Modernists and while they worked together on some projects, Charles was definitely in charge. They ascribed to the Bauhaus idea that good design could improve life and that well-informed consumers could make what Charles called "the right decisions," —decisions based on functionalism. John Neuhart, who worked for a period for Eames, wrote that "Charles once said that the hand of the designer should not be in evidence in a well-designed product—that good design should be anonymous. The opposite is true of his own work—from Eames chairs to the Eames exhibitions and films the name is always part of the expression."[8] This idea became a major point of contention with employees who perhaps misunderstood it, for as Neuhart explained, Eames believed a design should not be recognizable as the work of a specific designer.

Late in 1941 a doctor from St. Louis visited the Eameses at home, where he saw their experiments. He explained that the metal leg splints made for military use in the field could result in gangrene, amputations, even death. He thought molded plywood might be the answer for splints. A few months later, the Eameses took a molded plywood leg splint to the Navy in San Diego. Soon the Navy indicated interest but required some modification. They naturally complied. In addition to bringing great relief at the influx of funds and the pleasure of having succeeded, the military contract was an opportunity to use the best new materials, and it forced them to perfect their skills, because this work had to meet rigorous standards of precision. Learning to achieve near perfection would be of strong benefit in the future.[9] The splint is so sculptural that seeing it makes it seem more logical that they moved into sculptural forms in furniture and other items.

In mid-1942 Charles had resigned from MGM and, with a few investors, rented a small space on Santa Monica Boulevard. Working with Charles and Ray Eames at the time were the architects Gregory Ain and Griswold Raetze, as well as the British costume designer Margaret Harris, whose expertise lay in materials the others lacked. Neuhart described Charles Eames's business as "a kind of monarchy." That there was "no separation between art and life" was both an aesthetic principle Eames upheld and a fact of his employees' existence. They worked extremely long hours with little thanks or praise.[10]

The Navy accepted the second version of the leg splint, ordering five thousand. The design was effective and very efficient: easy to secure to patients, lightweight, and able to be stacked for storage and shipping. (The arm splints and litter that came next, however, were not adopted.) The Eameses made the tooling for producing the splints and, with Entenza's financial backing, officially became the Plyformed Wood Company. The size of the order required more help and more space, and in September 1943 the business expanded to Venice, but it was already in financial difficulty. Charles Eames then contacted Colonel Edward S. Evans, of Evans Products in Detroit, a company that supplied lumber and also manufactured industrial equipment. The two companies' needs and capabilities were a perfect match. Plyformed became a division of Evans Products, and the responsibility of producing the splints no longer rested on the Eameses.[11] They were free to undertake the projects that really interested Charles.

Photographs as well as written records document that employees, including Bertoia, worked on multiple projects. A 1943 photograph shows Bertoia modeling an arm splint, his elbow held at the height of his shoulder by a sculptural piece of plywood braced against his ribs. That year's work included experiments in molding complicated shapes—sculptures, really—that might be adaptable to future projects; it is likely that Bertoia was involved in making them. The Eames Office, as it would become known, worked on a wide array of projects, including designing radios for Detrola, a Detroit company with Alexander Girard as its director of design. Girard became a legendary fabric designer, gallerist, and curator of Modern design, as well as collector of textiles and folk art from all over the world. In 1943, he commissioned Charles Eames to design a radio, and they became good friends. A few years later, Eames had dinner at the Girards' house and saw

the plywood chair his host had designed in 1944 (now in the Vitra Design Museum in Weil am Rhein, Germany). The back and seat are separate pieces with a simple curve at each side. One piece of flat-sheet plywood forms the front legs, and another the back ones. The legs taper to the floor from a curve below the seat, and a similarly curved piece supports the back. Eames is reported to have said, "Well, I guess I don't have to do mine now."[12] His remark was disingenuous, however, for work on his chair not only persisted but intensified.

The scale of Eames Office designs, like their complexity, was increasing. Soon work focused on the very optimistic project of developing a glider to transport military personnel and equipment without the use of fuel, which would be a marvel—one that still remains only a dream, however. Photos show men standing and kneeling on expansive curves that look more like the wings of modern jets than those of typical gliders. In another picture, Bertoia stands beside Charles and Ray Eames inside one-half of the nose of an airplane that rises vertically, sheltering them in a space resembling the apse of church. The plane and glider projects never came to fruition, f or aluminum was found to serve better than plywood in aircraft. When time allowed, attention returned to molding chairs and other projects, including slide shows and soon films.

Bertoia's combination of design logic and creativity, as well as his experience working with both metals and chairs, suited the needs of the Eameses and their projects. In 1944 the Evans Company paid for Bertoia to take a welding course at Santa Monica City College[13]. With welding added to the Eames Office's repertoire of skills, the company could strengthen some designs without adding significantly to their mass. Having a welder on projects would increase design options.

As military work decreased in 1945, Eames Office projects returned to Charles's real interests, allowing him and Ray to work on slide lectures and plans for a Case Study house. Entenza's magazine invited individual architects to design modern housing that could be reproduced at reasonable prices as "case studies," featured in articles in his magazine. They became important examples for the post-war housing boom. The Eames Case Study House is made of standardized parts available at building supply companies, greatly reducing its cost and quickly entering it in the canon of art and architectural history.

During this period, the Eames Office generated at least a dozen experimental chair forms documented in photographs. Bertoia thought that Eames's method of splicing and folding plywood to allow compound curves would not be practical in large-scale production and wanted to start over with producing great numbers in mind. He explained:

> I spent about three or four weeks making very small quick models of various shapes—chairs, always chairs, you know—chairs that were for dining, chairs that were for relaxing, and in keeping all these as a group of sitting positions. And by the way, you know this approach has been with me right along; when I tackle one thing, I'm never quite sure that that is the answer, so I dwell around and about [an idea], and several will rotate around a central concept. . . .

> The thought of all these sitting positions brought about the idea of making a preliminary tube, which consisted of three positions. It followed the movements of the spine. You know, if we analyze our motions when we stand up and sit down, we break them down in about three basic movements—the legs, the spine, the head, and so forth. And this tube was very simple; [it] consists of two central tubes that had joints at such places, and the surfaces were simply covered with plywood to be adjusted and flexed according to the need, according to the positions. All right, having made this tube, it was then an easy step to determine what positions, to determine how much [space] to allow the person sitting and so forth.[14]

11 P. 84

Bertoia began by analyzing how people sit, making a life-sized study based on the human skeleton and its possibilities, but Eames "was beginning to see that it really was too far away from what he had in mind and had done before . . . that was the very beginning of a little bit of tension." But Bertoia persisted, developing "a number of prototypes."

> Charlie was still hesitant, but it was Herbert Matter . . . who was then also in the same group. . . . and Mercedes [Matter], I think, that actually won Charlie Eames [over] to at least give it a try. But once this was done, very shortly after, he got very enthusiastic and everything came his way.[15]

Some versions of side chairs had molded plywood legs, others metal ones Bertoia made. Leg configurations were a distinct problem, causing great experimentation. They needed to be small but strong, yet, unlike the chair shells, they were not limited by human anatomy, so they invited creativity. Many designs had three legs. At least one had a blunt "fin" that was a continuation of each side of the seat that reached the floor and served in the place of legs. The final chair with molded plywood legs was highly sculptural, with its curving seat, back, legs, and back support. The support for the seat, with plenty of open space beneath it, was especially unusual and striking. Another chair study had a single metal rod extending from the front of the seat to the floor and, in the rear, a vertical leg welded to a stabilizer bar running horizontally on the floor. In this period, the firm also produced fluid, abstract sculptural experiments that would lead to a whimsical plywood elephant, horse, frog, bear, and seal designed as toys children could sit on indoors, but they were not commercially feasible.

Voluminous Eames Office records document the development of the plywood chairs, but an unofficial oral history also exists. According to Bertoia, one day while Charles Eames was out, Bertoia and the visiting Eero Saarinen were studying one of two extant examples of the one-piece chair shell that Eames then favored. Bertoia and Saarinen found it somehow unsatisfactory and were considering possible improvements. Their discussion led Bertoia to saw the shell horizontally into three pieces, putting the center section aside. Then they addressed its support and began bending a steel rod to join the back and seat; other rods would become legs. Charles returned, saw what they had done, and flew into a rage. However, this chair he and Saarinen altered, Bertoia later insisted, led to the "Eames Chair," one of the classics of modern furniture. Bertoia, like Don Albinson and other participants in the development of the chair, had no desire for his name to be associated with that chair, but he certainly did not expect (or want) it to have the name "Eames."

The major efforts at the Eames Office in 1945 and 1946 culminated in two chairs: the LCW (Low Chair Wood) and its counterpart with metal legs, the LCM, the Low Chair Metal. The Herman Miller Company, of Zeeland, Michigan, produced the chairs. Having benefited appreciably from improvements resulting from the Eameses' experience with military contracts, the Low Chairs and their cousins, the taller Dining Chairs (DCM and DCW) resulted from a synthesis of experiments. Their complex curves approximate those of human anatomy and their splayed legs increase stability. Their delicately angled seats, from some views, seem almost to float over their supports. Marrying the chairs' parts was a nagging problem finally resolved by inserting rubber discs as shock mounts—a solution borrowed from automobiles—between the supports and both seats and backs. Shock mounts also allow sitters to shift their weight, moving slightly and comfortably without resistance from the chair. The slim, graceful chrome-plated elements and the pleasing, Modernist contrast of wood and metal made the LCM and DCM the versions of the chair that the market chose. It is a perfect example of deceptively simple design.

In 1946, Eliot Noyes, director of the Industrial Design Department at the Museum of Modern Art, and George Nelson, an architect recently given charge of furniture design at the Herman Miller Company, saw many Eames

Office pieces at a December 1945 exhibition of new furniture at the Barclay Hotel in New York. They recognized the name Eames from the splints that had been exhibited a few months earlier in the 1946 MoMA traveling show *Design for Use*. Noyes offered Eames a one-man show of furniture, and, in September 1946, Entenza's *Arts & Architecture* ran an article in which Noyes praised the plywood furnishings, especially admiring the "aesthetic brilliance and technical inventiveness" of what he called the "Eames chair." Never before had the LCM or LCW had that name. There is no evidence indicating that Charles Eames objected to receiving full credit for the chair.

As Neuhart recounted, "Molded Plywood Division staff members Gregory Ain, Griswold Raetze, Harry Bertoia, and Herbert Matter left the operation shortly after the article was published."[16] Like Bertoia, others believed their contracts had been violated. In the next few years, the Eames Office moved to making fiberglass shells that retained the form of older chairs, and those chairs too filled classrooms, offices, and other public places. In 1972 Bertoia remarked that "I learned from Charlie Eames quite a bit, and I'd also like to say that I think he learned from me, so the exchange was both ways."[17] Unfortunately, after Bertoia's departure from Eames's office, both men remained bitter about his departure. Marilyn Neuhart addressed the question of the true authorship of the "Eames Chair." She knew many of those involved and over years questioned them about it. She explained that Bertoia's work at Evans Products

> was crucial to its successful operation throughout the war, and his considerable aesthetic and technical contributions to the form and technology . . . [of the] the 'Eames chair,' helped to change the course of twentieth-century furniture design. His work was always obscured by the Eameses in later years.[18]

Bertoia, Neuhart explained, was "readily credited" by former Evans Products "design collaborative" members like Don Albinson and Fred Usher "with the design of the rounded, curving forms of the back and seat of the Eames plywood chairs, and the spine and leg section support system." Interestingly, Albinson and Usher refer to the great resemblance between Bertoia's own work and what he was doing at Evans Products. The similarity lies especially in the sinuous lines and biomorphic shapes of his monotypes, especially those that suggest sea life. Ray Eames, according to Neuhart, was "still angry 45 years later" that Bertoia had worked regular business hours, and left the company and designed wire chairs for Knoll. She "ever after considered Bertoia to be a traitor and an ungrateful turncoat" for competing with Eames wire chairs.[19]

Quitting the Eames Office left Bertoia unemployed with a wife and a two-year-old daughter to support (Mara Lesta—familiarly called Lesta—was born in 1944). While working for Eames, he had continued making graphics in his spare time and was receiving a $200 monthly stipend from Karl Nierendorf for the jewelry and monotypes sold at Nierendorf Gallery in New York. A banker and collector in Germany, Nierendorf had become an art dealer specializing in the work of German Expressionists of Die Brücke and Neue Sachlichkeit; he was particularly close to Paul Klee and Wassily Kandinsky. In New York he found an art market both freer and healthier than that in Germany, so he stayed. In 1937 he opened his 53rd Street gallery and began promoting the work of European artists, including works being suppressed under the Third Reich. He also exhibited art by Europeans like Bertoia who were working in the United States. He was especially active with the Guggenheim (then still known as the Museum of Non-Objective Painting), whose director and curator, Hilla Rebay, was both a client and good friend. Sadly, in 1947 he had a heart attack, a fatal one. The Guggenheim ultimately benefited greatly—Rebay engineered the museum's purchase of his estate, with its outstanding collection of Nonobjective and Expressionist paintings—but it was the end of Bertoia's stipend.

For much of his career, Bertoia worked in at least two modes, apparently in an effort to express a variety of ideas that were important to him. He often

switched between using biomorphic forms, which especially in the 1940s had Surrealist tendencies, and a more geometric vein that sometimes appeared as a loose, playful type of Cubism. These were not the polar opposites they might initially seem to be, however, and in the late 1950s he would find a synthesis of these modes as he developed his kinetic sounding pieces.

In August 1944, Bertoia monoprints were exhibited at Catholic University in Washington, D.C., for three weeks. Rebay wrote Bertoia saying that show resulted from her influence on a nun she knew at the university.[20] A major event in any artist's career is a first solo museum show, and Bertoia's came in 1945 when the San Francisco Museum of Art held an exhibition of his monotypes. That summer fifty-three of his works on paper were also shown at the Phillips Collection in Washington, D.C., a private house and collection that became an important private museum in the nation's capital. Leaving the Eames Office at five o'clock had allowed him to be productive as an artist and develop his career.

P. 86 4

An untitled monoprint from about 1945 appears to be a developing idea, its small size evidence that it was something he intended to evolve further rather than a direction in which he was prepared to invest a great deal of time and material. A few undulating lines rise into a dark triangle—the organic easily becoming geometric—to support a curious form with suggestions of eyes and mouth. A curve at the left is the color of the paper, with dark green ink behind it, pushing it forward, while to the right the green creature's head and another curve stand out against bare paper. These contrasts of ink with paper create depth and angles in space while letting the forms emerge from the background as if materializing from some primordial space. Dreamlike, this image is bizarre, not frightening, because the creature seems a bit perplexed. It was made at a time when abstract Surrealism was becoming increasingly known in the United States as works by artists like Joan Miró, Yves Tanguy, Roberto Matta, and Jean Arp were being exhibited in museums and galleries and appearing in journal articles.

P. 87 5

Several Bertoia works that appear to be from early in his marriage and time in California are closely related in imagery to that untitled monoprint. A larger, more finished and complex work shows two organic forms, that on the left dominating the one on the right, even though the second one occupies more of the paper. Emergence of forms from the space was not a concern here, for the background is only rapid lines helping to define the figures and their volume. The swirling lines create excitement and movement. They also call attention to the process of their making, for in visually following the lines, viewers retrace the paths Bertoia's hand took decades ago. Not quite human, these figures interact in a thoroughly organic, abstracted way.

P. 88 6

A quite Surrealistic work, probably from about 1945, is a superb demonstration of Bertoia's linear skill and his love of making lines. This untitled monoprint is most unusual in that it was done in oil and/or ink on unprimed canvas 36½ inches high by 25⁵⁄₁₆ inches wide (92.7 cm high by 64 cm wide). For both better and worse, however, the more developed side is marred by the fact that another work on the back shows through as vertical lines that are wider than those of this work. Artists' canvas is a somewhat roughly woven cotton or linen chosen for painting in oil because it keeps the slippery paint where the brush put it, preventing it from sliding. Because canvas is porous, however, it is usually primed or sealed with a material like gesso to keep the paint from soaking into the fibers of the fabric. Chemical tests have not been done to determine precisely what medium (or mixture of media) Bertoia was using in this work, because that would require removing pigment. Ink would be a poor choice to use on unprimed canvas, because it would spread or bleed as it was absorbed into the surface, so the bottom layer of color is instead likely oil paint. Bertoia's monotype technique on canvas would also be problematic because the texture of the weave would distort such fine lines. This suggests that this work is mostly oil paint, and the light lines result from using a stylus of some sort, even the wrong end

of a paint brush, to draw into wet paint. (Oil paint stays wet for days, weeks, or even longer, depending on the weather, so he would have had plenty of time to work.)

The dark ocean-blue expanse here is divided by quickly drawn horizontals into six registers that are much less formal than those of Bertoia's wood-block farm scenes of about a decade before. The slight curves result from a natural and fairly rapid sweep of the arm. The largest image, near the center, resembles a fluted giant clam (*Tridacna squamosa*), with its distinctively edged shell, while unidentifiable forms to its sides have both organic and geometric traits. Three registers above is a fluid land- or seascape with a more mountainous one below and a hole from which faint lines emerge to wander upward or angle down, bending at the register line and moving on, even disappearing in or emerging from an opening in the top of the clamshell. (These lines recall Bertoia's use of wires in some jewelry.) Beneath the clam, streamlined figures have both negative, cut-out spaces and protruding shapes. More narrow lines unite the entire picture, crossing registers, disappearing and reappearing without visible reason. This undersea world is an enticing mystery, a Surrealistic world of lines and color. Its imagery reflects Bertoia's life near the sea.

The back of this watery blue image could hardly be more different. There Bertoia made a much more geometric image, although the irregularities of its details make it immediately clear that this was entirely handmade. While it bears some likeness to spines of coral, had Bertoia wanted to depict coral, he could have. Instead, it is a predominantly geometric abstraction in paint or very thick ink. (After his death, Brigitta Bertoia inventoried her husband's two-dimensional works and numbered them in pencil, following the sequence in which he had stored them. There had been some discussion shortly before his death about creating a book of his graphics, and he wanted them in groups reflecting their original sequence to show the development of ideas. She sometimes added his initials to the number, as appears here at the upper right.) When Bertoia had it framed, he clearly did not consider this the primary side of the work, because the back of the frame is visible. A small sculpture from the 1950s seems to reprise this theme. Letting the brass settle in small masses on the steel, likely with some of the wires placed horizontally, allowed Bertoia to create an effect similar to that of heavily textured paint. Whether employing paint or brass, the artist was using the material in interesting, expressive ways. He was revealing much about the nature of his materials and processes and echoing some of what occurs in nature.

The year 1946, when he left the Eames Office, was also important because it was when Bertoia became a U.S. citizen, as Brigitta had done two years earlier. Deciding to change one's nationality must be a complicated and difficult decision. But Bertoia had been in the United States for sixteen years, one year more than he had lived in Italy. The United States had become his home and that of his wife and child.

Also in 1946 his jewelry was displayed in the exhibition *Modern Handmade Jewelry* at New York's Museum of Modern Art. The first national exhibition of contemporary jewelry, it opened at MoMA on September 19, 1946, and was on view through November 17 in New York before traveling to other museums across the country. The show was wonderful exposure for Bertoia but was important more generally because it exhibited jewelry as modern art, within the walls of the most prestigious museum of its kind. For artists, inclusion in such a show encourages sales and impressed on résumés, opening opportunities in the future.

Of the 147 pieces in the show, about three dozen were brass. The eleven Bertoias were all silver, a quite conservative choice of materials, although one pin had colored thread. His works were all brooches, except a silver wire necklace and earrings. Eight of Calder's ten pieces were brass, and of all the works on display, only seven were gold or gold-plated silver. Less traditional materials characterized José de Rivera's pins of chrome-nickel

steel, Ellis Simpson's Lucite works, and pieces by Anni Albers and Alex Reed of Black Mountain College that incorporated hardware, colored jacks, and coral beads. Many artists in the show became successful jewelers, textile artists, sculptors, painters, and designers. The museum was unconventional in including six modern Navajo pieces in the show, but the smiths who made the works were the only participating artists not identified by name. (Most Native silver from the southwest was hallmarked to identify the artists by the early 1940s, so identifying who had made the pieces was probably possible.) The show was unusually inclusive, since nearly half of the artists named were women.[21]

With the help of Brigitta's father, the Bertoias bought a house in Topanga Canyon, where the family spent time outside in the beautiful, varied landscape, much of it now a park. The combination of sales of Harry's work, Brigitta's discrete liquidation of some of her own jewelry, and her mother's monthly contribution of $200 supported them after he left the Eames Office. Harry made more jewelry than he had since Cranbrook and answered a newspaper want ad for someone to do some technical drawings, work that turned out to be for the Navy. It led, in 1947, to a full-time job at the Navy Electronics Laboratory at Point Loma in San Diego. This meant moving and finding tenants—and ultimately buyers—for their Topanga Canyon house.

Bertoia liked working at Point Loma, where he especially appreciated the contact he had with the scientists and engineers, whose ideas he found quite interesting. Having begun as a draftsman, he moved up eventually to designing cockpits for fighter planes. It was 1947 and the war was over, but the Cold War was heating up, and the work was classified—a requirement for the job was citizenship, so his timing had been fortuitous.[22] As he later explained, he was involved in ergonomic design, trying to make flying more physically efficient and comfortable so pilots could fly longer and farther more safely. He, like Dreyfuss, was participating in the early years of ergonomics as a field, although studying how people sat and moved was certainly not entirely foreign to him. It would be useful experience in a few years and a new context.

While he was employed at Point Loma, Bertoia produced a large number of monotypes, many with applied paint, and was pleased enough with their results that a few years later, when his income had increased, he had a number of those he thought most successful framed in walnut and a large crate made specifically to hold them. A significant number of them were the "wood-block monotypes" or "wood-block paintings" he had continued exploring since Cranbrook and would not leave entirely behind for some years. They increasingly had finely drawn or painted details related to the lines in the Surrealistic work with the giant clam shell. Some works with layers of imagery that he made at Cranbrook anticipate these works. One of his monotypes, *Silent Colors*, was accepted in the exhibition *Abstract and Surrealist American Art: Fifty-eighth Annual Exhibition of Paintings and Sculpture* at the Art Institute of Chicago, on exhibit from November 6, 1947 to January 11, 1948. Bertoia was listed in the catalog as "America's outstanding monoprint expert."[23]

P. 88 ⸻ 6

Bertoia was invited to serve as one of the jurors for the 1948 annual San Diego Art Guild exhibition and this polite, considerate man helped create what a headline in the *Union* newspaper called a "furor." Bertoia selected a nonobjective, geometric painting called *Hope Deferred* by John McLaughlin of Dana Point for a prize. When *Hope Deferred* was reproduced in the newspaper, it caused such an outcry that the mayor's office and newspaper switchboard were swamped with irate responses. As a result, the photo appeared in the paper once more the next day, again stirring strong reactions. San Diego was very conservative and Bertoia was too avant-garde for the time. McLaughlin, however, went on to become a respected hard-edged abstractionist, affirming Bertoia's early estimation of his work.[24]

P. 92 ⸻ 10

In 1948 ten pieces of Bertoia's jewelry were exhibited at the Walker Art Center, Minneapolis, in a show titled *Modern Jewelry Under Fifty Dollars*,

as part of the museum's forward-thinking Everyday Art series, a program of exhibitions of applied arts, including handmade jewelry, ceramics, and textiles, as well as industrial design. The other shows focused on more functional items than the jewelry by thirty-two artists, among them Bertoia, Margaret de Patta, Sam Kramer, Art Smith, Ward Bennett, Paul Lobel, and Claire Falkenstein, who still are well known and highly respected. The form Bertoia submitted to show organizers indicated that all the pieces he planned to exhibit—earrings, pins, perhaps a bracelet—ranged in price from $5 to $10.

The Walker's Spring 1948 edition of *Everyday Art Quarterly* included an article about the show with more than thirty illustrations, many of them showing multiple pieces. It reported that some works are in traditional gold and silver, while others rejected those materials and used copper, brass, aluminum, plastic, and ceramics. Familiar floral motifs, stars, and clusters had also given way to modern, simplified shapes. Participants broke with the past in circumventing jewelry shops and instead sold their works in specialty shops and directly from their studios. Jewelry of precious materials, the anonymous author maintained, is worn "as a sign of affluence" and "must be judged by different standards. But jewelry made of less valuable materials—costume jewelry—should be regarded as part of the wearer's clothing; its main function is to enhance a person's appearance."[25] Even in 1948 this statement would have seemed superficial and imperceptive, and it seems something of a contradiction of the museum's aim in mounting the exhibit.

12　　　　　　　　P. 93

Bertoia made a few highly unusual brooches in about 1947, two of which are now in the Philadelphia Museum of Art. A Surrealist example features an irregularly flowing biomorphic line. One of Bertoia's large pins, it is 3 inches (7.6 cm) high and 3½ inches (8.9 cm) wide. It is made of silver electroplated in gold, a choice of materials that allowed the artist to use silver's malleability and also create a piece that suited the market preference for gold. The pin's dominant form echoes the meandering bends of a river. Near the bottom of one bend, Bertoia reused the stitching technique familiar from earlier pins but here it functions only to suggest a plane in space between two segments of line laced together. This is another reference to functional ways of connecting things in daily life. Highly unusual three-dimensional effects add to the brooch as three wires arch together, projecting unexpectedly at the pin's left side. (Highly vulnerable, the wires' curves seem to reflect how easily they would bend.) The two ends of this meandering line merge over the largest curves, supporting the clasp and stick.

13　　　　　　　　P. 93

Another brooch from the same collection and time, also silver electroplated with gold, is Constructivist in style and technique. This angular, linear piece is as thoroughly Modernist as the previous example, yet the two are strikingly different in effect. They reflect Bertoia's ease, even pleasure, in working in more than one manner at a time, for it is almost certain that these works were done over a short period, if not simultaneously. The groups of repeated lines extending from and ending in upright bars call to mind musical scores, yet instead of representing notes, the small curved elements are the effects of hammering at the ends of wires. Both Oreste and Brigitta Bertoia played the piano, and sheet music was a constant in his life.

The larger, horizontal wire was spread by hammer blows in order for it to serve as the brooch's structural element. It forms ovals at each end to accept rivets holding the stick and clasp, and it also supports the verticals from which the horizontal wires extend. The width of the brooch—4 inches (10.2 cm)— combines with the predominantly horizontal elements to create a theatrical Modernist construction.

In *Messengers of Modernism*, a groundbreaking 1997 exhibition at the Musée des Arts Décoratifs in Montréal with an accompanying catalog, the curator Toni Greenbaum included a group of six superb and surprising Bertoia jewelry pieces. These were assembled by Mark Isaacson, Mark McDonald, and Ralph Cutler of New York's Fifty/50 Gallery, which specialized in

Mid-Century Modern art. The jewelry had all been collected from the friends and families of the artists in the 1980s. All six of the Bertoia pieces, which had been mostly unseen and unpublished for decades, had been bought from Fifty/50 Gallery by Paul Leblanc and given to the museum.[26] Among the most memorable examples were brass earrings composed of three nested, concentric, nearly full circles that Greenbaum dated as being from about 1948.[27]

P. 92

Instead of creating traditional, simple gold wire hoops, Bertoia made his more affordable by using the brass wire he so liked. Hammering made the wires wider from a side view but increased neither their cost nor weight. His hoops appear so handmade that they seem to have been cut from a thin sheet of brass, and each of their incomplete circles passes through a small hole that leaves just enough room so they can swing and even spin a bit.[28] Turning and spinning, these pieces make the void in the center not so empty as it initially seems.

These triple-hoop earrings are the only jewelry Bertoia is known to have made in multiples, and they were likely made not long before the Bertoias' son, Val, was born in 1949. Artists make multiples and numbered editions of works for three main reasons: to make each item more affordable, to have more available for a larger audience, and to increase their own income. That Bertoia is not known to have made multiples of other jewelry has led a curator to question their authenticity,[29] but their method of fabrication and provenance present strong evidence otherwise. Their acceptance as his work by such an authority as Greenbaum, as well as Brigitta Bertoia and, in 2016, Klaus Ihlenfeld, a longtime friend and former studio assistant of Bertoia, seems quite certain as authentication.[30] The kineticism of these earrings extends the playful approach Bertoia had taken in brass and silver brooches he had made at Cranbrook, some of them discussed in the preceding chapter. Unfortunately, establishing the exact sequence and dates of pieces made in the late 1940s is impossible, as often is the case with Bertoia's work. Their technical, formal, and conceptual relationships, however, place them in a group of late 1940s works that have much in common.

Some of the time that Bertoia worked for the Navy, he and his family lived in subsidized government housing at Torrey Pines in La Jolla, 32 miles (51.5 km) from the U.S. Naval installation. A monotype printed from blocks of wood that Bertoia reinked and used repeatedly over the surface of a 48 by 27 inch (122 by 68.6 cm) piece of paper, is larger than he usually made but consistent with a number of pieces he had framed in walnut. This work is exceptional in many respects, including that it is so large and signed at the lower right in his block printing that, unfortunately, is difficult to see, and on the wood at the back of the frame, Bertoia also printed, "Harry Bertoia, 176 Torrey Pines Homes, La Jolla, CA." Its playful overlay of fine lines, the illusion that the blocks tip and interlock because of their shapes all contribute to the great visual interest and inventiveness of this work.

P. 91

Always outgoing, Brigitta met and talked with interesting, sometimes famous people, including Vincent Price, who would buy some of her husband's "drawings," as she and her husband often called the monotypes. Rebay had recommended that Bertoia see Oskar Fischinger's abstract films, and the couple met and liked Fischinger and his wife, Elfriede, in 1944. Rebay had recommended Fischinger, who taught at Occidental College and made nonobjective films, to Bertoia because of Bertoia's interest in making monotypes in a sequence; she thought film was more suitable to sequential imagery than painting or prints. Brigitta was delighted to have German friends and to be able to relax in her native language, and she was fascinated by telepathy and mysticism, interests that she and Oskar, especially, had in common. Bertoia found the Fischingers interesting, pleasant company but was not a convert to filmmaking.

Only a year later the Bertoias met Norbert Schiller, a member of the anthroposophical society. Soon Brigitta began reading books by Rudolf

Steiner and learning about anthroposophy, the Austrian's idealist philosophy that sought to synthesize science and philosophy. From 1900 to 1942, Point Loma had been home to the Theosophical Society, which had a large campus of exotic buildings, including a temple with an amethyst dome that glowed at night. Shortly before the Bertoias moved nearby, it had become a school, but its curious buildings and esoteric past were well known and intriguing.

In 1946 Wilhelm Valentiner took his daughter for a quick visit to Henry Miller in Big Sur. Miller recommended that she read about Zen, beginning with R. H. Blyth's *Zen in English Literature* and Hermann Hesse's *Siddhartha*.[31] An avid conversationalist and very much an enthusiast of whatever interested her at the moment, Brigitta undoubtedly discussed such things with her husband, who had stayed home to care for their daughter.

Bertoia's love of, and faith in, nature seems to have piqued his interest in Asian ideas about the universe, and his wife's wide readings in mysticism also encouraged his thinking. It was likely during the California years that Bertoia encountered Taoism in the form of the *Tao Te Ching* by Lao Tsu, a book he suggested that others read for its own interest and as a key to understanding his beliefs. While Russian Constructivists had encouraged him to leave his works without signatures or titles, the *Tao Te Ching* reaffirmed his responses to nature and made him think about his work, after it was finished, in a new way. Lao Tsu wrote:

> The sage goes about doing nothing, teaching no-talking.
> The ten thousand things rise and fall without cease.
> Creating, yet not possessing.
> Working, yet not taking credit.
> Work is done, then forgotten.
> Therefore it lasts forever.[32]

The Bertoias loved California's weather and thrilled in living on or near the coast, with its diverse terrain and wildlife, but grew dissatisfied with Navy housing. Work at Point Loma had grown less interesting as time went on, and the Bertoias bought a piece of property on a bluff with lovely views. Bertoia had kept in touch with his Cranbrook friend Harry Weese, a Chicago architect he liked a great deal, and Bertoia asked Weese to work on a design for a house. The architect prepared sketches for a two-bedroom house, and then a second set of architectural drawings arrived showing a studio that Weese insisted was necessary. Soon Bertoia came home from work to find a letter from Florence Schust Knoll inviting him to come work for Knoll Furniture. She and her husband, Hans, offered him $20,000 for two years of work for them in Pennsylvania. Bertoia was a person who deliberated about things and did not jump at chances. The Bertoias discussed it. He dithered and hesitated. A second letter repeated the open-ended offer. They had reached no decision when, according to Brigitta, a telegram arrived insistently seeking a reply. He and she told the story of this event slightly differently, but both agreed that, believing her husband had considered and delayed long enough, she replied and accepted the offer for her husband. He came home one day to find a letter from "Shu" Knoll expressing delight that they were coming. Bertoia must have been more than surprised at the news, and soon, packing done, they were off to Pennsylvania.

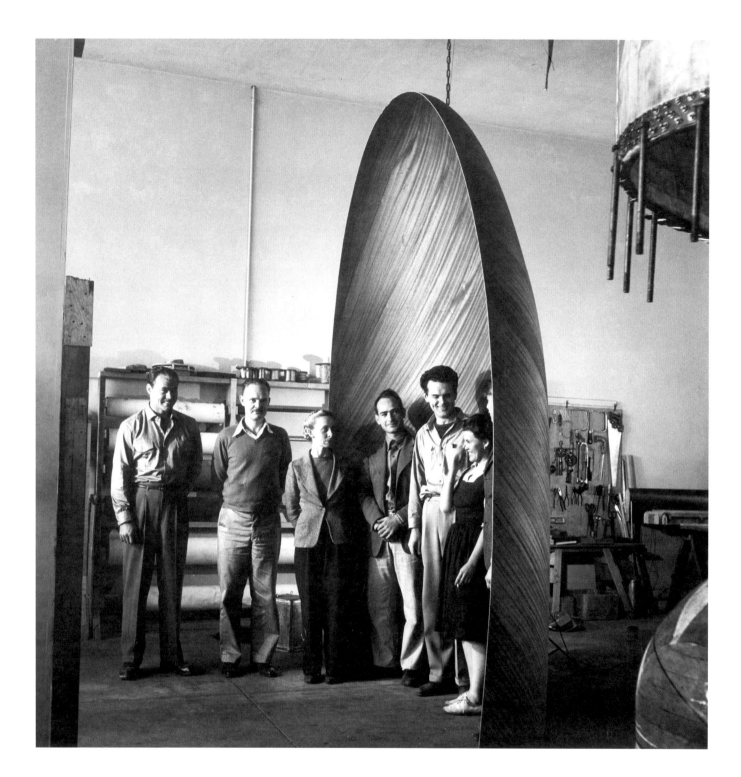

71

2

3

1 Charles Eames stands between Harry Bertoia and Ray Eames inside the plywood nose of an airplane, accompanied by others working on the project.
2 Harry Bertoia, 1943, demonstrating use of the molded plywood arm splint. A piece along the side of the chest curves up to support the arm at shoulder height.
3 Harry and Brigitta Bertoia on their wedding day, May 10, 1943.

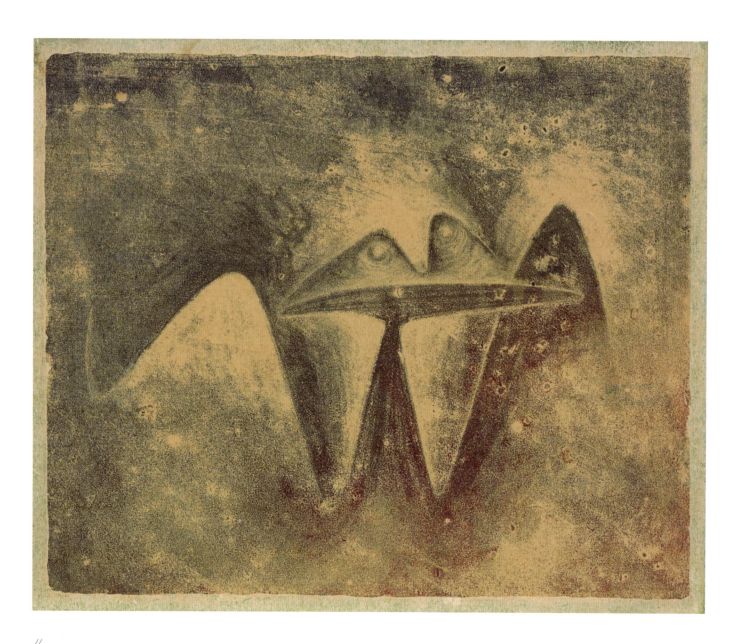

4

4 *Untitled*, c. 1943. Monotype hand printed on rice paper. 7 x 8½ in. (17.8 x 21.6 cm).
5 *Untitled*, c. 1943. Monotype, printer's ink on heavy paper. 24 x 17¾ in. (61 x 45.1 cm).

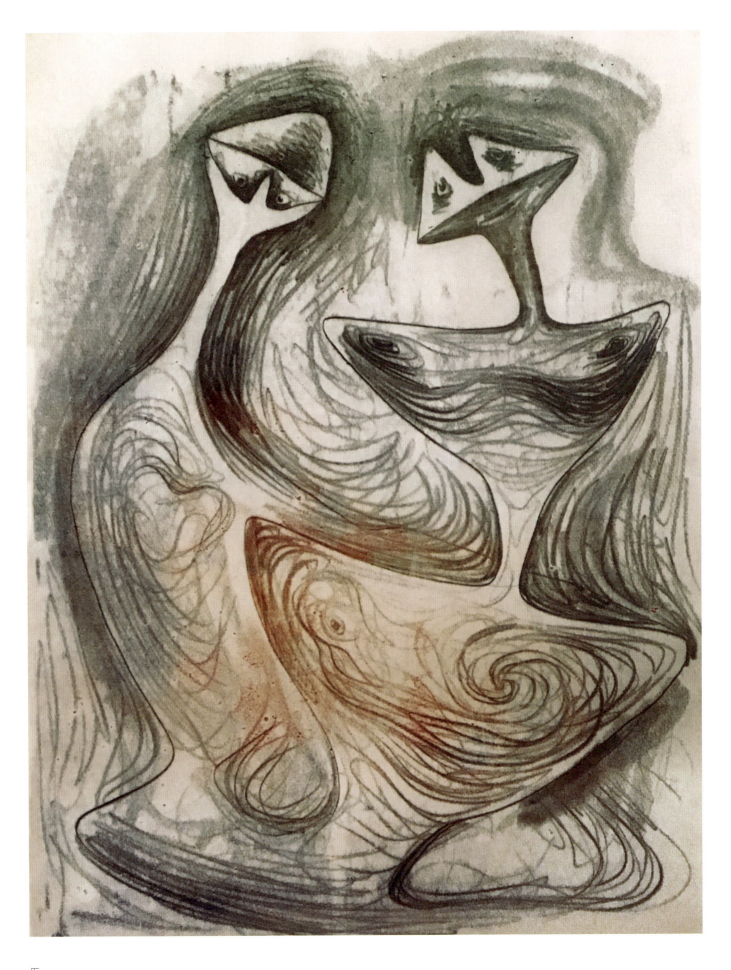

5

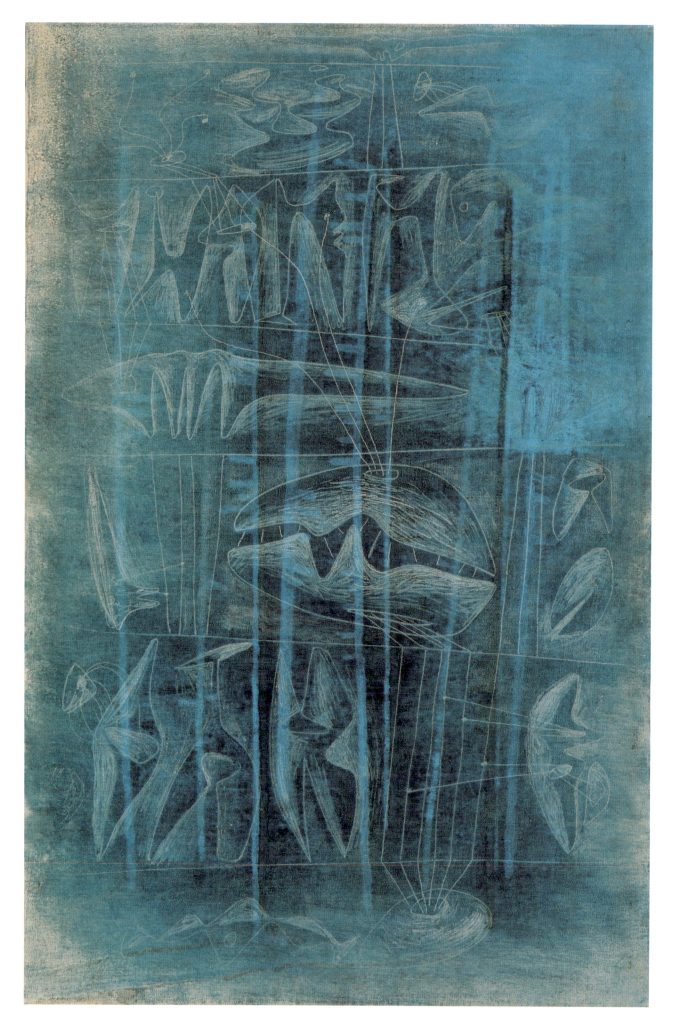

CALIFORNIA: ART AND INDUSTRY 1943–50

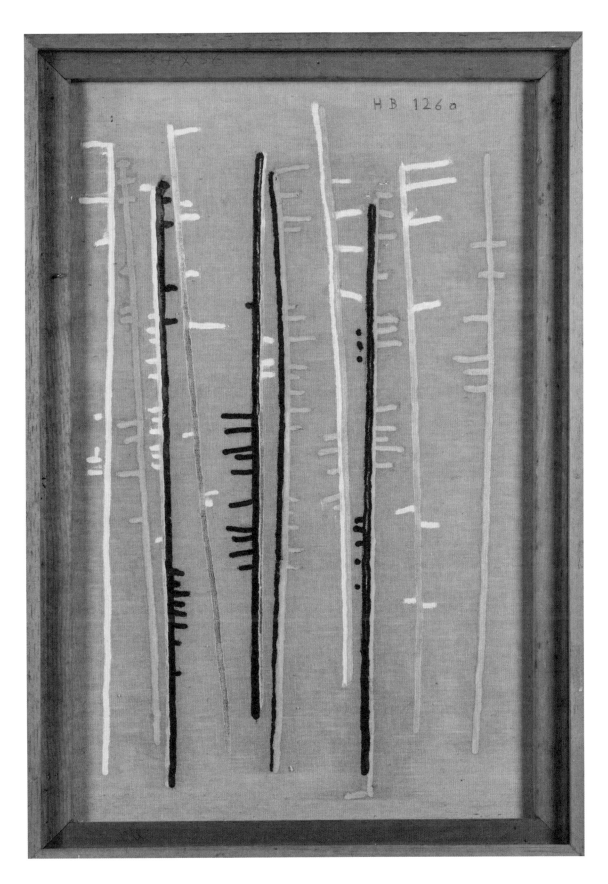

6 *Untitled*, c. 1945. Oil and/or printer's ink on unprimed canvas. 36½ x 25 ³⁄₁₆ in. (92.7 x 64 cm).
7 Reverse *Untitled*, c. 1945. Oil and/or printer's ink on unprimed canvas. 36½ x 25 ³⁄₁₆ in. (92.7 x 64 m).

8 *Untitled* (Welded Form), c. 1957. Brass-coated steel. 4¾ x 1¾ x 1½ in. (12.1 x 4.4 x 3.8 cm).
9 *Untitled* (Monotype), 1948. Printer's ink and oil paint on paper. 48 x 27 in. (121.9 x 68.6 cm). Signed
 lower right "Harry Bertoia" and printed again on the rear of the frame with his Torrey Pines address.

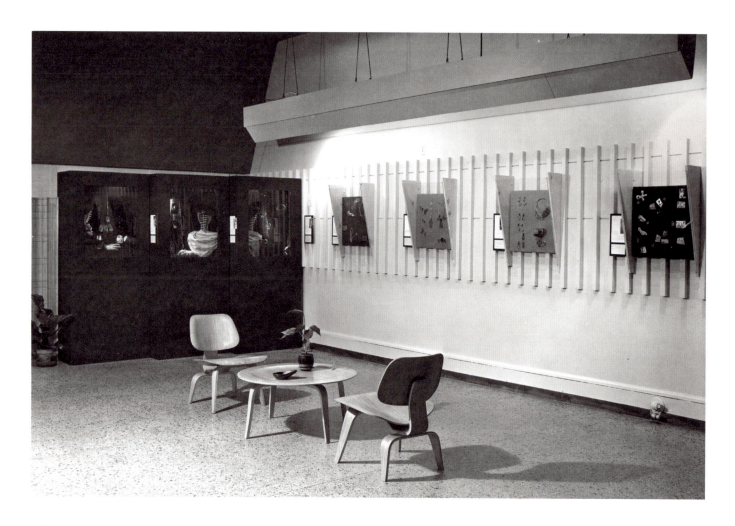

10

11

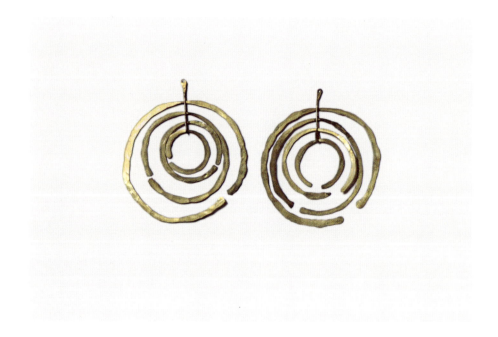

10　Eames chairs at the exhibition *Modern Jewelry Under Fifter Dollars*, Walker Art Center, 1948.
11　*Untitled* (earrings), c. 1948. Forged brass earrings, cold connected. 2⅞ in. x 2¾ in. x ⅛ in. (7.4 x 7 x 0.3 cm).
12　*Untitled* (brooch), c. 1947. Silver electroplated with gold. 3 x 3½ in. (7.6 x 8.9 cm).
13　*Untitled* (brooch), c. 1946. Silver electroplated with gold. 3½ x 4 in. (8.9 x 10.2 cm).

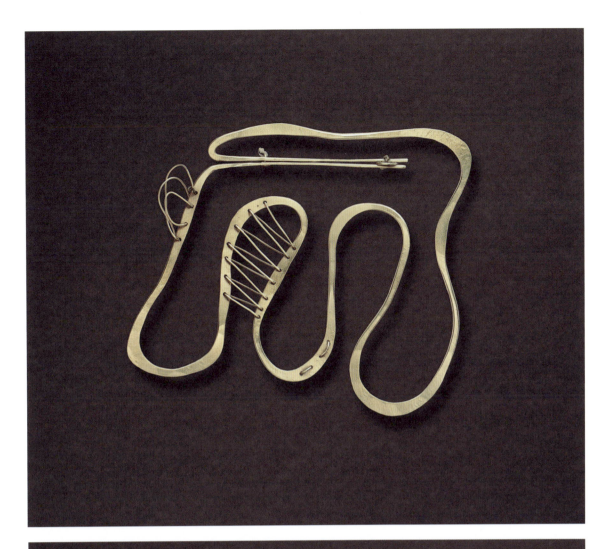

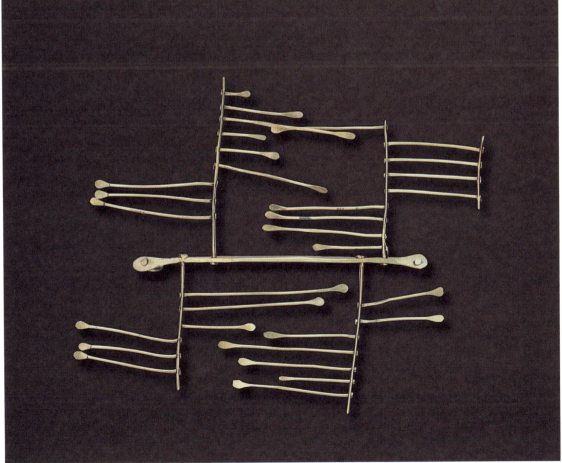

A chair is designed as much by one's behind as one's head.
—Harry Bertoia

The most memorable event of their trip from California, as Brigitta Bertoia remembered it, was their car breaking down. A mechanic provided a temporary fix, enough to reach Detroit, where the planned visit with Oreste and his family extended to unexpectedly purchasing a Ford, Bertoia's first new car.

Arriving in Pennsylvania, the four Bertoias stayed in a hotel in Quakertown, about 10 miles (16.1 km) from the Knoll plant in Pennsburg, north of Philadelphia, and then they visited for two weeks at the Knolls' luxurious beach house in East Hampton, New York. It was the first of a number of such visits. Their first year was enlivened by contact with interesting artists: the Bertoias lived in a carriage house outside New Hope, where George Nakashima, the superb furniture craftsman, and his family became friends of theirs. While Lesta and the Nakashimas' daughter (Mira) played, Nakashima fascinated Brigitta with tales of his year in an ashram in India and encouraged her to read Sri Aurobindo. He and Harry found commonality when they talked about design, materials, and nature. New Hope has tranquility and beauty that have long attracted Manhattanites. Seventy-five miles (120.7 km) from New York, eastern Pennsylvania allowed Bertoia the benefits of rural life with ready access to the city for business, attending exhibitions, and interacting with other artists and designers. Not only did the sculptor Richard Lippold and his wife come to visit, but also Brigitta remembered meeting Marcel Duchamp, Saul Steinberg, and Edward Durell Stone at events in New York over the next few years.

Finally, late in May 1952, after moving several times, Bertoia came home from work one day beaming. He had found the house he wanted.[1] It became more than the family home. Constructed shortly after the American Revolution on a small farm, it is built largely of the stone characteristic of the Philadelphia region, with thick walls that insulate against all but the most severe of winter and summer temperatures. Smaller and more isolated than the stone house where Bertoia was born, the residence must never-theless have felt more familiar than any place he had lived since leaving San Lorenzo. On one side a spring dripped into a horse trough, and on the other a stream had been dammed to make a pond. Surrounded by woods, the property was a serene spot for the house, which had plenty of rooms and a large porch. Twenty or thirty yards (18.3 or 27.4 m) away, facing the house was a "bank barn," a type of Pennsylvania structure sited on a slope that makes the building two stories on one side and a bank or ramp of soil on the other side providing livestock and wagons direct access to the upper floor. Initially, Bertoia made sculpture in the barn; after its restoration in the late 1960s, he reserved the loft for making graphics and used the main floor as the laboratory for his acoustic sculpture.

Immediately after World War II, most young, middle-class families lived in houses consisting of small rooms. Their parents' and grandparents' furnishings, usually handed down, were Victorian and Edwardian, which meant they were often big and ornate. It was furniture that consumed small spaces. Modernist furniture would help solve the problem of furnishing their living spaces, partly under the influence of architects like Harry Weese and Alvar Aalto, Charles Eames, and the designers affiliated with Knoll Associates. Before going to Cranbrook to study urban planning, Weese had studied architecture at the Massachusetts Institute of Technology (MIT) with his mentor, the Finnish architect Alvar Aalto. Even before Eliel Saarinen left Finland, he had been impressed by the furniture and buildings of his countryman Aalto. The appeal of Aalto's work lay especially in its clean, organic forms and its construction that reflected Finland's heritage of fine craftsmanship. Aalto's curving furniture depended on carefully plied and bent strips of wood and, with webbing filling the spaces between structural elements, it was comfortable and light in both mass and weight. Even more revolutionary, Aalto's Artek line was early "knock-down" furniture that arrived boxed, in pieces to be assembled—Ikea's ancestor. Personal,

practical, and aesthetic factors merged, leading to Weese's exclusive distributorship of Artek furniture in the Midwest.

Weese had been the force behind what likely was the first American Modernist design shop. He had encouraged Kitty Baldwin, his future wife, and her friend Jody Kingrey to open the Chicago shop with his financial and aesthetic backing. The store, named Baldwin Kingrey, incorporated display systems and graphics by Weese, whose architectural office was in the back room. After opening in 1947, Baldwin Kingrey became the outpost of Modernism in the Midwest despite having sold out of Aalto designs before it officially opened. Designer Richard Schultz remembers it as the local hangout for students at the Institute of Design a few blocks away, and others recall that students brought lunches and ate sitting in furniture displays. While other retailers tended to promote collections of furnishings by designer, Baldwin Kingrey mixed its offerings, putting Eames storage units with Eero Saarinen tables and Aalto chairs, presenting Modernism as a varied but coherent movement. Displays of Bertoia jewelry often rested on Weese's glass shelving system, sometimes with Bertoia monotypes waiting on a wall for the right collector. The excitement and promise of Modernism were tangible.[2]

The public was beginning to see Modernism as suitable for daily life, not simply as art in museums. While Baldwin Kingrey made living with Modernism comfortable, adaptable, and practical, Knoll would make it high style: arranged in elegant foyers and offices, Knoll's public face was more sophisticated and oriented to business. Much of Knoll's early market was corporations in new Modernist towers; it was a different world than the warm wood and domesticity at Baldwin Kingrey. They were different aspects of one broad Modernist trend.

Hans Knoll's father had inherited a company that produced wood furniture in Germany. When Hans began his own business in the United States, he too used wood for the furniture, especially chairs, that he produced. Hans had selected eastern Pennsylvania to manufacture his furniture because the landscape seemed familiar, resembling the land of his youth, and he trusted its Pennsylvanian-German heritage of hardworking woodworkers. Bertoia and others who knew him realized that Hans had real business acumen. He had hired Florence Schust ("Shu" to her friends) in 1941 and renamed his company Knoll Associates. Shortly thereafter she established Knoll's Planning Unit, an interior architecture and design group that also commissioned pieces from architects and artists affiliated with Knoll. Florence had the artistic eye and ties to artists like Bertoia, whom she knew from Cranbrook. In 1946 Florence and Hans married, and she took a leading role in the company. She not only practiced interior architecture but also led the Planning Unit. In addition, she designed what she called "fill in" pieces— storage units, desks, and couches compatible with the more sculptural works by Bertoia, Saarinen, and Mies van der Rohe. (Schultz accurately maintains that hers were important, large pieces, much more than mere "fill ins."[3] In Chicago, Weese had done much the same, though his pieces were produced locally and in small numbers.) But Florence designed her furniture as if it were architecture, based on the same geometry as the buildings where it would reside. Her ideal was a "humanized modernism": rigorous structure softened and warmed by textiles and color. She stressed professionalism and that interior design was intellectual, relying on exactly the same processes that other architects employed. She also dismissed interior "decorators" as dilettantes whose sphere was domestic. "I am not a decorator," she insisted.[4]

Initially, the Knolls had asked if Bertoia preferred to work in New York, as they did, or in the country in Pennsylvania.[5] He probably did not have to weigh that decision for long, the city was not for him. Hans Knoll initially suggested that Bertoia design hospital furniture, an idea that had no appeal to the artist at age thirty-five. "My tendency," he explained, "was to stay away from hospitals as much as possible, in any part, in any connection," but he much later acknowledged the merit of Knoll's idea. He and Knoll

agreed instead that Bertoia would work as he chose, and if he arrived at something he thought would interest the Knolls, "so much the better." As he got to know Hans and saw more of his old friend Florence, Bertoia found all the interaction positive and his new job situation increasingly supportive. It offered "stimulation," he explained. "It created an atmosphere of well-being, of projections, expectations. I think it was essentially Hans's way of recognizing an individual's ability and bringing it out as much as possible."[6]

Bertoia's financial agreement with Knoll became more specific: he later explained that "I would receive a certain sum [$20,000] in case the chair wouldn't sell, but once the sum was reached, then the chairs would become sole property of Knoll Associates." He added that the amount "to me sounded so vast at the time that [it] was one of the quickest decisions I ever made; I said yes. Well, you know . . . in about a year's time, it was all paid, and from there on, of course, it became Knoll property."[7] True to his nature, Bertoia never expressed any regret about the terms of the financial arrangement but instead was pleased that his chairs and the company were so successful.

When Bertoia arrived at the small plant in Pennsburg, he found that Knoll had made an unfurnished shed available for him to work in at the factory. Describing it later, the situation seemed more amusing than it had initially: "There was not a single pair of pliers, a hammer, a grinding wheel, nothing." Knoll, as a manufacturer of wooden chairs, had no metalworking equipment. In retrospect, Bertoia realized that "the scarcity of equipment" was a factor that had encouraged him to work with wire; another was "the fact that wire, if properly used, obtains a great deal of structural strength with an economical amount of bulk." He might also have added that he had considerable experience with wire and liked working with it. All of these factors contributed to the solution he found for the chairs.[8] He did some preliminary work on the chairs in Pennsburg and sometime in late 1951 moved to a building belonging to the Chevrolet dealer in Bally, which Knoll was making into its metal shop. It was there that the chairs were refined and first produced. It would eventually become Bertoia's workshop.

The process of designing the chairs is consistent with evidence of Bertoia's later approach to design problems and accords to a degree with Eero Saarinen's, since both men had been molded by Eliel Saarinen. According to the designer Niels Diffrient, who had studied at Cranbrook before working for Eero Saarinen, his boss "never solved a problem by doing one solution. He came at a solution by process of elimination. He did a thousand solutions for one design. You got what you got by throwing away everything that wasn't as good, but you *tried* everything.[9] At least in later years, Bertoia drew as a way of pondering and exploring ideas. It is likely that he sketched possible designs for the chairs Knoll produced, although none survive.

The keepers of the history of Bertoia furniture are Schultz, who joined Knoll Associates in 1950 and went a year later to that shed in Pennsburg to assist Bertoia and then to Main Street in Bally; and Bill Shea, an industrial designer who worked for Knoll Product Development in the late 1970s and 1980s. Shea has studied the history and production of the chairs. Schultz and Shea both believe Bertoia designed the chairs for Knoll at full scale, in metal, without any sketches, in order to be able to judge their comfort by sitting in them.

Schultz remembers going to the Knoll plant in Pennsburg in 1951 to assist Bertoia; there, some months later, Bob Savage joined them, then Don Petitt. So highly inventive was Savage, Schultz explained, that they called him "our little Leonardo." With a degree in philosophy from Princeton and fine blacksmithing skills, Savage contributed significantly to developing ways to manufacture the chairs.[10] Petitt, Schultz's roommate at the Institute of Design, was a designer and a fine welder who later created upholstered bentwood chairs for Knoll. At Cranbrook, it had been traditional to work nearly around the clock, especially as competition deadlines neared. Out of both habit and preference, Bertoia worked late on his chairs, sometimes all night, but, unlike Eames and Saarinen, he did not expect others to put in

such long hours on his project. This had been a point of contention between Eames and Bertoia in California, because there Bertoia worked nine to five, then returned home to his family, monotypes, and jewelry. When Bertoia worked for Knoll, by contrast, his team kept regular business hours, but he worked until he reached either a logical stopping point or exhaustion. He persisted in working like that until the design of the chairs and the process of manufacturing them had been resolved.[11] A perfectionist, he understood that his associates would be less intense about his projects, but he found anyone who lacked direction, initiative, or discipline incomprehensible.

Bertoia relished the challenge of designing an entire collection of chairs and enjoyed working with colleagues he liked and respected. It was his nature to be driven; he simply loved working. His work ethic was encouraged largely by his determination to find the form that was exactly right for the project at hand, but his wealth of imagination meant that there were always other projects waiting for his attention. Bertoia designed the chairs one by one, beginning with the small Diamond, Knoll's model 421. One day Hans Knoll phoned to ask Bertoia about his progress and Bertoia described the chair's shape as "sort of a diamond."[12] The name stuck.

113 P. 116

114 P. 116

Next came the Large Diamond (Knoll's model 422) and the High Back Chair, or "Bird Chair," and its ottoman (Knoll's models 423 and 424). As each piece neared completion, the Knolls came to look at it. The metal-legged, wooden slat bench went on the market in 1952 and was the simplest to design and manufacture. Its Y-shaped legs were available in a black or white finish and eventually in chrome; originally, the outdoor model came in various kinds of wood. It could serve as either a bench or coffee table, like the *Nelson Platform Bench* of 1946, which it strongly resembles. Weese would also design a slat bench. Bertoia's is visually lighter, more elegant and graceful than that produced by Herman Miller under George Nelson's name. Bertoia's slat bench relies on a visual play typical of his wonderfully linear sensibility, for the narrow slats are lines juxtaposed to form a plane. In 1954 the bench was among the one hundred objects selected by the jury of the *Good Design* show in Chicago.

Bertoia later described Eames's approach to making furniture as "forcing plywood into a shape it did not want to take." Wire, not subject to the limitations and constraints of molded plywood, allowed Bertoia to begin instead with the human body. He wanted to make a chair, he said, "as an expression of bodily and skeletal behavior. How long was the chair to be sat in? The longer, the larger the seat surface should be to take account of the body's motion."[13] Since wood has for centuries been the traditional material for furniture, Bertoia's premise that it was possible to make a comfortable chair of metal wire was revolutionary. Two everyday items, he once explained, contributed to his chair designs: window screens and baskets, both of which are made of linear materials woven into expanses that become planes, whether curved or flat.

Schultz stressed that Bertoia's approach was above all sculptural and "what was uppermost was comfort." He continued:

> Harry would build a plywood platform that we could sit on. It was adjustable. He sat on that and sketched the whole thing out in wire in three dimensions. No drawings were ever made, because if you look at the chair you'll see a drawing would be useless from the point of view of making something.[14]

Bertoia was most interested in designing a chair suited for informal conversation, an activity that he enjoyed enormously, because it was at once relaxing and stimulating. While he likely sketched early chairs, he showed no studies to anyone. Working initially directly in wire, he arrived at many outlines and then mesh to support the body. He wanted to document these ideas and the stages of a chair's evolution in photographs, knowing that it would be impossible to revert to an earlier stage after further manipulating a form, even if he wanted. Photos might help to reproduce a good

form that was gone.[15] In a preliminary experiment, seeing through the linear study to its opposite side provides a preview of the mesh that might result from overlapping such successions of wires.

P. 108 3

Bertoia's aim to create a chair that was both comfortable and beautiful was far from the norm in furniture design, then a highly profit-driven business, Schultz remarked. The combination of ergonomic and aesthetic concerns really set Bertoia's chairs apart. With iron tie-wire holding the intersections in position, Bertoia used a torch to melt the bronze fill-wire and unite the steel wires of the basket; such brazing was a process he used to turn steel wires into experimental mesh forms he might use to support a human body.[16] Eventually, he settled on the approximate diamond shape he described to Hans Knoll, which was a roughly square form that he had rotated forty-five degrees, pointing its corners to the sides, top and bottom. In a profile view, the mesh had a deeply curved profile that came to be called a "basket." It would contain a sitter's torso, and it was slightly flattened at the front so it would support the person's thighs. The shapes within the mesh, like the shape of the entire chair, look diamond shaped, and an implied line extends through the diamonds from the apex of the back to the bottom at front. It visually stabilizes the basket and is compatible with the angles of the base and legs, which rise first from the skids to the horizontal brace, then to the wires that reach out to support the arms. This prototype Bertoia made with fine wires is very open. The base attaches to the basket below the arms, close to the body. Petitt's more precise prototype and those Knoll manufactured from it used larger wire and tightened the mesh but maintain the implied axes and graduated openings of the mesh.

PP. 110–111 5 6

Schultz has described how those involved viewed this entire undertaking:

> We were all very much aware that we were doing interesting and innovative things. . . . But at the same time, we didn't think in terms of history or posterity. . . . As soon as a piece of furniture, a chair, was superseded by another version, that was just thrown away. The whole idea was that we were going to get to the perfect chair and then we'll produce that chair and that will be it. But nowadays because there's so much interest in these things, it makes you wonder why we were so unconscious about it. I talked to Shu about that. She said 'oh we didn't think we were doing anything marvelous.' Well I think we knew we were doing marvelous things but there was no sense of it being historic.[17]

Herbert Matter, the skilled and imaginative photographer and graphic designer who also left Eames in 1946, was central to creating Knoll's image and early success. Matter combined photographs documenting some versions of the Diamond Chair as they evolved with studies for the mesh, turning them into a fascinating abstract design. As the shape evolved toward the final chair, the form as well as the openness of the mesh varied. The lines at right in Matter's study are experiments leading to the profile of a chair as well as the mesh.

P. 109 4

Decades later Bertoia stated that designing the chair was "a two stage craft process: first making the tools that are going to make the chair and then actually making the chair using those tools."[18] Necessity repeatedly drove invention as unanticipated obstacles cropped up. For example, Schultz explained that the seat of the early prototype of one of the Diamond Chairs was too small. To make a larger version, they inverted the small basket and applied a layer of "hardware cloth" (or "rat wire") that resembled mesh fencing, and Bertoia brazed another, larger basket over it. He repeated the process until the size seemed right. At one point, the chair was "too fat, [so] we took a big rubber mallet and banged it so we had less chair," Schultz recalled. This unprecedented process was entirely done by hand. When it was finished, Bertoia had not only invented the chair and made the early versions but also invented how to manufacture it.[19]

At first glance, the chair's mesh seems consistently spaced; changes in its weave may appear to be optical illusions. In fact, subtle shifts characterize the spacing of wires in the Diamond Chair. The mesh gets tighter toward its edges but maintains the vertical and horizontal axes important to giving it order and visual balance. The chair's back is straight enough to provide support for the lumbar area and sufficiently angled to let the upper back comfortably rest; its generous pentagonal seat combines with the back to accommodate and support the torso well. The sides bend up, holding the body between curves that sweep simultaneously up and out into armrests. This single mesh basket replaces the back, seat, and arms of most lounge chairs. Its width easily accommodates some shifting of position and gesturing with the arms. After working for Eames and the Navy, Bertoia understood that different chairs are necessary for a variety of activities. It was his attention to ergonomics that enabled him to arrive at designs that are so comfortable and well suited to their purpose. The seat of the Small Diamond is narrower and shallower than the larger model's; its basket is smaller and its narrower arms are closer to the body. Its back is more vertical. Designed for shorter periods of sitting, it encourages a more formal posture than does the larger version. Because it demands little space in a room and is less casual, it is used much more frequently than the Large Diamond Chair, especially in businesses. A small, covered Diamond is the chair Bertoia provided visitors for talking with him at his desk.

Bertoia designed the Large Diamond for relaxation, enlarging the rather pentagonal seat to accommodate some movement of the body, tilting the back at a more casual angle (which also lowers it 3 inches [7.6 cm]) and opening the basket to make it wider. It is 1 foot (30 cm) wider than the small version, so its sculptural form and size combine to make it command considerable space and make it a focal point in a room, especially when covered in "Knoll red." Despite fine-tuning over the years, the Large Diamond has retained its aesthetic effect and its unusually deep seat, while more recent shifts in the angle of the back leave it still supportive and comfortable. Sometimes Bertoia did acknowledge, with a smile, that rising from the Large Diamond is not always entirely easy or graceful.

Interior designer Betty Pepis attended the December 21, 1952, opening of Bertoia's first show at Knoll's 575 Madison Avenue showroom and reviewed the works for the *New York Times*. She noted that both models of the Diamond Chair rest on what she called a "cradle." The cradle, now at times called "Bertoia legs," is a construction of two rods bent in a series of acute angles. The larger, lower portion descends to the floor at the rear of the chair, bends into a skid, and, having moved to the front, bends again, this time rising as a front leg to cross horizontally, under the seat. From there it descends as the other front leg, forms the other skid, and rises at the rear. It is welded, front and back, to an inverted, smaller copy of the lower part of the cradle. Where the upper and lower sections meet is clearly marked by short lengths of rod extending and revealing the cradle's structure. This base is attached to the basket under each arm, welded to a straight metal piece. The Large Diamond, like some Eames chairs, gains flexibility by the addition at each side of a shock mount between the basket and the cradle. Pepis explained that Knoll removed its usual display in order to focus attention on Bertoia's "wire and metal structures, some meant simply to be looked at, others to be sat upon," and she added that the furniture would be for sale in the New Year. "The first impression is that these chairs are closely related to the wire shell chairs designed by Charles Eames" that the Herman Miller Company marketed almost a year earlier, also using steel wire, she observed. However, the effect of the Bertoia chairs was different from that of Eames's wire chairs: "Because the scale is larger than that used by Mr. Eames, one is more aware of the airiness of the mesh used for the frames and less conscious of the bulk of the over-all design."[20]

The Asymmetric Chaise is the most astonishing of Bertoia's chairs. Its unique form results from a design thoroughly based on the anatomy of the reclining body. Unfortunately, due to limited market potential, manufacturing it in the 1950s was not economically feasible. The design was too

111 P. 114

112 P. 115

unconventional, especially in a piece of furniture that takes up a great deal of space. It wasn't until April 2005, when the market had changed considerably, that Knoll finally put the Asymmetric Chaise on the market.[21]

Two Asymmetric prototypes have surfaced. The original, the one Bertoia himself made, was a gift from the artist to James Flanagan, Bertoia's longtime shop assistant; in April 2005, more than fifty years later, it went from the Flanagan family to Wilbur Springer.[22] Bertoia's prototype is easily distinguished from the second version, which Petitt constructed in 1952 after the December 1952 introduction of the Bertoia line. Petitt's prototype was based on Bertoia's prototype, but Bertoia's grid is more open, and small lumps of brass left from brazing are visible at some junctions of the wires.

Petitt's version of the chaise was advertised in May 2004, for auction in Chicago the following month. It belonged to a member of Bertoia's extended family. Knoll obtained permission to study it for "a brief window of time" with the aim of putting it into production. Unable at the time to go to Chicago himself, Shea asked an old friend, industrial designer David Vandenbranden, to go. He and his associates measured the intersections of all its wires, placing butcher paper below it and marking where plumb bobs, hung from the intersections, hit the paper. With the resulting diagram, measurements, and photos, they returned to Knoll to begin the process of re-creating it. "If only 3-D scanning had existed then." Shea observed. Knoll worked rapidly, getting it into production in 2005.[23]

Wilbur Springer is a long-time friend of the Bertoias, and the former owner of an art gallery near Allentown, Pennsylvania. He was instrumental in settling Bertoia's estate. Springer's study of Bertoia's prototype, Petitt's prototype, and Knoll's copy of Petitt's version of this unorthodox chaise reveals both their differences and commonalities. They are similar in size, construction, and design, with doubled wire perimeters and the Bertoia base. But they differ aesthetically and in some details of construction. The Bertoia-made prototype appears simpler and its structure clearer because it has fewer wires; its longitudinal wires run the full length, and the lateral ones all go the full width. Petitt's chair, like Knoll's reproductions, has three added wires at each side, beginning where the chair bends to start forming the seat. Springer believes the extra wires in the Petitt-Knoll design were added to strengthen it. He thinks that Petitt added the wires to compensate for the weakness caused in welds when the electricity fluctuated, but Shea insists that when that problem arose, it was compensated for periodically by testing the strength of welds on short wires.[24] Shea maintains that the extra wires were actually added as a way of making the mesh more consistent with that of the other Bertoia chairs. It is at the expense of the airiness of the original design and, paradoxically, at the expense of its linearity.

Bertoia had been working out his ideas for a chaise on tissue paper that came in a roll. He kept the roll at the left of his desk, pulled some across the work surface, and drew. He would tear off used paper and usually throw it away. Flanagan found some drawings of rocking and adjustable, reclining chaises that are interesting in a number of ways. They indicate that Bertoia sketched ideas for chairs, though they do not relate directly to chairs that Knoll produced.[25] Some are a bit more structural than others that are more focused on aesthetic effects, but none is more than a very early thought, and Bertoia's usual surety, elegance, and economy of line is missing from them all. In one pencil drawing, Bertoia's Constructivism is sharply angular, more reminiscent of the work of Gerrit Rietveld than of Bertoia. Its lines and angles hardly seem the work of a designer whose first concern was human anatomy, and only the footrest support survived in any other drawings.

A quite different approach is evident in a drawing of a cantilevered recliner with a long base to counter the weight and compression of both the footrest and the head of the chair. Angular, it has metal supporting its perimeter, indicated in green pencil, and a covering indicated in red that has turned orange with time and the acidification of the paper. In another sketch,

P. 112 — # 8

P. 113 — 9 10

P. 126 — 25

P. 126 — 26

Bertoia explored rods forming a triangle to support both the lower back and the legs. At right, however, he made reference to the Mies van der Rohe Barcelona Chair by extending its elegant curves into a chaise longue. Bertoia of course never proceeded with so obvious a borrowing.

A more detailed study explores the small pyramid that would be the bottom of a chair's support system. Bertoia was considering using a "preformed strap," as he noted at right, which would extend to the chair's frame from the hinged pyramid that has a "locking sleeve." This design is clean and elegant but might have been unstable. At left, a note in graphite suggests Bertoia was thinking about an event in the afternoon of the 21st or on the 22nd, as though interrupted by a phone call and making a note while speaking to a caller. The Asymmetric Chaise seems to have replaced the ideas in these and other extant sketches.

Knoll's Side Chair (model 420) filled an important and practical role in the collection and was the most difficult to design of all the Bertoia chairs. It has been revised over the years more than other chairs in the Bertoia line.[26] Bertoia had been grappling with the problem of side chairs since 1939 but knew from experience that wire forms were not subject to the practical limitations of molded plywood. Having considered versions of this design problem so extensively in the past may have actually complicated Bertoia's arrival at a solution. Sometimes old ideas can block new ones.

Making a side chair related to the Diamonds may appear straightforward, because it seems so simple and logical. Two questions were involved: Should there be a one- or two-part shell, and how should the mesh be oriented? Consistent with the Diamond Chairs, a single-piece shell answered the first question. Designing the mesh was complicated, and a horizontal format was the eventual answer, but with nuances. The gradual convergence of the mesh at the sides frees the chair from geometric rigidity, allowing it to expand to hold the sitter and then curve gently to the sides. The perimeter wires also expand, giving the chair the organic profile that is initially one of its most distinctive traits. The essentially upright form of this armless chair is livelier as a result of the contrast of its horizontality with its verticality and curves. Mesh, legs, and the single-piece shell mark it instantly as related to the Diamond Chairs.

Intended for use at dining tables, side chairs need to be narrow to allow enough chairs at a table. Interestingly, like the Eames chairs, Bertoia's Side Chair lacks arms. There is no evidence that Bertoia ever planned to include a larger chair with arms. Perhaps he rejected the traditional hierarchy of dining chairs with its long-standing convention of large armed chairs at the head and foot of tables. Omitting arms was not only more democratic but also, importantly, more efficient for manufacturing and retailing, because only one model of the chair was needed.

While the Side Chair was under development, Matter made a photographic study of relationships between Bertoia chairs. His presentation of various shells standing, suspended, and at angles not only stressed their lightness, openness, and linear pattern, but also invited comparison, and documented an early stage of the Side Chair when its grid echoed that of the Diamond Chair. The shape of the rounder chair at center left reappeared with slight modifications in the plastic shell that Bertoia would later make for Knoll.

The 1956 Knoll price list first includes the Child's Diamond Chair (model 425) and the "Baby" Bertoia (model 426), perfect miniatures of the Side Chair that reflected not only the ages of Bertoia's children but also a rapidly expanding market for children's products, the result of the postwar baby boom.[27] In photographs, these chairs appear identical to the full-scale versions except in proportion to their surroundings. The tiny chair was discontinued in the late 1960s or early 1970s. The child's chair remained in production for at least another decade in the United States before it was finally discontinued because of stability problems. However, it is still produced in Italy and distributed worldwide.

A long-legged side chair with a deeper cradle and footrest but no skids came out as a barstool in the summer of 1964. It originally was offered in a bar height (model 428B) and somewhat later in a shorter, counter height (model 428C). While the same width as the Side Chair, they have a deeper footprint. The bar-height stool is taller than the counter-height chair. The extra height provides no aesthetic advantage but was market driven.

The last chair Bertoia designed was the High Back, often referred to informally as the "Bird Chair" because of its shape. He explained that his wife's discomfort when she was pregnant in 1954 with their third child, Celia, led him to design a chair that would allow her to rest comfortably. Years later, Bertoia would laugh as he spoke about how with the passing months, Brigitta needed help to get out of her chair. It was a good story, but Bertoia, like many people, enjoyed the role of raconteur, and his lively manner of telling interesting stories, accompanied by expansive hand gestures, sometimes allowed details to undergo some metamorphosis. As Celia points out, this chair was designed and produced well before she was born in 1955. It had nothing to do with any pregnancy of her mother. Aesthetically, it is a synthesis of the two Diamonds with an added headrest. It has much in common with the Large Diamond Chair, but at 35½ inches (90.2 cm) wide, the arms are narrower and its back not only supports the head but is also tilted further back. The height of the ottoman suits the High Back and Diamond Chairs, and its legs are consistent with their designs.

P. 125

24

TOWARD MANUFACTURING CHAIRS

Only after Bertoia had arrived at designs that satisfied him ergonomically and aesthetically did he consider how to manufacture them. It was "the approach of an artist, not of a hard-nosed industrial designer," explained the industrial designer Shea. The team working with Bertoia focused on manufacturing the chairs. In addition, Schultz had two other rather complicated roles: devising upholstery for shapes as complex as those of the Diamond Chairs and setting up European production. In December 1953, Schultz moved to Paris with his bride, Trudy, also a Knoll designer, and began teaching manufacturers in France, Belgium, Germany, Sweden, and Switzerland how to produce the chairs.[28]

Bertoia bent the wires for his chair prototypes by hand before brazing them, according to Petitt, who heard Schultz describe this unusual process that had occurred before Petitt joined the group. To a skilled metalworker like Petitt, this was remarkable because it is so difficult and required pre-visioning the entire chair.[29] Petitt's fabrication of the refined "master baskets" for the definitive chairs was an essential step for building the production weld tooling. Each intersection of wires is individually welded, making the chairs labor-intensive. Taking Bertoia's slightly asymmetrical and very handmade form, Petitt regularized the shape and imposed symmetry. In the process, and inevitably after lots of discussion, the grid was tightened considerably, making the openings smaller while maintaining both the orientation and axes. The gradual shrinking of the openings toward the corners of the diamond is evident in the early Bertoia prototype and survived the general tightening of the grid that Petitt initiated. While the grid also tightens as it moves across an implied horizontal to the tips of the arms, the vertical axis is visually strongest, making the chair seem taller, while the less prominent horizontal emphasis stresses its welcoming width.

When Petitt had completed the finalized, or "master," basket, it was time for Savage to devise a way to approach production. He arrived at a "fascinating machine for prebending the wires" while Schultz was constructing a way to cover the chair with fabric backed by latex foam, providing some padding between the wires and the sitter. Latex rapidly became brittle and crumbled, and a more durable foam would be found to replace it.[30]

Bertoia experimented with legs, drawing on what he had learned while working with Eames. Skids simultaneously solved both structural and

design problems, for the skids brace the legs, strengthening the support physically and aesthetically. To the Large Diamond, Bertoia added shock mounts between the legs and basket, making the chair more responsive to a sitter's movement, which Bertoia always considered an important criterion for a chair for relaxation. The finer, more flexible wires used by Knoll to produce the Diamond Chairs in the early years not only made them look airier but at the same time increased their responsiveness to a sitter's movement.

The initial chair production run had a "very high failure rate—welds started popping sometimes [when a chair was] right out of the box. It was before the era of regulated power supplies and solid-state controls; it turned out the cause of welding problems had to do with voltage fluctuations between day and night and seasonally in Bally that compromised the welding," Shea said. "It was a seat-of-the-pants operation," he explained, although these elegant chairs betray nothing of the small scale and ad hoc informality of their early production.[31]

22 P. 123

The Bertoia collection was introduced in Knoll's New York showroom in December 1952, in groupings that included Side Chairs, Small and Large Diamonds, High Back Chairs, and ottomans with a steel sculpture of a type Bertoia would call a multiplane construction. Photographs showing a representative group of furniture and sculpture began appearing in periodicals like *Interiors*, *Fortune*, and the *New Yorker* before enough chairs had been produced to actually sell them. Achieving durable, consistent, smooth finishes was still a work in progress when the chairs were introduced in print advertisements. A white chair, for example, had simply been painted.

The chairs did not actually go into production until 1953 and did not appear on the Knoll price sheet until 1954. That year a covered Large Diamond Chair cost $96, which, adjusted for inflation, was $910 in 2017 dollars, about half the price of the current model. (In 1954 the average American earned $3,960 a year, lived in a $22,000 house, and ate bread that cost seventeen cents a loaf.)[32] Production increased in 1956 with the addition of two welders, a setup person, and several others preparing chairs for finishing. Shea explained that "They'd cut wires to length, prebend them on a Masonite jig board, then bend and test the wire for springback. They put the wires on a rack with a compartment for each piece and moved it to the welder. Then the wires were assembled on a fixture for welding that was suspended, so the welder could reach each intersection. It required a large amount of hand work." Shea continued, explaining how, by contrast, Eames wire chairs

16 P. 118

were produced: "All the wires were flat, welded together by two electrically charged plates and then formed into a shape before the perimeter wire was added." That, he explained, is exactly how grocery carts are made: welded, bent up at the sides, and then the rim added.[33]

In 1953, when Richard and Trudy Schultz went to Paris, they took one of only two master baskets Petitt had made and tracings of the wires. With this modest equipment, they set up initial European production of Bertoia chairs. Shea explains that formal engineering drawings would have been useless, because the chairs are very difficult to document in two dimensions. He considers Bertoia's designs "prophetic, anticipating later computer modeling with contoured grids."[34]

The Diamonds have retained their great popularity in part because of their clean lines but also because they were designed and produced to allow unusual variety and versatility, making them suitable for many situations. Some have finishes durable enough for outdoor use, and the chairs have always been available uncovered and fully or partially covered. Such efficiency and adaptability in one furniture line was as unusual as it was practical. Actually a sculpture that accommodates a sitter, the Large Diamond Chair was, in Bertoia's view, the most successful both ergonomically and aesthetically. In interviews over the decades, Bertoia often commented that he especially liked the notion that the Diamond Chairs were mostly air, as Matter's images often suggested.

Matter contributed greatly to Knoll's success and to that of the Bertoia bench and chairs; subsequent Knoll photographers and graphic designers have continued his tradition of fine work. His imaginative approach relied on human nature and appealed through often surprising combinations of elements within images. Matter's ads encouraged seeing Bertoia chairs as abstract design as well as places to sit. One day in a Knoll showroom, Matter realized that he could use in an ad the spontaneous rambunctiousness of an employee's children playing on a Large Diamond.[35] The resulting image drew attention to the chairs, showing a serious product with humanity and wit. The sophisticated appeal of the furniture is enhanced by its contrast with children's unfettered enthusiasm.

After having fulfilled the terms of his employment with Knoll, Bertoia often served as a consultant at Hans Knoll's request, not only evaluating designs proposed by others but also making suggestions about adaptations of his own designs.[36] In addition to the barstools, a molded plastic side chair was introduced to expand the original line of chairs. Bertoia consulted on those, even sculpting the plaster shell for the plastic chair, and made recommendations about color, the design of legs, and attaching legs to the shell. He also advised about production.

The Bertoia collection has had an enduring popularity, which reflects the timelessness of its uncluttered design as well as its comfort and versatility. It quickly joined Mies van der Rohe's Barcelona Chair as a classic of Modernism. Bertoia chairs are used in many countries, because of their aesthetics and practicality. They are familiar sights in New York, whether in the Museum of Modern Art (MoMA) or nearby in one of the most beloved oases in the city, Paley Park. A pocket park at 3 East 53rd Street between Madison and Fifth Avenue, it is on the site of the former Stork Club.[37] The curtain of its waterfall softens the wall and masks the sound of traffic in this outdoor room with ivy-covered side walls and locust trees providing a canopy. This space seems both lively and tranquil, public and private. The mesh of the crisp white Bertoia chairs is echoed in the paving and the linearity of the trees. MoMA used black Bertoia Side Chairs in its garden as well as its terrace cafe.

Bertoia's work for Knoll Associates was a milestone in his career. It brought his chairs, his sculpture, and his name to the attention of architects, interior designers, and a sophisticated public that was inclined to be interested in art. Some still think of Bertoia primarily as a furniture designer, but his work for Knoll would serve to spur even more important sculpture.

P. 121

P. 120

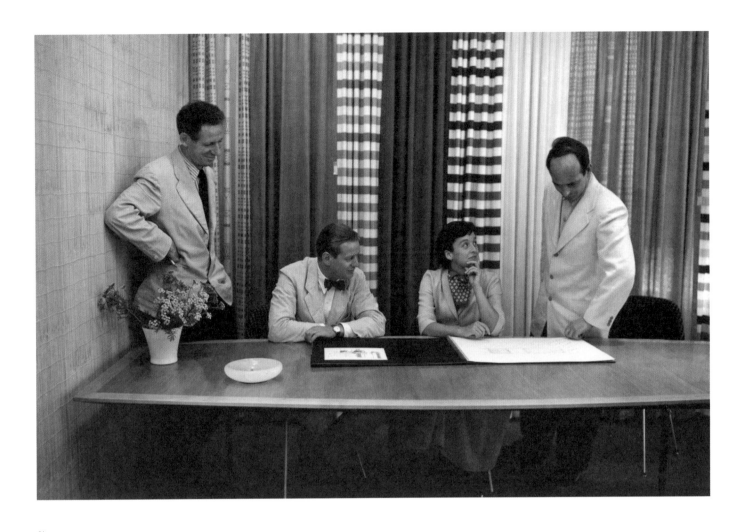

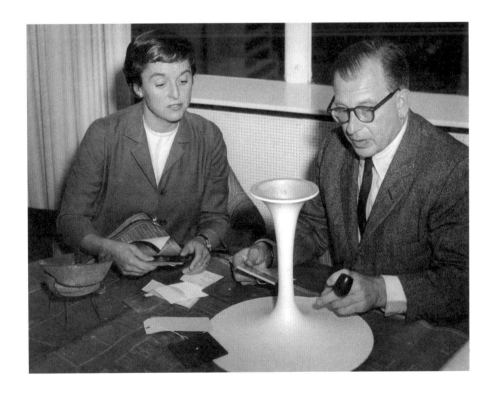

1 From left to right: Herbert Matter, Hans Knoll, Florence Knoll, and Harry Bertoia, early 1950s.
2 Florence Knoll and Eero Saarinen discussing a model for the base of his Tulip Chair, early 1950s.

③

3 Experiment leading to the Bertoia Diamond Chairs, 1950-51.
4 Herbert Matter (1907–1984). Photomontage of studies for Bertoia chairs, c. 1951–52.

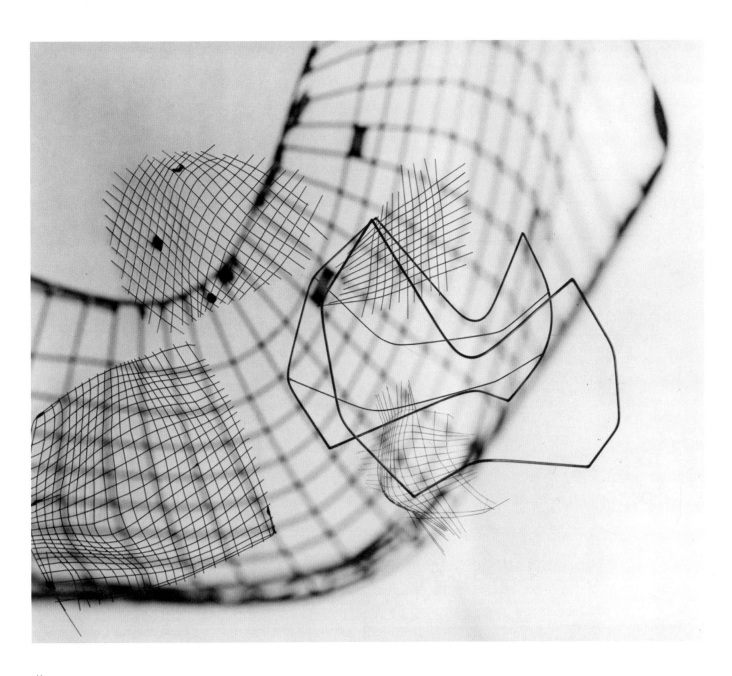

4

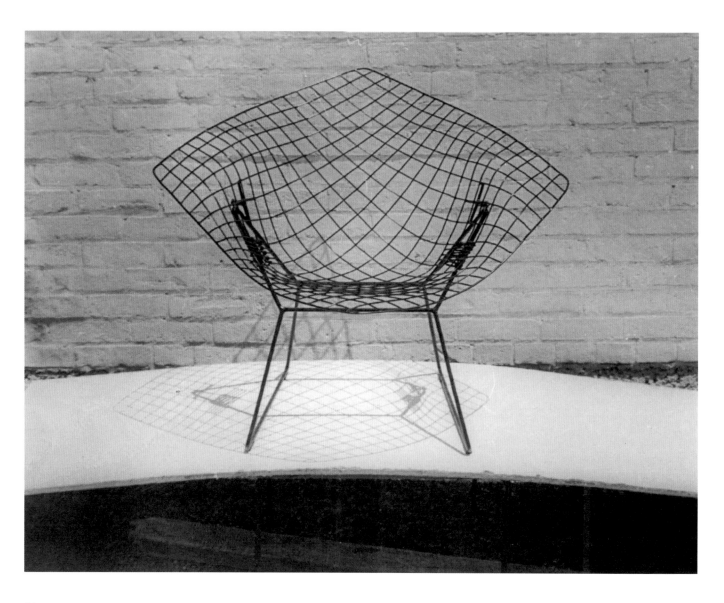

5

5 Early version of the Diamond Chair with thin wires and open mesh, c. 1951–52.
6 Prototype Diamond Chair, c. 1952. Enameled steel. 23¼ x 34½ x 30 in. (59.1 x 87.6 x 76.2 cm).

6

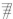

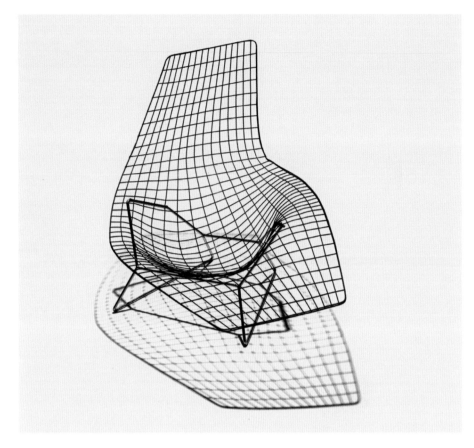

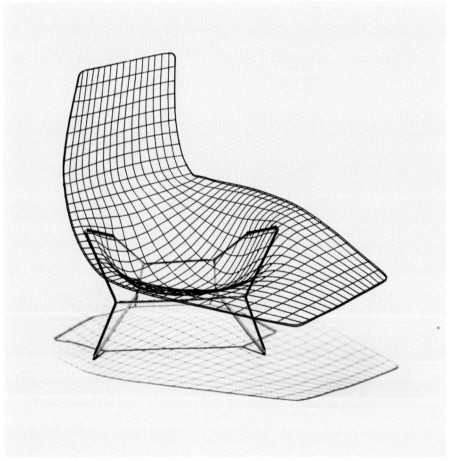

7 & 8 Original prototype of the Asymmetric Chaise, 1951. Brazed steel wires.
 37 x 52½ x 32¼ in (93.9 x 133.3 x 81.9 cm).

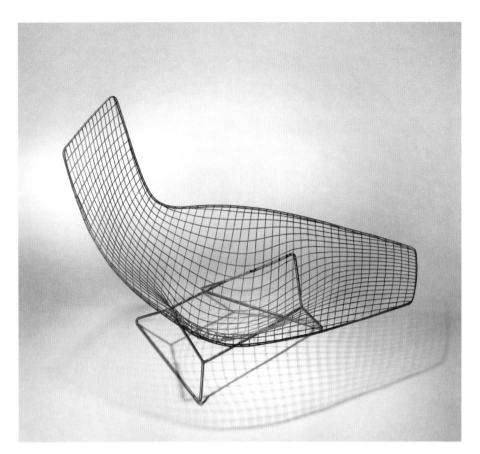

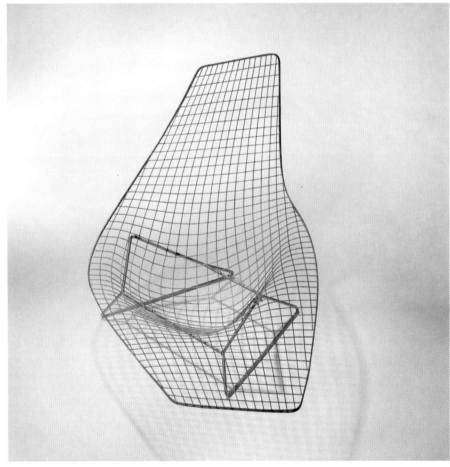

9 & 10 Bertoia Asymmetric Chaise, prototype by Don Pettit, 1952. Welded steel wires.
40¼ x 52 x 38½ in (102.2 x 132 x 97.7 cm).

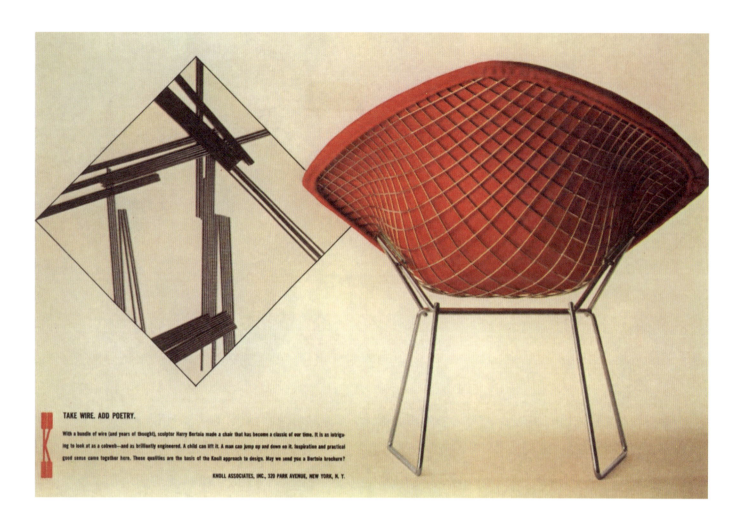

11

11 Knoll ad for the Bertoia Small Diamond Chair showing the back of the chair and implied vertical
 line from apex through intersections of the mesh, essential engineering and aesthetic principles
 of the design.
12 Bertoia Large Diamond Chair, fully covered, 1951–52. Chromed steel. 27½ x 45 x 32 in.
 (69.9 x 114.3 x 81.3 cm).

12

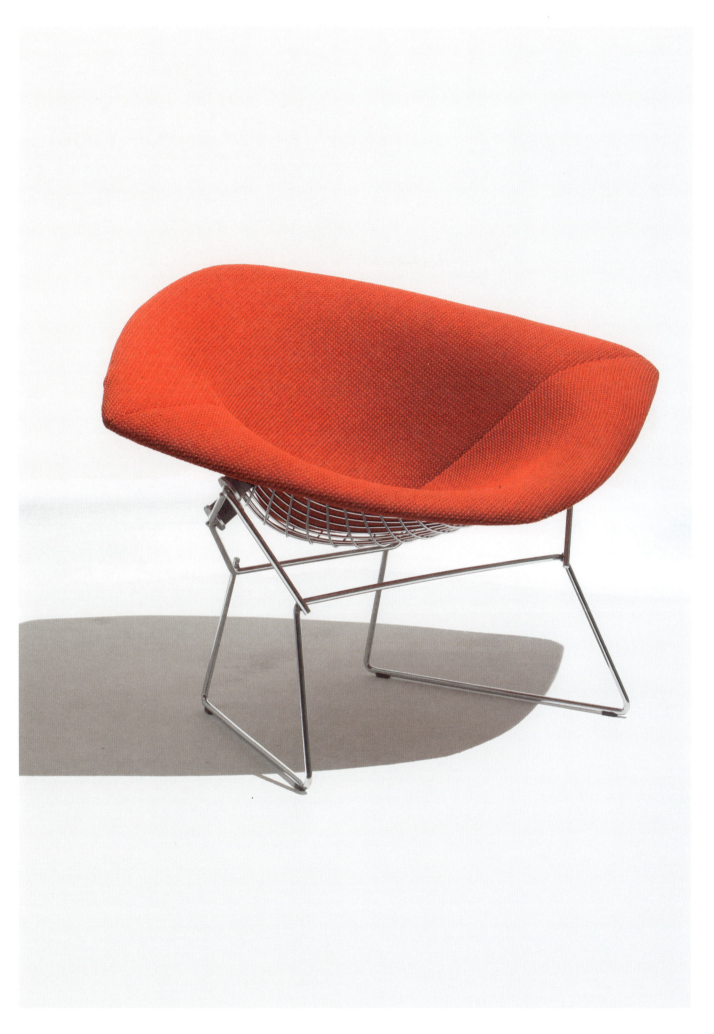

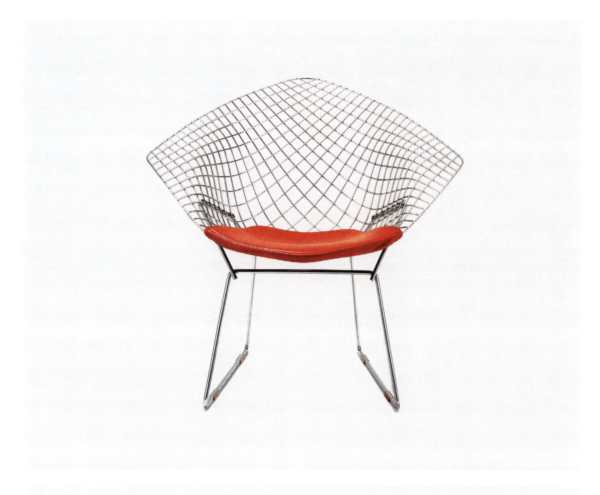

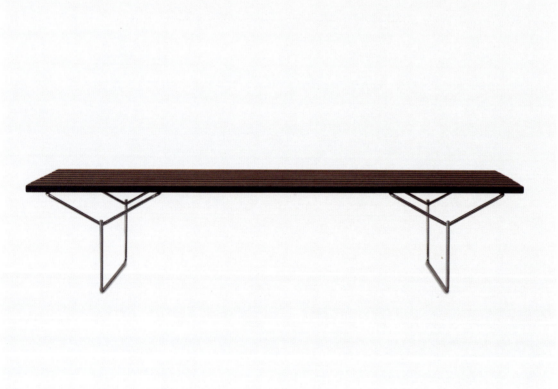

13 Bertoia Small Diamond Chair (model 421), 1952. Welded steel rods with Rilsan finish and vinyl
 seat pad. 30¾ x 33 x 28 in. (78.1 x 83.8 x 71.1 cm).
14 Bertoia Bench, 1952. Stainless steel and teak wood. 15¼ x 72 x 19 in. (38.7 x 182.9 x 48.3 cm).
15 Bertoia Side Chair, 1951–52. Welded steel rods with vinyl seat pad. 28¾ x 21¼ x 22¾ in.
 (73 x 54 x 57.8 cm)

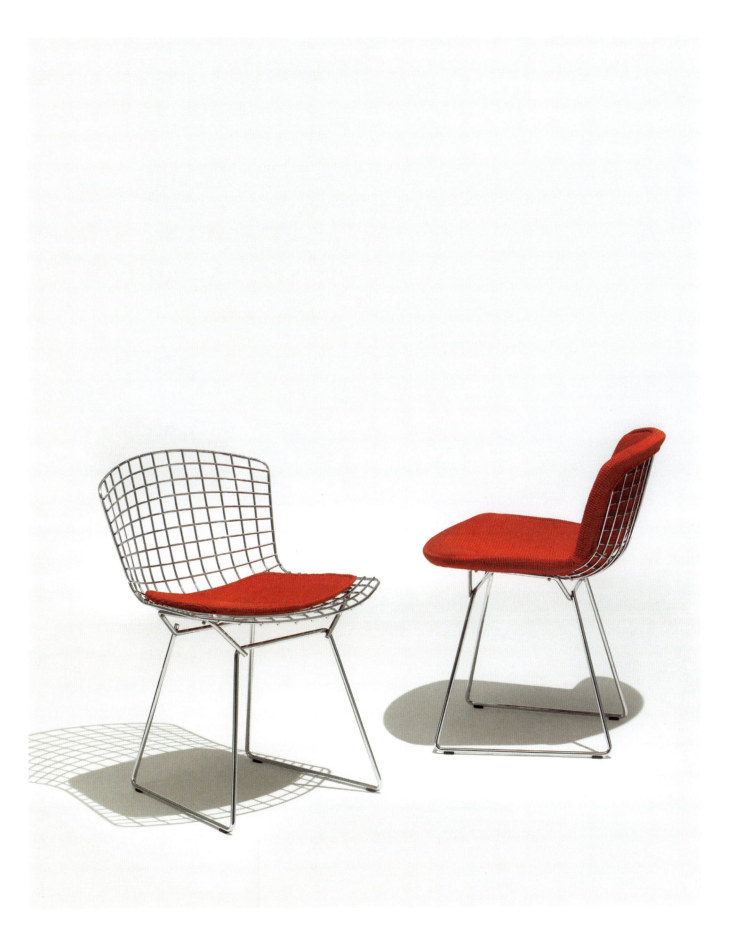

115

16

16 Steel rods for Bertoia chairs on a cart waiting for assembly.
17 Herbert Matter (1907–1984). Bertoia chairs in various stages of assembly, early 1950s.

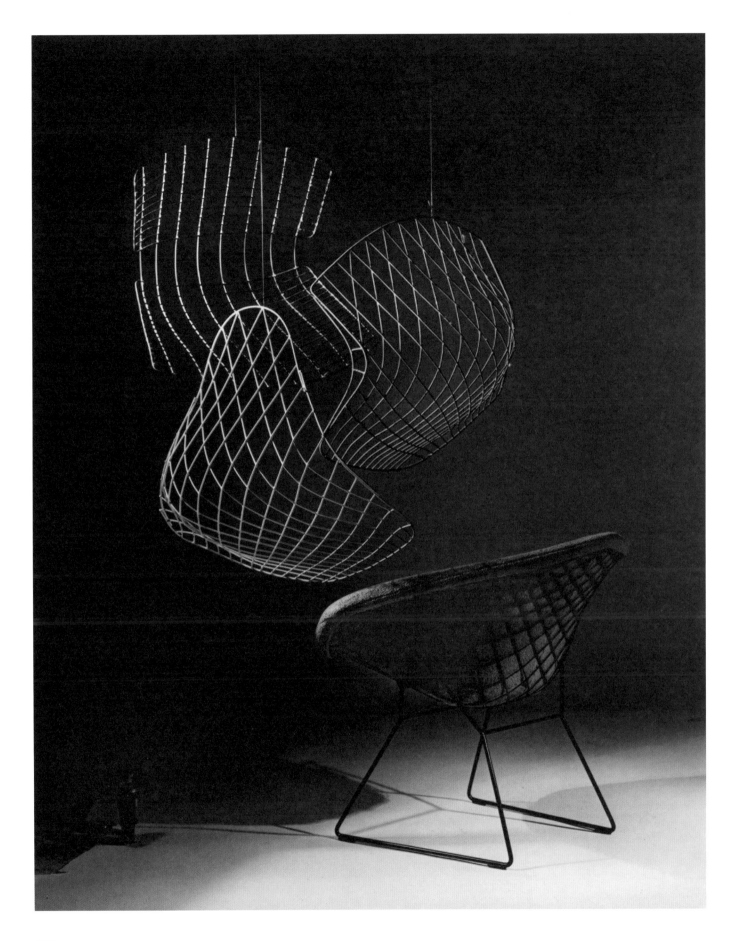

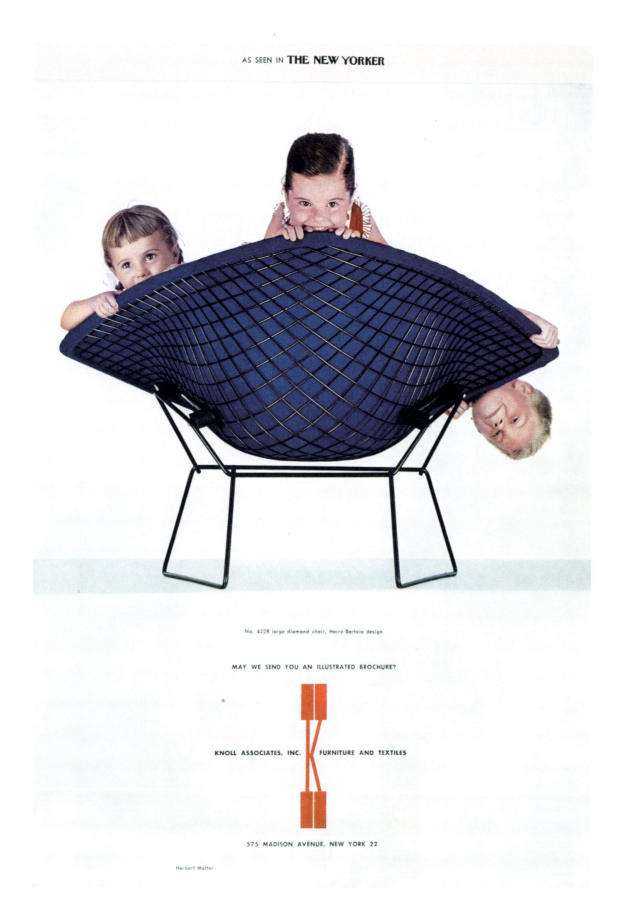

No. 422R large diamond chair, Harry Bertoia design

MAY WE SEND YOU AN ILLUSTRATED BROCHURE?

KNOLL ASSOCIATES, INC. FURNITURE AND TEXTILES

575 MADISON AVENUE, NEW YORK 22

Herbert Matter

18 Herbert Matter (1907–1984). Knoll ad for the *New Yorker*, Large Diamond Chair with children.
19 Herbert Matter. Knoll ad for Bertoia Diamond chairs, c. 1954.

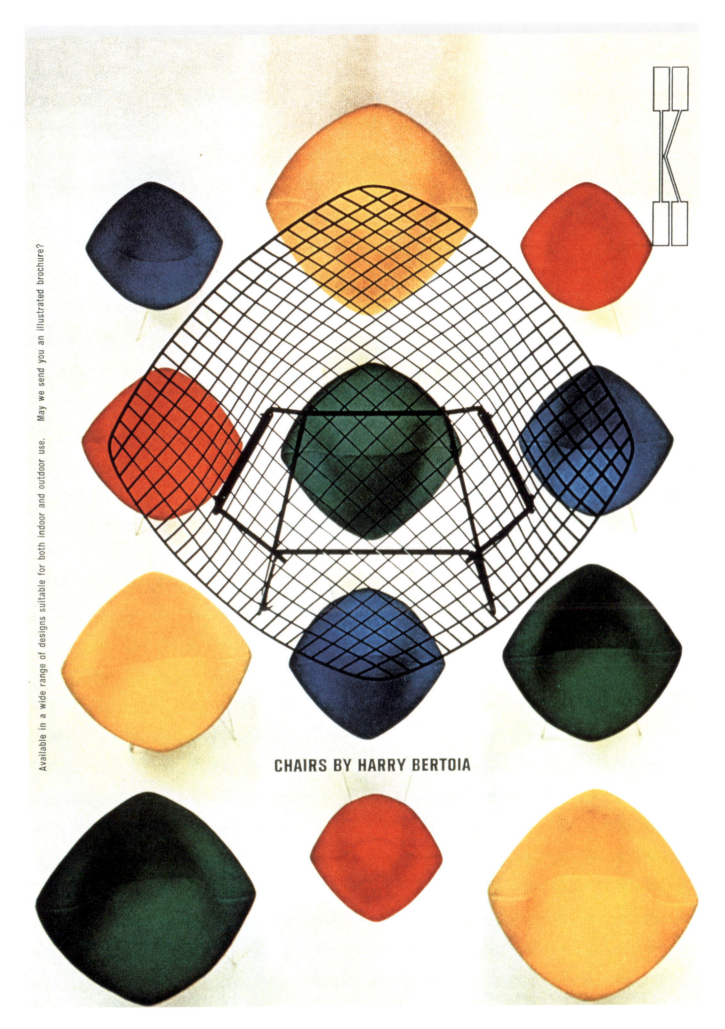

Available in a wide range of designs suitable for both indoor and outdoor use. May we send you an illustrated brochure?

CHAIRS BY HARRY BERTOIA

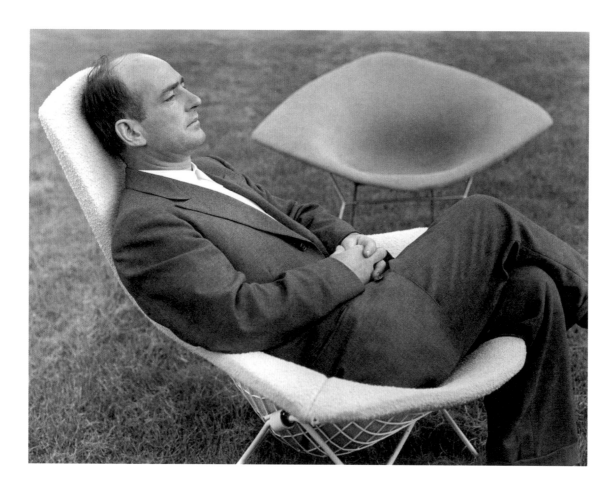

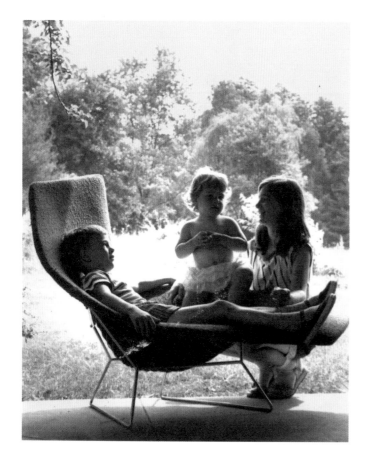

KNOLL AND CHAIRS 1950–52

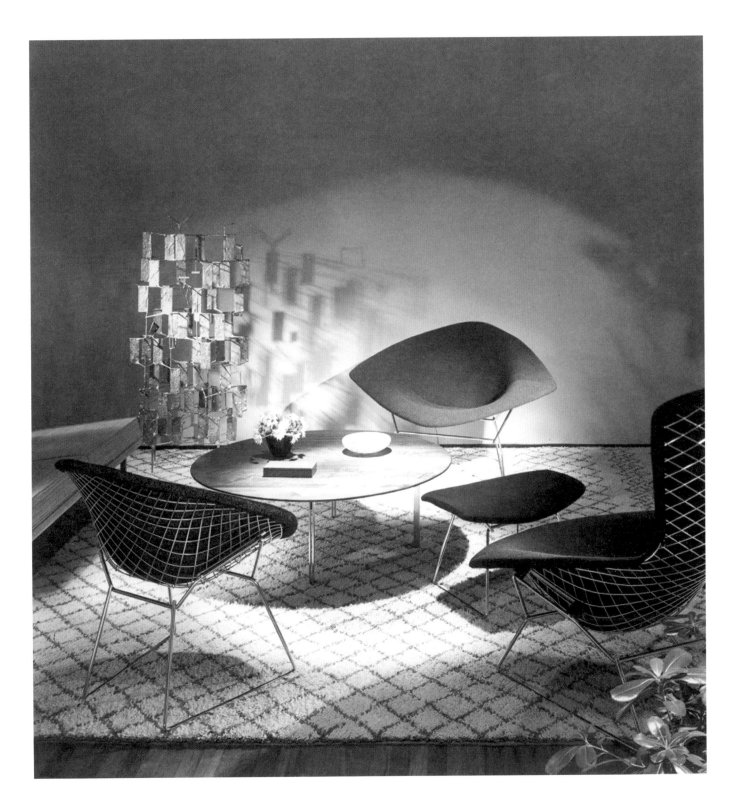

22

20 Harry Bertoia in a High Back Chair ("Bird Chair") with a Large Diamond Chair, c. 1953.
21 Val (seated), Celia, and Lesta Bertoia with their father's prototype chaise, c. 1957.
22 Knoll New York showroom, Bertoia exhibition, 1952.

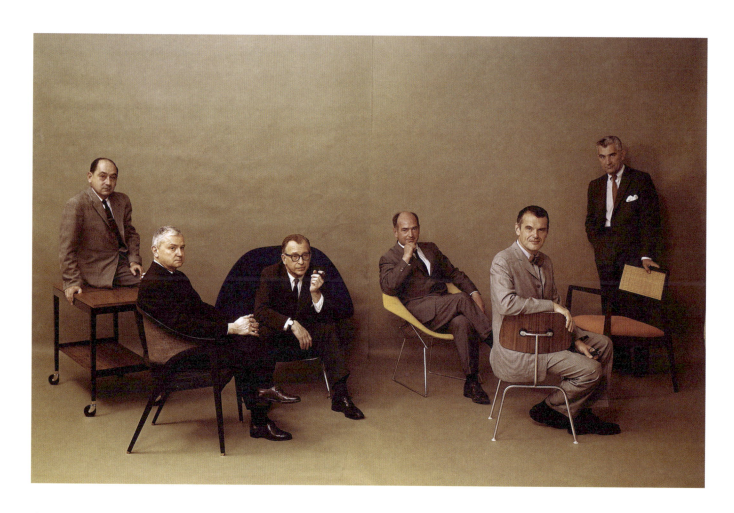

23

23 George Nelson, Edward Wormley, Eero Saarinen, Harry Bertoia, Charles Eames, and Jens Risom,
 "Design For Living," *Playboy* magazine, July 1961.
24 High Back Chair ("Bird Chair"), 1953. Welded steel rods with fabric cover. 40.25 x 38.5 x 33 in
 (102.2 x 97.8 x 83.8 cm).

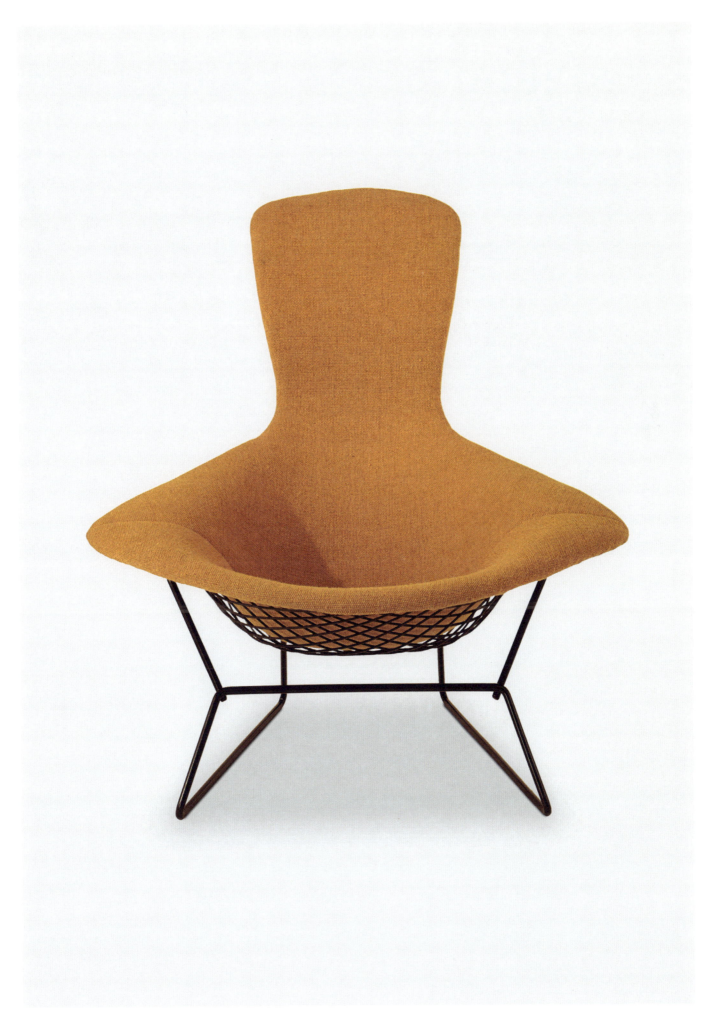

25

26

25 Study for a geometric chaise, c. 1952. Graphite on paper.
26 Study for a cantilevered chaise, c. 1952. Colored pencil on paper.
27 Studies for two chaises, c. 1952. Colored pencil on paper.
28 Studies for chaises and support systems. c. 1952. Colored pencil on paper.

27

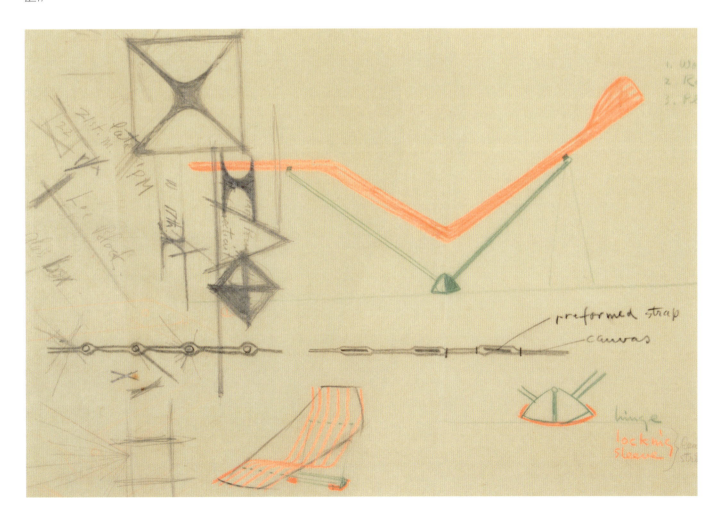

preformed strap

canvas

hinge

locking
sleeve

28

5

While working for Knoll, Bertoia was also making small wire sculptures and graphics upstairs in the shop in Bally. A Herbert Matter photograph from about 1952 directly conveys the relationship between Bertoia's works in two realms. Matter must have appreciated the difference between the irregular cells of the sculpture and the Side Chair's more consistent intervals. As Bertoia's ties to Knoll grew more informal, he increasingly used the chair's material in new, freer ways to make sculpture from wire.

P. 145 1

The earliest wire sculptures are among the most playful of Bertoia's entire oeuvre. He made these wire constructions in a quick, intimate, often whimsical way that must have been a pleasurable contrast to the pressure of his downstairs work, which was much more practical, problem-solving involvement with chairs. After beginning on a small scale, the wire constructions would gradually grow in size and complexity. First, they gained irregular textures that increased their organic character and volume, as Bertoia melted other metals onto the wires using a torch. Soon small shapes in sheet steel made their way into sculptures, gradually increasing in size and prominence in a logical progression to become what Bertoia would call multiplane constructions. These multiplane constructions had their origins in the three-dimensional "wood-block paintings" and in his 1943 Cranbrook experiment taking the block monotypes into the third dimension by using wires within a wooden frame to support squares of white paper at various heights and distances. That antecedent of his multiplane constructions was only about 15 inches (38.1 cm) high and twice as wide.[1] Bertoia's early planar constructions would be the genesis of his major early commissions, the ones that would join the chairs in making his name in the art world.

P. 69 48

Melting brass or other metals with a torch along wires and across surfaces left swirls, puddles, streaks, and drops that varied the mass and texture of the metal; traces of motion left by the movement of the torch in his hand created surfaces that caught light at many angles and transformed geometric, industrial materials into interesting forms that appear almost natural. Bertoia's experience with brazing in making chairs had introduced him to results of this technique, which, though undesirable in chairs, could be appealing in a context where they could be expressive. This process allowed Bertoia to give movement and texture to surfaces in a manner approximating the heavy impasto of oil paint that painters, especially Abstract Expressionists like Willem de Kooning and Arshile Gorky, were then using in their works. There is no knowing if this parallel in effects resulted from influence, confluence, or chance. The simplicity, scale, and character suggest that this technique is from his time with Knoll.

The "wood-block paintings" are evidence that small pieces of wood often shared Bertoia's work space with him. In order to use both hands while fabricating an untitled kinetic sculpture from about 1948, even in its early stages he had to mount it on something—his workbench or a block of wood. He may have originally attached the largest wire to the block of spruce that ended up serving as the sculpture's base, but it would have been typical of Bertoia's methods to have grabbed a convenient and serviceable scrap of wood and later, pleased by or interested in the work, transferred it to that cleaner block. Bending the largest wire into an approximate question mark, Bertoia hung from it an eccentric group of wires, including inverted Ys and pieces with globular or curved ends. The largest wire nearly surrounds most others, but a few escape and dangle below. The pendant elements are light enough to sway, adding motion similar to that of brooches, earrings, and pendants he had made a few years earlier. Although mounting this group of wires was done out of necessity while making it, the block also adds to the finished work's height and increases the space it commands. Humble and delightful, the work is a direct and important link between Bertoia's jewelry and sculpture.

P. 146 3

A photograph among Bertoia's papers from about 1950 shows an early, small wire construction held up by what appears to be the artist's hand. Clearly evident in the photo is how a small amount of brazing transformed

P. 145

bent wires into rather organic and sculptural forms. Near the center, a few angled, soldered wires suggest limbs gesturing as well as subtle interaction between two forms. Such slight touches bring life and character to simple wires and enliven this ethereal combination of wire and air. Bertoia often sought to maximize effects with minimal materials, as he did successfully here. Minor works like this often reveal a great deal about Bertoia's thinking, methods, and personality, traits that become less clear in larger works that demand more time and, like architectural commissions, must meet criteria beyond the works themselves. Acknowledging his lighthearted side is essential to fully appreciating Bertoia's work.

A more serene, complex, and sparse piece is a wire construction in steel that stands nearly 1½ feet (47.7 cm) high and rests on two intersecting wires that form an X. Like many examples from this period, it is on short legs that make its focal area seem to float. Vertical wires rise at fairly regular intervals from the X, most of them only about 4 inches (10 cm) high. Taller individual wires rise at various points, especially at the ends of the X, sprouting clusters of short, fine wires as if they were some unfamiliar form of sea life. The piece is ordered and symmetrical, extending in four directions from the center, where the tallest wire stands. Together the wires create a quiet, mysterious world.

P. 147

Similar motifs appear in several monotypes from about 1950–52. One lyrical, Surrealist monotype is more fanciful and organic than the wire sculpture. To create it, Bertoia added swaths of delicate color to ghosts of the print pulled before this one. Ascending black lines waver at left and bend slightly as if with a water current. The boldest of the lines are topped with short "feelers" at angles familiar from the preceding wire construction. Fainter uprights appear in the distance with branches curving toward the top of the page. Every short line extends from a dark dot and ends with a smaller one. The stalks supporting the feelers reach down, stretching delicate roots near the lower edge of the page. This fluid world has a few organic shapes too, and the two more solid, geometric forms offer contrast. Within their shapes, soft-edged bands of color distinguish them from the background while also relating them to the vaporous colors that gradually flow into each other. The organic and geometric coexist in this tranquil, aquatic world without interaction or explanation.

P. 149

For Bertoia, the period when he was with Knoll was a time of great sculptural experimentation. At night and on weekends, free for the moment from the pressure of producing chairs, he worked alone and explored a great variety of forms. One highly unusual piece is a small brazed steel sculpture. Its wires are thicker than those of most works of the era, and the small plates of sheet steel at the ends of the wires result in a sculpture so dynamically composed that it appears as if the slightest touch could send it rolling to the floor. Its muscularity and energy are unique in this period of Bertoia's work, perhaps in his entire oeuvre. Resting on three tiny points brazed to its base, its strong implied motion persists from many angles. An anomaly in the progression of Bertoia's work, this active, even aggressive nature exemplifies his willingness to experiment widely, especially between 1950 and 1952, the period when he really became a sculptor, if it is possible to pinpoint such a thing. Its sheet-metal elements anticipate the multiplane constructions of 1953.

Unlike that sort of fully three-dimensional sculpture, many wire constructions were frontal, designed to be seen from a particular angle, like paintings. At 3 feet (90 cm) wide, the sculpture *Untitled (Vertical Elements)* is larger than most of this type, even though it is only a fraction over 3 inches (7.6 cm) deep. It is composed of about two dozen nearly vertical wires and a single perfectly upright one just to the left of center. That wire's true perpendicularity calls attention to the many subtle angles in the work, the predominance of nearly vertical wires, their branching into Ys. By again creating a ground line of paired horizontal wires, Bertoia mounted this sculpture slightly above the surface where it stands. The floating effect that results from their standing on small legs benefits these works by distancing

them from the surface on which they rest, making them appear even more airy and otherworldly. Several small planes near the bottom of the sculpture capture so much light that they look white, attracting great attention despite their small size. These wires exist as pure relationships in space. Viewers are admitted to this quiet, highly orderly private realm, this Surrealist stage set that calls to mind the small but compelling figurative groups of Alberto Giacometti.

Naturally, Bertoia continued making graphics while he worked on both chairs and small wire constructions. One monotype is an exploration leading to sculptures, demonstrating the great continuity between his works in various media. The work's proper orientation is suggested by a faint ground line at the bottom of the drawing (a conclusion reinforced by the number Brigitta Bertoia added at the lower right, reflecting the position in which her husband had kept it carefully stored). The concept behind this print is closely related to sculptures done shortly before his first big commission, the 1953 General Motors Technical Center screen. The vertical and nearly vertical lines refer to his use of wire sculptures, and the limited depth suggested on paper correlates accurately with the shallow space and frontality of the early wire constructions. Animating this graphic is a vocabulary of short, straight lines, including some angled or horizontal ones, alone or grouped, some that outline rectangles of empty or partially filled space. Small triangles are solitary or meet as diamonds. This modest composition is full of small surprises.

P. 147

A sculpture in steel and brass has melt-coated or brazed surfaces that provide greater irregularity. Probably dating no later than 1953, this delightful piece has strict frontality but has an unusually pronounced structural framing device. Small paired feet elevate the sculpture, making it less earthbound. Photographed at a slight angle, its shallowness is apparent even though small brass sheets and wires bent into triangles are among the forms enhancing its depth. As is characteristic of Bertoia's works of this sort and era, the nature of the details and the unpredictability of their placement make the work at once fascinating and playful. The surfaces of the wires and pieces of sheet metal are enlivened by the touch of the torch, as the molten metal left streaks and small drops. This is the perfect development from the simple monoprint that precedes it.

P. 149

Bertoia continued working, retaining some aspects of the preceding examples but multiplying the complexity of pieces to push into new expressive ground. One work, with many wires creating angles and tension, rejects the simplicity and whimsy of many examples. It is topsy-turvy, as if Bertoia had been thinking of the works of M. C. Escher, which years later he remarked that he found extremely interesting. Here he made ladderlike structures of wires that twist as they rise and descend between levels within the space. Tightropes of wire move into nothingness, while a few small shapes in sheet brass hang from wires. Brazed wires at times gain enough volume to be perceived as masses. The brazed outer wires stress the limits of the sculpture, and this example, too, stands on paired legs but with small feet. At one corner an organic form seems to be violating the work's confines, but whether it is entering or leaving the sculpture is anyone's guess. Bertoia's inclusion of several pebbles reflects some of the spontaneity that is not always evident in his works, despite its being a strong aspect of his nature. The tranquility and playful innocence of the earlier wire constructions are gone, replaced by tension and great—if incomprehensible— activity. Bertoia liked this piece so much that he installed it in his barn a year later, resting on a plank of wood that he suspended in a corner, where he could see it when playing his tonal sculptures and from the ladder leading to the loft where he worked on graphics.

PP. 150–151

An intriguing, delicate, and perhaps slightly amusing piece clearly resulted from Bertoia's abiding interest in motion and balance, although chance events while he worked may also have encouraged him to make it. Wires and small, more solid elements that serve as weights bring this kinetic piece to life. Slightly over 2 feet (60 cm) high and nearly that long, it is a drawing

P. 148

brought to life. Delicate wires rise above the base on sturdier wires, and the small, round weights set the wires in motion at a slight touch or movement of the air.

Although continuing to create monotypes, Bertoia focused primarily on sculpture in the 1950s and soon was rapidly developing his multiplane constructions. Their "planes" were metal plates, most often in rectangles that were welded to wires that hold them at various heights and depths. Most of the metal sheets were brazed. They originated in both the block monotypes and the wire constructions, and as their size increased, their support became increasingly regular, often shaped as approximate grids or honeycombs. Bertoia found commercially produced pins at building supply providers that could replace the wires that enclose the work. True Constructivist that he was, he used the ready-made pins to save time and effort. The tapered pin became a module repeated throughout many works.

11 P. 153

A very early example using these pins is in the Albright-Knox Art Gallery, in Buffalo, New York. Accessions documents indicate the piece dates from 1953. Its inclusion of no more than a few planes is consistent with that date (early in the development of this genre), as is its small size. The grid is interrupted by perhaps a dozen planes of sheet metal that were placed and brazed to create interesting plays of light and texture. Welding the pins at slightly eccentric angles, Bertoia suggested a grid while also avoiding the rigidity of such a pattern. Like the earlier wire constructions, it has small feet. Gordon Bunshaft, the lead architect for Skidmore, Owings and Merrill beginning in the 1950s, noted in an interview that his friend Hans Knoll had given him a sculpture for Christmas not long after he attended an early Bertoia exhibition in the Knoll New York showroom.[2] This is that piece.

A dozen years later, Bunshaft, architect of the Modernist addition to the Albright-Knox Art Gallery in his hometown of Buffalo, gave this work to the museum. When he received the sculpture, he was designing the Manufacturers Trust Building, one of the masterpieces of the International Modern style, and he would commission Bertoia to make two sculptures for the bank, including the largest and perhaps most important of the multiplane constructions. Perhaps Knoll's gift of the sculpture encouraged the architect to commission Bertoia for the Manufacturers Trust screen.

19 P. 159

10 P. 152

An early multiplane construction may survive only in a snapshot. A board rests on a stone wall, and Bertoia holds the sculpture there while the picture is taken. A corner of his house is visible in the background. This work has considerably more depth than previous multiplane constructions, and all its planes are frontal. The grid is much more regular and geometric than in the work given to Bunshaft, and even the small, old photo reveals the heavy texture of the brazing and the length and tapering of the pins holding the plates. Estimating based on the size of Bertoia's head, the piece approaches 4 feet (1.2 m) in height. As these sculptures developed, their modular nature became increasingly important. Soon Bertoia would realize the possibility of making large works in modules that he could assemble on the site of a commission.

12 P. 154

Another example from about 1953 reveals that the artist was exploring multiple relationships between the planes he was placing in space. By combining several pins as longer sections, he could open up his grid and align the rectangles to create relationships between planes that alter greatly when seen from different angles. Changing points of view simultaneously revealed large open areas and cell-like spaces. Brazed to the ends of some pins are very small steel squares that add variety to the work, increasing its interest.

13 P. 155

Matter took a number of photographs of Bertoia with a variety of multiplane constructions and whimsical wire constructions. His photographs reveal a great deal about the evolution of these works and are a reminder that the multiplanes evolved from the wire constructions. The figurative works behind Bertoia show that his humor was intact, but by 1953 he had turned to

working primarily in a more analytical manner. One of his multiplane constructions has planes hanging from wires that may have allowed them a bit of motion. Bertoia made a great many early variations of multiplane constructions, exploring ideas. When he found what he thought was the best solution to a problem, he pushed it as far as possible in subsequent works. If he concluded that a particular direction was less promising than another, he took the more productive route. One particular piece he must have considered successful and interesting: he kept it for many years, exhibited it a number of times, and developed it in a larger version. Perhaps he favored it for its stability, rich textures, and interplay of dense and open areas. Matter also must have found it intriguing, as a 1952 photograph he took of it with two Diamond chairs suggests. His treatment of the chairs emphasizes their volume and depth, which he contrasted with the space and shapes of the multiplane construction in the background.

The works of the early 1950s, facilitated as they were by Bertoia's association with Knoll and the recognition that came with the success of the chairs, opened many opportunities for the artist. Knoll continued showing Bertoia sculptures in its showrooms in many cities, selling them when clients requested and taking no commission for doing so. In addition, Hans Knoll acted unofficially as Bertoia's major dealer, serving as an intermediary, for example, with George Staempfli, who would become Bertoia's official New York dealer. Bertoia was highly disciplined and made wise decisions about both his art and career, including setting aside works that he thought were particularly successful or that offered real promise for future development. They now stand as key evidence of how his work developed and what he achieved. He could be prolific and explore ideas extensively because he usually worked eighty or more hours a week.

Commissions for multiplane constructions would come from important sources, and while he made few additional pieces directly evolving from the early wire constructions, his use of wire was far from exhausted. Instead, wires would return in more substantial forms bundled together, and as bronze rods welded alongside each other in sculptures both small and monumental, finally appearing in the welded rods and sheets of various alloys of his famous sounding pieces.

Bertoia's first sculptural commission was for a metal screen to go just inside the door of the cafeteria at the General Motors Technical Center in Warren, Michigan. Eero Saarinen designed the vast Tech Center, which involved so many structures and so complex an infrastructure that it was, in effect, a work of community planning. It was a huge undertaking to house an essential part of the nation's largest corporation. Eliel Saarinen died soon after winning the commission, and his son, who had increasingly been taking the lead role in their firm, nevertheless had to win the commission with his revision of his father's Art Deco plan. The younger Saarinen's design ingeniously acknowledges aspects of automobiles and their production in his design.

While many architects settle into an individual style, altering it slightly to suit particular projects, Eero Saarinen began each commission from scratch, using the forms, materials, and processes he thought best suited the specific client, function, and location. At the Tech Center, he therefore used metal frequently and adopted Henry Ford's mass-production methods in using interchangeable metal panels to clad the buildings.[3]

The predominantly rectangular steel-and-glass buildings were dramatically punctuated by the large stainless-steel hemisphere of the Styling Dome, where General Motors (GM) displayed new automobile models. The architect even shaped the water tower for the Tech Center as a second stainless-steel aerodynamic form—a big, functional metal sculpture towering over every-thing and tied by material and curves to the Styling Dome.[4] Commissioning Bertoia to make a sculpture for GM introduced metal that was handled in a completely different and artistic way.[5]

In 1952 Saarinen had visited Knoll's New York showroom, where he saw the small Bertoia multiplane construction displayed with the first Diamond Chairs. Soon thereafter he commissioned Bertoia to make the large screen for the GM complex. Saarinen had studied sculpture in Paris, considered becoming a sculptor, and believed sculpture was an important complement to architecture. He often conceived his buildings as highly sculptural and then commissioned sculpture to go in them. Writing from New Hope on September 5, 1951, to Wilhelm Valentiner, Bertoia gave him an account of his recent work: "I am working on numerous metal things and perhaps there may be a show this coming winter. It has also been arranged for me to work on an interesting project for General Motors [underlined twice] by way of Eero Saarinen. I look forward to very active times."[6] This suggests that Saarinen saw some of Bertoia's metal sculptures before the Knoll show and did not deliberate long before enlisting Bertoia for the GM commission.

In a letter of Christmas Day, 1951, the artist wrote to Wilhelm Valentiner that he had

> completed three metal sculptures and a fair amount of furniture, perhaps not as much as Knolls would desire and certainly not as much as I would have wished completed, but much has been commenced. . . . We think of showing [the sculptures] in New York early in the Spring, secondly, I am now in the middle of an important project for Eero Saarinen's G.M. Technical Center. I have much confidence that it will develop into something very wonderful as I have indeed visioned for many years something very brilliant in color for it shall be stained glass suspended in space in multiple planes.[7]

Bertoia's original conception of the screen for the Tech Center arose from his 1943 exploration of color shapes in sculpture. Extending this idea to stained glass, which would allow light to play through it, was an inspired concept. It would have had technical complications, including not only finding a provider of stained glass in the desired colors, but also devising a framework strong enough to support the heavy glass. Such a piece would have been stunning but was not to be, at least in part because Saarinen wanted to emphasize metal in both the building and the sculpture.

After exploring many designs for multiplane constructions in 1951 and 1952 with the GM commission in mind, by 1953 Bertoia was working outdoors, behind his barn, on the actual multiplane construction that would be the formal entrance to the dining room of the Tech Center, delineating much of one side of the room. The screen separated the dining room from an entry area along an exterior glass wall. Approximately 36 feet (11 m) long, 10 feet (3 m) high, and 8 inches (20 cm) deep, the screen has steel plates and rods covered in melted brass and bronze, creating a great variety of textures, colors, and reflective surfaces. Rods support the metal plates, holding them in three distinct layers in space that create negative spaces and allow groups of small plates or wires to contend for attention with larger planes nearby. The screen gave some privacy to those having a meal and, seen from the outside, even at a distance, the large, horizontal golden wall accented the rather austere building.

On returning from a visit to the Tech Center in February 1954, before curtains and furniture were added, Hans Knoll wrote Bertoia, calling the screen "outstanding" and "more beautiful than I ever imagined." He especially admired the "highlights" on some panels and thought it would be wonderful when the entire interior was completed.[8] An early 1950s photograph from Bertoia's papers shows a new multiplane construction at night, with artificial light, but it gives a sense of the brilliance and sparkle of these works when they were new. They simply dazzled, not only because of the gilded effect, but also because of their texture and the new conception of sculpture's potential.

Nearly twenty years later, Bertoia acknowledged how important this commission was for his career, saying that Eero Saarinen was the first who

14 P. 155

"risked" asking him to do a large-scale work. "I was unknown and untried, but he knew me personally and he probably knew what he might expect." That first commission, he said, "brought me to the attention of the architectural profession, so from there on I never lacked in being asked by one director or another to do something." It gave Bertoia practical challenges and let him undertake "works [that] on my own I would not dare—what I mean to say is that . . . only a madman would go about doing [something this large] on his own."

Bertoia recalled that he enjoyed working outside behind his barn on the GM screen: "I was simply enchanted by the play of light, and really this was sufficient. . . . I just enjoyed the transition [from] morning to noon to evening." His children played nearby and observed what he was doing, he reminisced, and

> I was very pleased during all of its construction, and in the very end, Eero Saarinen and Aline (he was just at a period when Lily Saarinen [his wife] was on the way out and Aline was coming into his life), they stopped here and they looked around and walked about and so forth. The day was a little brighter but there were some thunderclouds, and what they saw satisfied them—they were thrilled by it.[9]

After it had been installed, however, Bertoia visited the Tech Center and saw his screen in situ. He was greatly disappointed. It was some distance from the window, and the "other side of the cafeteria was dreadfully dark." As a result, the screen was reduced to a

> silhouette, and there was very little play of [light] and dark, and this to me was a little bit of a shock, because I had seen it here and I had seen it full of light. I had seen it play with the elements, but in the building everything had quieted down to silhouette. So that was my first real observation in the nature of a work of art, that Rembrandt should stay in Holland, a medieval stone should stay where it is; when [we] carry them and change [their] places, they become something else. And this kept working in me, so now I'm going to face that once and for all. What I have in mind is to do a piece right here in the woods where it will make sense exactly where it is built.[10]

Learning from this disappointment, Bertoia would in the future always make great effort to visit the sites for his commissions, even going in the early stages of construction and visiting more than once. For him, the first step in approaching any commission was considering the shape and scale, materials and light characterizing the space where it would go. Bertoia believed that it was most efficient to understand the conditions that would surround a work, from his first exploratory sketches all the way through construction of the piece. This would contribute greatly to the success of his commissioned pieces. At least once, when seeing a building early in its construction, Bertoia convinced the client the sculpture did not belong in the spot the client originally wished but should go elsewhere. He was right.

In the Smithsonian Institute's Archives of American Art oral history interview Bertoia discussed the topic of scale and working not only both large and small, but switching scale readily:

> Although it appeared big, I was working on a small scale using my approach to work out small things, and in turn, you know, it reflects back to the [block prints] I had done at Cranbrook. . . . Even then the spatial element comes in, but still essentially it's a flat small-scale [work]. In my mind I will think of it as being big—big as it should be—and then when I actually came to do it in the actual scale, I [had] a reverse mentality, think[ing] of it as rather small.

Bertoia often worked in multiple ways simultaneously. From 1953 to 1955, for example, complementing his focus on multiplane constructions, he was making wire constructions of a quite new and different sort, perhaps

influenced by the structural supports of his commissions. He made a few abstract monotypes of heads, including one portrait of his wife and another that may be more generic, a human head. This work uses short straight lines, placed at angles to define the exterior of the head, while the volumes have been established by gray areas that are indistinct, as if he had made them by rubbing his fist on the back of the paper and then adding the lines. Here and there, dots of ink, larger than the width of the lines, add variety, contrast, and interest, recalling the small drops of metal that he frequently used in his wire constructions. Seen in profile, the sculpture is consistent with the graphic image, but the question is, which came first, the two- or three-dimensional version?

A cloud form that Bertoia made at approximately this time is much less dense than the drawing. As he had in some of the rectangular wire constructions shortly after 1950, Bertoia used short pieces of fine wire, welding them together at angles. The density of the piece varies, increasing near the bottom center, and small quadrilaterals of sheet steel contrast with the wires and add density. These geometric metal elements result in a surprisingly buoyant form. Bertoia made this during one of his most intense periods of sky watching, a hobby he pursued during his daily activities and more scientifically at night.

Bertoia's next major undertaking was a commission for two pieces for the Manufacturers Trust Company at 510 Fifth Avenue in New York, which was being designed by Bunshaft of Skidmore, Owings and Merrill. Bunshaft wanted one piece to go over the escalator and a major screen in the main banking area. The comparatively small piece that would be above the escalator would provide clients with an interesting experience, especially as they descended, catching their eyes just after they stepped onto the escalator. Bertoia made an airy and linear piece, a mostly transparent cloud of wires and small, nearly rectangular shapes. He experimented with fine steel that he welded into a long cluster, letting air occupy much of the space. He suspended studies from trees, sometimes above his pond, and referred to experiments along these lines as clouds. As he had done with the chairs, he used photographs to help him understand their effects better.

Another example, from 1953, is quite similar in shape and technique, but its added density makes it appear much less buoyant. Bertoia clearly ensured that photos included nature—clouds, rocks, and reflections on water—to reinforce the sculptures' references to nature, even though the photographs were primarily to be records of works, not expressive pictures. At several points in the 1950s and again in the 1970s, Bertoia took snapshots of works, locating them carefully on his property for the 1950s photos. These snapshots reveal that he was thinking about having his sculptures in the landscape; they were so strongly influenced by nature that it seemed fitting for them to be outdoors. Like his contemporaries Henry Moore and David Smith, Bertoia was always drawn to the idea of having his work outside, within the context that was the main point of reference in his work.

By inserting a steel "cloud" over the escalator at Manufacturers Trust, in the heart of Fifth Avenue, Bertoia was bringing into the bank both an allusion to and an illusion of nature, light, and movement. Appropriately installed well above the heads of people as they descended to street level, it cast a lovely shadow on the wall. After his experience at GM, Bertoia was always very concerned with the lighting of his pieces, discussing it at length with architects as he developed his ideas for sculptures for specific sites. He enjoyed producing interesting shadows as bonuses—immaterial sculpture enhancing walls.

The major piece for Manufacturers Trust would become the focal point of the Modernist building and would differ greatly from the cloud over the escalator. Brazed in brass, copper, and nickel, the screen's eight hundred steel plates are brilliant, warm in color, and full of detail across nearly the entire expanse. From a distance—from other buildings nearby or from a bus—the screen complemented the pristine steel-and-glass cube.

An otherwise cold structure, it was transformed by the addition of the glowing golden screen and plants. Only half the height of the bank's lowest floor projects above the sidewalk, and four more floors rise above it. The escalator's diagonal leads the eye from the first to second floor and the screen. The coordination between architect and sculptor resulted in making the screen unusually prominent in the building.

The screen's functional role was to separate the bank's public space, where tellers made simple transactions for standing customers, from the area where customers sat to discuss loans and other confidential topics. This utilitarian aspect of the screen had some parallels to that of the screen at the Tech Center, which separated those arriving and leaving from less public behavior as people ate and talked. But the bank's screen had a more important physical function and, at twice the size of the GM work, it also had a major role in the aesthetic of the building. Describing his initial discussion with Bunshaft about the project, Bertoia said:

> It was amusing at the time. Gordon Bunshaft called me up; he said, we're going to do a bank, but before we start, I'd like you to come up with something—you know, a real big sculpture. Well, I said, how big? Oh, it's about twenty feet high, seventy feet long. Good heavens, I dropped the phone. I said, let me go out. And I actually came out and looked at the field—you know what I mean—seventy or eighty feet, and I looked up at the tree and I returned, and I said, all right, I'm willing to do some work on this. And a date was set for a meeting and so forth. But he was very diplomatic. He said, once you come up with something, then we'll build a building around it.[11]

As he did at GM, Bertoia explored the composition of the work, creating constant shifts of texture, shape, and size, as well as placement of elements in depth. But the GM piece had its metal rectangles in three distinct planes in space, whereas in the bank sculpture, he added complexity by creating five layers in space while retaining some transparency. By varying the rectangles with negative spaces as well as irregular elements (some forms suggesting African shields, small organic shapes, and fanciful linear elements related to his monotypes), Bertoia provided much for waiting customers to examine and enjoy. Ada Louise Huxtable, long the architecture critic for the *New York Times*, accurately described it as a "screen wall" that added "a note of Byzantine splendor in an otherwise austerely elegant interior. Brilliant gold in color, primitive in texture and pattern, it is the perfect accent for the polished surroundings."[12] Especially for those working behind it, however, it was not a wall, for it was sufficiently transparent to allow them some visibility and light. Rather than closing them in, it shielded them from the public.

Bertoia constructed (and later shipped) the screen in seven sections, each weighing 1,500 pounds (680.4 kg). As June Kompass Nelson observed, the GM screen and Manufacturers Trust screen "beg to be compared. Almost twice as big and with its component parts scaled accordingly, the latter has a greater proportion of open to closed form, a more complicated five-plane structure and more favorable overhead lighting, which clearly reveals the interlacing of its structural members."[13]

Bertoia always focused on unifying his sculpture commissions with their architectural setting. To do this, he sought to plan pieces from their inception through a meeting of the minds of the architect and sculptor.[14] Only when they shared a common vision, in his view, would the result be truly effective. It was Bunshaft's usual habit to leave the selection of art to interior designers, but in this case, he wanted the sculpture to be an architectural element. Achieving that marriage of sculpture and architecture would require unusual cooperation and exchange between him and Bertoia. Nineteenth-century interest in unifying the arts survived with Modernists, including Buckminster Fuller and Isamu Noguchi, both of whom Bertoia would come to know and admire, and the Constructivists also believed that artists and the arts needed to be further integrated

into society. These ideas coalesced again with Mid-Century Modernists. One way this would be manifest resulted from the 1963 General Services Administration program, Art in Architecture, which allocated one-half of 1 percent of the cost of federal buildings to art. Most states followed suit with similar initiatives.

In a letter simply dated "1954," Bertoia wrote to his father-in-law, saying he was sending him "a small Diamond wire chair covered in bright yellow thinking of it as a gay note in your nice apartment," adding that he should let him know if he preferred gray. He continued:

> I have now completed one half of the project for the New York bank. Up to this phase everything has developed just the way I want it. The metallic color is really marvelous and I believe to have found a way to keep it for a long, long time. The form and size are beginning to take a very impressive aspect. Yesterday Don Pettit with his camera took some photographs, he got some closeups which will reveal the richness of the texture that takes the form of fantastic scapes—land, sea and moon.
>
> For the same building, I have also made a galactic construction which will hang freely from the ceiling—it measures ten by twenty feet entirely composed of wire and specks of metal which will catch the light and appear as so many stars. I find it exciting to have stumbled on such an inexhaustive subject, if one may call it so, for there is a great range of form, density and direction. With them, for me, there is consoling feeling that one may be located in New York [or] somewhere in New England and others toward the West thereby attaining the proper relation to each other. In my mind's imagination I can easily dispose of the intervening obstacles.
>
> Mr. [Pietro] Belluschi of the M.I.T. is preparing for an exhibition of drawings, paintings, sculpture and furniture for May so all of this keeps me very active. . . .
>
> Brigitta has helped much with the large sculpture.[15]

Bertoia finished the sculpture in July 1954, after working on it for eight months, attaching its seven sections to the metal plates in the bank's ceiling and to its floor. The combination of brass, copper, and nickel applied in a molten state to the steel wires and plates resulted in a constantly changing surface of gold, copper, rust, and silver colors, all dramatically enhanced by black. Its contrast with its surroundings is key to the effectiveness of the sculpture, a contrast so well planned that the building seems to be a frame for the sculpture.

The "bank job," as Florence Knoll referred to it, contributed to overwhelming public interest in the building on opening day. Later that week, the building had to be kept open until nine o'clock, long past regular closing hours, to accommodate the great number of visitors. A New York Times article titled "15,000 Ooh and Ah at Opening of Dazzling, 'Newfangled' Bank" noted that some bankers "snorted at the 'newfangled architecture' and appointments." The crowd was "almost unanimous in admiration," the Times continued, calling Bunshaft's building a "dazzling $3,000,000 'showcase of banking.'" As journalists are wont to do, the Times reported some negative responses to the screen ("Oh, I see you didn't get that wall finished" and "It looks like a pile of broken egg crates"), but the article was predominantly laudatory, noting that the term most used in describing the branch was "breathtaking."[16] It has had a controversial afterlife, unfortunately.[17]

Soon after installing the Manufacturers Trust piece, Bertoia shifted his attention to a second commission from Saarinen, this time on the campus of the Massachusetts Institute of Technology (MIT) in Cambridge. Saarinen was designing two buildings that became quite controversial because they differed so greatly from the prevailing neoclassicism of surrounding

buildings. For an open green area in the center of campus, Saarinen designed two structures based on three-dimensional variations on the circle. The larger one, the Kresge Auditorium, is one-eighth of a dome resting on three points. Its three sides are huge glass arcs. It is a modern rotunda, but unlike other rotundas, it has no main facade or focal point. Paved walkways instead draw attention to the entrance, leaving the geometry uncompromised by porticoes. Saarinen designed the auditorium in tandem with the Kresge Chapel, which faces it. The buildings are in many respects opposites. The chapel refers to the circular form of its much larger neighbor but contrasts with it in function, shape, and some materials. Rather than hosting large public assemblies like the auditorium, the chapel is a quiet space for private contemplation. Many think it is one of the great religious spaces of the twentieth century.

P. 162

24

Below the brick cylinder, the chapel's concrete foundations rise from a small body of water that surrounds the building. Spanning the gap between the concrete of the foundations and the larger brick cylinder of the chapel is glass set below floor level, parallel to the water and invisible from the outside. The glass allows light and reflections from outside to reflect up the walls inside the darker space, bringing the outside in.

A rather low, rectangular structure leads to the chapel, serving as a narthex, a space the ancient Romans invented and early churches adapted. A narthex provides a physical and psychological transition between the material and spiritual worlds. Saarinen's also bridges the water. The textured stained-glass rectangles of its walls repeat the glass that spans the gap between the building's brick exterior and its concrete cylinder. The subdued colors of the glass only slightly filter the light admitted. This modern narthex leads to the chapel's doors that open to the undulating, brick-walled sanctuary ahead. The chapel was designed as a contemplative, nondenominational space that, in a multicultural era, has become a multifaith space. That updates and is consistent with its references to ancient structures from both pagan and Christian traditions.

A study Bertoia made for the altar screen, or reredos, for the chapel indicates that he knew the basic form the building would take but not the details. It is more vertical, linear, and sparse than other sculptures of the period. With aspects of both the wire and multiplane constructions, the study has planes that are biomorphic, like the up-facing leaves of many plants. It must have been in anticipation of the planned oculus overhead that Bertoia curved the planes of his sculpture, turning them toward the light. In other constructions, the planes faced viewers. Comparing this study with the maquette for the Kresge Chapel and the final work, however, reveals how much Bertoia modified his design as building plans evolved, allowing him to integrate the reredos seamlessly with the architecture.

P. 162

22

The maquette, despite its small size, is a much more subtle and effective response to the architecture than Bertoia's earlier study, suggesting that the building's design (like Bertoia's awareness of the plans) was much more complete. By spreading the wires so they form a more lateral design, Bertoia allowed the screen to occupy more space or, more precisely, more of the shaft of light coming from the oculus above. The planes are no longer organic but instead reflect the proportions of the bricks, while the arrangement of wires supporting the shiny rectangles is angled rather than perpendicular, so the plates are exposed to more light and avoid casting shadows on those below them. Saarinen and Bertoia had overcome the difficulties posed by the chapel's interior design with great elegance.

P. 161

21

As might be expected, Bertoia worked out ideas for the reredos graphically. One monotype emphasizes its shimmering highlights and how the darkness behind the screen emphasizes the light. Contrasts of light and dark, with many intermediating tones, suggest the layers in space and the transparency of the piece. Its descending light and evanescence are the major effects of this graphic rendering, as of the sculpture itself.

P. 160

20

In a 2016 interview, architect David Adjaye noted that the chapel and auditorium reflect the contrast between the sacred and the profane in both their forms and uses, and pointed to Saarinen's use of natural elements—water, light, wood, and earth fired into bricks—in the chapel. The undulating inside of the cylinder and use of "rejected" bricks, the ones usually discarded because of their flawed shape, enliven the interior as well as the exterior walls. But light is the essential feature of the interior, activating the reredos, reflected up the walls from the moving water outside and descending dramatically from the oculus over the altar.[18]

Behind the plain rectangle of the marble altar, the reredos is another element derived from medieval churches, though here it is Modernist, smaller and more open than its predecessors. The close accord between Bertoia and Saarinen as the building developed is evident in the screen, for Bertoia's sculpture refers to the building's most significant features. Wires extend from the oculus to the floor, approximately 21 feet (6.4 m). To absorb sound, Saarinen designed sections of the interior wall with gaps in the brick; the spaces and planes in Bertoia's screen have similar intervals. The screen's steel rectangles have the proportions of the bricks. The nickel and brass brazing on the steel plates comes alive with silvery and golden reflections, and their irregular textures recall those of the imperfect bricks. The metal planes are welded to their wires so they tilt down in front, toward the congregation, an important alteration of the study discussed previously.

As Adjaye observed in 2016, the plates "catch light falling from above." "The sculpture's purpose," he continued, "is to slow down the light. . . . The petals of the sculpture slow down and almost hold the light."[19] Invisible from a distance, some fine brazed details in the sculpture reflect the whimsical and lighthearted details and enhance the negative spaces. The chapel is a true sanctuary, not merely the area around an altar, but a space apart from the world, a refuge that invites contemplation and tranquility.

In 1955 Minoru Yamasaki of architectural firm Hellmuth, Yamasaki & Leinweber commissioned Bertoia to make a screen for the Lambert Airport in St. Louis. The screen, unfortunately, is thought to have been destroyed. Eight feet (2.4 m) high, 40 feet (12.2 m) wide, and 2 feet (0.6 m) deep, it incorporated painted metal plates suspended within a metal frame. The screen was fabricated of one hundred hand-painted metal pieces in various shapes. In this work, Bertoia returned to the ideas he had begun exploring in the study he had made in 1943 at Cranbrook, bringing into reality one logical outgrowth of a work conceived over a decade earlier. Several other studies and at least one other commission would further develop this series.

Celestial themes also recurred in Bertoia's works. In addition to clouds, there were references to stars and galaxies. A fine example of this is a rare piece of 1950s jewelry, a sunburst pendant in bronze from about 1955. This small explosion of gold-colored metal is wearable sculpture nearly 3 inches (7.6 cm) high and 5 inches (12.7 cm) wide. Organic spikes of metal erupt from the center, ending in small daubs, a frequent motif in Bertoia graphics and sculpture of this era. The petals or tentacles are unusually aggressive for a piece of jewelry and for a work by Bertoia. The piece is extremely dramatic. In a photo it seems monumental, and it is consistent with Bertoia's interest in working both large and small: it once astronomical and floral.

In 1953, Bertoia had purchased the house and barn he was leasing, as well as the 50 acres (20.2 hectares) on which they sat. He would, over the next twenty years, buy up adjoining land to protect his property from encroaching development, eventually owning 200 acres (80.9 hectares). Early in 1955 the Bertoias' third child, Celia, was born. He made his wife a gold-link necklace to mark the occasion of Celia's birth. Perhaps to refine the design and process before working in gold, he made a similar belt and bracelet in silver. It may have been coincidence that also in 1955 Hans Knoll requested that Bertoia design children's chairs, a very small side chair and a larger one.

Bertoia had been commissioned to sculpt a screen for the Cincinnati Public Library in 1953, and two years later he was commissioned to create one for the Dallas Public Library, which would be the first public art for Dallas. To say the piece was controversial is an understatement. The 10 x 20 foot (3 x 6 m) screen was prominently installed above the circulation desk, its plates of steel gleaming with bronze, nickel, and chrome brazing. Bertoia wanted it to remain untitled so that viewers might form their own ideas in response to the work; he called the piece "a mirror" of the viewer. R. L. Thornton, the mayor, called it a "bunch of junk" that looked like a "cheap welding job," and some public officials said the money would have been better spent on books. The screen was removed. The library's architect, George Dahl, paid the city the $8,700 that Dallas had invested in the work and had it taken to his home. Soon the Dallas chapter of the American Institute of Architects and private citizens bought the work and convinced the city to reinstall it in the library, arguing that if a work were to be for the public, the public ought to own it. The 1955 building eventually fell into disrepair, and in 1982 a new, central library opened, housing the sculpture, now known as *Textured Screen*. Its installation in the newer building was well guided by the character of its original location, and while it is in a different type of space, it is more visible now. Many elements of the piece are inventive and surprising, including plates that were punctured or shaped into pyramids and cones. The results of the controversy were ultimately positive, for not only did the public regain the opportunity to enjoy the sculpture, but also a fine-art commission was established and charged with making future decisions about public art.[20] This skirmish in the growing acceptance of Modernism concluded successfully.

Shortly after 1955 Bertoia arrived at another variation on the multiplane works. He developed a number of vertical pieces with short branches reaching to each side and ending in metal plates. These frontal works were conceived for hanging on walls, projecting to the sides and forward, into space. The metal plates vary in proportion from one work to the next: some are nearly square, others vertical or horizontal, although the plates within one sculpture all generally conform in shape and size. Like the screens, they have details and brazing that increase their biomorphism. A fine example of this type is just over 6 feet (1.8 m) tall and nearly 2 feet (60 cm) wide while projecting forward 10 inches (25.4 cm). This format strongly suggests a tree, and the tapered curve at its peak asks to be read as a bird. Identifying that arc as a bird then encourages reading the round form, to the right of the "trunk" above its midpoint, as a nest. Bertoia took great interest in patination, treating the surfaces of steel, bronze, and other metals with chemicals that oxidize and change the color of the metal. The shapes and attention to patinas link these works to the wood-block paintings in their variations of the colors' values and temperatures. A monotype with similar forms, despite its monochromatic palette, is very three-dimensional in effect because the branches are rendered in perspective with light and dark playing against each other.

In order to work on pieces of such differing scales as jewelry and architectural commissions, Bertoia sat on a backless chair that his friend George Nakashima made for him to use when welding. When working on large pieces, Bertoia sat in front of a large, low platform, but when he turned to small sculptures, he put another platform on top of the bigger one, raising his work surface. This let him attend to details comfortably. At times he also placed pieces horizontally to work on them up close. Bertoia combined working horizontally with using color in one welded multiplane construction. Reference to the wood-block prints of Cranbrook and California is evident in this piece, whose planes he painted with enamels. Working horizontally suggested displaying or installing pieces that way too, and the piece can hang on a wall or lie on a shelf or tabletop, where its coloration, texture, and shadows can be readily seen.

Bertoia received a grant of $10,000 from the Graham Foundation for Advanced Studies in the Fine Arts in 1957 that allowed him and his wife to travel to Italy that year, where they visited museums, buildings, and the

P. 165 27

P. 165 28

P. 166 29

P. 167 31

P. 167 30

landscape of Bertoia's fatherland. They traveled from Venice to Florence and Rome, as well as San Lorenzo, where they saw friends and family. The trip fulfilled a dream at once personal and professional. The foundation introduced Bertoia to such trustees as James Johnson Sweeney, Mies van der Rohe, and José Luis Sert. Soon Bertoia became a participant in panel discussions and programs bringing together perspectives as different as those of John Entenza, Buckminster Fuller, György Kepes, Robert Venturi, and Jack W. Burnham. Bertoia now belonged to a circle of stimulating colleagues, many of whom became friends, and was publicly acknowledged as part of the intelligentsia of art and architecture.

The honor and opportunities were only temporary, if valuable, distractions, and Bertoia continued exploring his series of works structured around a vertical axis; he was, perhaps unknowingly, making sculptures that belong to the nearly universal iconographical tradition of the *axis mundi* or tree of life. Photographs of several examples of such works from the early to mid-1950s were part of his estate, each showing a work outdoors, on grass. Night allowed the background to disappear, and artificial light enhanced the sparkling, golden surfaces. These works' structures are based in nature, and Bertoia wanted them to be in nature.

33 P. 169

In 1956, Bertoia was to make a screen for Dayton's department store in the Southdale shopping center in Edina, Minnesota. It was a pair of glowing trees, side by side, at the main entrance to the department store, facing a large open space where several stores in the shopping mall could be entered. The screen was a striking and effective way of distinguishing Dayton's from its neighbors. It was also an interesting adaptation of the modular approach Bertoia had used at Manufacturers Trust.

35 P. 170

For the lobby of the Denver Hilton Hotel, in 1961 Bertoia made two trees to stand side by side, 8 feet (2.4 m) high, 12 feet (3.7 m) wide, and 4 feet (1.2 m) deep, faithfully represented in a monotype. The graphic representation seems to merge the trees into a screen, rather like a hedge or a plantsman's row of espalier fruit trees. The monotype reflects the nature of many of Bertoia's works of this decade, for they generally explored ideas he was considering for sculptures. Perhaps the largest and most historically important example of this general type of Bertoia's work is *Tree* (1957, Virginia Museum of Fine Arts, Richmond). Bertoia was among the artists selected by the U.S. Department of State to have their works exhibited in the U.S. Pavilion at Expo 58, a world's fair in Brussels. That fair emphasized science and Modernism embodied in its landmark building, the Atomium, a memorable nearly 60-foot-tall (18.3 m) stainless-steel replica of a cell from an iron crystal. The U.S. Pavilion, designed by Edward Durell Stone, showed a computer and color television. Metal sculptures by José de Rivera, Alexander Calder, and Bertoia exemplified American Modernism in art.

36 P. 171

One of the studies preliminary to the 1957 *Tree* is *Singing Oak*, likely also from that year but only a couple of feet high. It was lent to the Virginia Museum of Fine Arts in Richmond by Eugene B. Sydnor, Jr., on the occasion of the museum's first exhibition of *Tree* in 1958. From a small center, *Singing Oak*'s branches radiate 360 degrees, and every branch ends in a shape like the cupule retaining an acorn and left empty after it falls. Some of these "cups" are hemispherical; some converge at the sides or have recurved edges. Brazing heavily textures the trunk and the branches, many of which bend almost as if swaying. The branches' irregularities suggest how plants move, whether quickly in response to wind or slowly as they reach toward light. Hans Knoll had intermediated between Bertoia, Staempfli Gallery, and the State Department in securing Bertoia a commission for a tree brazed with brass for the courtyard of the U.S. Pavilion. Early in 1958, after *Tree* had been sold, it was donated anonymously to the Virginia Museum of Fine Arts and installed in a small, walled garden on February 13, 1958.

Bertoia created a drawing as a working study for *Tree*, diagraming how he would perform the technically difficult act of welding rods projecting from a sphere. He printed his name at the upper right of the page, which suggests

he was sending the sketch somewhere, likely to George Staempfli's Gallery, which would forward it to the State Department so it would have an idea of his design. The forms at the ends of the rods are geometricized, making them much simpler than those in *Singing Oak* and less like parts of a tree. His note indicates that the "stem" is chrome, now known to be a hazardous material, and the rectangular or square base is wood. A monotype suggests some geometric explosion of forms that are triangular in section being forced away from a core. In its final form, *Tree* is a synthesis of those two works, with brazed stems propelling their terminals outward. Rectangles and diamonds at the ends of the stems are suggestive of leaves, many with ribs down their centers encouraging their sides to bend at angles. The upper portion of the tree is slightly flattened at both top and bottom, avoiding spherical form, and a sizable base balances the weight of the treetop.

P. 170 — 34

Standing beside *Tree* at its unveiling, Bertoia looks self-conscious in a photograph. In later years, he only wore a necktie under duress, so this is a rare photo showing him with a tie. *Tree* is constructed of brass and copper brazed onto steel. At 7½ feet (2.3 m) tall, it is imposing, and, before decades of surface oxidation, it gleamed and glistened as if full of the bravado characteristic of postwar America. Its base is symmetrical, unlike that of *Singing Oak*, and the leaf forms ending the branches are bold and geometric. Unlike many of the slightly curving branches on the small tree, the branches projecting from the central core here are straight and stiff. Combined with their solid, angular "leaves," the branches form a flattened ball, rather than a sphere. Like the smaller version, the tree's shapes suggest an oak, a famously strong and long-lived one. The shapes forcing their way from the core of *Tree* make this sculpture dynamic to suggest nature's energy and power.

P. 171 — 37

P. 171 — 38

Bertoia's works of the 1950s had great continuity but also differed significantly in appearance. He continued making screens and trees and began making bushes. The balance of geometry to organicism within particular works varied, while his sculpture and graphics increasingly referred to life. Bertoia's accomplishments in the 1950s were truly numerous. In 1952 he won many prestigious awards and, more interesting to him, was voted visiting critic in sculpture for 1953–54 at Yale University, suggested by Josef Albers, head of the art department. Bertoia traded works with a number of artists he knew, and one of Albers's *Homage to the Square* paintings on Masonite was in the loft of Bertoia's barn in the early 1970s. Not usually a collector, Bertoia at that time added to his living room fine pieces of Veracruz and preclassic sculpture from pre-Columbian Mexico. Josef and Anni Albers were among the earliest and most enthusiastic collectors of such works, visiting archaeological sites in Mexico from the 1930s to 1950s, and they may have influenced these acquisitions.

Hard work allowed Bertoia to accomplish an enormous amount. The pleasures of owning a house and farm and having a new child were tempered in late 1958, when he sat with his dying father-in-law, whom he so loved. Wilhelm Valentiner had been a father figure as well as a mentor in art for fifteen years. Bertoia's work was in group exhibitions at major museums in the 1950s,[21] and his chairs had been introduced in December 1951 at Knoll's showroom in New York. Bertoia had little interest in a career: what concerned him was his work, and he hoped the quality and nature of his work would cause other things to happen. In the 1950s, he established warm relationships with two galleries that he would work with for the rest of his life: Fairweather-Hardin, in Chicago, would represent him in the Midwest, and Staempfli would represent him in New York.

The success of the 1950s pleased and reassured Bertoia. He and his family were settled in a place where he felt comfortable, but he was focused on the future. Opening a new calendar as the next decade began meant little to Bertoia. He would keep on working, developing the ideas that were occupying him in the late 1950s, and inventing new ways of working with wires that would extend through the 1960s and beyond.

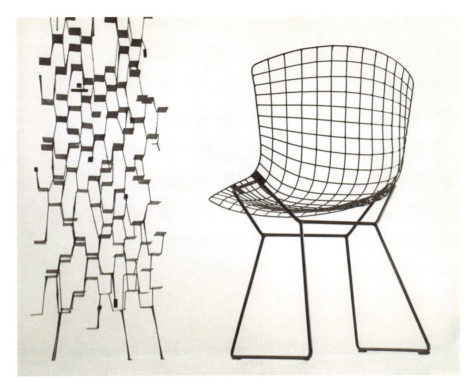

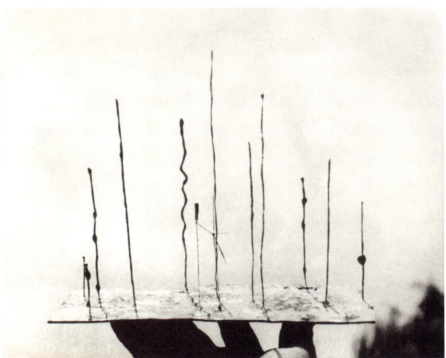

1 Herbert Matter (1907–1984). Bertoia Side Chair and sculpture, c. 1952. Vintage gelatin silver print. 11½ x 9¾ in. (29.2 x 24.8 cm).
2 Photograph from the Bertoia estate showing a c. 1950 wire construction approximately 6½ x 8 x 2½ in. (16.5 x 20.3 x 6.4 cm), in what appears to be the artist's hand. The piece was formerly in his backyard; current location unknown.

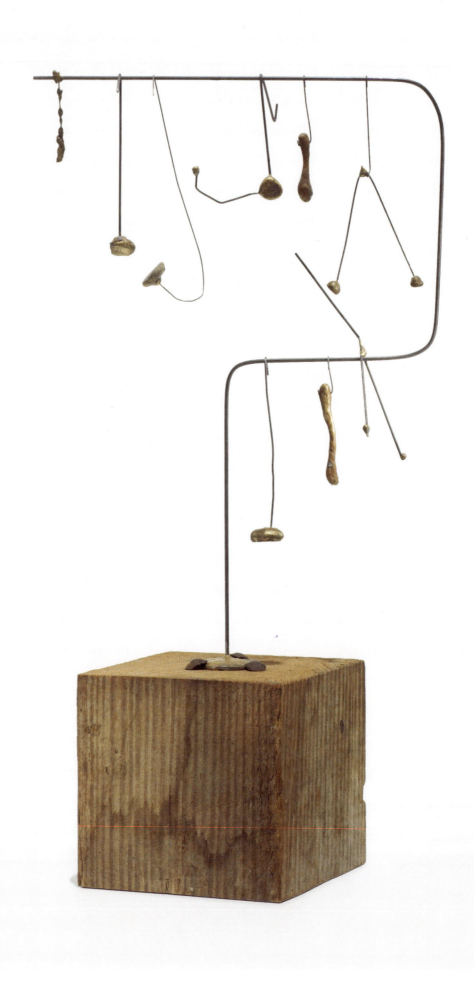

3

4

5

3 *Untitled* (kinetic form), c. 1948. Copper, bronze, blackened steel, and spruce. 15 x 7½ x 4 in. (38.1 x 19.1 x 10.2 cm).
4 *Untitled* (monotype), c. 1950. Printer's ink on thin paper, "672" penciled at lower right. 17⅞ x 24 in. (20 x 60 cm).
5 *Untitled* (monotype), c. 1952. Printer's ink on thin paper. 5½ x 11 in. (13.9 x 27.9).

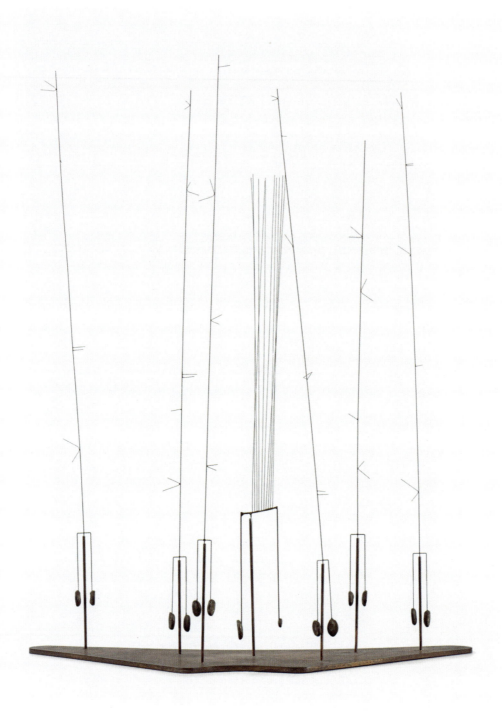

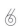

6 *Untitled* (kinetic form), c. 1950. Brass and silicon bronze. 28 x 22 x 9 in. (71.1 x 55.9 x 22.9 cm).
7 *Untitled* (welded form), c. 1950–55. Brazed steel and brass. 31¼ x 30 x 4 in. (79.4 x 76.2 x 10.2 cm).
8 *Untitled* (welded form), c. 1950–52. Welded steel, brass solder. 9¼ x 10 x 8 in. (23.5 x 25.4 x 20.3 cm).

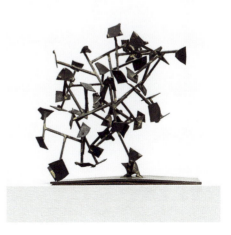

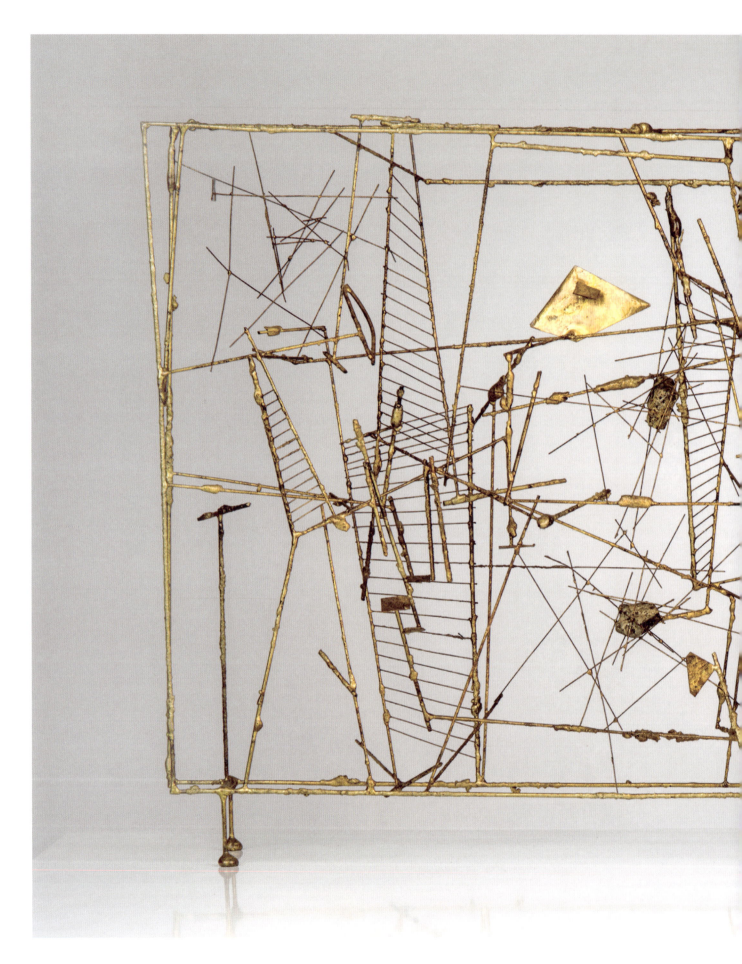

SCULPTURE AND GRAPHICS OF THE 1950s

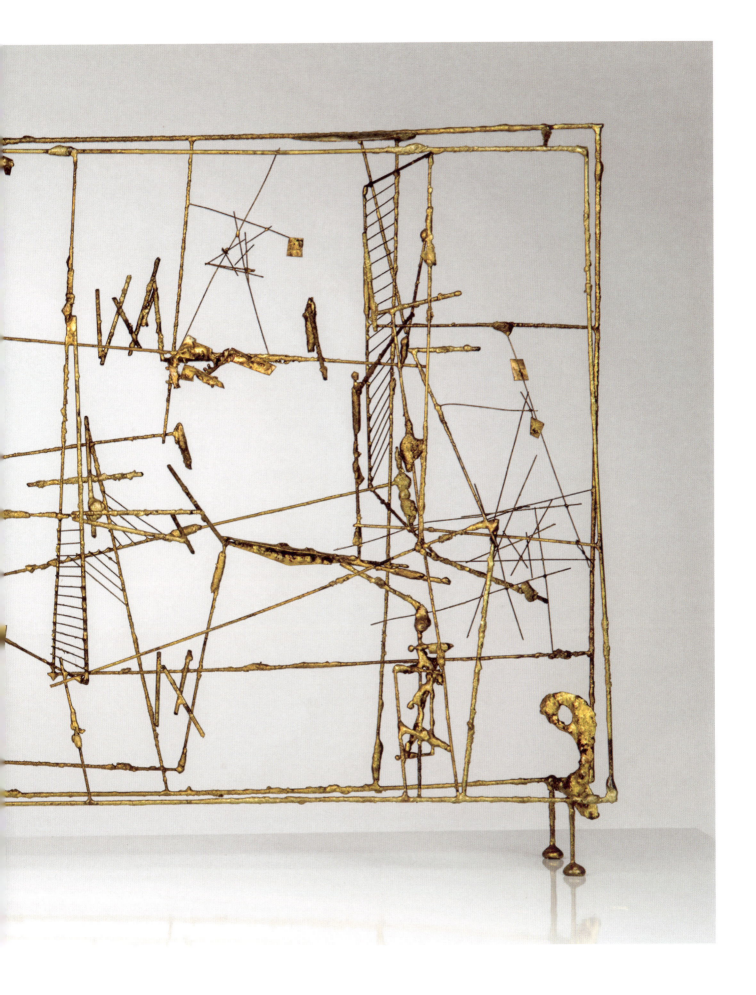

9 *Untitled* (wire construction), c. 1950–52. Brazed steel. 17¾ x 29½ x 4 in. (45.2 x 74.9 x 10.2 cm).

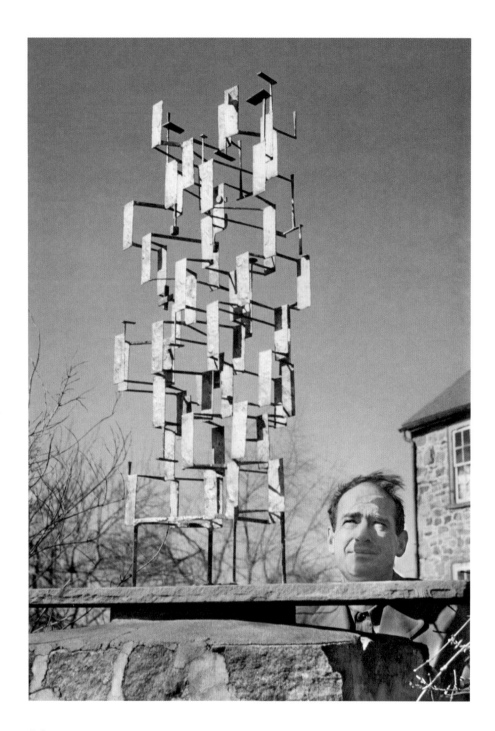

10

10 Harry Bertoia with a multiplane construction at his home, c. 1952.
11 *Untitled*, (sculpture/construction), 1953. Bronze-coated iron. 33 x 17 x 10 in. (83.8 x 43.2 x 25.4 cm).

SCULPTURE AND GRAPHICS OF THE 1950s

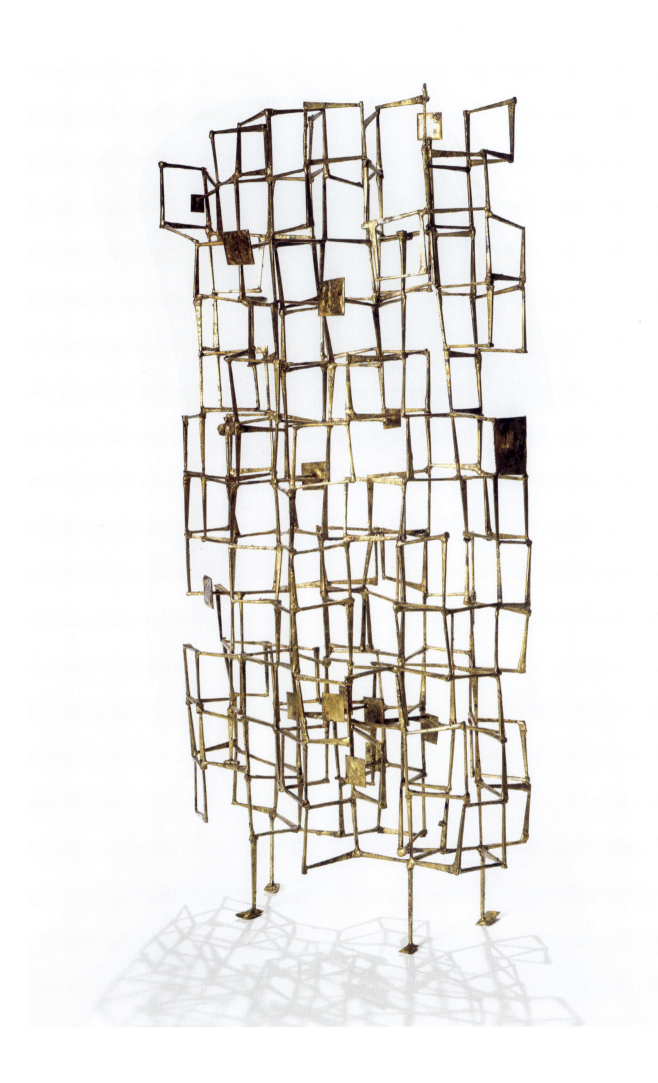

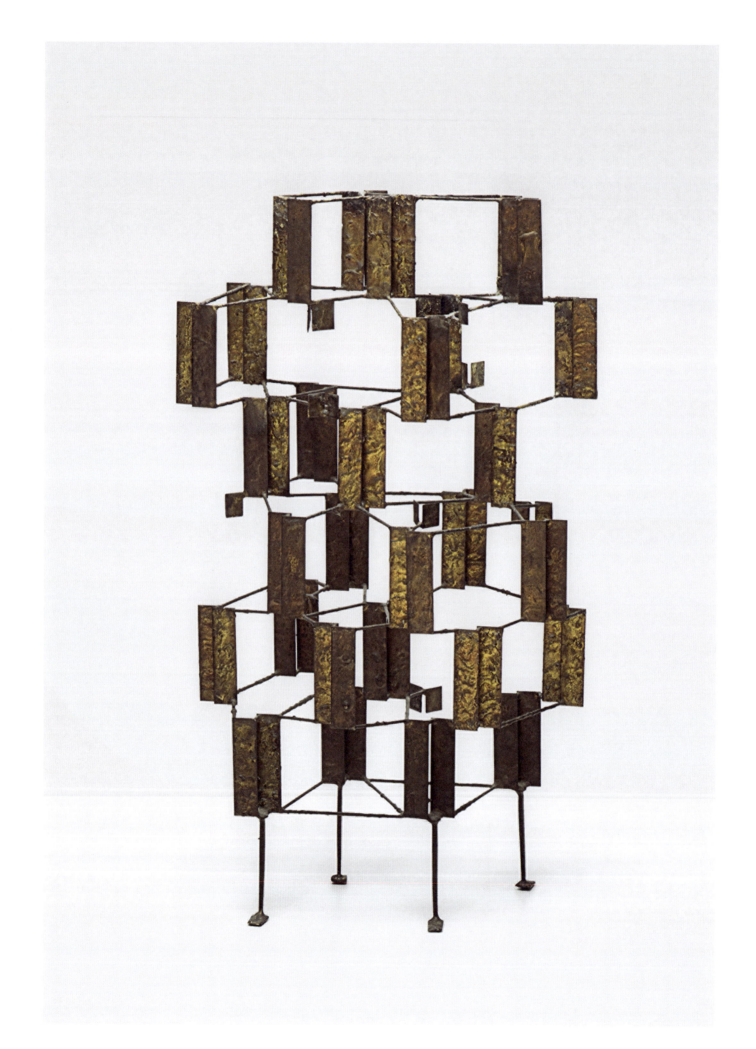

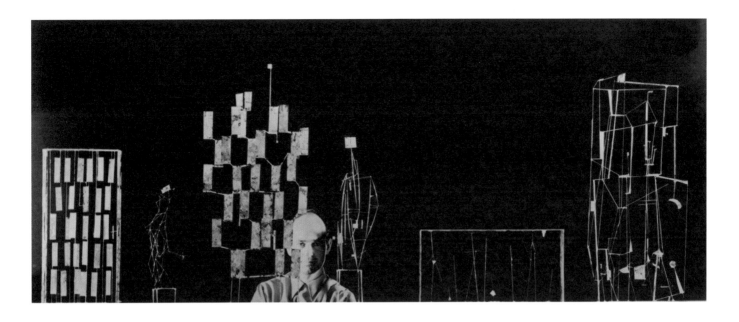

13

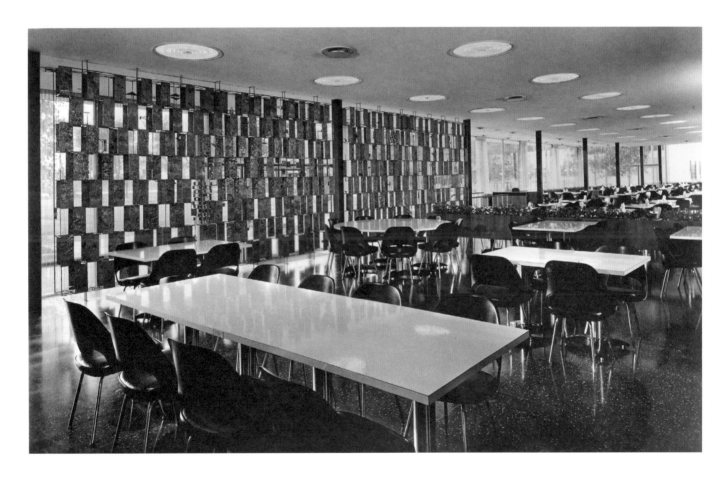

14

12 *Untitled* (multiplane construction), c. 1952. Brass melt-coated, welded steel, 28 x 16 x 9 in.
 (71.1 x 40.6 x 22.9 cm).
13 Herbert Matter (1907–1984). Harry Bertoia with wire and multiplane constructions, c. 1953.
14 *Untitled* (screen), cafeteria of the General Motors Technical Center (now Kettering Hall), Warren,
 Michigan, 1953. Steel plates and wires coated in melted bronze, brass, and nickel.
 10 ft. x 36 ft. x 8 in. (3 m x 10.9 m x 20.3 cm).

12

15

15 *Untitled* (head), c. 1952–54. Monotype, printer's ink on paper. 22 x 17½ in. (55.9 x 44.5 cm).
16 *Untitled* (cloud), c. 1953–55. Melt-coated brass over steel. 28½ x 54 x 6⅓ in. (72.4 x 137.2 x 16.1 cm).
17 Color photograph of welded steel, wire, and sheet cloud, c. 1953.

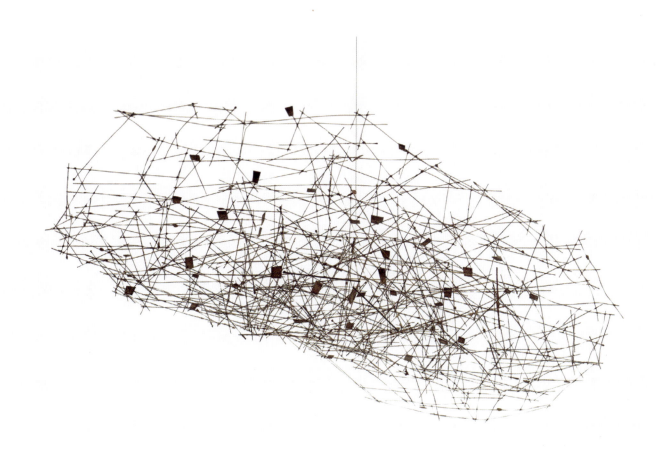

116

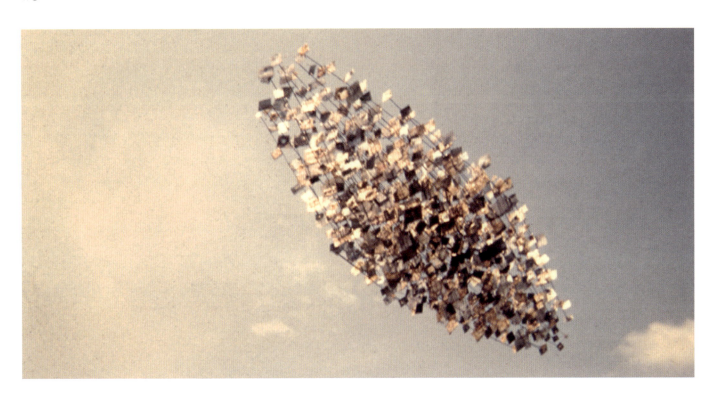

117

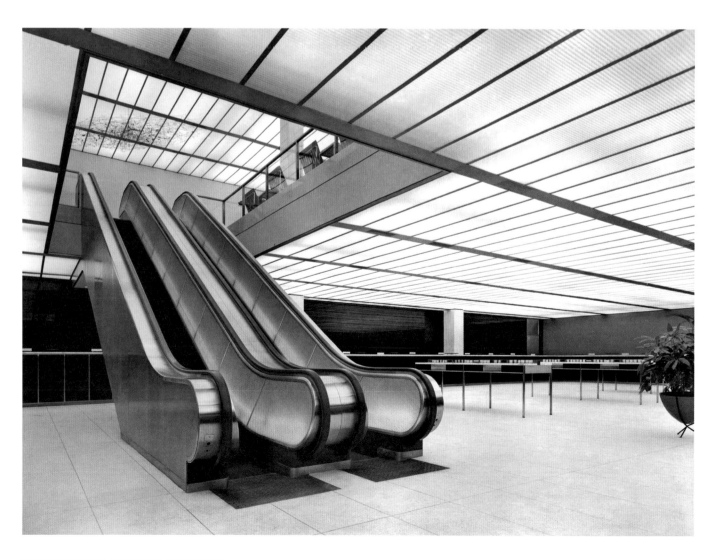

19

18 *Untitled* (cloud), above the escalator at Manufacturers Trust Company (510 Fifth Avenue), 1954.
 Steel wire and sheet, brazed with various metals. Approximately 132 in. (335.3 cm) long.
19 Screen and waiting area, Manufacturers Trust Company (510 Fifth Avenue). 1954. Steel melt-coated
 with brass, copper, and nickel. 16 ft. x 70 ft. x 22 in. (4.9 m x 21.3 m x 55.9 cm).

20

20 Study for screen at Kresge Chapel, MIT, c. 1953–54. Printer's ink on rice paper. 18½ x 11 in. (47 x 27.9 cm).
21 Maquette for Kresge Chapel, MIT, c. 1953–55. Welded, painted, and gilt metal, mounted on
 a hardwood base. 24 x 9¾ x 4⅝ in. (61 x 24.8 x 11.7 cm).

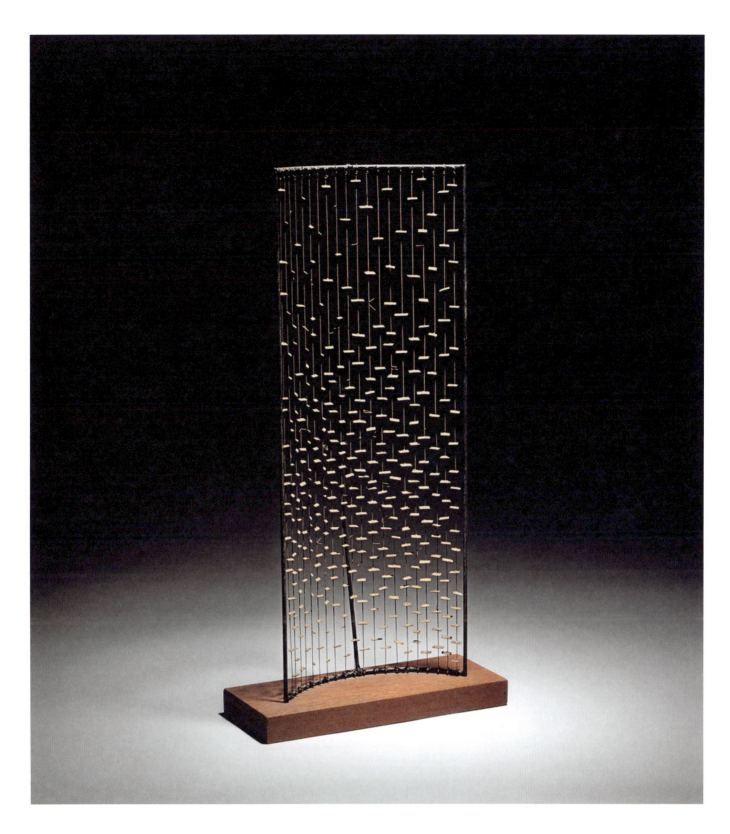

21

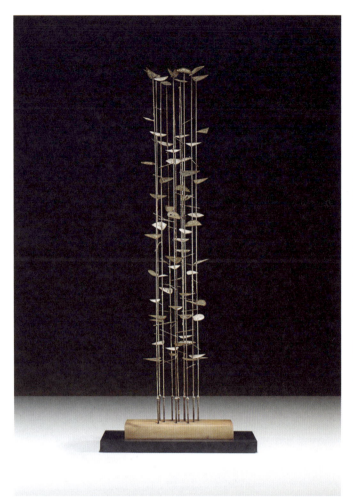

22

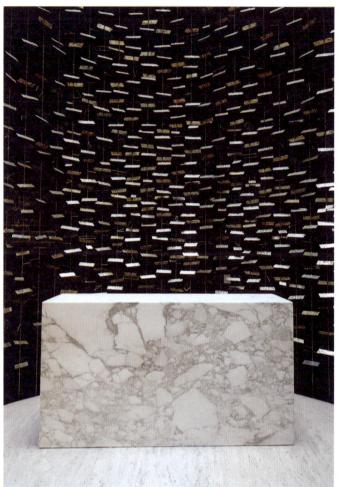

23

24

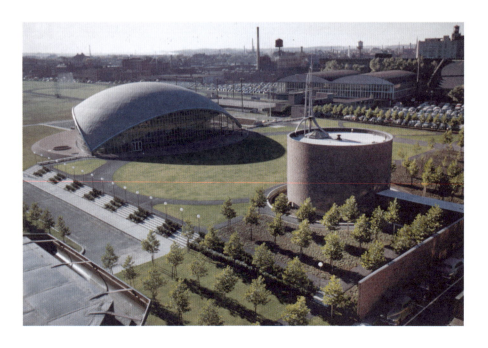

 25

22 *Untitled* (study for the MIT chapel), c. 1952. Melt-coated brass over steel, with maple base.
 28½ x 11½ x 5½ in. (72.4 x 29.2 x 14 cm).
23 *Reredos*, Kresge Chapel, MIT, detail, 1954–55.
24 Eero Saarinen (1910–1961), Kresge Auditorium and Chapel, MIT, Cambridge, Massachusetts,
 1950–55.
25 Eero Saarinen, Kresge Chapel, MIT, Cambridge, Massachusetts, with *Reredos* by Harry Bertoia,
 1955. Steel, nickel, and brass. Approximately 21 ft. x 12 ft. x 4 in. (6.4 m x 3.7 m x 10.2 cm).

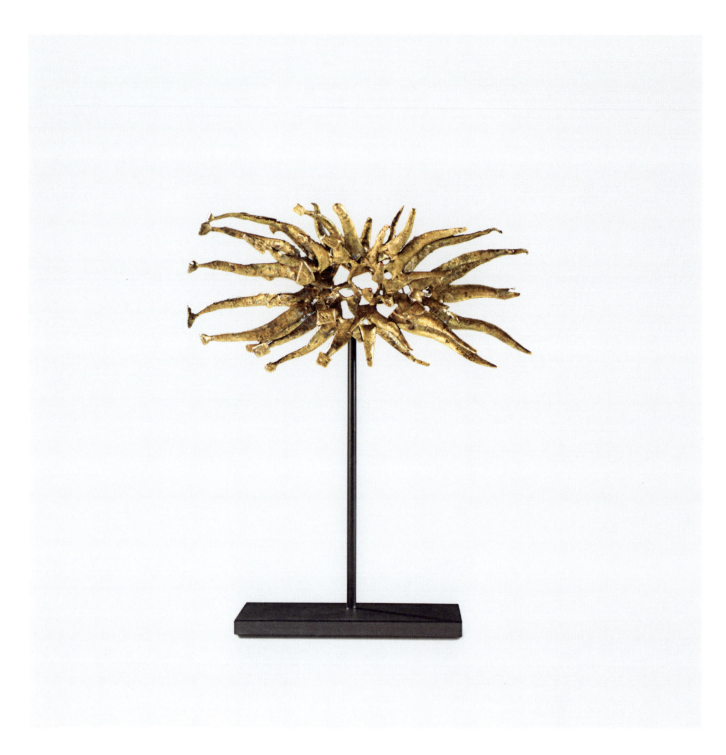

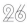

26 *Untitled* (pendant), c. 1955. Bronze. 2¾ x 5½ x 1 in. (7 x 14 x 2.5 cm).
27 *Untitled* (screen), 1953. Steel sheet and wires, melt-coated in brass. 10 x 20 ft. (3 x 6.1 m). Dallas Public Library.
28 *Untitled* (screen), 1953. Steel sheet and wires, melt-coated in brass. 10 x 20 ft. (3 x 6.1 m).
 First installed in Dallas Public Library, 1953; installed in 1982 in the J. Erik Jonsson Central Library, Dallas.

27

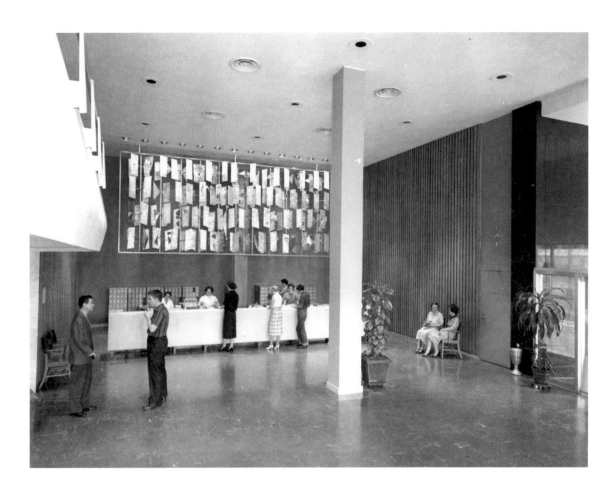

28

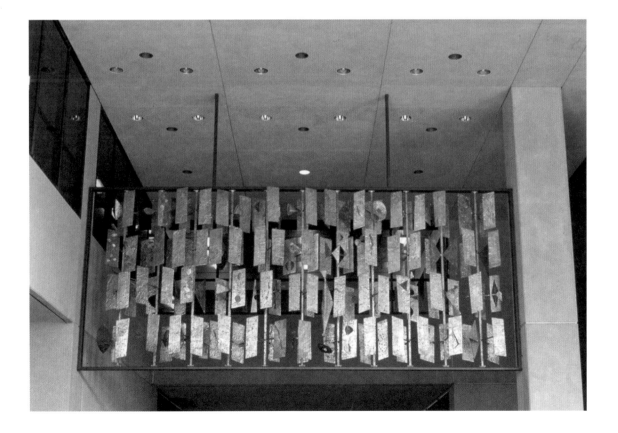

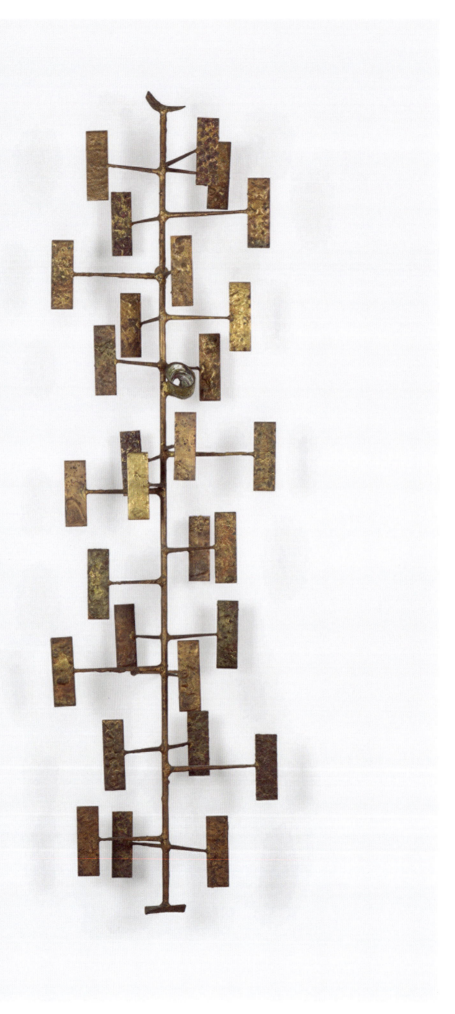

SCULPTURE AND GRAPHICS OF THE 1950s

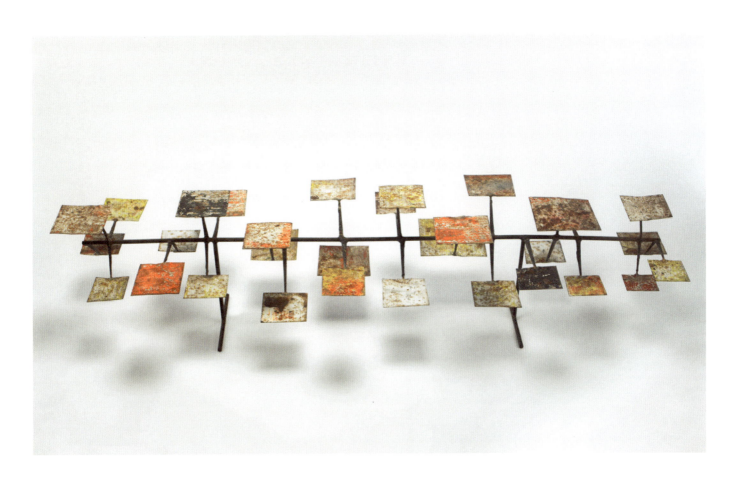

30

31

29 *Untitled* (multiplane construction), c. 1955. Melt-coated brass over steel.
 74 x 21 x 10 in. (188 x 53.3 x 25.4 cm).
30 *Untitled* (multiplane construction), c. 1958. Welded steel with applied
 enamel. 8¾ x 38 x 12 in. (22.2 x 96.5 x 30.5 cm).
31 *Untitled* (monotype). c. 1955. Brown and black ink on rice paper. 18 x 11¼ in.
 (45.7 x 28.6 cm). Numbered in pencil on verso, lower right, "3443".

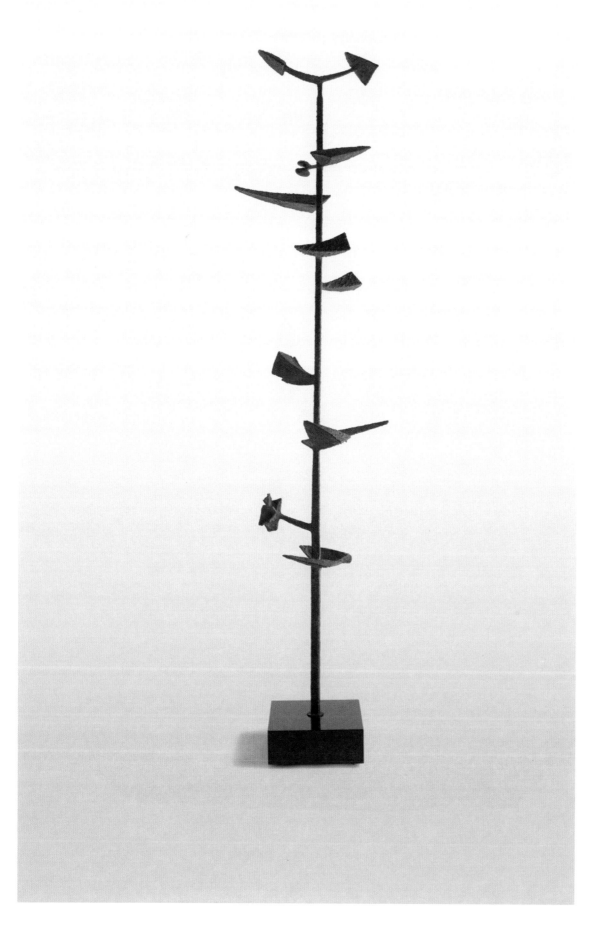

33

32 *Untitled* (welded form), c. 1957. Welded bronze and steel with applied patina. 136 x 30 x 24 in. (345.4 x 76.2 x 61 cm).
33 Screen for Dayton's department store made up of a pair of glowing trees, Southdale Shopping Center, Edina, Minnesota 1956.

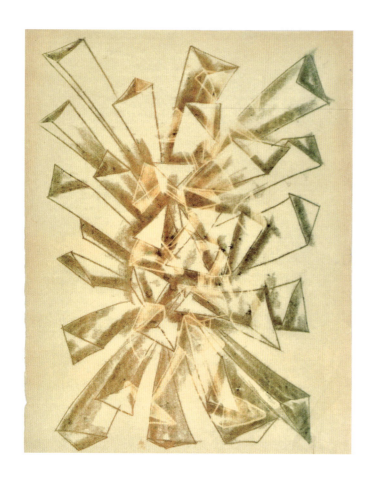

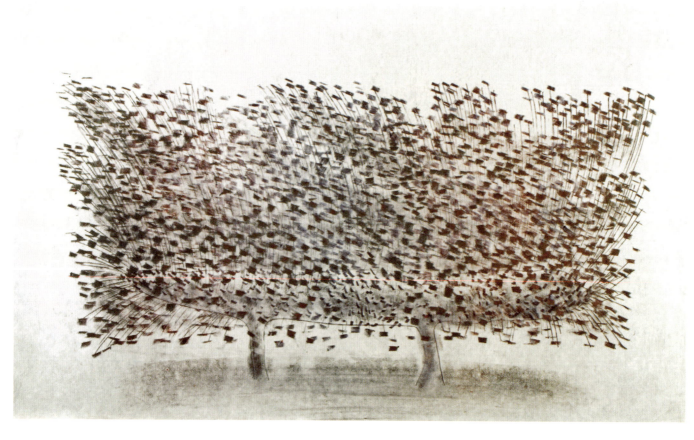

36

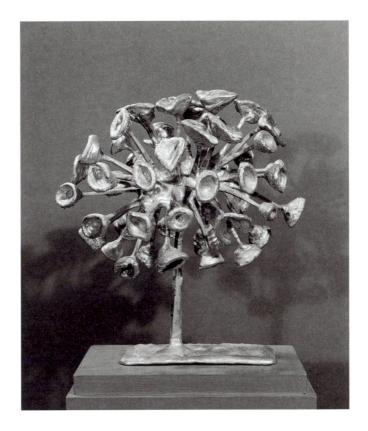

37

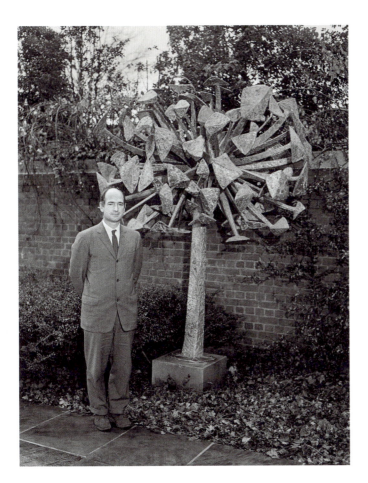

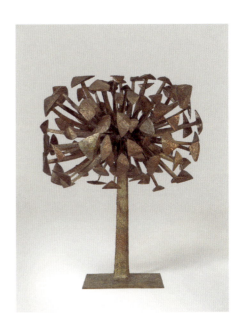

38

34 *Untitled* (monotype), c. 1957. Printer's ink on paper. 22⅝ x 18⅛ in. (57.7 x 46 cm). Numbered on the
 verso, lower right, "3443."
35 *Untitled* (monotype), c. 1960–61. Printer's ink on paper. 24 x 39 in. (60.9 x 99 cm).
36 *Singing Oak*, c.1956–58. Steel with melt-coated bronze. Approximately 18–24 in. (45.7–61 cm) high.
37 Harry Bertoia beside *Tree* in the Members' Suite Sculpture Garden at the Virginia Museum of
 Fine Arts, Richmond, February 13, 1958.
38 *Tree*, 1957. Brass, copper, and steel. 92 x 78 x 46 in. (233.7 x 198.1 x 116.8 cm).

NEW FORMS, NEW TECHNIQUES 1960–78

Design is examining the possibilities.
—Peter van Dijk, quoting Eero Saarinen

As the 1960s began, Bertoia was continuing to experiment with sculptural ideas, as his monotypes of the period reveal. He would still work simultaneously in at least two sculptural modes on a small scale while making monotypes. Meanwhile, he also was developing the late multiplane constructions, although he was making fewer of them. He would return to working primarily with wires, sometimes using them to construct planes.

As the experiments began to become more certain in direction, their new forms and techniques would begin to appear in major commissions. A factor contributing to all the development of his work then was that Bertoia was happy in Pennsylvania: in an August 22, 1958, letter, he explained that he had never been more productive than in recent years in Berks County, and that the neighbors and the landscape—mostly farm people and farmland—suited him well, both personally and professionally.[1] He was close enough to New York to go to Staempfli Gallery on business, see exhibitions, and consult for Knoll, so he could stay au courant yet live and work in another, more tranquil and private world.

Bertoia often still thought about outdoor sites for his sculptures, as he had when he went to considerable effort to move pieces from his shop in Bally to the yard at his house. He had arranged them to stand perfectly vertically at the edge of the woods, posed for the camera as if for a group portrait. Less physically arduous was making monotypes of real and imagined pieces, set outdoors, as he did multiple times in the early and late 1960s.

Over several decades Bertoia created monotypes depicting sculptures that he imagined making, would actually make, and had already made. His graphics are a rich store of possibilities as well as executed works, though they pose the problem of determining what is real and what is imaginary— which would have amused Bertoia. A number of monotypes show Bertoia sculptures lined up on a grassy lawn, documenting them on paper. They strongly parallel the photos Bertoia took of the shiny, golden pieces on an evening late in the 1950s. Some of the sculptures depicted, however, would have been virtually impossible to fabricate or support and existed only in the artist's imagination, although some ideas recurred years later and came to some form of fruition. These elongated, quite fanciful pieces depicted never were realized in three dimensions, but their ideas survived to exist in other manifestations. The idea of small forms inside larger ones recalls some aspects of Bertoia's 1940s jewelry, and the delicacy of the drawn works is jewellike as well. From the 1940s through the 1970s, Bertoia often revisited earlier ideas. He had made a sequence of basketlike forms in about 1955 that stretch like a fantastic fishing weir. The multiple patterns seen through each other are like a phenomenon Bertoia had enjoyed when he was working on chairs for Knoll. As late as 1973, when he was preparing for a major commission at the Standard Oil Building in Chicago by Edward Durell Stone, Bertoia considered wires or rods in diamond shapes that have much in common with the fanciful pieces in his monotypes, although since the Standard Oil piece was to be a fountain, water flows from many points in the monotype study.

One monotype depicts, on the far right, a sculpture that is remarkably similar to one that does in fact exist, *Untitled (balancing kinetic form)*. The wispy sculpture has been dated about 1950, perhaps erroneously, for the monotype is consistent with other works that appear to be from a decade later. At over 7 feet (2.1 m) high, it has two elements: the upper one rests so delicately on the lower part that it can move. It must be the earliest large kinetic piece Bertoia made and omits the wire upper section of the drawing where wires seem to outline a cone containing vertical wires. It seems almost a mirage, and Bertoia emphasized reflectivity by adding small silver elements. He likely hoped that stainless steel would retain the reflectivity and shine that he liked—the new metal's industrial, Modernist sheen. Bertoia had clearly enjoyed the kinetic aspects of much of the jewelry

P. 187 1

P. 190 6

P. 188 3

P. 187 2

P. 191 7

he had made, with pieces hanging off others, able to swing. When he worked with wires, they were always moving. He would hold a wire up between his thumb and first finger, testing its resilience and strength according to how high it could go before the top bent or drooped. Combining the sheen of the material with motion greatly appealed to him, and, in some respects, this is a large, delightful toy. It also called into play the natural phenomena like breezes, reflections, and changes of light that Bertoia found fascinating and evidence of more profound forces in the universe.

Between the late 1950s and early 1960s, Bertoia also made a number of monotypes showing vistas that he gave tremendous motion through flocks of migrating birds, clouds, and wind-driven wires or rods. Bertoia's love of deep, subtle color is evident in blacks enlivened in some areas by contrasting reddish blacks with bluer tones. Natural forces dominating the hillside and grassy plants blowing counter to the prevailing wind above are not quite cyclonic, but convey a sense of nearly circular winds and the power of nature. A few ghost lines suggest that this was one of several pieces executed in sequence over a short period of time.

Commissions from corporations generally came to Bertoia through their architects, who admired his ability to work from plans and create works suited to their sites, on time and within budget. By collaborating with Eero Saarinen and Gordon Bunshaft, Bertoia was able to undertake sculpture on a scale that was challenging and that would be unimaginable for someone working on his own. He loved the interaction with architects because it was intellectually stimulating and the results were beyond his abilities alone. His business transactions were generally amicable and pleasant, with one notable exception. Late in 1957 Charles Nagel, director of the City Art Museum of St. Louis (now the St. Louis Art Museum), wrote Bertoia about commissioning a metal screen to go in front of the doors to the sculpture court in the museum's neoclassical building. Bertoia quickly rejected the offer, saying his work had nothing in common with the style of the building. He elaborated, explaining that his interaction with a building's architects during the planning stages was the source of sculpture both suitable to the building and which influenced the building. Collaboration was the source of the designs for the works at Manufacturers Trust and the Kresge Chapel, the examples that Nagel admired and had made him hope Bertoia would undertake a commission for the St. Louis museum. Bertoia essentially replied that as a Modernist, he and his work were focused on the present. This exchange continued with some insults, but its importance is in revealing how committed Bertoia was to working in tandem with an architect toward a better building as well as sculpture than either might have created without the other.

By contrast, an unusually rewarding experience resulted from Bertoia's working with the Cincinnati architect John M. Garber, who visited Bertoia in December 1959 to initiate discussions about a commission for St. John's Unitarian Church. Bertoia visited Cincinnati early in the church's construction and proposed a sculpture for the wall behind the altar rather than for the facade of the church, as the congregation and architect had envisioned. The large tree in front of the church, he argued, cast a beautiful shadow on the facade where they initially had wanted sculpture, and he believed that shadow was enough decoration. Walking up a plank across foundations to point to the space he thought most suitable for a sculpture, Bertoia convinced them of the worth of his suggestion. His multiplane construction, 12 feet (3.7 m) high and 2 feet (60 cm) wide, cost $5,500, which the congregation needed to raise, and a member made the $1,000 down payment. The final work pleased the artist and the congregation. Its sharply angled wires hold their planes in very high relief from the wall, catching reflections and casting constantly changing shadows. The warmth of its golden tone was a perfect contrast to the gray brick of the wall.

In a letter to Bertoia, Garber described how the screen had "become an integral part of the building and an integral part of the Sunday worship service." During services, he explained, sunlight strikes the whole sculpture,

4 P. 189

casting shadows on the wall. He admired the contrast between the delicate shadow and bold mass and rich golden surface of the piece itself. "There is an irregular rhythm to the play of sunlight both on the object and on other surfaces inside the building due to sunlight going in and out of clouds. This pulse of light is sometimes bold and at other times very quiet. . . . The sculpture always manages to be sunlit at some dramatic moment—say when the organ reaches a climax or when the sermon begins or when a Christening is taking place." Bertoia must have been touched and pleased by Garber's perceptive and eloquent response to his work. At the bottom of Garber's September letter Bertoia noted that he was contributing the remaining five hundred dollars himself.[2]

These two experiences concerning commissions could hardly have differed more. The interactions involved in the St. John's project were more typical of Bertoia's commissions (if more profound than most). By 1957 Bertoia had resigned himself to accepting that, when commissions were involved, his art had to be a business. In the early 1950s, during his first major commissions, Bertoia was unsystematic about keeping documents, and few remain. Later he would start careful record keeping, amassing well more than ten thousand pages of documents—correspondence, orders for materials, bills of lading, proofs of insurance, and so on. Working with the Saarinens, Knoll, and Eames had introduced him to this necessity. Experience would teach him that minutiae like having the precise dimensions of an elevator when a commission was still in its infancy could save time, money, and frustration later by greatly facilitating the installation of a sculpture. Making large metal sculpture would require having assistants, training them, and keeping them productive between major pieces. Success required Bertoia's practice to change. As a result, his most creative time would be at night and on weekends, when he was alone in his work shop.

In the early 1960s, Bertoia was experimenting with wires in many metals, including bronze, other copper alloys, and stainless steel, in various gauges and lengths, often buying 100 or more pounds (45.4 or more kg) of a type at a time. They arrived in wooden boxes shaped like troughs with a plank lid nailed on. The wires could be removed by dumping them out all at once or by the handful, grasping them in the center or at the ends. For Bertoia, even taking the wires from their boxes revealed their potential as sculpture.

Bertoia considered possible configurations of wires in bundles, twisting and soldering them. He made a small metal cup that fit the bundle's circumference perfectly and fixed it to a base large and heavy enough to ensure the sculpture was stable. The materials, length, and weight of the wires determined the material and size of the base—it was more a matter of physics than art. In some cases, both ends were gathered into cups. To keep a piece like the wire bundle from collapsing of its own weight, he inserted a stainless-steel rod up its center and carefully circled the rod with spaced wires. Making the pole a bit shorter than the wires allowed the delicate wires to droop, sway, and swell as much as he wanted. Part of the appeal of these works is their delicate reflectivity, for they have soft-edged highlights that gleam quietly rather than shine brilliantly. Their texture and girth contribute to how light reacts to the wires much as texture and gauge also determine the fluid, tactile appeal of this industrial material known more for its strength and durability.

P. 193

Stainless-steel wire is a surprisingly sensuous material, both pleasant in the hand and highly mobile. It whispers slightly as it moves in a group. A draft of air sets the wires in motion, attracting reflections of light and color from their surroundings, even casting reflections around the space the sculpture occupies. A pair of these bundled wires 6 feet (1.8 m) high always stood in a corner of the barn. He liked their subtle motion when he passed them or a breeze touched them, and he was charmed by their soft sound. Surely they were among many stimuli leading to the sounding sculptures.

To determine which metal best suited specific forms, Bertoia experimented with multiple alloys and variations of the forms. He liked the warm color of

beryllium copper and the rich sounds it could produce. Bertoia usually made his vase shapes, which he called "sprays" in stainless steel, for it is much more flexible than this stiffer, thicker copper alloy. However, he did make some sprays from copper. The warmth of its color and sound are very appealing, especially when the spray is set in motion gently at its tips or gathered by encircling fingers at its base. Sliding the hand partway up the wires' length and then letting go allows a piece of this type to expand and contract in an extended sequence of pulses than gradually grows increasingly subtle as its energy wanes.[3]

Bertoia took the next logical and pleasing step of gripping a group of stainless-steel wires in one hand, inverting them so they fall over and around his hand and arm. He called this form "willow," after the trees that respond so gracefully to the law of gravity—willow trees always enchanted him. The willow sculptures sway and utter a low hum in motion. Resisting setting them in motion is difficult, and watching them respond, the arcs of reflections falling down and crossing their flanks, is mesmerizing. Seeing them from below is also fascinating, which Bertoia would exploit. The idea of mounting stainless-steel wires from a ceiling came to fruition in 1968 when Bertoia suspended thirty-six willow shapes from the ceiling of the headquarters of Seattle First National Bank.

The ability of stainless-steel wires to exist under great tension yet also relax and drape in sensuous ways interested Bertoia, as many monotypes demonstrate. Those rather antithetical traits are shown in a monotype from the early 1960s when Bertoia was intensely involved in his work with stainless-steel wires. Against a background of smudges overlaid with parallel lines so fine that the context indicates they are wires, Bertoia depicted two angular forms at the left of the page. These forms or figures are composed of bundled wires pulled taut. At one end each bundle is tightly grasped, and at the other, fanned out. They stand, touching, dark and dense, against a white space, while their extremities disappear into darkness. Surrounded to the right by this atmosphere of dark smudges and fine lines, however, another form, this one horizontal, rests against a light space, framing it as two ovals, one above the other. Stainless steel's fluidity defines the ovals with curves familiar from the willow sculptures, especially when seen from their undersides. Defined by paired arcs to left and right, a narrow bundle of wires is under tremendous tension as it stretches between the willow forms. In this monotype Bertoia diagrammed the characteristics of stainless steel that fascinated him.

Some monotypes from the period are more technical than a reflection of Bertoia's understanding of life. They show Bertoia considering alternate possible forms in stainless-steel wires. Engineering is inherent in much sculpture. Imagining new ways of holding a bundle of wires in short tubes, attached to large supports, would allow Bertoia to mount shapes including double sprays from ceilings. The warmer and cooler tones in the monotypes perhaps suggest that wires are copper or stainless steel. One day Bertoia perceived that the wire brush belonging to his poodle would be perfect for drawing sculptures made of groups of wires, beginning with these stainless-steel works. It is an excellent example of Bertoia's perception of the world around him: everything is a possible subject or tool.

It is apparent that the bundled-wire sculptures resulted from Bertoia's appreciation of their ability to take fleeting and unexpected shapes. He sought to preserve those ephemeral forms by permanently fixing the wires in carefully controlled ways to suggest what nature had done so quickly. One of his solutions was to solder the tops of wires while they were fixed at the bottom to a base, doing so with enough slack that the wires curve and take on ever-changing volume. Another approach to that problem is evident in a few pieces with wires soldered where he wanted them before fitting them with tops and bases, some of concrete, others of much lighter gypsum.

Bertoia created multiple sprays and willows in various dimensions, while fabricating other wire-bundle sculptures only once or twice. He might

explore an idea generated by what he saw walking to his car on a snowy morning when white pines, with needles covered in heavy, wet snow, stooped under the weight on their soft limbs. In other cases, drawing led him to ideas, even moiré patterns. The general form is an adaptation of multiplane trees, but the result is more unusual, because it combines a simple structure with a complex appearance. He included these rectangular wire "fans" in several sculpted forms.

Bertoia's experimental forms and techniques using stainless-steel wires demonstrate his logical and systematic approach. One idea generated the next or, often, several others. An important example of wires bundled and released is a hanging hemisphere from 1965 for architect Peter van Dijk's Cuyahoga Savings Association building in Cleveland, Ohio. Van Dijk had been aware of the artist's work long before the commission. He recalled "falling in love with Harry Bertoia" while in grad school at the Massachusetts Institute of Technology (MIT) in 1955 to 1956. "I walked into the MIT chapel and there were all those golden dollar bills floating out of the sky. That's what we called them," he said. After earning his master's degree in architecture at MIT, van Dijk had worked for Eero Saarinen, which was such ` a learning experience that it was like being in grad school, he remarked.

Harris Bryan, president of the Cuyahoga Savings Association, was, van Dijk thought, "the ideal client; he knew what good architecture was," and "we wanted something, a focal point, in a space with a ceiling that was about twenty feet high. We thought, let's look at Bertoia and get one of those sprays or dandelions." Van Dijk and the artist had a great deal in common, and their backgrounds ensured that they approached projects in much the same way. Van Dijk contacted Bertoia, who visited Cleveland and the bank site, and they both quickly realized what would work as a sculpture for the building.[4] The enormous piece hung from the ceiling of the bank lobby for forty years beginning in 1965. With a diameter of 12 feet (3.7 m), this graceful form dominated the glass-walled space and its Modernist furniture. It managed to be both stunning and understated at the same time.

Perhaps to compensate for working so often with geometric forms, Bertoia also began making organic wire constructions, pieces somewhat similar to his 1950s wire constructions. These brazed forms often were associated with the sun, sometimes so indirectly that they suggested straw. These brazed wire constructions appear in both sculptures and monotypes. Although such drawings and sculptures sometimes closely resemble each other, Bertoia did not simply transfer one work to another medium and size. Process, whether drawing the monotype or welding and brazing wires, would lead to some elements taking on a life of their own. Both monoprint and welded steel versions are much more solid than the cloud at Manufacturers Trust and are entirely linear, lacking its small accents of sheet metal.

Many studies resembling straw preceded the commission from Chi Omega sorority at Syracuse University. A student, Eleanor DeWitt, led the effort to commission Bertoia and fund a sculpture for a wall in the lobby of Huntington Beard Crouse Hall. The piece, entitled *Nova*, was a further elaboration of Bertoia's themes of the solar system and the dynamism of nature. In a letter to F. Gordon Smith, a university administrator, Bertoia wrote that he had been considering the request for a title for the piece. He specified that his "suggestion should not take priority, but simply be one among all those who want to give it a name, I come up with this: The Syracuse University "Nova." Remembering a conversation on campus, he jokingly added, "I claim no credit for 'Flying Haystack' but that strikes me as a good one."[5]

The technique Bertoia used in these sculptures reflected the farmwork he saw every day. Cutting hay in summer, spreading it to dry in the sun, and winnowing and preserving it for winter were all familiar sights and signs of the changing seasons. He created a group of works inspired by straw. The form therefore differs from the more astronomical works despite its

P. 196 14
P. 196 15
PP. 198–199 18 19
P. 158 18
P. 197 16

use of the same technique. The wires remain more individualized, mostly vertical with some angling across them.

Bertoia kept some studies of *Straw* that he particularly liked hanging from the ceiling in his office. Works of this type later became more complex in structure and less suggestive of straw. Gradually one or two of these works left his shop, but at least one was overhead for more than a decade. At once airy, delicate, and elegant, these are denser than *Straw*. The architect Minoru Yamasaki had admired Bertoia's work since 1945, when he began his architectural practice in Detroit. Yamasaki commissioned Bertoia to produce a large sculpture for the Minneapolis headquarters of Northwestern National Life Insurance he was designing. Yamasaki designed a long ledge in the lobby for *Sunlit Straw* to stand on, lit from the front, above, and below, visible through the glass walls of the ground floor. Although it uses different forms, this 1964 work has the same enlivening effect on this Modernist building as the Manufacturers Trust screen has on its site, but here the sculpture is closer to the ground and more visible.

Bertoia began thinking about constructing monumental wire pieces that suggested plant growth. They were quite geometric, because he was thinking about using large, rather rigid wires—rods—which would impose more geometry on the works. This is, for example, evident in a felt-tip-pen drawing on Japan paper that he gave to Edward Flanagan (brothers Edward and James Flanagan were his assistants). Its lines describe angular, volumetric sculptures, some even resembling Venus flytraps. The pressure Bertoia exerted on the pen determined the darkness of lines but, more importantly, combined with their angles to establish their position in space. The simplicity of these forms suggests that they could be realized on a great scale, while their angles suggest motion.

Going in a new direction after first experimenting with copper wires on a smaller scale, Bertoia in the late 1950s made a large sculpture of bronze and copper wires. Almost 6 feet (1.8 m) in height, the piece is an unusual mixture of organized and seemingly randomly placed wire, although Bertoia was unlikely to have done anything haphazardly. The copper wires curving along much of the rim of the piece imply rotating movement, and the wires elsewhere form a mat of densely overlaid and curved, fine extrusions. They seem to move in many directions at once. Bertoia loved this piece so much that he placed it at the head of the pond behind his house, where it was sheltered by overhanging trees. Long pine needles and leaves transformed it as nature gradually adopted it. That greatly pleased the artist. After he cleaned it in preparation for an exhibition, purple was suddenly visible in the mostly green patina. The effect of this abstract arrangement of lines, colors, and space is impossible to convey in a photograph. Its depth of 17 inches (43.2 cm) and the balanced movement of the wires create volume, mass, and constant interest in this surprisingly massive sculpture.

Bertoia also experimented with welding a sphere of projecting wires, an extremely difficult technical feat. He arrived at several solutions to this challenge, each influenced by its scale and materials as well as his expressive aims. A sphere of welded copper nails and bronze from this time, just under 10 inches (25.4 cm) tall, demonstrated how Bertoia could proceed when making other spheres: welding the pointed end of the nail to a small core allowed the heads of the nails to complete the surface of the sphere. Soon he would work groups of pointed forms together, then weld them to a core in order to form large spheres. These led Bertoia to examine forms from nature, works that varied greatly in size, density, and predictability.

Dandelions were something Bertoia found fascinating. The way their radiant yellow sections wither and how the wind disperses their plumed seeds. An early piece influenced by this transformation appears to reflect the appeal of these weeds. By making the seedhead very open yet defining nearly the entire circumference, Bertoia showed a late phase in the dandelion's life, using radiating wires familiar from some 1950s constructions. His habit of challenging perception of scale by reducing large forms and enlarging small

ones here produced a dandelion nearly 7 feet (2.1 m) tall. The Eastman Kodak Company commissioned Bertoia to create seven gilded dandelions for the Kodak Pavilion at the 1964 New York World's Fair, siting the sculptures around a basin and fountain. Their intricacy, golden surfaces, and readily understood imagery were immediately well received by the public.

P. 202 24

In preparation for the artwork at the Kodak Pavilion, Bertoia made what he called the "Dandelion Project," a bigger group of dandelions than he expected to use for the commission, so he could select those he thought best. This entailed enough time and effort that, in discussing one particular dandelion, Bertoia insisted that it be dated "1957–65," the period during which he had worked on dandelions. (Many believe that the accepted practice of dating works is arbitrarily limited to the period of the artist's physical involvement with one particular piece, when the artist had been developing and refining the idea and techniques for the work over an extended period.) Bertoia appreciated the greater density of that example that made its segments less distinct than in early works. Bertoia's daughter Celia remembered the bumper crop of yellow flowers that appeared the year he began producing the sculptures.[6] While these works may seem to indicate that Bertoia had abandoned nonobjectivity, closer observation reveals that the structure and color only suggest dandelions. The sculptures actually were more influenced by geometry and industry than nature. They are a celebration of nature's vital force, and their effect is that of oversize jewelry overhead.

P. 203 26

Another unusual commission came from the Reynolds Metals Company, a producer of aluminum. In 1957 the company established a prize for a new building. As part of the prize, the architect of the winning building received a sculpture. The building was selected by the American Institute of Architects, but the sculptor was chosen by the American Federation of Arts. The sculptor was required to make two identical aluminum sculptures, one to go to the architect and the other to enter the Reynolds Metals collection.[7] Bertoia began by asking, "What would be the form aluminum would take by way of making a portrait of itself?" His solution, *Cube*, was developed on the idea of molecular structures. Bertoia made his sculpture with "ordinary aluminum mill products" and traditional processes.[8] Oscar Niemeyer's Museum Cultural Center of LeHavre was the winning building. *Cube* is composed of aluminum cubes connected by aluminum rods. The material and extreme geometry of this piece make it unique in Bertoia's oeuvre. The best solution he found for this commission, which interested him intellectually, was not within his usual formal or technical repertoire.

P. 204 27 28

Bertoia's move into extensive experimentation with bronze was encouraged by a complicated commission for Eero Saarinen's Dulles International Airport in Virginia. Bertoia was to create a screen or wall for the international airport, a major new entrance to the city of Washington, D.C. The commission involved navigating a maze of bureaucracies, including the Federal Aeronautics Administration, the U.S. Commission of Fine Arts, and the governments of Loudoun and Fairfax Counties in Virginia, whose land Dulles straddles. Shockingly, fifty-one-year-old Eero Saarinen died suddenly of a brain tumor early in the process. His associate, Kevin Roche, completed the huge project, working closely with Bertoia. Their initial meeting with the authorities was at best unpromising, but just before the end of the meeting, Bertoia suggested a sculpture that was a map of some sort. That novel idea was enough to keep the process alive.

Soon Bertoia took two trips that would influence the outcome of the Dulles piece: one to an island off Georgia and the other to the Anaconda Brass foundry in Connecticut. Remembered images of the erosive effects of the ocean that he had seen at the beach blended with Bertoia's experience in Connecticut, an experience he would never forget. The mill produced ingot and extruded copper. While walking by enormous vats of molten metal, to his host's great embarrassment, an inattentive employee caused three or four tons of molten copper to spill on the floor. Defying his host's attempts to escort him away, Bertoia watched in fascination, thinking, he later said,

that it was "fantastic." The outcome of those two experiences, plus considerable trial and error, was the wall of poured bronze at Dulles International Airport. On September 1, 1962, Bertoia signed a contract with the Federal Aviation Authority for a sculpted bronze wall of nine 4 by 8 foot (1.2 by 2.4 m) panels that would weigh approximately four tons. He was to produce, crate, transport, and install it at Dulles for $16,000 and deliver it in fifty-six days.[9]

Bertoia had begun to experiment, remembering how the molten two-thousand-degree copper had produced forms suggesting how flowing water transforms land. He admired how wind and water sculpt landforms into aerodynamic shapes, and he was drawn to forms in nature that were eroded and corroded. Bertoia began experimenting by pouring molten bronze on a bed of sand behind the shop. It is hard to imagine his anticipation when Edward and James Flanagan first walked out with a big ladle of molten bronze. It was risky, even dangerous, and skilled metal-working was not very relevant experience. After spilling the molten metal, Bertoia would toss in chunks of metal to divert the flow and encourage movement in bronze that would suggest natural phenomena. With experience, he gained reasonable control over the material. He could manipulate the bronze with water from a hose or with long handled rakes. The process, which he called spill casting, was exciting, spontaneous, and risky, as were the results. Over time, Bertoia learned to make highly encrusted surfaces that resemble aerial views of dramatic landscapes. Putting rocks in the metal, he discovered, sometimes caused explosions, leaving interesting negative spaces in the sculptures. Other pieces have an assemblage of sections from one spill casting or possibly more, with fine detail and delicate openings that make them especially intriguing. Whenever Bertoia spoke of using this process, merely remembering it seemed to energize him and enliven his words and gestures.

After achieving interesting forms and textures, Bertoia explored the results of pouring from different directions, observing that specific movement was visible in the resulting bronze. He recorded this in drawings. To display the irregular results, he would mount many spill castings on feet that held them vertical. He explored these ideas in sketches and monotype studies. Bertoia realized that the most difficult challenge would be to make the Dulles mural in panels consistent enough to cohere as one piece. Their cohesiveness would depend not only on the texture and flow of the material, but also on the coloration. So he studied patinas and placed bronzes outside to observe changes in the sculptures' surfaces over time. He decided that the only way to achieve homogenous sections would be to cast them without stopping for meals or sleep. Finally, exhaustion set in. He and the Flanagans, who were operating the furnace that melted the metal, had to cast the last two of nine panels the next day. Rarely completely satisfied with his results, Bertoia continued spill casting after he had completed the wall for Dulles.[10]

The Dulles bronze wall, called *View of Earth from Space*, is overwhelming, not only in its tremendous scale but because of its complex surface. Much as the paintings of Jackson Pollock draw viewers up close in part because they cannot get far enough away to see the entire work at once, viewers of the Dulles mural are drawn close to examine sections and details. This proximity makes experiencing the huge work very physical and intimate. The experience is quite different from that of the Manufacturers Trust screen, which kept viewers at a distance. The Dulles mural was eventually removed and stored while the building underwent renovation, but has been reinstalled in a much more prominent place, where it can be viewed from several angles as well as closely inspected.

While spill casting and preparing for this major commission, Bertoia continued to make monotypes. His desire to place sculpture in the landscape remained powerful, but it was easier to realize late at night on paper than in actuality. Two such monotypes show spill cast works, nearly all readily identifiable. The protrusions from these sculptures generally represent rocks, with the exception of the second piece in both prints.[11]

31 32 P. 206

30 P. 205

29 P. 205

33 34 P. 207

The upper knob appears instead to be bronze referring to or imitating a rock. Bertoia kept the two pieces at the right in both monotypes, and the perhaps fanciful work depicted second from the left in both prints is seen from different sides. The works are carefully spaced and displayed in these graphic representations in a register defined by crisp, fine lines, without the landscape elements included in the 1950s photos and monotypes of sculptures outdoors. The monographs are unusual in that Bertoia clearly executed one before the other and drew a pattern of small irregular circles in ink directly on the first work. In another context these approximated circles might look like flagstones, but here, curving up, they almost seem to float. Because so many of the works depicted in these prints have been documented in photographs, it is certain that Bertoia was revisiting works he had completed, rendering them as accurately from memory as he initially sketched works on bills of sale. The ones from his imagination show what he had not had time or opportunity to create, or sometimes what was not feasible to bring into the third dimension.

P. 187 1 2

In the 1960s Bertoia was using a great diversity of forms, materials, and techniques. He was generally able to create such a range of pieces by working in one manner during shop hours for a number of consecutive days or weeks while turning to another technique or medium working alone at night, a habit he had practiced since he was at Cranbrook. Thus, while making large, new wire constructions and spill casts, Bertoia was also welding bronzes. Still refusing to cast bronze traditionally, he had to invent new ways of using the ancient material. He began utilizing bronze welding rods, which others used only to fill seams when uniting sections of big cast works. Bertoia began working with bronze rods that were one-third the diameter of an ordinary pencil. He sometimes melted a portion of a rod, manipulating small puddles into shapes, but soon he started welding rods lengthwise, side by side, creating surfaces that could bend, twist, endure piercing, and otherwise take on three dimensions. The resulting texture was often corrugated, giving works a linearity that the artist liked. It also directly expressed the process and materials.

P. 208 36

His experiments rapidly gave Bertoia great control over directly welding bronze rods, an inventive new technique. In some delightful small pieces, Bertoia shaped the fine bronze rods into undulating areas relieved by unworked sections of rod, all standing on a bronze base made by the same technique. As practice and experimentation increased his control, Bertoia made more complex works using this process. A rather linear and open piece vividly suggests how he made it: heating a rod with the torch, he could press down, rotating it in a tight circle to make irregular cylinders, then leaving some of the rod exactly as it came from the supplier before making more loops and knots. The result is a direct expression of the materials and the process, but beyond that, each vertical element, rising above its bronze puddle, has its own expressive character.

P. 209 37

Bertoia employed this technique to construct several other nonobjective pieces that seem to reflect human interactions. By organizing small forms as a group on a horizontal, slightly raised base, he returned to a device he had used fifteen years earlier. New materials and techniques encouraged him to create stout, organic forms that fill space and admit interesting intervening volumes of air. By turning the melting bronze rod in circles or loops, Bertoia created heavy but hollow little creatures. They face the empty space between them as if focused on conversation or an invisible element. Such a serious exploration of technique could, in Bertoia's hands, also encompass a reflection of human behavior.

P. 208 35

Bertoia's new technique of welding bronze rods together allowed him to assemble sculptures with a torch and gave him great freedom in construction. He could take sheet bronze and combine it with welded rods, forging them together and piercing forms to assemble unusual shapes. Patination unified them, controlled their surfaces, and related them to nature. Verdigris, the gray-green that bronze acquires over time, is also traditional in sculpture and suggests age.

P. 209 38

Bushes are among the most important and numerous of the welded bronzes. With one, sometimes two, trunks, they branch out repeatedly, expanding their exteriors to become increasingly sculptural. In most cases, the trunks are copper and both the branches and tips are bronze, but pieces exist made entirely of only one of those metals. These sculpted plants hold an audible surprise. When rubbed slightly, they resonate with an almost chantlike hum, vibrating as a result of the metal's resilience. The tone of each piece depends on its metals, form, and placement of parts. Bertoia's sense of proportions was determined in large part by the proportions of living things, as was the ancient Greek notion of the Golden Mean, to which this work conforms.[12] Achieving such consistent curving of the surface and spacing of branches required great care, and each twig ending in a recessed bud is an unanticipated enrichment of the piece.

In 1964 Bertoia received a commission for a sculpture to go inside the entrance to the Woodrow Wilson School of Public and International Affairs at Princeton University in Princeton, New Jersey. He concluded that a globe of some sort was the perfect form for a place devoted to international studies. Whether the irregular form was a result of the process of making it or was intended to reflect an understanding of a world with some places accorded more importance than others is the kind of question Bertoia was willing to leave to viewers.

In this period Bertoia also began making more irregular, globular forms, which were interesting and varied when seen from different angles. They also posed more complex technique challenges and allowed him to be more inventive. An even more irregular globular form was in a private Michigan collection. (Bertoia's reputation has been strong there since he was at Cranbrook, and many pieces are in Michigan collections.)

Bertoia's taste for exploration led him to exaggerate the familiar bush form. He even created a piece that could be an animal, a plant, or simply sculpture, but its undulating surface seems to amble slowly, shifting its weight as it goes, encouraging reading it as a creature of some sort. It is the only bush he seems to have supplied with feet of small, circular hardware that allows for hanging it on a wall. Bertoia enhanced the hints of motion by varying its outer surface, thus altering the density of its interior.

Bertoia was always interested in how light revealed his works. He knew that lighting bushes to capture their shadows and intricate structures benefited the sculptures; for similar reasons, he insisted that his commissions be lit to expose their structure, density, and openness. Bertoia never explained why he decided to braze certain pieces rather than others. It likely struck him to do so as he worked on a piece and looked at it from various angles, thinking a particular surface should be shiny and golden. Over time, however, such brazed surfaces could become dull.

Other welded pieces offer a reminder of the continuity that is characteristic of Bertoia's oeuvre despite all the differences in materials, techniques, scales, and functions that his work encompasses. Fabricated like a bush, such pieces show a logical outgrowth of the wall-mounted multiplane constructions in their treelike forms, but they are smaller in scale, highly detailed, and fully three-dimensional. He also defined small bumps, like buds, along their central stem and at the top. The treelike form goes back to a brooch that Bertoia gave his daughter Celia, a classic example of his Cranbrook jewelry from about 1942. The brooch seems to be not only a precursor to this bush but also a small-scale, flatter predecessor of the form of the wall-mounted multiplane constructions. The small dots and drops that ended lines and wires for decades in his work here (as in a ring and bracelet) are kinetic, explaining why their ends are not aligned. When looked at closely, however, the vertical bush shows a great number of drops of copper and bronze in a very complicated but natural-looking form. The idea of defining surfaces by extending lines from a central core to the exterior of a form seems to have interested Bertoia increasingly as time went by.

For about fifteen years, the artist occasionally made large, complex pieces using the techniques he had developed for bushes. Because of their techniques and patinas, these are generally categorized as bushes, although they are more abstract and do not mimic nature in form. The expanses of complex surface on the exteriors of works of this type ripple almost rhythmically, full of motion. Making such consistent and undulating surfaces from tiny knobs on small branching rods is a technical tour de force. This transformation of meticulous technique into monumental forms suggests life without explicitly imitating nature. From certain angles, many of these pieces expose unusual interior forms, thereby uncovering their structures and disclosing other secrets.

P. 217 48

P. 217 49

Some bushes are much simpler. Having reached a stage between seedling and sapling, with many buds on the branches, they suggest growth, foliage, perhaps even flowering. The modest works of this type have an appealing vitality and honesty.

P. 216 47

While working on bronze fountains over 10 feet (3 m) tall in the mid-1970s, Bertoia constructed a few highly sculptural and relatively large bushes. A fine example of this is a piece approximately 20 inches (50.8 cm) in every direction that Bertoia made in about 1975. The surface of its fluid mass is constantly changing and twisting. The resulting folds not only emphasize motion but also influence the final shape. Using his familiar technique, Bertoia enlarged the tips of small branches by welding small, round knots on them. A stem or seedpod emerges from the core of the piece, small welded adhesions along it. Its surface varies the texture of the outside of the sculpture, for the buds or seeds are pointed. Although the piece appears solid, small shafts of light appear, contradicting that impression. Structurally it is highly complex.

P. 215 46

Bertoia refurbished a barn near his home to hold works he wanted to keep, having outgrown the storage in his shop. Since Cranbrook he had continued to retain works that he thought particularly successful or that suggested ideas he hoped to develop in the future. He was wise and discerning about his works and financially prudent, so he could afford to keep many works, lending some for exhibitions and occasionally parting with a few. He knew that most would be a legacy he could leave his family. The barn was an amazing place when it held hundreds of pieces of sculpture and the crates he had filled with monotypes nearly thirty years before. In one area of the new barn was a big group of welded forms, mostly small bushes, placed close together. Despite their similarities, each is unique.

As patrons contacted Bertoia about commissions, he would often suggest fountains, which he loved and thought suited many sites. When Bertoia was approached about creating a monumental piece to be placed on a plaza in front of the Philadelphia Civic Center's new convention center, he proposed a fountain with organic forms in bronze to complement the rectangularity of the architecture. He wanted shapes reflecting life in imagery abstracted from plants and flowing water. The real problem was transferring his technique of welding aligned small bronze rods to a grand scale, which required a method of supporting the formidable weight of the bronze without detracting from the expressive forms, textures, and patina. Bertoia would resolve this dilemma by welding copper plumbing pipes as a skeleton and welding the bronze around and between the pipes. This solution to his design problem was ingenious. It was structurally strong and preserved the rippled or corrugated effect he wanted. Hollow but strong supports added minimal weight to the sculpture.

P. 219 54

The undulating rhythm of a welded copper piece, thought to be from the late 1950s but perhaps slightly later, was one of Bertoia's earliest efforts that would culminate in the Philadelphia fountain. The distinctive, deep metal waves came to dominate the fountain well before it reached completion. Photographs of Bertoia and James and Edward Flanagan constructing the fountain make the process quite clear. First, they began the skeleton of plumbing pipes, bending and welding them, then welding

P. 218 51–53

bronze around and between the copper tubes. As the piece grew taller, they climbed on stools, then ladders, and finally scaffolding.

Photos of the fountain's installation at the Civic Center clearly reveal its form, its original site, and its size in relation to people. Later images show it with more than twenty jets of water striking it from the rim of its basin, obscuring the sculpture itself. Bertoia wanted the water to flow up from the center, then fall down to the lower curves, finally returning to the pool and recirculating. In preparation for sculpting forms that would achieve the desired effects, he shaped planes and used water from hoses on studies, read, and consulted with experts in the hydraulics of fountains.

Bertoia's fountain was commissioned by the City of Philadelphia in 1967 as part of the city's Percent for Art Program and installed that year. In response to the city's request that he give the piece a title, Bertoia came up with *Free Interpretation of Plant Forms*. For the fountain's unveiling at the Civic Center, Bertoia prepared a statement explaining his expressive aims:

> Conceptually, the initial intent was to produce a work embodying gentleness and strength. To partake of basic qualities, to have an inherent sense of growth, movement, and vitality and to make poetic sense to every walk of life. I endeavor to shun the particular, such as a wave, but to capture the motion of all waves through time, to echo the sound of the first, the viscera of the female, the unfolding blossom and the shadow of the mother's hearth and lapping water, briefly to offer the observer a glimpse of identity with the formative power of an earthly life and the associations from his own experience. Simply stated—to have a fountain that would be great fun and enjoyed by many.[13]

The universality of his aims, both in terms of the work's expression of the force of life in nature and its potential effect on people of every sort, are nearly as powerful in his words as they are in these bronze forms. Having developed his technique for welding massive bronzes, Bertoia was then able to sculpt other fountains of similar size, varying the forms to suit other sculptures' sites and expression appropriate to the situations.

Bertoia remarked that he had always been interested in the long history of funerary and memorial sculpture. When he was invited to compete for the commission for a memorial fountain at Marshall University, in Huntington, West Virginia, he was very interested. He received information about what was desired and the technical specifications, and he began to work on studies. He thought less exuberant forms than those of the Philadelphia fountain would be more appropriate. Bertoia intended the work to balance memory and contemplation with the energy of life and renewal. He had sufficient perspective to realize that in a generation or two, the accident and individuals the fountain memorialized would be history to most who experienced the fountain. That insight and his own beliefs led the artist to make forms that embody a profound and beautiful life force while also memorializing the event that the commission marked.

57 P. 221

Two maquettes are evidence of Bertoia's evolving ideas as the fountain's forms evolved. The earlier maquette is more open, active, and energetic, which suggests Bertoia made it before deciding more restraint would be appropriate. The version that he presented to the Marshall University Foundation as his final working model is more subdued in its movement, more vertical and enclosed. It seems more inward, more contemplative.

55 P. 220

Comparing the fountain itself to the final maquette (the one he presented to the foundation) suggests that Bertoia thought even the second maquette was too open. It is, however, also possible that after having transported other fountains to their destinations, Bertoia wanted to ensure that it did not exceed the weight or clearance of roads, bridges, and tunnels en route. The 13-foot- (4-m-) tall 1972 piece, weighing several tons, was strapped with padding to a flatbed tractor trailer for its journey.

The fountain has been moved twice from its original small, square concrete pool, where it was aligned with the door of the Memorial Student Center. The central design of the building, with its glass doors on both the campus and street sides, made the fountain visible from Fifth Avenue as well as from the center of the campus. Enlarging the plaza and moving the fountain off the building's axis, however, permitted adding seating and planters. The fountain is now an important symbol of the university, and the space around it has become essential to campus life. In its large granite basin, it now appears to float on a copper shelf, which is visually effective but has altered the sound of its cascading water. More removed from pedestrians, it is in a more formal, less intimate setting.

Between executing the Philadelphia Civic Center and Marshall University fountains, Bertoia made a lively, very open fountain for the Manufacturers and Traders Bank in Buffalo, New York, designed by his friend Yamasaki. In 1973 he was awarded the Gold Medal from the American Institute of Architects (AIA) for the Marshall University Memorial Fountain, because of its exemplary relationship between art and architecture. Then in 1974 he created a dramatic form suggesting a partially open flower for the Wichita Redevelopment Authority.

Perhaps the least known of Bertoia's fountains but one of the most successful was made for the National Bank of Boyertown in 1974, a few miles south of his shop in Pennsylvania. The site for the fountain was problematic—a wall of stone veneer only 4 feet (1.2 m) wide on a corner of the building a few feet from the street. There is an extremely high degree of correlation between the study and fountain, for Bertoia had already mastered translating maquettes of fine rods to large-scale welded-bronze-and-copper-tubing sculptures. Standing in its small, rectangular basin, the fountain balanced the door at the opposite side of the facade.

P. 221

56

Bertoia often had lunch in Boyertown and was delighted to create a fountain for his extended community. That it was a rather humble commission was of no consequence to him, as the quality of the result demonstrates. Not only was it admirably suited to its site, but also it was a rare example where water, circulating from a pool only about 6 inches (15.2 cm) deep, was kept at the volume that Bertoia preferred. His fountains were often flowing full force, sending water cascading down the exteriors of sculptures, splashing noisily, and veiling the sculpted forms. Bertoia wanted the water within each fountain's cavity to fall to carefully sculpted areas to slow its descent and let it go gently and musically into its pool. The bank was renamed in 1993 and moved in 2006, without the fountain. The fountain was donated to Pennsylvania's Reading Area Community College in 2005, where it was installed outdoors.

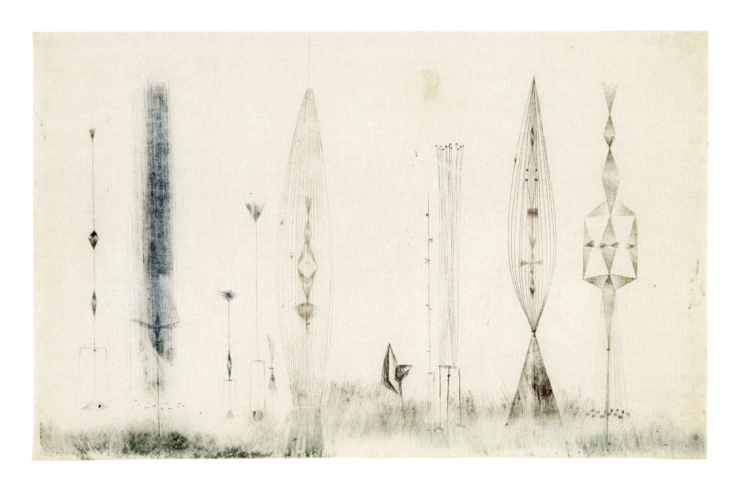

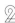

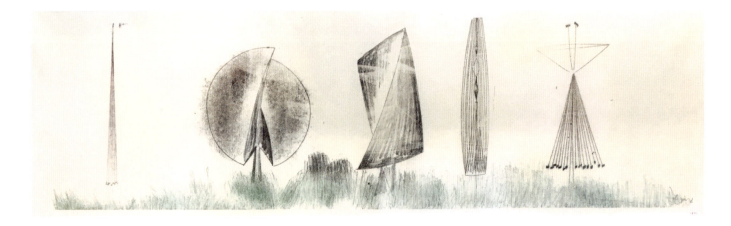

1 *Untitled* (monotype), c. 1960. Printer's ink on rice paper. 24 x 38¾ in. (61 x 98.4 cm).
2 *Untitled* (monotype), c. 1960. Printer's ink on rice paper. 15½ x 39 in. (39.4 x 99.1 cm).

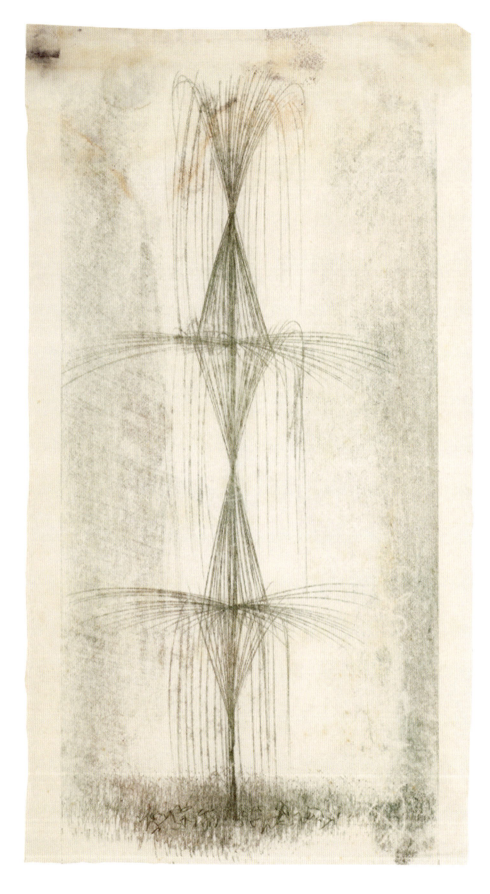

3

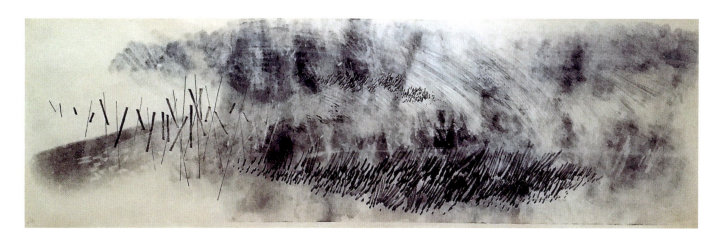

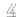

3 *Untitled* (monotype—study for the Standard Oil Commission), c. 1973. Printer's ink on rice paper.
 24 x 13 in. (61 x 33 cm).
4 *Untitled* (monotype), c. 1960. Printer's ink on rice paper. 11½ x 38½ in. (29.2 x 97.8 cm).
5 *Untitled* (monotype), c. 1965. Printer's ink on rice paper. 11⅜ x 38¼ in. (28.7 x 97.3 cm).

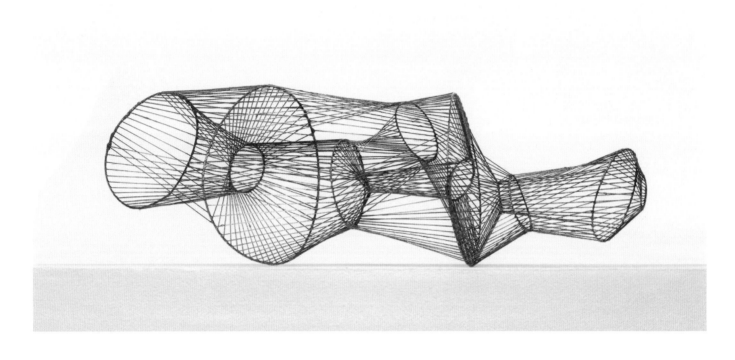

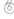

6 *Untitled* (wire form), c. 1955. Melt-coated brass over steel. 12½ x 29 x 9 in. (31.8 x 73.7 x 22.9 cm).
7 *Untitled* (balancing kinetic form), c. 1950. Silver, stainless steel, granite, and silver solder.
 79¾ x 11½ in. (202.6 x 29.2 cm).

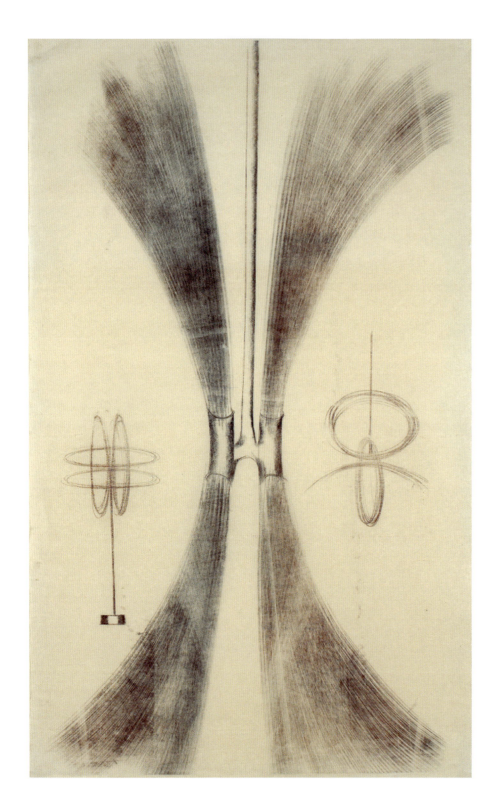

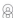

8 *Untitled* (monotype), c. 1961. Ink on rice paper. 39 x 24 in. (99.1 x 61 cm).
9 *Untitled* (wire bundle or pod), 1967. Stainless-steel wire, bronze, silver solder. 30½ x 5½ in. (77.5 x 14 cm).
10 *Untitled* (monumental spray), c. 1961. Beryllium copper and granite. 63 x 40 in. (160 x 101.6 cm).

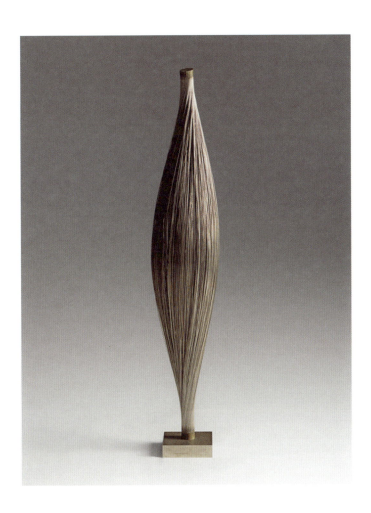

9

10

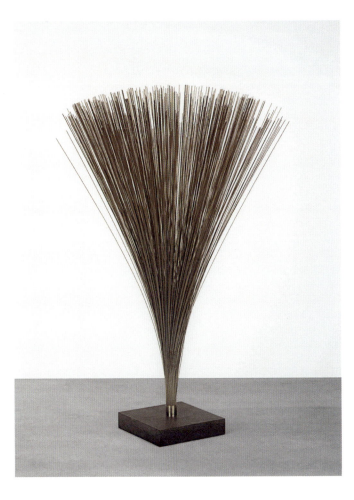

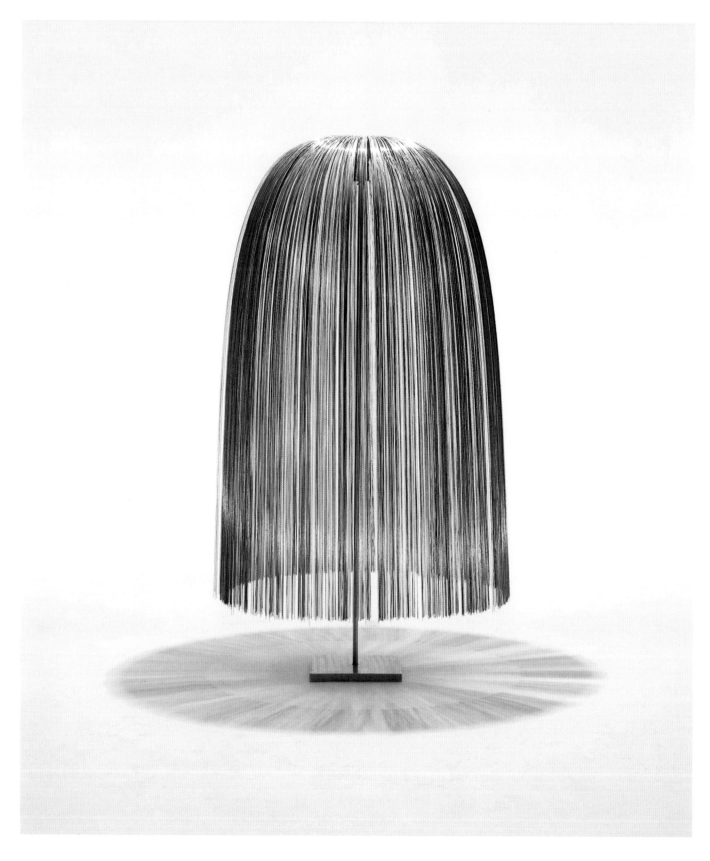

111

11 *Untitled* (willow), c. 1970. Stainless steel and steel wire. 69 x 39 in. (175.2 x 99 cm).
12 *Untitled* (bundled wire form), c. 1968. Steel, wire, bronze, and silver solder. 60½ x 16 in.
 (153.7 x 40.6 cm).
13 *Untitled* (bunded wire form), c. 1965. Stainless-steel wire, concrete. 12 x 4 in. (30.5 x 10.2 cm).

NEW FORMS, NEW TECHNIQUES 1960–78

12

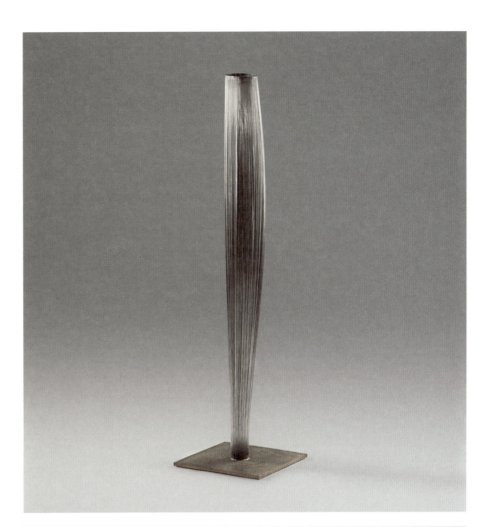

13

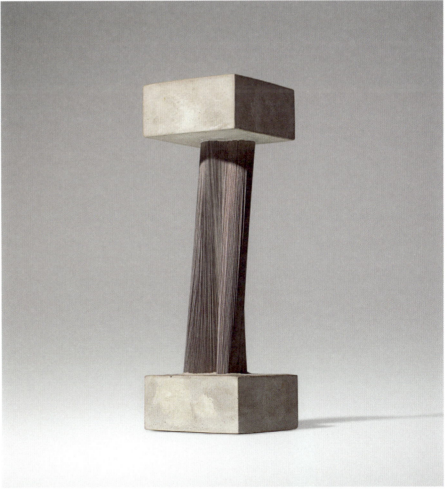

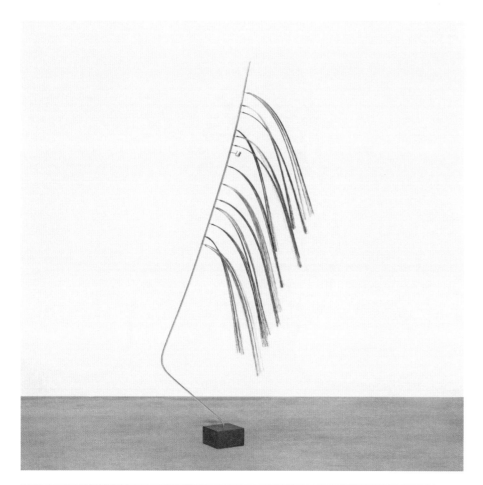

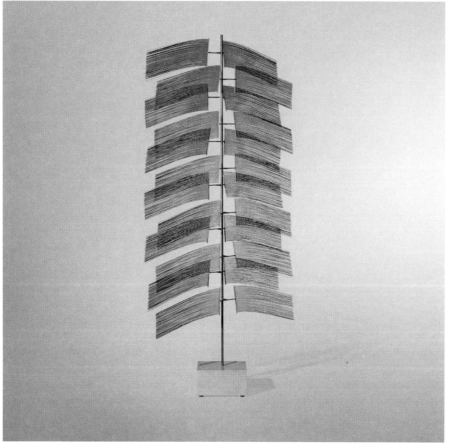

14 *Untitled* (pine, wire form), c. 1963. Stainless-steel wire, slate. 86 x 26 x 35 in. (218.4 x 66 x 88.9 cm).
15 *Untitled* (wire form), c. 1963. Stainless steel, steel wire, aluminum. 82 x 40 x 9¾ in. (208.3 x 101.6 x 24.8 cm).
16 *Syracuse Nova*, 1961. Welded bronze and steel, 117 x 66 x 36 in. (297.2 x 167.6 x 91.4 cm). Courtesy of
 the Syracuse University Art Collection.
17 *Straw*, c. 1961. Melt-coated steel. 18 x 20 x 6 in. (45.7 x 50.8 x 15.2 cm).

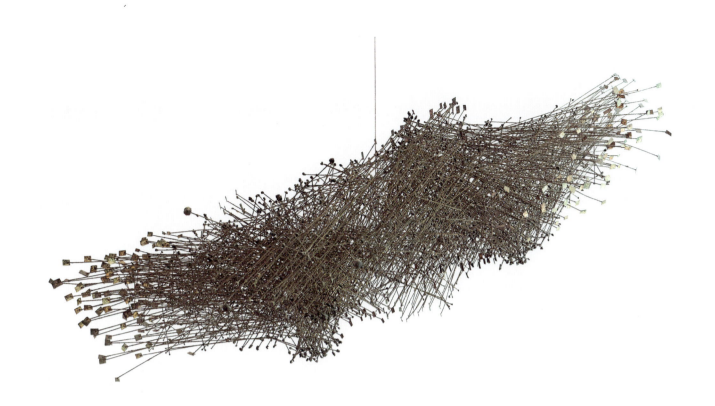

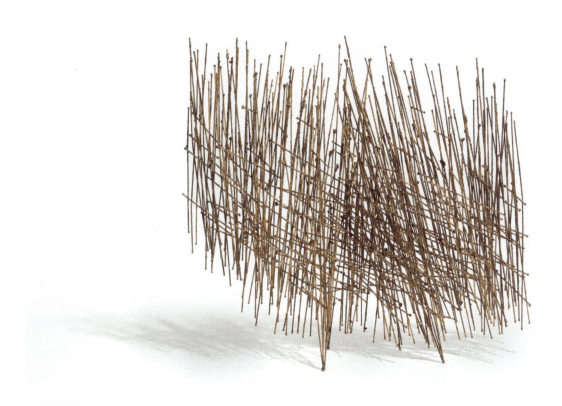

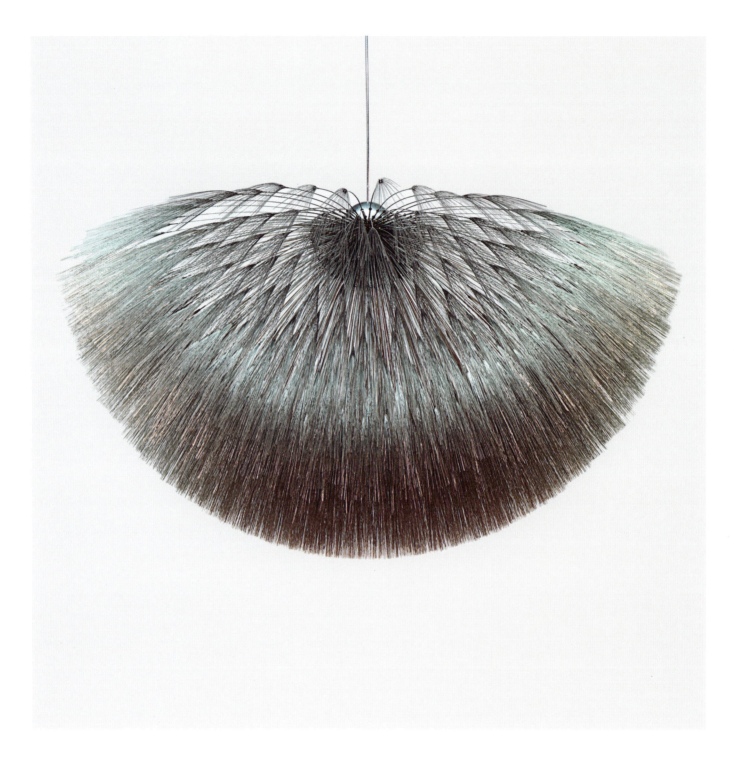

18

18 *Untitled* (wire construction for the Cuyahoga Savings Association building, Cleveland, Ohio), 1965.
 Stainless steel and steel wire. 126 x 138 in. (320 x 350.5 cm).
19 Alternate view, *Untitled* (wire construction for the Cuyahoga Savings Association building,
 Cleveland, Ohio), 1965. Stainless steel and steel wire. 126 x 138 in. (320 x 350.5 cm).

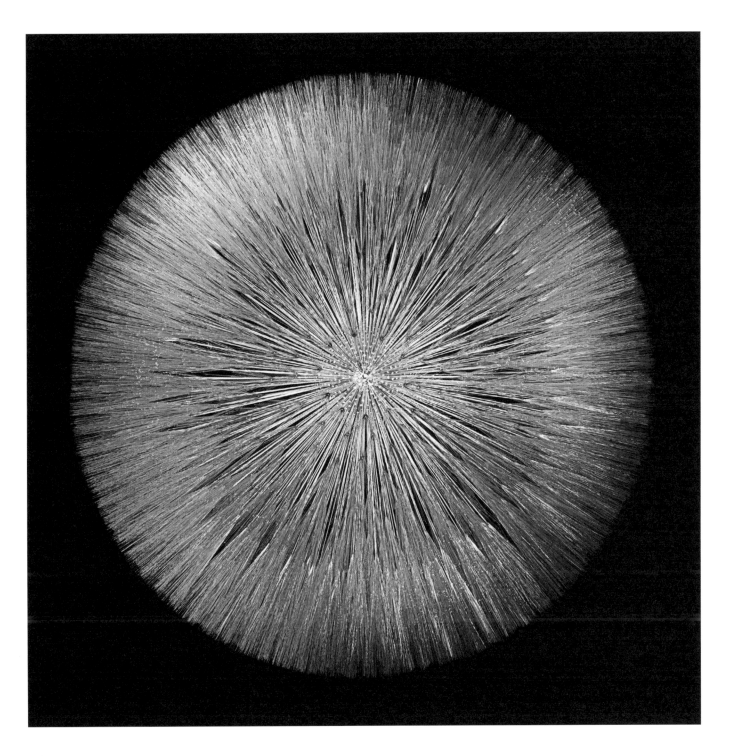

119

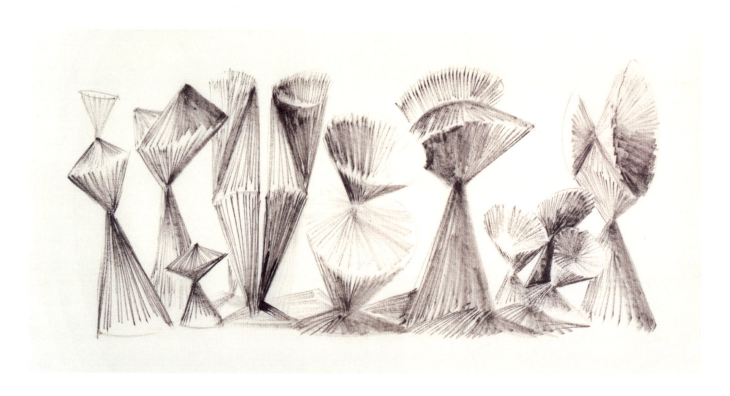

20

20 *Untitled*, c. 1965. Felt-tip pen on paper. 17⅝ x 22½ in. (44.7 x 57.2 cm).
21 *Untitled* (bush form), c. 1960. Welded copper and bronze with applied patina. 9¾ x 9½ x 9½ in. (24.8 x 24.1 x 24.1 cm).
22 *Untitled* or *Firey Circle*, late 1950s. Welded copper and bronze with patina. 68 x 58 x 17 in. (172.7 x 147.3 x 43.2 cm).
23 *Untitled* (bush form), c. 1960. Welded copper and bronze with applied patina. 6 x 8½ x 9 in. (15.2 x 21.6 x 22.9 cm).

21

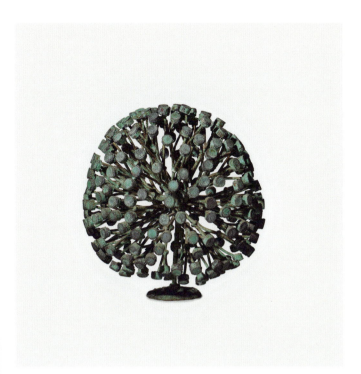

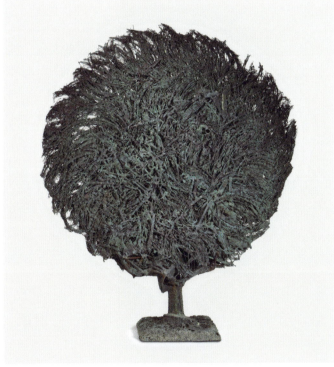

22

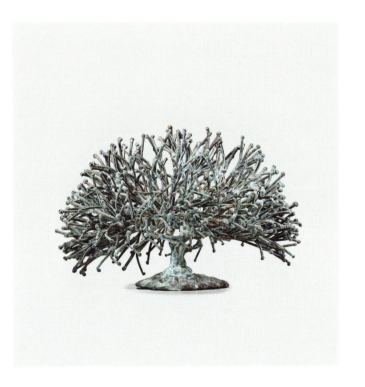

23

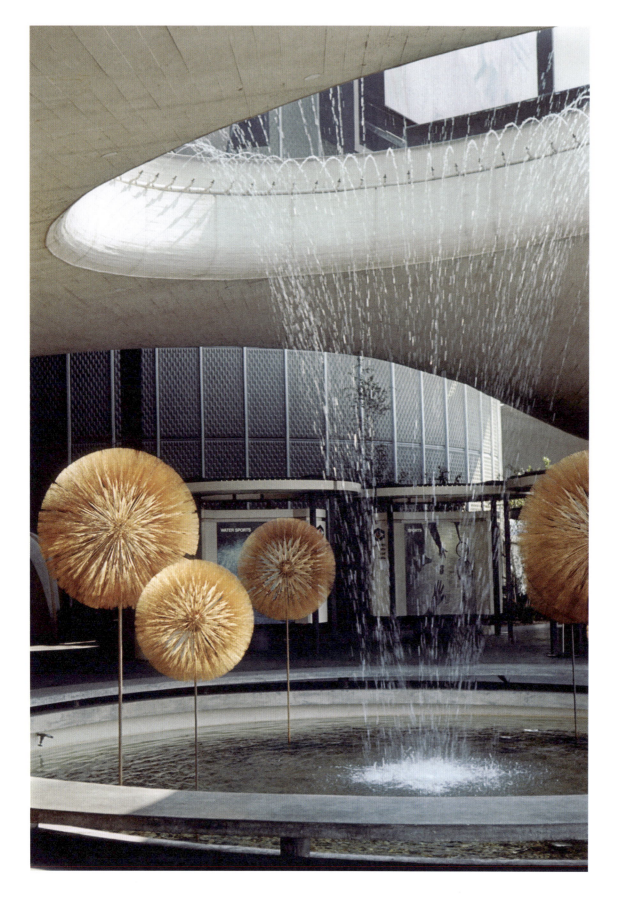

24 Six dandelion sculptures at the basin and fountain, Eastman Kodak Pavilion, New York World's Fair, 1964.
25 *Untitled* (dandelion), c. 1963–64. Welded bronze, steel, and granite. 81 x 32 in. (205.7 x 81.3 cm).
26 *Untitled* (dandelion), 1964. Gilt stainless steel, brass, and slate. 86 x 41 in. (218.4 x 104.1 cm).

25

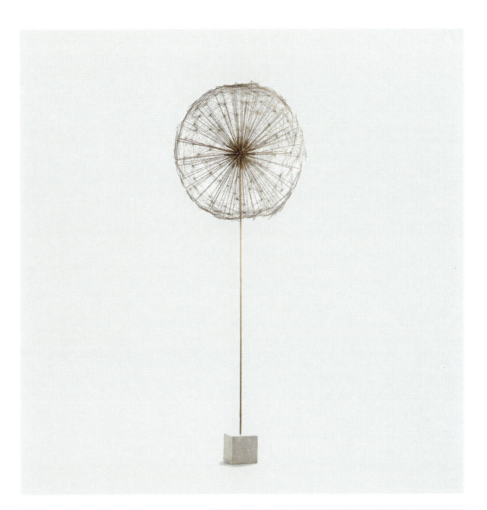

26

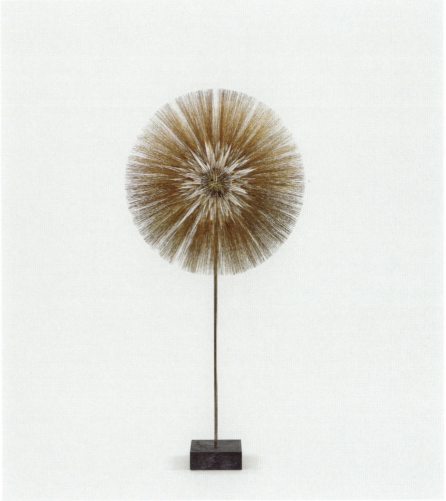

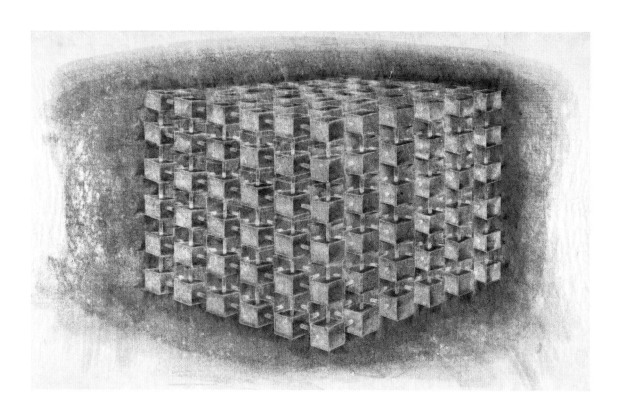

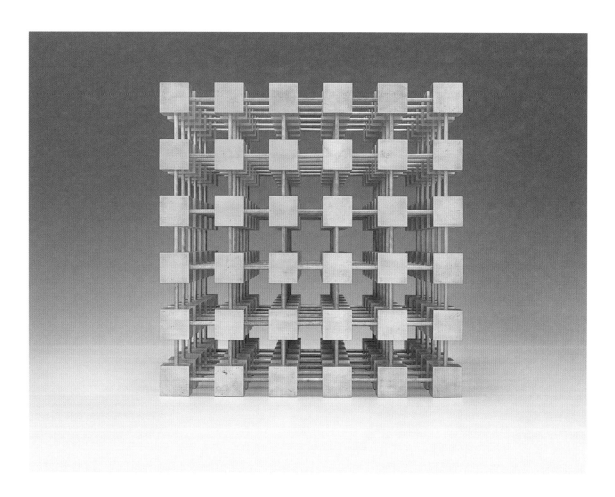

27 Preliminary sketch for *Cube*, 1962. Printer's ink on Japan paper. 24 x 39 in. (61 x 99.1 cm).
28 *Cube*, 1962. Aluminum. 18¼ x 18¼ x 18¼ in. (46.4 x 46.4 x 46.4 cm).
29 *View of Earth from Space* (mural, nine sections), 1963. Spill cast bronze. 8 ft. x 36 ft. x 4 in.
 (2.4 m x 11 m x 10.2 cm).
30 *Untitled* (study for spill casting). Monotype in ink on Japan paper. 17⅝ x 22⅜ in. (44.7 x 56.9 cm)
 Numbered in pencil on the back "3379," with a small blue ink drawing of a sculpture.

NEW FORMS, NEW TECHNIQUES 1960–78

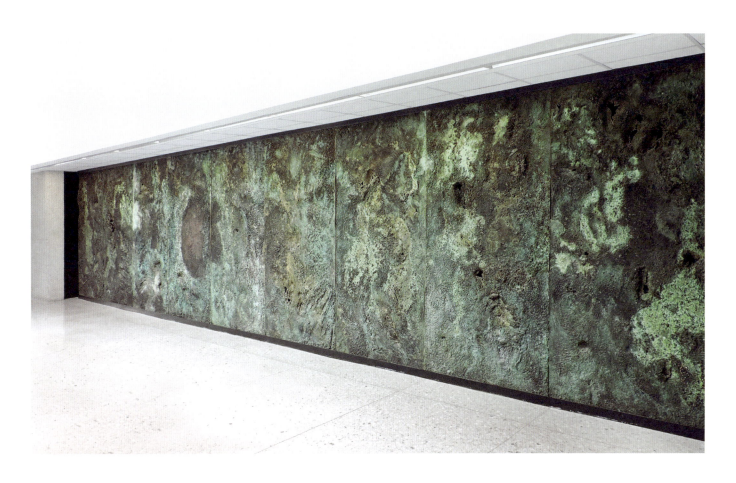

29

30

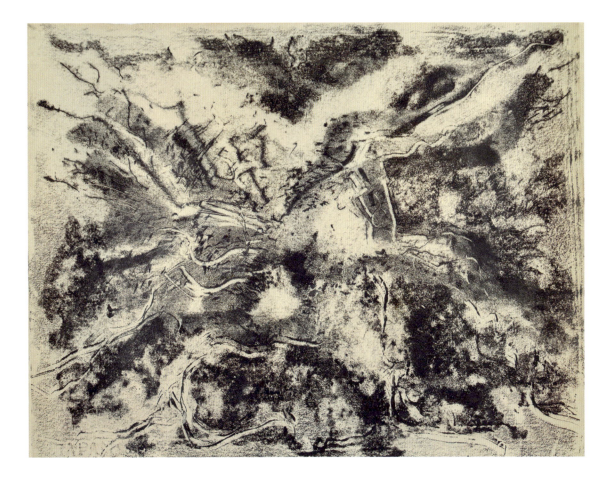

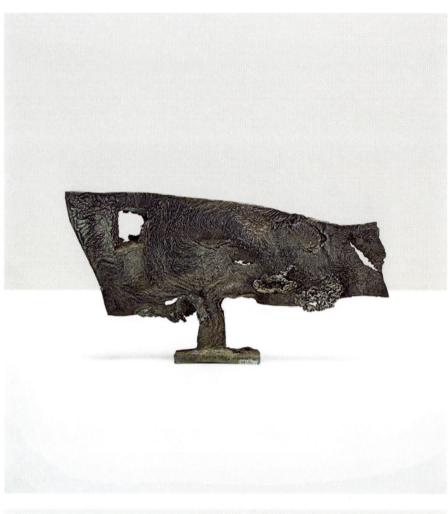

33

34

31 *Untitled* (spill cast), c. 1963–65. Bronze with applied patina. 25 x 50 x 7 in. (63.5 x 127 x 17.8 cm).
32 *Untitled* (spill cast), c. 1965. Bronze with applied patina. 22¾ x 66¾ x 6¾ in. (57.8 x 169.5 x 17.1 cm).
33 *Untitled* (monotype), c. 1963. Printer's ink on rice paper. 13 x 23½ in. (33 x 59.7 cm).
34 *Untitled* (monotype), c. 1963. Printer's ink on rice paper. 13 x 23½ in. (33 x 59.7 cm).

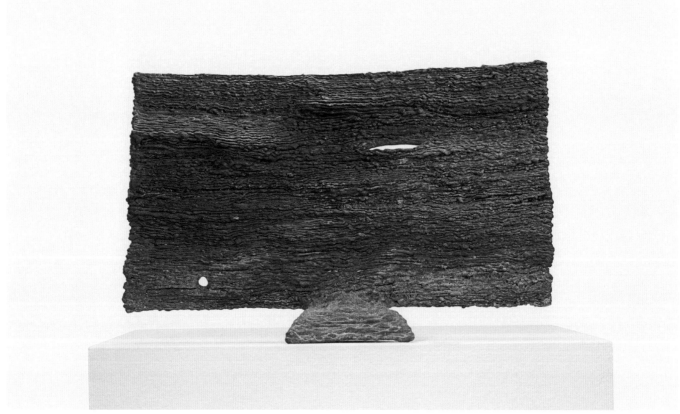

35 *Untitled* (directly formed bronze), c. 1965. Bronze with applied patina. 6 x 13¼ x 7¾ in. (15.2 x 33.7 x 19.7 cm).
36 *Untitled* (welded form), early 1960s. Welded bronze with applied patina. 8½ x 13¾ x 3½ in. (21.6 x 34.9 x 8.9 cm).
37 *Untitled* (welded form), c. 1960. Welded copper and bronze with applied patina. 11½ x 12 x 7 in. (29.2 x 30.5 x 17.8 cm).
38 *Untitled* (directly formed bronze), c. 1965. Welded bronze with applied patina. 6¾ x 5¼ x 2 in. (17.1 x 13.3 x 5.1 cm).

35

37

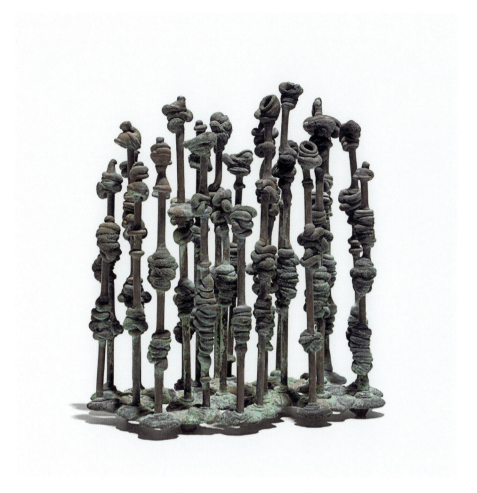

36

38

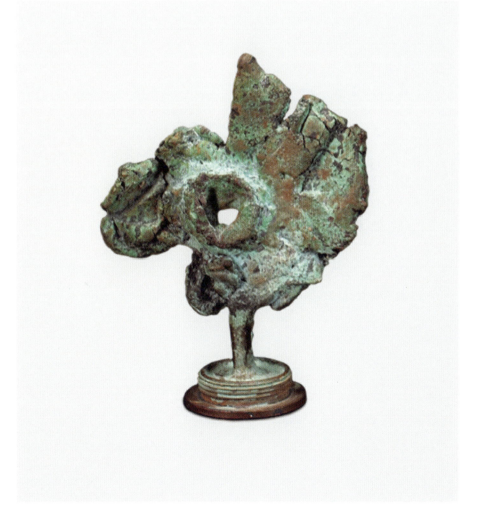

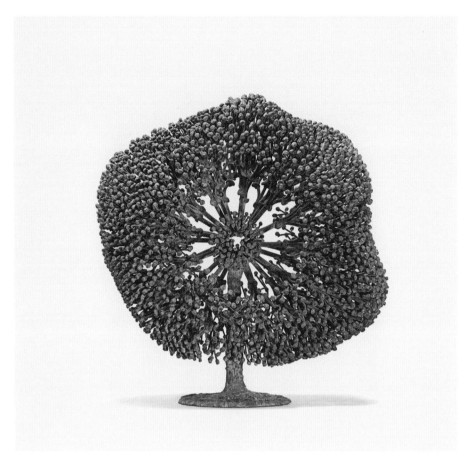

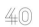

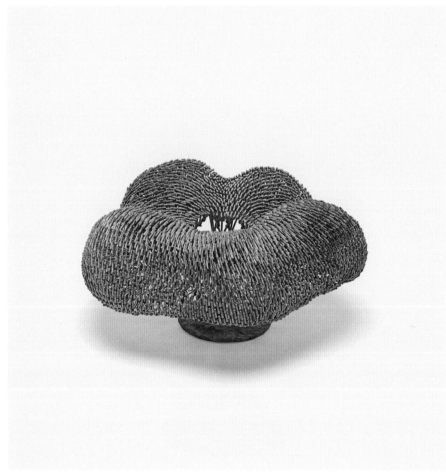

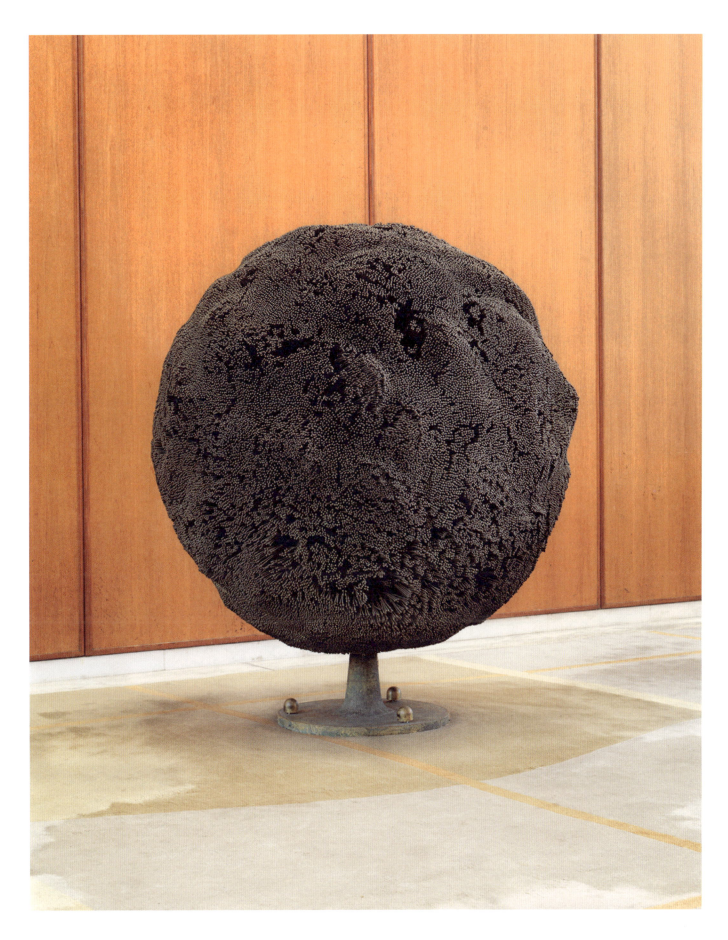

41

39 *Untitled* (bush form), c. 1970. Welded copper and bronze with applied patina. 16½ x 16½ in.
 (41.9 x 41.9 cm).
40 *Untitled* (bush form), c. 1977. Welded copper and bronze with applied patina. 12½ x 24 in. (31.6 x 61 cm).
41 *The World*, 1964. Bronze. 54 in. (137.2 cm) in diameter.

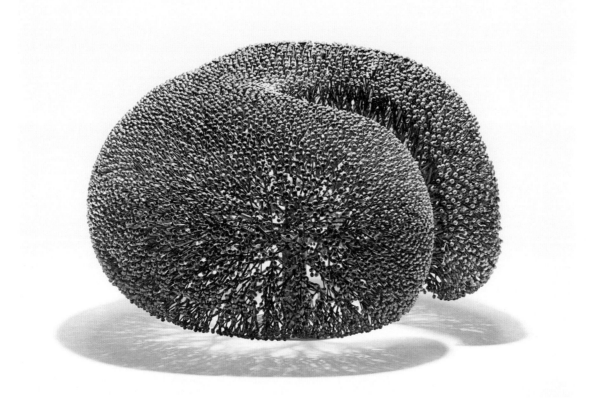

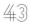

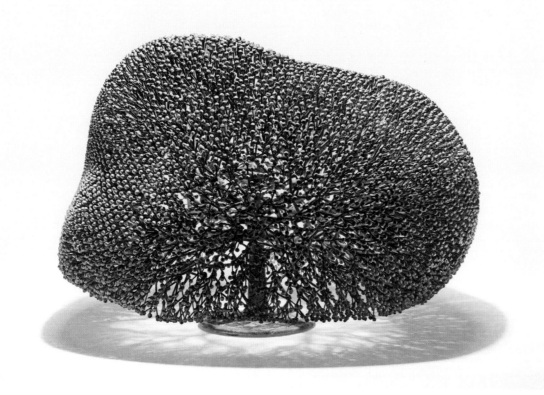

42 *Untitled* (bush form), c. 1970. Welded bronze and copper. 18 x 24 x 24 in. (45.7 x 61 x 61 cm).
43 Alternate view, *Untitled* (bush form), c. 1970. Welded bronze and copper. 18 x 24 x 24 in. (45.7 x 61 x 61 cm).
44 *Untitled* (bush form), c. 1968–72. Welded bronze. 7 x 22 x 9 in. (17.8 x 55.9 x 22.9 cm).

NEW FORMS, NEW TECHNIQUES 1960–78

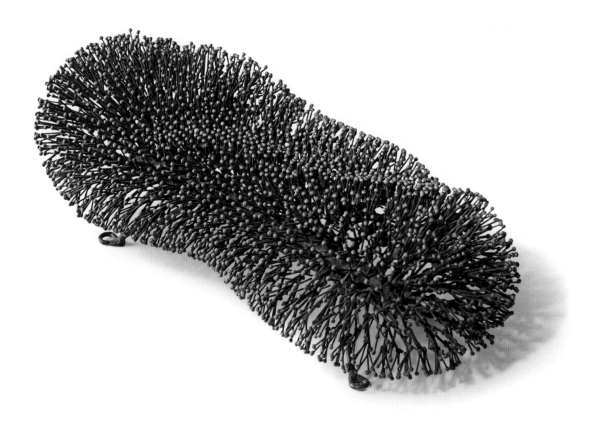

44

45

45 *Untitled* (welded form), c. 1960. Welded copper and bronze with applied patina. 28¼ x 6 x 5 in.
 (71.8 x 15.2 x 12.7 cm).
46 *Untitled* (welded form), c. 1976. Welded bronze. 20½ x 20 x 21½ in. (52.1 x 50.8 x 54.6 cm).

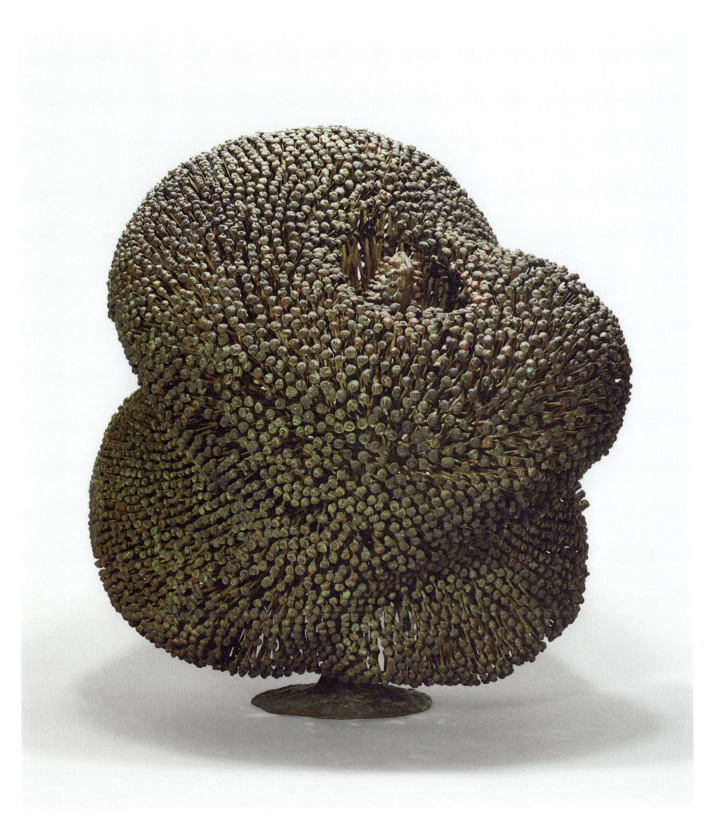

46

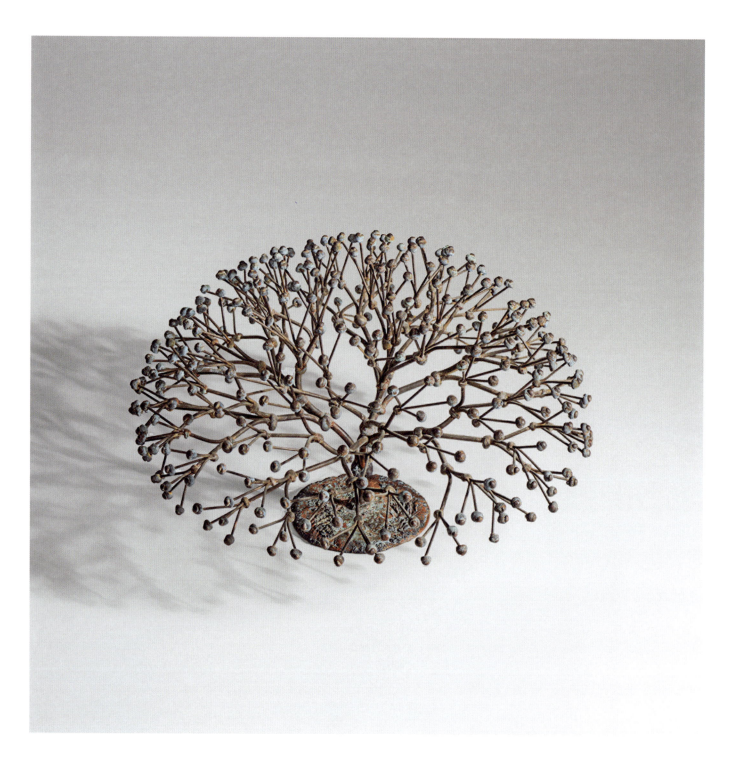

47

47 *Untitled* (bush form), c. 1970. Welded copper and bronze with applied patina. 6½ x 11¾ in. (16.5 x 29.8 cm).
48 *Untitled* (monumental bush form), c. 1962. Welded copper and bronze with applied patina. 42 x 25 x 22 in. (106.7 x 63.5 x 55.9 cm).
49 Detail, *Untitled* (monumental bush form), c. 1962. Welded copper and bronze with applied patina. 42 x 25 x 22 in. (106.7 x 63.5 x 55.9 cm).

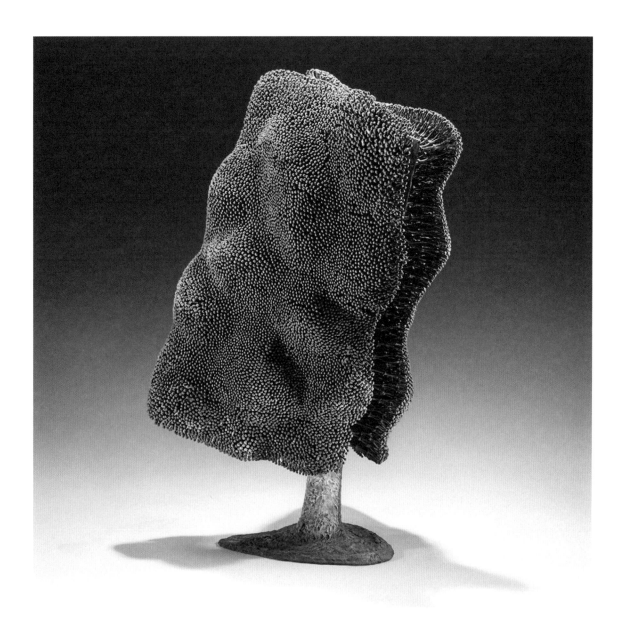

48

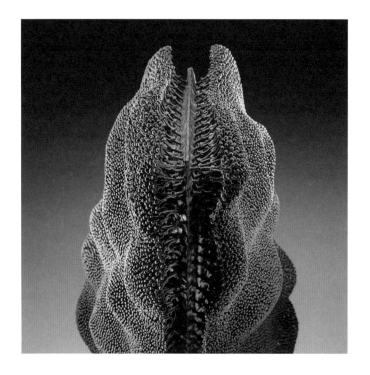

49

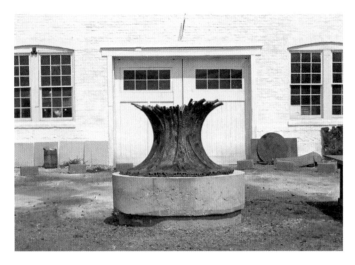

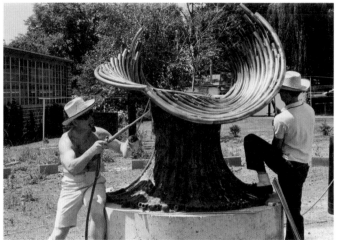

50

51

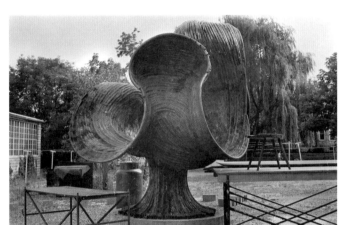

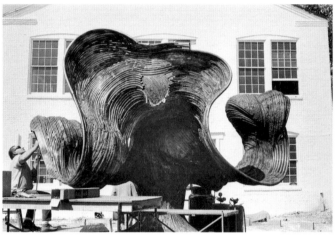

52

53

50 The Philadelphia Civic Center fountain has begun, with the first copper tubes in place and bronze
 welded around them, 1967. The eventual diameter is marked on the ground, and under the window
 at right is a spill cast piece.
51 Harry Bertoia and one of the Flanagan brothers weld copper tube to the lower portion of the
 Philadelphia Civic Center fountain but have yet to weld bronze to the upper section, 1967.
52 The Philadelphia Civic Center fountain sufficiently developed to require use of scaffolding, 1967.
53 The final form of the Philadelphia Civic Center fountain is quite apparent. 1967.
54 *Untitled* c. 1958. Welded copper. 12 x 10 in. (30.5 x 25.4 cm).

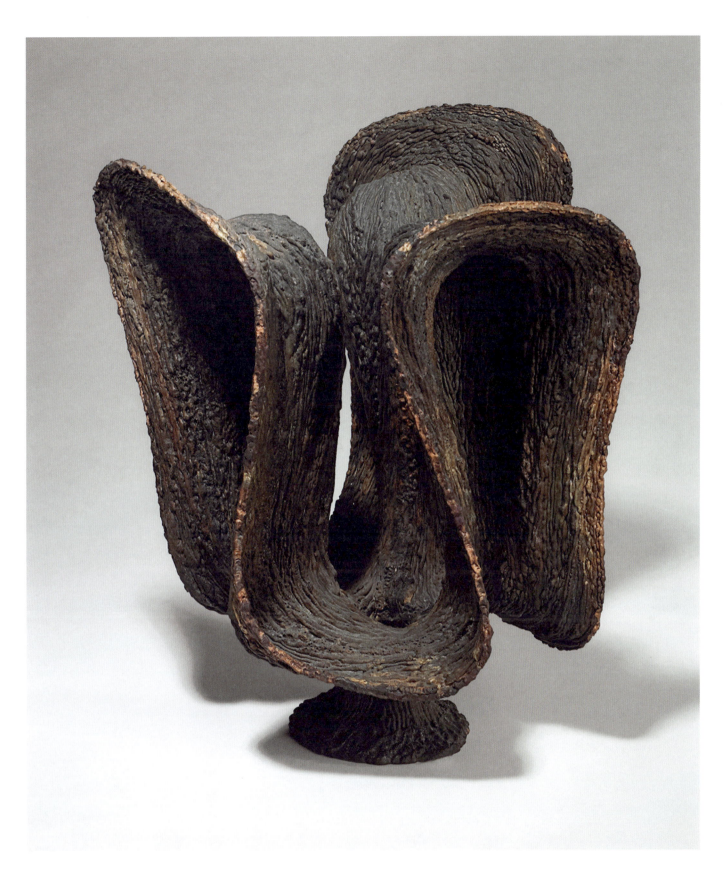

54

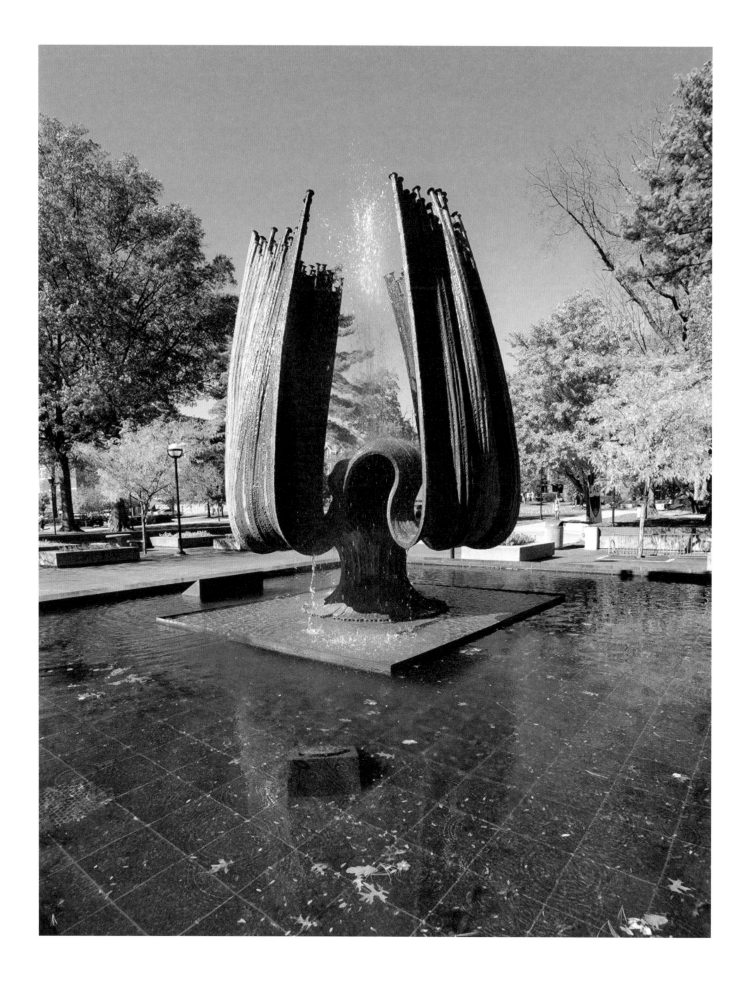

55 Marshall University Memorial Fountain, 1972. Welded bronze and copper, with applied patina. 13 ft. (4 m) high.
56 National Bank of Boyertown Fountain, Pennsylvania, 1974. Welded bronze, copper tubes. 96 x 102 x 36 in. (243.8 x 259.1 x 91.4 cm).
57 *Untitled* (welded form), working model, Marshall University Memorial Fountain. Welded bronze with applied patina. 11½ x 11 x 11 in. (29.2 x 27.9 x 27.9 cm).

55

56

57

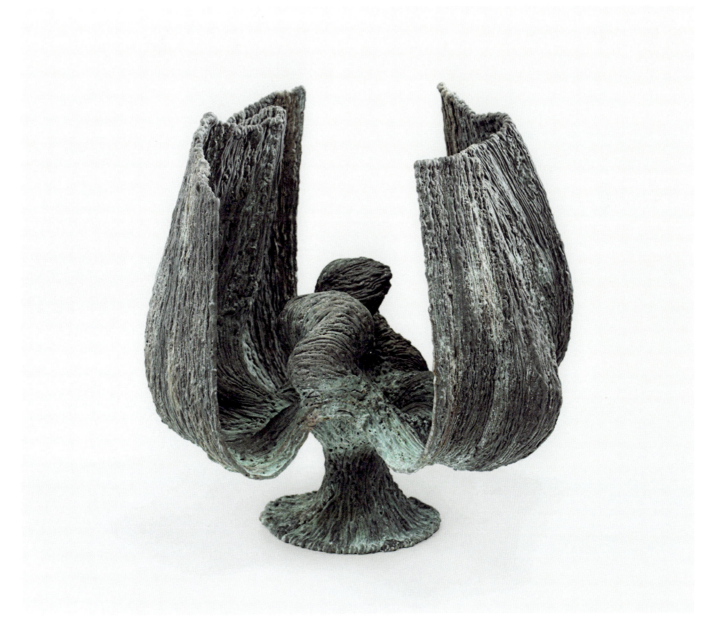

... even though they are invented sounds still the idea is to see how close I can get to what appears to me another reality or a reality which has not yet come within my senses.
—Harry Bertoia

Harry Bertoia said that one day he bent a wire, and it made a sound. He had clamped a wire to bend it and heard a sound that stayed with him. He associated that event with assembling his son Val's first bicycle late one Christmas Eve, so he believed that it had been in 1959. That experience made him think, "Well, if one wire produces such a sound, what would two rods produce, or what would ten or a hundred? And this placed the whole thing on a little more systematic way of investigating so that there was a period of experimentation." He always tried various alloys and lengths of rods. "And this introduce[d] me to the potential that was there and actually evolving sounds that probably were not ... heard before, at least not in that way."[1]

Bertoia's time was soon occupied with major commissions for screens and then the Dulles commission, so most of a decade would elapse before he could explore the germ of an idea that the sounds had stimulated. Only then could he begin seriously investigating the idea of acoustical sculptures. It was not an entirely new concept for him, because he had made jewelry that rattled and tinkled with motion and bushes that chanted discretely. For each piece, at least early in the process, the artist would have to decide on the particular balance between visual concerns and sound production. Thereafter, experience usually guided him.[2]

Bertoia's focus now was on the acoustical sculptures he would consider the culmination of his career. He used multiple terms to refer to these works, and others have added their own, so the terminology is inconsistent. Two main types of his sculptures were designed largely for their possible sounds: "tonals," or "sounding pieces," and gongs. The largest number are tonals, sculptures composed of multiple wires or rods that resonate in motion. They also include a small group of variations on sounding pieces he called "singing bars," sections of beryllium copper rods hung overhead. They strike each other, ringing out, when set in motion.

Gongs comprise Bertoia's other acoustical pieces. Though more familiar, they are not traditional sculpture. Some were made from one piece of sheet metal carefully shaped to produce particular sounds. They range widely in shape, generally having both organic and geometric characteristics. Other gongs consist of two sheets of hammered metal welded around their edges with an air space between. Some gongs not only sound when struck with mallets or hands but also when fingers move with pressure on their surfaces. Bertoia's large, muscular hands could produce eerie noises. He would pound repeatedly on a large two-sheet gong, and after the sound had maximized, he would sometimes remark that it sounded as if it had come from "the bowels of the earth." The loud, low noises created sound waves that made your body vibrate—a truly visceral experience.

The earliest works Bertoia made to create sounds were intricate wire constructions. First, he had to discover the properties of various alloys, especially their flexibility, resilience, and sounds, all of which varied with the length and gauge of the wires. After he had learned from working with wires, he would move on to studying rods, extrusions that are larger in girth, and then the larger pieces could evolve.

Beyond exploring the nature of the wires, it was essential to invent a structure to support them. While that support would be a significant determinant of form, it would also have some influence on the sound. Bertoia's brother Oreste, with his passion for music, was naturally very interested, and the brothers talked at length about Harry's experiments. Oreste would visit during many summers, and Harry at times went to Detroit, taking or shipping pieces to Oreste, who applied his musical instincts to discussions about the pieces' sounds.

The design problems that needed to be solved were essentially ones of materials and form. Structure depended on the nature of the materials and the intended scale of each piece. Bertoia always maintained that if a sounding piece looked right, it sounded right, and vice versa. That intuitive understanding is consistent with principles of physics, for acoustics and visual proportions are rooted in mathematical relationships. Beyond that, Bertoia had to struggle with balancing visual concerns with those related to producing sound. At times he must have had to compromise either the visual or acoustic properties of a work.

The technical development of the tonal works reflects problem-solving as Bertoia would experiment, see possibilities, recognize inefficiency, and streamline his process. He repeatedly chose methods that were very direct but allowed for making choices and the opportunity to develop and elaborate ideas. Each step in the evolution of the sounding pieces introduced new possibilities. One very early piece, created before 1965, is a rare example in which Bertoia welded wires into a mesh for the support. He had been soldering or welding meshes since Cranbrook, and he used mesh as the support on which the vertical wires would resonate. The patinated copper piece is constructed on a rectangular mesh with short wires welded to it; each short wire then served to support longer wires that were welded at an angle, leaving slightly knobby joints that Bertoia echoed in drops of copper at the tips of the wires. He raised all of this on a stand using thicker wire and a circle of molten copper. The wires differ slightly in length, which became a consistent feature of the sounding pieces early in their development and always remained important to their tonal production. The total height of this piece is slightly over 1 foot (30 cm), making it at least twice as tall as the smallest of the early sounding pieces.

2 P. 238

The angle of this piece and its size encourage fingering it, even plucking or picking individual wires as if it were a stringed instrument. It calls to mind the mbira, known in some places as the *marímbula* or thumb piano, an African instrument that emigrated to the New World. That instrument has both intimate scale and metal acoustic elements in common with Bertoia's diminutive, early sounding pieces.

Soon Bertoia began using phosphor bronze, a tough, hard form of bronze containing a small amount of phosphorus. He used phosphor bronze wires for tonal sculptures because they were strong, and reasonably resilient and pliable, and they made an unusual sound. It may have been their weight that led him to devise a different platform for the wires, resulting in *Wheatfield* in about 1960. Approximately 3 feet (90 cm) in height and width, it is one of the earliest of the larger tonal works. To hold the wires, Bertoia welded an organic network of bronze rods that make small curves, forming oval spaces or cells. Welding vertical wires to this network approximately midway between intersections in the base, Bertoia created a sounding sculpture. Standing on small feet, the network of cells in the base supports the vertical elements, visually lightening it and allowing the sound some space. But that gauge of the metal is rather stiff, which limits both its sound and motion.

3 P. 239

Bertoia was quoted in *Time* magazine reminiscing about walking home by "wheatfields swaying in the breeze and [I] can hear the rustling." This Pennsylvania memory would have been regenerated late every summer, and its combination of sight and sound was important for him. He went on to explain that "sculpture comes alive when the sculptor works with the same basic things that please us in nature—color, light, motion and sound."[3] Bertoia's statement is a very perceptive observation that makes the connection between art and life in a unique way. Art was not simply the imitation of life but relied instead on abstracting the essence of a particular experience and transforming it into a valuable principle. As so often was the case, his observation was honest and direct.[4]

By the mid-1960s Bertoia was experimenting with sounding pieces of fine phosphor bronze wires. His intention was to create both motion and sound that would only suggest but not imitate nature. He spaced wires closely and

precisely, aligning them in perfect grids or staggered rows. For example, rows of nineteen wires placed between rows of twenty not only altered the visible density of the work but also created slightly different sounds. Bertoia varied formats as well, often grouping the wires in a square on the base, sometimes arranging them in two distinct rectangles or even in four small squares. Each arrangement would create nuanced changes in form, motion, and sound.

The artist made other important refinements. To create a richer sound, he slightly altered the lengths of the wires, as he would do later with rods. Therefore, rather than creating one sound, a group of verticals produces multiple, slightly different but closely related sounds. Sometimes particular sounds are distinguishable, like a voice that stands out in a choir because of its character, its timbre, rather than its volume. Pieces sound different from several feet away than when you are next to them, so in order to hear a sculpture from across the room, Bertoia might throw ping-pong balls at it, then "tune" it by slightly trimming the tips of wires with clippers. The resulting pitch might approximate one pitch in the Western diatonic scale but was intended never to produce it exactly. The unpredictable complexity of sound created the effect of an aural cloud that envelops the listener and the space before gradually dying out. Sometimes the sound comes in waves, swelling and then ebbing.

P. 241 5

Bertoia replaced meticulous handmade mesh with brass bases, usually a sheet about one-quarter of an inch (6 mm) thick. This was efficient, not only because it avoided the intense work of welding mesh or a cellular support like that of *Wheatfield*, but also because it was simpler to make a tonal piece by beginning with a true horizontal. Bertoia welded each fine wire individually to the base in a predetermined pattern, using a template to help keep the wires perfectly vertical. A small amount of metal rising slightly up the wire from the base is evidence of his process, which he applied to fine wires. Sometimes pieces also received small feet, lifting them to a height equal to the thickness of the brass plate.

P. 241 6

Some tonal sculptures had fine, mobile wires with caps that are slightly larger in gauge than the wires supporting them. While an elaboration of pieces without caps, these sculptures could also be an abstraction of plants with inflorescences or seeds. In motion, they rustle softly and pleasingly, recalling tall grasses but still sounding metallic. The tall proportions and the close spacing of the wires give them considerable density. The motion and sound are greatly influenced by the thicker wire caps with their enlarged tips, as well as the increased girth resulting from the weld joining the caps and wires. This example has familiar, small metal drops at the ends of the wires, finishing them neatly and echoing the form of the intentionally enlarged weld just over 1 inch (2.5 cm) below. Bertoia made several such works that, while abstracted, are among his sculptures that most closely represent nature. The combination of the metal's resilience with weight at its tips enhances its motion. The thicker part of the caps limits striking to their widest points, despite the proximity of the wires This creates their delicate and tranquil sound.

P. 243 10

Most of Bertoia's mature tonal pieces had beryllium copper rods on a brass plate base. Slender in form, they have broader and taller weights at the top than those of earlier examples. The tall, supporting rods and their caps both vary in height, producing rich and nuanced tones that are deeper than those of the early wire pieces. Beryllium copper has a bright sound and is supple, moving easily and responsively, producing lively pieces. Bertoia liked this alloy and used it extensively.

He explained some relationships between shape and sound:

> You see the purpose here [taking the top of a big rod in his hand] is that it doesn't matter what shape this is—you can take the same amount of weight in a lump like a fist, and it will do the same thing. If it were a square, it would not be as satisfactory, because in some

positions squares would lock. So the limitations, if you recognize the limitations, may or may not restrict you. You realize the roundness is important for fluidity.

If the two touch for the full length, the sound is not as clear, but if they touch at one point, the sound is better. So a great deal of precision is involved in the placing, since they undergo so much handling. For some reason, it's the practical aspects that determine the shape. Perhaps it's a limitation, perhaps not. There are many, many, many things that have not yet been tried. There's so much to do. I have not yet tried hollow forms, and that would probably give it another meaning.[5]

About 1970, Bertoia began using a drill press, which allowed him to make tonal sculptures with rods as their uprights more efficiently. The machine could make concave indentations in the brass plate base in exactly the configuration he desired. This provided easier and extremely neat welding of the rods. Bertoia welded sitting on a backless chair that his friend George Nakashima had made expressly for this purpose. It was exactly the right height for Bertoia to sit while he delicately welded sculpture. As a result of the large windows providing the natural light so beneficial to working, Bertoia's shop tended often to be hot or chilly, despite radiators. Straw cowboy hats protected him from the sun when working outdoors on large pieces and kept the sweat out of his eyes.

The metal Bertoia used in the sounding pieces was industrially produced, extruded metal. The caps were sections of large rods, and the rods supporting them were narrower, smaller gauges. A major step in this development came with the adoption of caps up to about 2 inches (5.1 cm) in diameter. Larger tops or weights contain enough metal to produce sounds that resemble the ringing of distant church bells. Most were of copper alloys, especially beryllium copper, but Bertoia used other metals as well, including nickel alloys, such as Monel and Inconel, to increase the variety of sounds. At times he mixed metals, using rods of one alloy and caps of another. The nickel alloys are silvery gray and produce harsher, colder sounds, especially in tall pieces with closely spaced rods. Bertoia increasingly thought of his sounding sculptures as a group and decided that the sound, as well as the appearance, of the nickel alloys provided a good contrast to the brighter copper alloys. It is interesting, and perhaps chance, that these metals sound much like they look.

Bertoia was asked if these pieces, with their lack of ornamentation, use of commercial materials, repetition of forms, and creation in series, had a great deal in common with the Minimalist sculpture so prevalent at the time. He grinned, replying that he considered them "maximal," not Minimal. His joke made a good point, and he avoided acknowledging any truth to the suggested relationship. When he wanted to, Bertoia could easily make a small joke that eased sidestepping a difficult topic in order to keep conversation light.

A mature example from the mid-1970s has large tops, clearly placed at slightly different heights from the base and each also differing in height. These slight differences in height and proportion result in closely related sounds that, heard simultaneously, have the effects of an extended chord. Weights this large in girth produce greater volume and sounds that are deeper, richer, and much clearer than do thin wires. Their cylindrical shapes allow the weights to strike and glide freely.

Asked about the decisions he made in the process of creating sounding pieces, in August of 1974, Bertoia explained:

> I go about understanding, first, all factors that are going to be involved, such as available materials and remembering other units. In putting one [piece] together, the intent is to find the proper spacing for a certain size rod and a certain kind of alloy. So spacing is important, the height and the total number—the bulk, in other

P. 237

P. 243

P. 242

words—all these will bear insofar as result. The quality of the sound cannot be predetermined precisely, but I can get some notion about it simply by taking a single rod and holding it in space (by a string or so) and striking it. I don't think the visual aspect determines solely what it's going to look like; it's the sound as well. If the sound comes out, a good or different sound, the visual seems to confirm it. If the sound is hard or clumsy, it can also end up with a similar shape. I have observed this a number of times, because I have done so many: I was surprised at one time to see the relationship between the quality of the sound and the visual aspect of the same work: it seems to be a sound portrait of what it looks like.[6]

Process was crucial to Bertoia, and sometimes the unexpected made him reconsider how he worked, at least momentarily. He made a sounding piece of fine beryllium copper rods in early 1976. Usually when he finished a sculpture, he sprayed it with a household cleanser to remove residue, then took the hose to rinse it off. One day he was interrupted and forgot to rinse a sounding piece. The next morning he was amazed and amused to see that the cleanser had caused rods to turn a variety of colors. He wanted it photographed to preserve the colors before washing them away, uncertain of the long-term effects of the cleanser.

Pieces like these can be played a variety of ways to bring out particular sounds. Bertoia most often played them with his palms and fingers perpendicular to the floor, with one or both hands at the sides of a piece gently pushing the outer caps toward the center, where they hit the inner ones. Doing this several times, he would gradually increase the volume as the rods increased in speed, then let them decrease in motion and volume as energy dissipated. By that time he had moved silently in his stocking feet, to prevent any sound from his shoes from interfering, to one or more other pieces, usually introducing their sounds while the previous pieces were sounding strongly or quietening. The possible variations of sound and form were vast.

P. 244
111

It is not surprising that the child who had been fascinated by the sight and sound of a gypsy tinker hammering out a copper pot would be attracted to gongs as an adult. After the early sounding pieces had been made, Bertoia initiated the large gongs. They came about as the result of an even more immediate and unanticipated origin one summer when Bertoia promised his children that he would devise a toy for them to use when swimming in the pond by the house. After they pressed him about it, he went to his shop, "put two pieces of sheet metal together, welded at the edge, and poured water in to expand the two. This produced a hollow form." After he released the water and plugged its opening, he took it home. It floated, and the children had great fun for several years with "the turtle." "It dawned on me once," Bertoia explained, "that if it wasn't built of copper, if it was another material, it might have a good sound. . . these other materials had become familiar to me, and I began to be able to select so that the next time I said I'm going to try to make a gong, which is built pretty much the same way but using bronze, . . . the sound [would] be nice."[7]

From the early 1960s until the late 1970s, Bertoia expanded the types of works he was making. Over the course of a day, week, or month, he would be making gongs, tonals, and monotypes, as well as creating small bronzes and large fountains. All these activities influenced each other and stimulated his imagination. He developed gongs made of two sheets of metal, mostly producing large, hanging rectangles with surfaces hammered to enhance and vary their sounds. This allowed different sections of gongs to make distinct sounds.

P. 247
118

The artist also made a few standing gongs on small bases that are composed of two sheets of convex metal to trap volumes of air. An unusual and especially successful freestanding example is of hammered and patinated copper. Dated about 1970, it is slightly over 5 feet (1.5 m) tall. Although Bertoia had given up painting at Cranbrook, the abstract images

P. 246
117

that he created through patination on the expansive surface of gongs in essence mark a return to painting. Color usually played a strong role in his work and reflected his subtle and unusual sensibility. So effective was his sense of texture, pattern, and color that even this basically geometric form refers to nature, its surface suggesting the effects of water on mineral-bearing rocks over centuries.

When Bertoia sold a gong, he usually included the mallet that he had made for striking it. He referred to the mallets as "clappers," the term he remembered from the church bells of San Lorenzo. He made most of his clappers from baseballs, adding a wooden handle and covering them with either a piece of cloth or chamois leather tied with a leather thong. Just as he determined the sounds of gongs by shaping their air spaces, he designed his mallets to create various effects. Bertoia inlaid a hammered spiral of silver in a clapper's end so that striking a gong directly with the head of the mallet produced a sharper sound, distinctly different from the quality produced by striking with the mallet's side. He muted the effects of the silver slightly and helped keep the mallet together by covering it with cloth.

Bertoia also invented less traditional gongs. Welding bronze rods into roughly conical forms, he built up bases to hold large gongs designed for the outdoors. The sound-producing surfaces of these works were sheets of bronze that he patinated carefully, creating highly nuanced, apparently weathered and painterly surfaces. The top of the bronze sheet, like the conical base, is patinated verdigris, while its underside is a variety of warm tones of brown, both of which are colors that occur naturally in the metal. Metal resting on metal did not make a pleasing sound, so Bertoia inserted a baseball at the top of the cone and found that the piece was suddenly transformed, becoming much more pleasing and sonorous.

Bertoia decided that a double gong with two striking surfaces of different sizes should produce interesting sounds, and by making one bronze sheet ring, he might create sympathetic vibrations in the other. If the two surfaces were not identical in size, the sounds would differ. Several enormous double gongs taller than humans resulted. Some have two bases to support the bronze plates; others have one base with two branches to support the plates individually. The larger disks, usually about 6 feet (1.8 m) in diameter, are supported by hooks of bronze in a reinforced hole penetrating the center of the bronze sheet. Bertoia would make the bronze sheets sound, then stand between them to listen. For him, works of this sort were explorations of both form and sound but also of integrating sculpture into the landscape.

19 20 P. 248

The artist's exploration of gongs made of one piece of sheet metal began with regular forms that soon became more organic and complex. After playing circular and oval forms, he realized that where and how the mallet struck a gong determined the sound. He wondered what would happen if he split a form so that the metal on both sides of the cut vibrated. Each section could vibrate individually or sympathetically—each vibrating in response to the other—creating a complex sound, which he liked. This encouraged him to adapt shapes he explored in monotypes to sheets of metal.

A tour of Bertoia's workshop in the early 1970s would give an accurate impression of much of his activity at the time. Generally, there were gongs overheard, maquettes of fountains on workbenches, and bushes sitting on benches, as well as tonals standing out of the way. Sometimes there were pieces of various types in meticulously crafted shipping crates. An almond-shaped gong hung in Bertoia's barn for years and he played it often, using a small clapper made with a strong, straight wire handle and fabric strips neatly wrapped around the end. His experimentation included the tools for making sculptures sound.

Gradually, the shapes of gongs became increasingly organic, appearing first in monotypes and later many existing in metal. Bertoia had to consider what would work best both visually and acoustically. He was realizing that various amounts and shapes of metal influenced the tones that one piece could

produce. Forms with areas of diverse shapes would give one gong a greater potential range of sounds. In two monotypes, lively images of gongs, including the almond-shaped one in the barn, appear to float rather weightlessly, free of the clotheslines from which real ones were suspended in the shop and barn. They are rendered as negative shapes in white against an inky ground, and their irregular spacing and the balancing of the smaller pieces at each end is an inventive way of giving potential movement to the image. In the second of these gong monotypes, Bertoia has moved well beyond the first in his use of shapes, textures, and overlapping. The large, organic gong forms appear to be ghost images from a previous work to which Bertoia added ink in order to create their textures. Exactly how he created the negative, geometric forms superimposed on them, however, is not easy to imagine.

P. 249　　21 22

Bertoia could afford the luxury of working on these acoustical pieces, because he was still working on commissions for large bronze fountains. Studies and maquettes for them sat on workbenches, accompanied by wooden cutouts of human forms that helped determine the final scale of commissions. In 1974 Bertoia was working on a fountain for the Wichita Redevelopment Authority, thinking about form, scale, and patina. He used cutouts of human forms with the fountain studies. A piece that is too large overwhelms, while one that is too small seems insignificant, so scale is important. In addition, scale was a particular concern from the time he was making jewelry at Cranbrook.

A most unusual Bertoia work used the same techniques as the maquettes for fountains but was instead a complex study of implied motion. Like the Wichita fountain and its studies, it is constructed of layers of fine bronze welding rods and is an abstraction of the process of a flower's maturation. Sections of cylinders comprise the exterior, each built up of horizontal welding rods. Some form nearly complete tubes, and others have unfolded into curved planes. Their open sides are implied lines suggesting motion that continues their curves. Radiating from the center, all these spinning forms project from a core of detailed wires. The sculpture's implications of time, movement, and the potential opening of sections all emphasize life, growth, and change. As an exploration of implied motion, it is an interesting companion to Bertoia's emphasis at that time on actual movement and sounds. While the materials, technique, and expressive content of this work are pure Bertoia, the forms are more naturalistic than in most of his works. Bertoia kept this piece at home, seeing it daily in his final years.

P. 250　　23 24

Like many who grew up during the Great Depression, Bertoia used materials and equipment carefully, even frugally. He kept small pieces of leftover metal, certain that a good use for them would appear one day. He especially liked making small, experimental sculptures out of these pieces of rods about 1 inch (2.5 cm) in diameter, the size of his thumb. He made them in the evenings or on weekends, forging gestural, expressive, and sometimes rather brutalist works with a torch and a few strokes of his hammer. The effort was part serious, part play.

P. 251　　25 26

A number of Bertoia's works suggest relationships to trends in art at that time, especially works of Italian Arte Povera, in which humble materials were used to express their own nature as well as the fragility of existence. His simple forms, cut and welded to stand as if they were a bit unstable, have much in common with the Minimalism prevalent when they were made.

Working on tonals was delicate and meticulous work. Making small, bold forms like these, some of them the result of considerable physical force, must have been a relief and needed contrast. Working in this general vein, Bertoia made some geometric works using blocks of bronze and rods that address how pounding a rod could force it to change directions. How encountering strong forms could change them was a theme he explored in a number of works. These forms also have monumentality, the effect characterizing some works that makes them seem much larger than they actually are.

P. 252　　27 28

30 P. 253

Other small forms that reflect the expressive potential of his materials and processes reveal an increasingly physical approach. Great downward force in combination with heat created one particular work. Its base has spread slightly from the temperature and downward blow, and, halfway up, increased heat and force softened the metal and made it expand sideways. The torch allowed Bertoia to curve the upper section and, pushing down on it, give the form a rounder head. This work's powerful form is a record of the forces used in making it. Its carefully applied patina makes it seem at once ancient and new.

29 P. 252

The muscularity necessary to create another example of the small form corresponds to the force and tension it expresses. A densely knotted form, it is fully isometric, for each end works against the other. Mounting this straining mass on a small cube has an interesting effect, for while the materials unite the work with its base, the great contrast between compact geometry and highly organic center is particularly effective. Bertoia continued this theme of similarity and contrast to the ends of the work, where the polished rods resemble their original state. It is a compact study in tension.

Such small works afforded Bertoia the opportunity to use alternative approaches to welding bronze and copper rods—a diversion and exploration that provided reminders of the materials' potential. Always working in several modes at once, Bertoia enjoyed the variety and appreciated that one material, process, or idea led to others, often in other media or for other types of works. He kept discovering the properties of the materials in these pieces but was most compelled by exploring rods in sounding pieces.

As he made more tonal sculptures, Bertoia wondered increasingly about the possibilities inherent in having multiple tonals sounding simultaneously, which he no doubt discussed with Oreste. He found a source for recycled wood from a nineteenth-century barn in North Carolina and used it to replace the barn floor, insisting that it be pegged traditionally, without nails that might alter the sound of pieces in the barn. The basement was used for storing sculpture, but its main purpose would be to act as a sounding box for the sculpture upstairs. After repairing the walls and rebuilding the loft, where he would make and file drawings and monotypes, the barn was complete. Bertoia sometimes called it his "laboratory."

Bertoia's barn, a stone structure with half timbered and plastered interior walls, was at once rustic and elegant, antique and modern, a place of great tranquility, a meditative space, and a refuge from the rest of the world. Off a country lane with woods on two sides, across the lawn from his home, it usually sat silent with a few shafts of sunlight streaming into the dim space. The double gong was in the grass to the left of the entrance for several years, only to be replaced by a very tall beryllium copper tonal that was two "kissing" rods. Each of those works seemed to announce what was inside.

Approaching Bertoia's barn up the bank of earth, you reach a fieldstone wall, the traditional building material in the region. Its original wide entrance is filled by a plain modern door and wooden planking to narrow the old opening. To one side is an abstracted sculpture, The Seal, rendered in squared white marble by Masayuki Nagare, Bertoia's friend who also exhibited at Staempfli Gallery. Bertoia liked it and its references to Constantin Brâncuşi's piece and the ocean mammals. A large fieldstone—this sculpture by Mother Nature—sits on a shelf that, two centuries earlier, was for a lantern.

Stepping up to enter, visitors are immediately struck by the change in light and temperature. The thick walls keep the barn's interior moderate compared to the outside temperature. A few narrow, floor-to-ceiling expanses of glass light the barn, and several small windows near the ceiling admit more ambient light. Trees just outside the windows filter the bright sunlight, giving a green cast to the interior in summer, and in fall the golden tone of their leaves steals into the space. The barn was a realm of sensory delight, transporting visitors through sight and sound to a unique,

rather serene state. A small space in a corner held a few chairs for conversation with visitors, separated from Bertoia's recording equipment by a monumental hanging gong. The main floor of the barn, perhaps about 35 by 45 feet (10.7 by 13.7 m), feels at once intimate and grand. Bertoia carefully arranged the sculptures in rows. To permit easy access, there was an aisle down the center with smaller pathways between the walls and ends of rows. Bertoia wanted to be able to move where he needed to go rapidly. From the ladder leading to the loft, it was possible to see nearly half of the sculptures at once. Bertoia sometimes used two or three floodlights in the barn, shining from beams along the side walls. They produced intense reflections and nearly phosphorescent colors. The same pieces seen from the floor, in other light, appear colder, shinier, newer.

At one side of the back wall stood a pair of stainless-steel bundled rods called "pods," while at the center in 1973 was a round gong perhaps 3 feet (90 cm) in diameter, its recurved sides and repoussé center shining with a brassy gold patina. The following year it gave way to a round verdigris gong twice as big, a commanding piece of sheet bronze with a subtle patina. It could ring out boldly, especially when struck with a mallet. The wood of the floor and timber framing combined with the rough plaster to create a sense of naturalness despite all the industrial metal that filled the space.

Pieces varied greatly in size, with some reaching hand height, others level with the waist or shoulder or well above normal reach. Many resembled squared clumps of tall grass, others reeds or cattails, and some, only a few inches high, sat on carefully made, horizontal boxes to increase their sound and require less bending to play. Taller pieces often had large caps that resulted in interesting abstract visual patterns, contrasting with the wires and thin rods surrounding them. Overhead were pairs of singing bars from about 6 to 24 inches (15.2 to 61 cm) in length, made of beryllium copper as golden and bright in color as in sound.

Bertoia could set the singing bars into gentle motion, for they hung just within his reach. They would ring intermittently for five or more minutes. Well after they appeared to have run out of energy, an unexpected note would sound. In late 1950s monotypes of abstracted landscapes, Bertoia repeatedly used lines placed at angles in indeterminate space to suggest the dynamism of living things. These landscapes anticipated the singing bars and provide context within both Bertoia's oeuvre and his beliefs. The beryllium copper rods floating overhead embody the *élan vital* so important to the artist and brought it into tangible reality in his barn, while in the landscape monotypes, they float and swing across vistas and into the sky against swaths of colors. Their implied motion makes them seem wind-borne or, at times, suggests flocks of birds.

The monotype numbered 2002, from the 1960s or early 1970s, is more active (even chaotic) than most of the images in which the artist used these bars to represent cosmic energy. Emphasizing the longer, bolder ones, Bertoia gives a sense of a hierarchy and implicit order within this field of otherwise rather uncontrolled motion. This is a continuation of the active landscapes Bertoia made for several years. Here he chose to omit the landscape, allowing the format's suggestions of a vista and the series to provide the landscape context. He let the energy of nature exist freely.

Bertoia explained that among the strongest factors contributing to the arrangement of pieces in the barn "was my brother's awareness [of] the possibility of orchestrating these." Periodically, Harry Bertoia would edit them: new pieces "enter," and others are "put aside, wait[ing] to see whether they are going to be recalled or not."[8] White metals look cold and can sound positively icy, providing a striking contrast to the beryllium copper that Bertoia found most satisfying for both its motion and sound. As he arranged about one hundred pieces in the barn, Bertoia carefully placed works in interesting groups determined by relationships of their sound and what he could reach easily. He used to say that bringing a new piece to the barn was like introducing a new baby to a family, slightly

P. 254 31 32

P. 255 33

P. 255 34

P. 257 37

changing all the relationships. He often rearranged works, especially after adding one or more new ones. The serenity of the barn changed as soon as the first sculpture emitted a sound. The way its character changed depended entirely on what piece was activated and how. Bertoia came to insist, however, that these sculptures were actually one work of art with many components.

When Bertoia played, time disappeared, and sound carried you to another state of mind. The concentration visible on his face showed how carefully he was considering which sounds he wanted and where to get them, stretching high to play a piece or bending low. Often the result was a sense of the sublime, that intense response combining beauty, awe, and fear. That emotion was very important to painters and writers of the Romantic period, who experienced it before nature. It is often associated with the transcendental.

13 P. 245

Bertoia knew exactly where the sculptures that created the sounds he wanted to produce existed in the barn and moved quickly and silently to reach them. Always conscious of which piece he wanted to move gently, strike, or strum next, Bertoia was clearly hearing its sounds in his head. He would grasp a group of rods and push them gently against each other, making a slightly harsh rustling sound that would change drastically when

15 P. 245

he let go and the rods flared and rushed in, pulsing for a good while until they returned to stasis. At times he leaned down to strum low tones from

12 P. 245

rods just above their bases. He chose heavy wire—1 foot (30 cm) or longer, with its ends carefully wrapped—to use in strumming the bases of sounding pieces, for lower frequencies are generated near the base of pieces. He made many implements to bring out specific sounds, including a stylus he wrapped in fabric and held like a pencil to urge unusual sounds from a gong.

14 P. 245

Sometimes Bertoia would gently use his fingertips to make the caps of the center rods of a piece move back and forth; they in turn activated their neighbors, resulting in a sustained sound. His playing involved many changes of dynamics as he created soft murmuring sounds, building gradually to powerful ones, even punctuating the whole with a booming sound from a gong. Realizing the ephemeral nature of what he was playing in his barn, Bertoia studied the possibility of recording. He researched and purchased what was then state-of-the-art recording equipment. With the help of a young audio enthusiast who lived nearby, he installed the system and began recording.[9] Bertoia studied recording technology and hung four carefully spaced microphones from the beams after having diagrammed how he wanted to arrange them. Suddenly, he was using terms like "megahertz" as naturally as his dog's name.

By 1969 Bertoia was recording the first of a total of about four hundred reel-to-reel tapes. He placed a scrap of paper in each tape box noting the date and giving a simple description. Over time he would listen to them again, adding comments, noting how long a tape lasted and perhaps which sections he thought particularly effective. Unlike his sculptures, these recordings often received titles, some rather literal, like "Near and Far," and others more poetic, like "Ocean Mysteries." As he explored recording techniques, sometimes Oreste played with him, and once their sister, Ave, joined them, vocalizing. Bertoia experimentally played a tape on one recorder while he performed on sculptures and recorded the result. The results of his recording sessions pleased him, and he decided to explore the possibility of producing his own long-playing album that would include some of the best pieces.

His first album was ready in 1970, but he struggled for a title, eventually settling unenthusiastically on *Sonambient*. The term was used in 1971 by Jeffrey and Miriam Eger, who made a film with Bertoia about the sounding sculptures in the barn, *Sonambient: The Sound Sculpture of Harry Bertoia*. In 1965 Clifford West, Bertoia's friend from Cranbrook, had made *Harry Bertoia's Sculptures*, and the combination of films helped introduce these works to a wider audience. An unintended result of Bertoia's album and the

Egers' film is that the sculptures were increasingly called "Sonambients," and the barn became known as the "Sonambient barn," although it was never Bertoia's intention that the word apply to anything but the album.

In the last two years of his life, Bertoia would revisit his tapes in preparation for issuing more recordings as a set of LPs. He did not live to see them released, although he had matched sounds to photographs for their sleeves. A group of ten more albums was released following his death. John Brien, who has studied and remastered the original tapes, wrote:

> Bertoia's recordings are as much a celebration of sustained tones, intervallic relationships, healing vibrations, deep listening and shimmering harmonics as Indian Classical music, singing bowls, The Well-Tuned Piano or Benjamin Franklin's glass armonica. Through these rich harmonics and pulsing pure tone, Bertoia was able to more clearly articulate his inner spirit than he could with sculpture alone—a point he made himself many times in interviews.[10]

In 1972 West introduced Bertoia to Kaare Berntsen, a Norwegian art dealer, and a show of Bertoia's works was soon arranged.[11] For a few years, Bertoia traveled to Oslo and Bergen for shows of his work. He appeared on Norwegian television demonstrating sounding sculpture, including taking a powerful swing at a gong. Berntsen shared with Bertoia a particular interest in outdoor sculpture and bought large pieces for his own garden. The artist's shows in Norway were not without problems. In 1977 a storeroom fire at Henie Onstad Kunstsenter, in an Oslo suburb, destroyed two large sculptures and a dozen monotypes.

A friendship developed, and Berntsen was able to convince Bertoia to return to making jewelry. The art dealer had in mind reproducing the new jewelry in multiples. Bertoia developed these works in fine beryllium copper wires, and the intention was probably to reproduce them in silver and gold. He revived his technique of welding wires side by side to create planes, a technique he used for jewelry once before in a copper necklace in honor of his daughter Lesta's high school graduation. The later examples unfortunately lack the delicacy of the piece Bertoia made for his daughter. He also made gong pendants, resembling miniatures of the large gongs but in silver, however no reproductions were made.

In the 1960s and 1970s, the avant-garde in art became enormously active, with a great proliferation in the number of artists, styles, movements, and galleries. Innovation was one of the best ways to attract the attention of critics and collectors. Bertoia's acoustical sculptures were first introduced to the public in the midst of this flurry of innovation, although they had been shown earlier in small numbers at his Chicago and New York galleries.

The year 1975 was important for the introduction of Bertoia's actual, rather than filmed, sound sculptures to wider audiences. There was a well-received retrospective exhibition at the Allentown Art Museum in Pennsylvania, and works were shown at Staempfli and Fairweather-Hardin Galleries. An exhibition and accompanying catalog, *Sound Sculpture*, was arranged by John Grayson of the Aesthetic Research Centre of Canada, in Vancouver. Most of the participating artists were Europeans whose works required electricity, although some only exhibited drawings and ideas. Several of the artists exhibited and published studies for proposed works or photos of actual pieces with essays about their works. Bertoia, whose works were technologically simpler and generally more refined than the others, only submitted a few photographs of himself with sculptures in his barn.[12] The show was ultimately more important than the works it included, because it gave evidence that sound sculpture was an international movement, encompassing an array of pieces. Bertoia's finely conceived and crafted works had found their rightful place.

The artist received a commission from the Standard Oil Company in 1973 to create a large outdoor piece for a plaza behind its new headquarters, a

38 39 40 PP. 258–259

tower by Edward Durell Stone that would be the tallest building in Chicago, if only for its first year. Bertoia studied Chicago's famous wind and aligned pieces carefully, at perpendiculars. He designed the placement of pieces to allow some sounding sculptures to be seen through the transparency of others. The design would include eleven sounding pieces, most in beryllium copper but others in Inconel and Monel, which would stand on granite bases just above water level in a shallow black pool. The tallest piece was only two capped rods. Most works were extended pieces of single or double rows of rods. It was highly acclaimed for its tranquility and beauty.

In the context of the Standard Oil pieces, Bertoia said:

> The big pieces are a result of metal knowledge and physical forces; they can be any size, on up and up. . . . They too are part of me, of course; however, I am following certain laws of metal and its reaction to bending, falling, cutting, etc. Thus when these objects are played on by the wind and sun they will move, change shape, but always return to obey the law by which they were created.[13]

The largest horizontal tonal was 11½ feet (3.5 m) high, nearly that in length, and 20 inches (50.8 cm) deep. When such elongated pieces move, they form a sequence of waves rolling from one side to the other, their sound reaching viewers in waves. For years Bertoia had been making tonals of only one row of either rods or wires, depending on the scale of the piece, because their action and sound were so pleasing. The complexity and the number of pieces and sizes, and the variety of their configurations made this commission unique.[14] Richard Wright, a Chicago art dealer who specializes in Bertoia's works, called Stone's building "a modernist focal point" in Chicago and observed that "Bertoia's original design perfectly echoed the quality of Stone's architecture while adding movement and sound to the exterior plaza of the building."[15]

The Standard Oil Plaza is an unusual example of the fate of large commissions. It was Bertoia's biggest and most complex public installation of sounding sculptures outdoors, and he spent several years determining how to place his twelve large tonal sculptures in the pool. The sculptures reflected the surrounding architecture, and their sounds masked the noise of nearby traffic. However, the building went through several owners and the plaza was reconfigured twice and the basin was reduced. Six of the largest pieces were sold, and the remaining sculptures were rearranged. The installation is now far different in both scale and appearance from the artist's intention.

41 P. 260

Bertoia used fine beryllium copper rod in several of his last commissions, some of which were neither kinetic nor acoustical. His last major commission, however, was both. His monumental design for the Federal Reserve Bank of Richmond, Virginia, in 1978, featured copper rods standing in two towering horseshoe shapes, one 16 feet (4.9 m) tall, the other 18 feet (5.5 m). They stand beside each other, their open sides facing in opposite directions. Three horizontal limiters protect them from damage caused by strong winds but allow the enormous pieces of metal to move and make sounds. The rods are so carefully selected and balanced that only a five-mile-an-hour breeze is needed to set them in motion.

With the elegant simplicity of form that characterizes many of Bertoia's best works, this was another successful design collaboration with the architect Minoru Yamasaki, his friend. The sculpture rises from an oval pool on a plaza facing the building's entrance. Bertoia echoed the clean lines and verticality of the building while contrasting with its cool color and rectangularity, explaining that he wanted it to be more human in scale than the enormous building and for it "to make good sense in relation to space, the building and the context it is set in."[16]

The Federal Reserve Bank of Richmond piece was as close as Bertoia came to achieving his dream of making an Aeolian harp. He loved the Ancient

Greek notion of a huge harp played by the wind and would walk visitors to see the long, steep hill near his home that he thought would be a great site for such an instrument.

Bertoia sounding sculptures pose an aesthetic conundrum. Are they sufficient as sculpture when silent? Is their visual or acoustical nature more important to the aesthetic effects of these works? Are their sounds music, or are they interesting, effective, even moving, as sounds? Does it matter whether they are indeed music?

Bertoia's sounding sculptures went beyond traditional notions of sculpture as a form in space by including both kinetics and acoustics. Bertoia was not alone in revolutionizing, broadening, even breaking, the traditional confines of sculpture in the 1960s and 1970s, which at the time was the most innovative and challenging medium in art. When his sound sculptures were at their greatest refinement, other artists were making kinetic and sounding sculpture, light, laser, and computer art, and because such works defied traditional categories, they were considered sculpture. What really distinguishes Bertoia's sounding sculpture from other experimental art of the period is its content, for in addition to the intelligent decisions that led to its elegance and superb craftsmanship, Bertoia's art is reverential, even spiritual, in its emphasis on the life force in nature, *chi*.

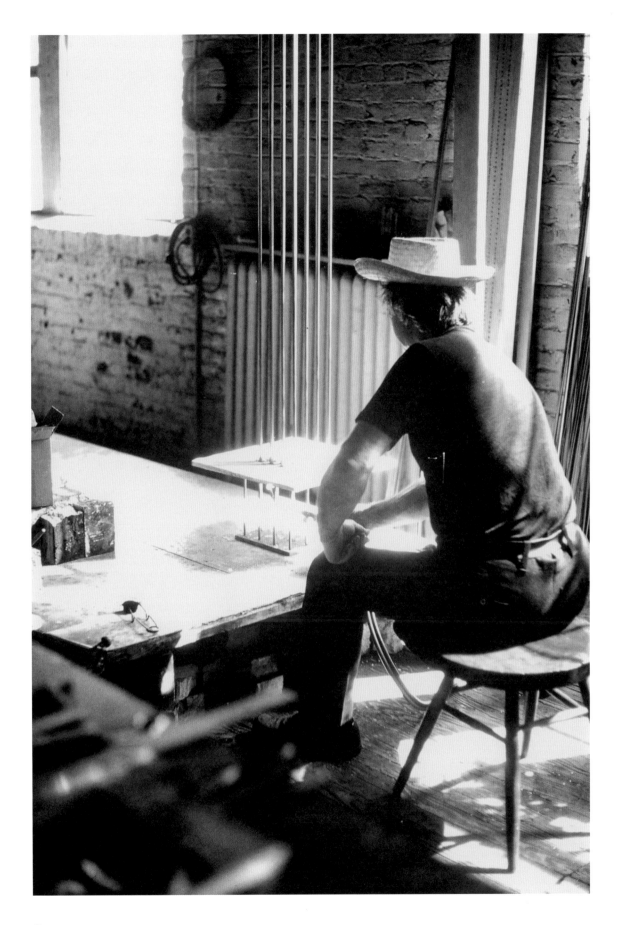

1 Harry Bertoia welding a tall sounding piece, 1974.

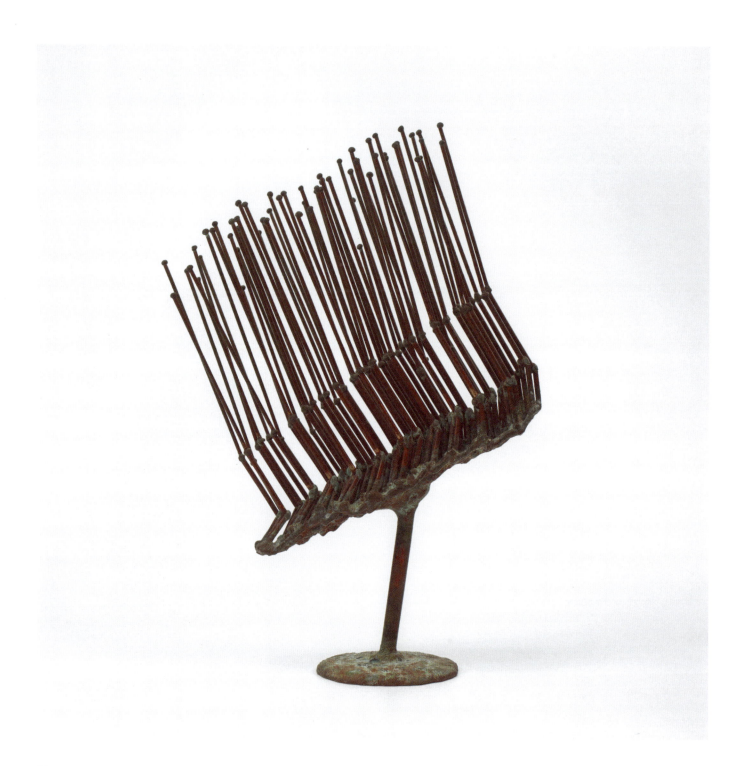

2

2 *Untitled* (welded form), before 1965. Welded copper with applied patina. 13½ x 8 x 4 in. (34.3 x 20.3 x 10.2 cm).
3 *Wheatfield*, c. 1960. Welded bronze. 38 x 36 x 7 in. (96.5 x 91.4 x 17.8 cm).

3

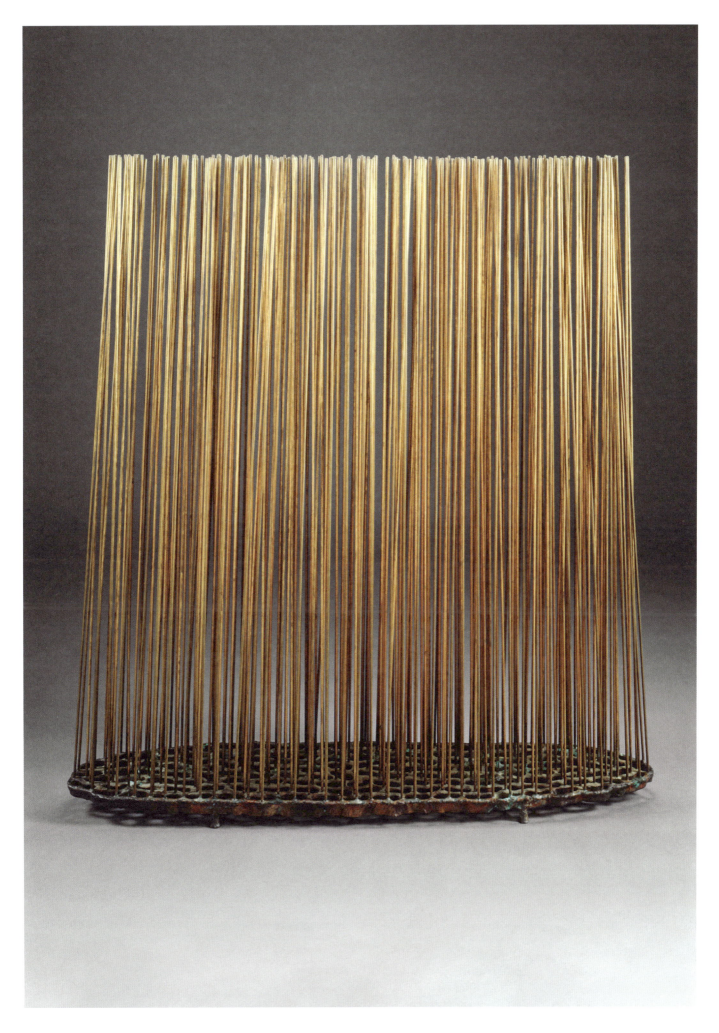

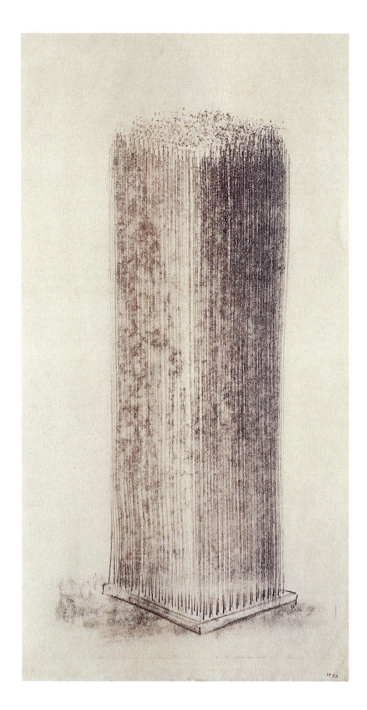

4 *Untitled* (monotype #1023), early 1960s. Printer's ink on rice paper. 24 x 12 in. (61 x 30.5 cm).
5 *Untitled* (tonal), c. 1970. Beryllium copper. 61 in. (154.9 cm) high on a brass base 10 x 10 in.
 (25.4 x 25.4 cm) with feet, 144 rods in a twelve-by-twelve configuration.
6 *Untitled* (tonal with narrow tops), c. late 1960s. 32⅜ in. (82.3 cm) high (including 2 in. [5.1 cm] tops),
 on 6 x 6⅛ in. (15.24 x 15.5 cm) brass base, 196 phosphor bronze rods in a fourteen-by-fourteen
 configuration.

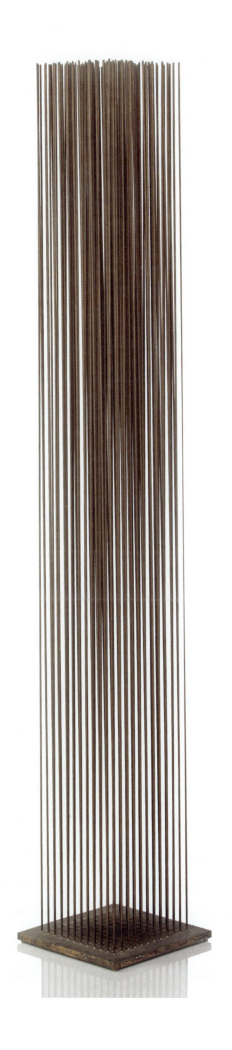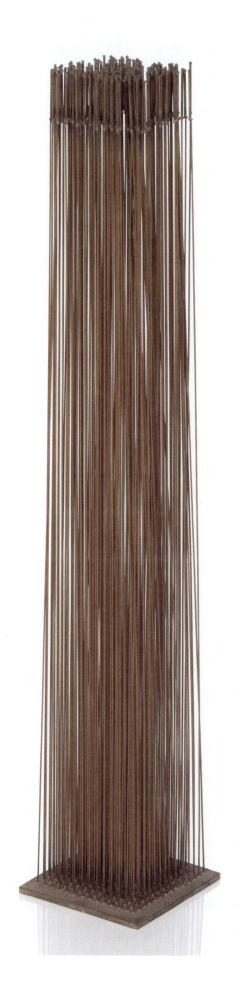

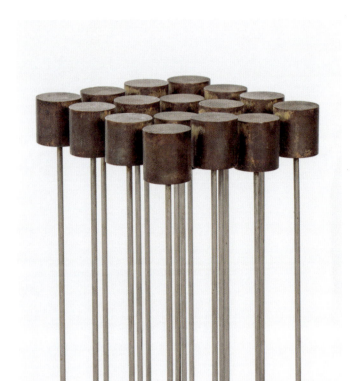

7

8

7–9 *Untitled* (tonal with cylindrical tops), c. mid-1970s. Brass base on feet, aluminum rods with beryllium copper tops, sixteen rods in a four-by-four configuration. 38 x 12⅛ x 12⅛ in. (96.5 x 30.7 x 30.7 cm).

10 *Untitled* (tonal with cattail tops), c. 1970. Beryllium copper and brass. 48⅛ in. (122.2 cm) high (including 5⅛ in. [13 cm] high tops) on brass base 8 x 8 ½ in. (20.3 x 21.6 cm), twenty-five rods in a five-by-five configuration.

RODS, SHEETS, AND SOUNDS 1959–78

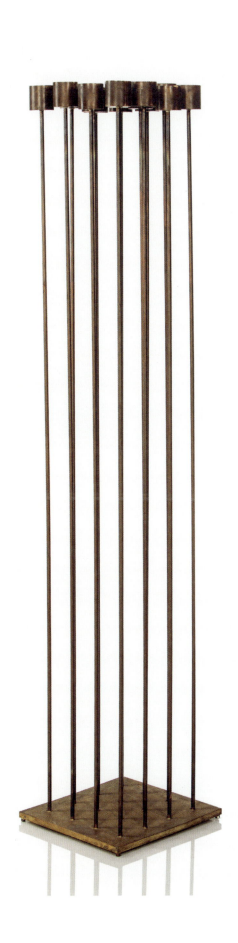
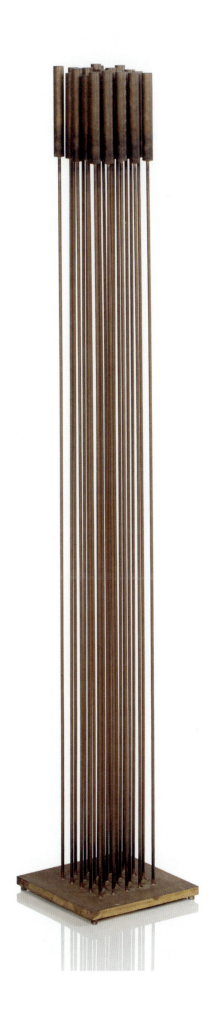

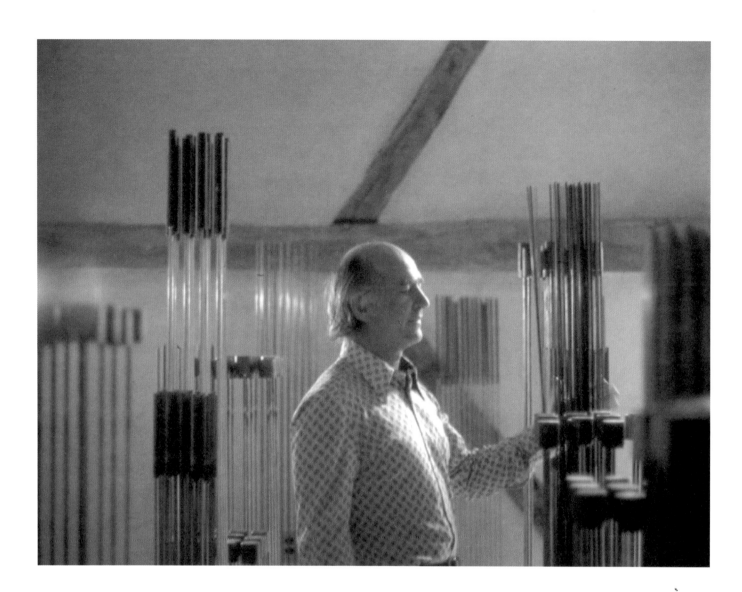

111

11 Harry Bertoia playing sounding pieces in the "Sonambient" barn, 1975.
12 Harry Bertoia using implements to strum the bottom of single-row sounding pieces, 1974.
13 Harry Bertoia using a short stylus to play a hanging split gong, 1974.
14 Harry Bertoia playing tonals, 1974.
15 Harry Bertoia playing small pieces, 1974.

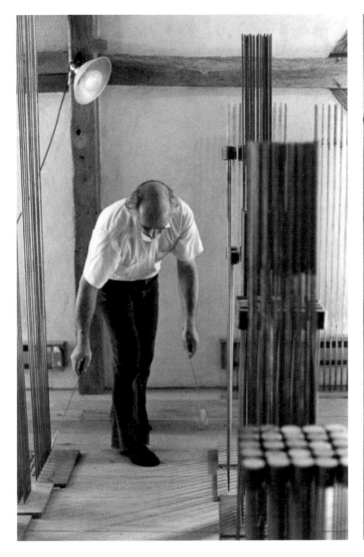

12

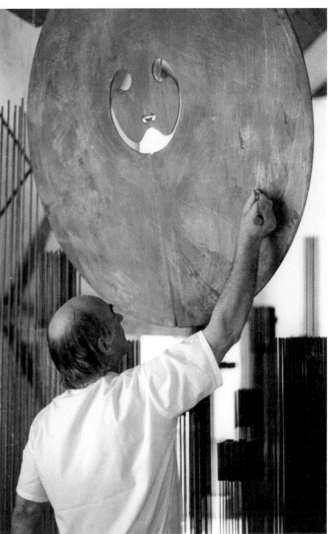

13

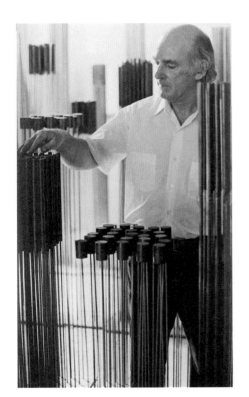

14

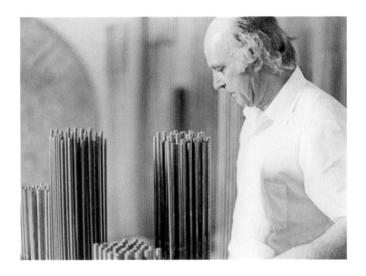

15

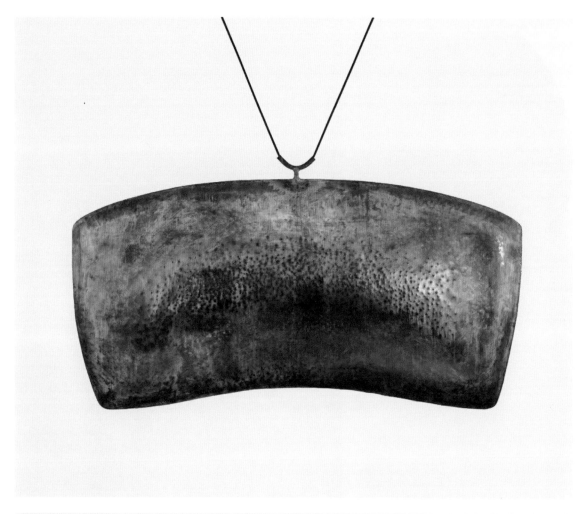

RODS, SHEETS, AND SOUNDS 1959–78

18

16 *Untitled* (gong), c. 1965. Hand-hammered copper with applied patina. 53 x 95½ x 6 in.
 (134.6 x 242.6 x 15.2 cm).
17 *Untitled* (standing gong), c. 1970. Hand-hammered and welded copper with applied patina.
 61½ x 36 x 12 in. (156.2 x 91.5 x 30.5 cm).
18 *Untitled* (gong), c. 1976. Hand-formed and welded bronze. 120 x 48 x 3 in. (304.8 x 121.9 x 7.6 cm).

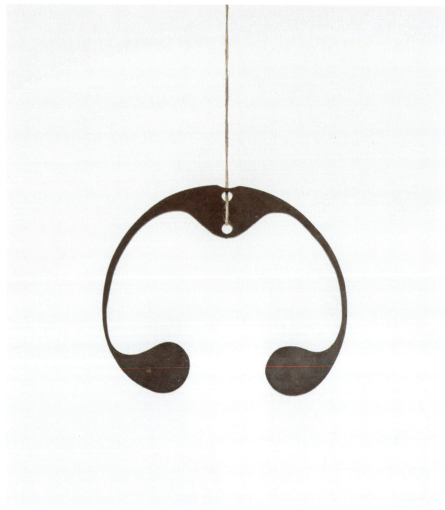

RODS, SHEETS, AND SOUNDS 1959–78

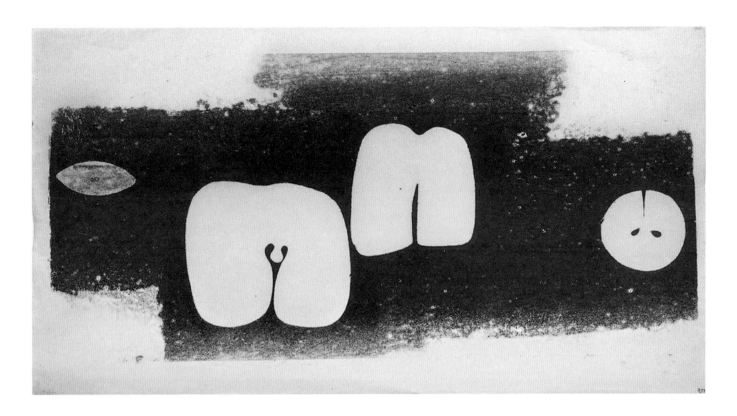

21

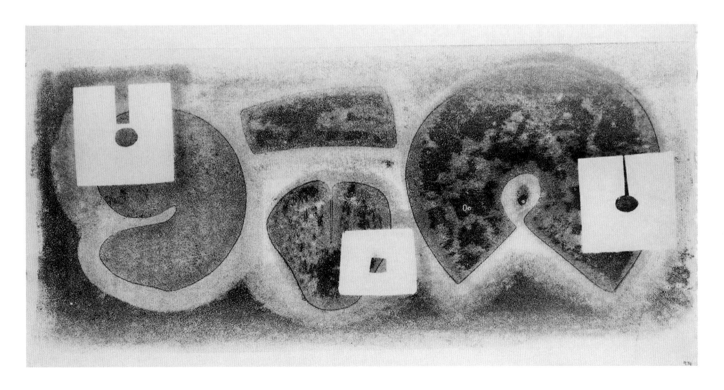

22

19 *Untitled* (gong) c. 1970. Cut and drilled silicon bronze. 48 in. (121.9 cm) in diameter.
20 *Untitled* (gong) c. 1970. Silicon bronze. 10¼ x 12 × ¼ in. (26 cm x 30.5 cm × 6 mm).
21 *Untitled* (monotype #973), c. 1970–75. Printer's ink on rice paper. 13 x 25 in. (33 x 63.5 cm).
22 *Untitled* (monotype #974), c. 1970. Printer's ink on rice paper. 12½ x 24¾ in. (31.8 x 62.9 cm).

249

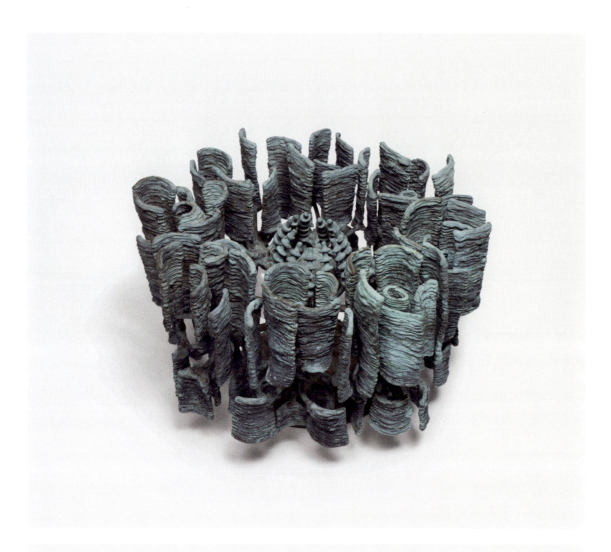

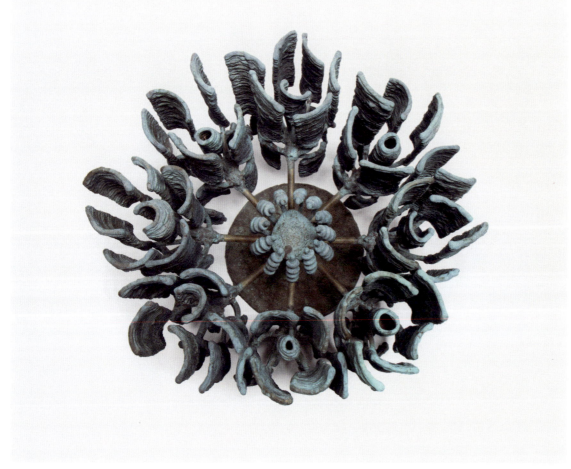

RODS, SHEETS, AND SOUNDS 1959–78

25

26

23 *Untitled*, early 1970s. Welded bronze. 10½ x 16 in. (26.7 x 40.6 cm).
24 Alternative view, *Untitled*, early 1970s. Welded bronze. 10½ x 16 in. (26.7 x 40.6 cm).
25 *Untitled*, 1970s. Melt-pressed bronze. 7¼ x approximately 4 in. (18.4 x approximately 10.2 cm).
26 *Untitled*, 1970s. Melt-pressed bronze. 10 x 2 in. (25.4 x 5.1 cm).

27

28

29

30

27 *Untitled*, 1970s. Melt-pressed bronze. 6 x 6 x 6 in. (15.2 x 15.2 x 15.2 cm).
28 Alternative view *Untitled*, 1970s. Melt-pressed bronze. 6 x 6 x 6 in. (15.2 x 15.2 x 15.2 cm).
29 *Untitled*, c. 1973–75. Melt-pressed bronze. 8 x 14 x 5 in. (20.3 x 35.6 x 12.7 cm).
30 *Untitled*, c. 1975. Melt-pressed bronze. 9¼ x 6 in. (23.5 x 15.2 cm).

31

32

31 *Untitled* (singing bars), c. 1977. Beryllium copper rods suspended on rope. 6½ x 1 in. (16.5 x 2.5 cm).
32 *Untitled* (singing bars), 1977. Beryllium copper rods suspended on thread. 15¾ x ½ in. (40 x 1.3 cm).
33 *Untitled* (monotype), c. 1958. Printer's ink on rice paper. 23½ x 38⅓ in. (59.7 x 97.3 cm).
34 *Untitled* (monotype # 2002), 1960–75. Printer's ink on rice paper. 12 x 24 in. (30.5 x 61 cm).

33

34

35

36

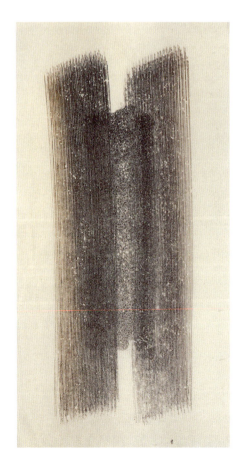

RODS, SHEETS, AND SOUNDS 1959-78

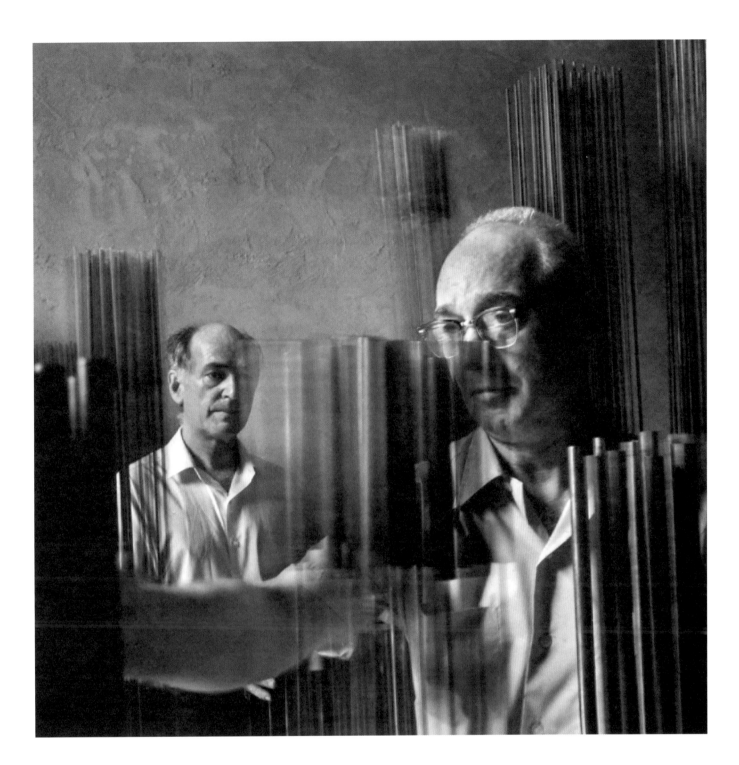

37

35　*Untitled* (monotype #921), c. 1970. Printer's ink on rice paper. 24 x 39 in. (61 x 99.1 cm).
36　*Untitled* (monotype #981), c. 1970. Printer's ink on rice paper. 24 x 13 in. (61 x 33 cm).
37　Harry and Oreste Bertoia playing sculptures in the barn, c. 1968–70.

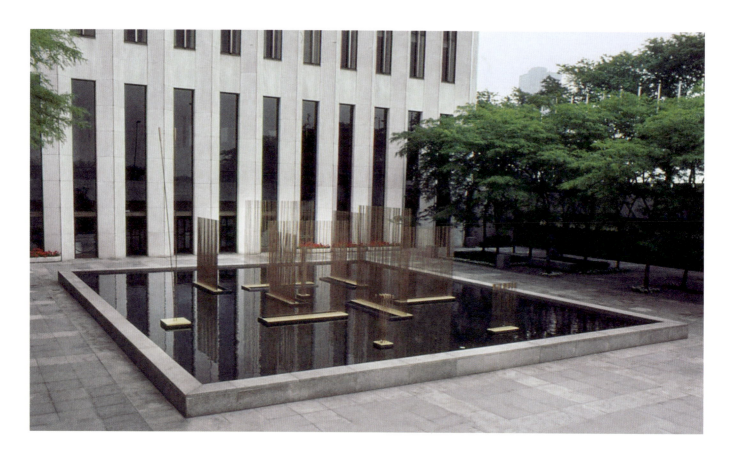

38

38 Eleven sounding pieces of the Standard Oil Plaza, Standard Oil Building, Chicago, 1975.
 (now greatly altered as the Aon Plaza).
39 Detail, Standard Oil Plaza, Chicago, 1975.
40 Standard Oil Plaza, Chicago, 1975.

39

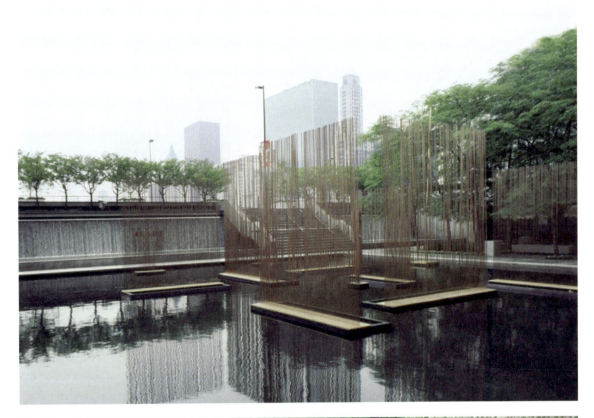

40

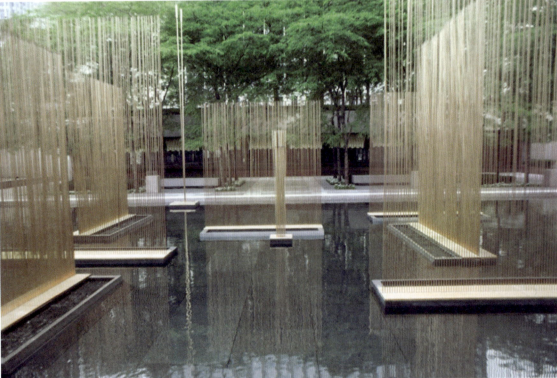

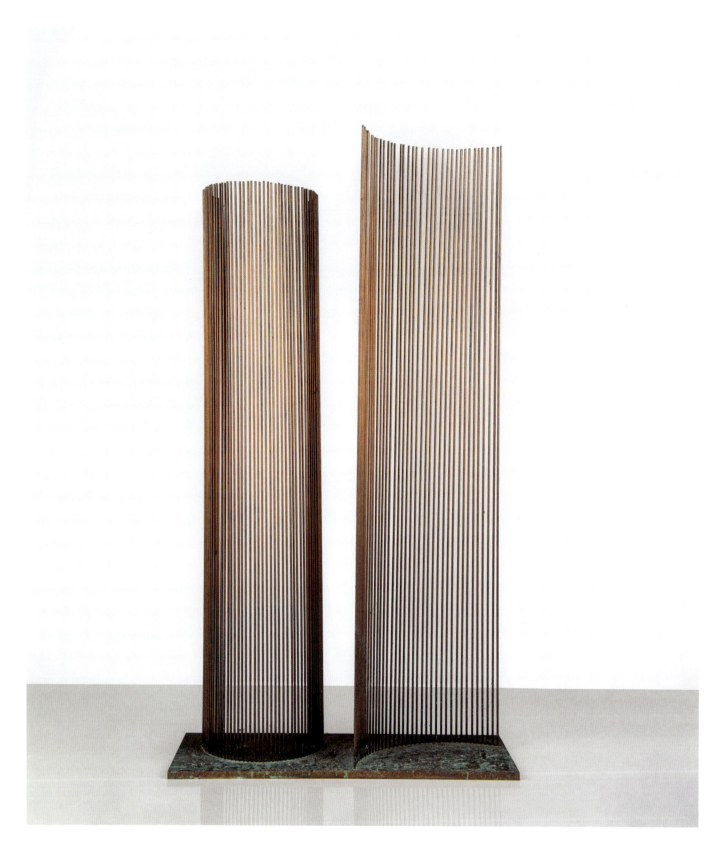

41

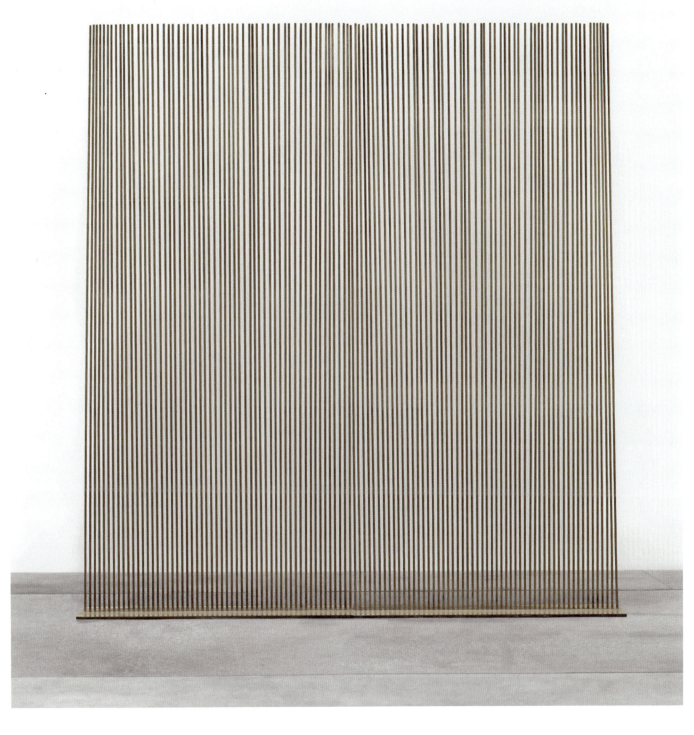

42

41 Maquette for the Federal Reserve Bank of Richmond (without the horizontal limiters), c. 1976–78.
 Beryllium copper on brass base. 36 x 19¼ x 7⅞ in. (91.4 x 48.9 x 20.1 cm) base, fifty-two rods (no tops)
 on two arcs of twenty-six rods each.
42 *Untitled* (sounding piece from the Standard Oil Plaza), 1975. Beryllium copper and naval brass.
 138¾ x 131½ x 20¾ in. (352.4 x 334 x 52.7 cm).

CONCLUSION

In 1977 Bertoia developed an unshakable cough and procrastinated about going to the doctor. The diagnosis was lung cancer, probably caused by extensive work with beryllium copper, his favorite metal. Beryllium is a carcinogen. This was exacerbated, no doubt, by his pipe, ever present when welding. He often joked that the smoke helped ward off the effects of the metal. He approached his death simply and gracefully, carefully saying farewell to those he loved. Harry Bertoia died on November 6, 1978, at home.

He had not sought fame or wealth but thought his art made a contribution. He had avoided signing and giving titles to his work because he wanted people to respond to it directly. He sent it out into the world, believing that it could stand on its own. The honesty, subtlety, and gentle humor that were essential to his personality were also fundamental to his art. He made it affordable and wanted it to be widely accessible, hoping people would respond to its order and beauty. Bertoia designed his work to appeal to viewers' senses and hoped they would realize that what their senses experienced was also an expression of the life force in nature and the unity of all existence.

Artists often reject having their work labeled stylistically, seeing such categories as aesthetic straitjackets that are the province of critics and historians, not artists. Bertoia's mature work evolved, varying in form more than that of most artists, so it defied any overall stylistic classification. How others categorized his work's style was of no particular interest to him. When he worked as a designer, he had just needed to solve each design problem and always did so within a Modernist frame of reference. Seeing the historical sources of his work reveals that it evolved and was thoroughly Constructivist, but also influenced by Surrealism. In his last years, he returned to making jewelry while also sculpting and producing monotypes. He believed, as Walter Gropius had insisted long before, that the creative process in all media relies on the same intellectual processes. Working in craft, industrial design, graphics, and sculpture was standard for Bertoia, and in that respect he was a classic Modernist.

The art critic and historian Jack W. Burnham, whom Bertoia knew when they were Graham Foundation fellows, discussed Bertoia's work in the context of other contemporary metal sculptors. Labeling their art "American vitalistic," he attributed to them "the desire for a transcendent apparition, the feeling for casual textures, the desire to break away from European prototypes, and a willingness to explore nontraditional mediums and materials." He discussed Bertoia's Kresge Chapel screen at MIT with other "fragmented sculpture" by Richard Lippold and Ibram Lassaw, noting that their "semi-random, reflective surfaces positioned in spatial configurations" encouraged experience of the transcendent. Bertoia had some understanding of these ideas from his readings in Eastern philosophy but often described himself simply as "a metalworker," so it was natural for him to use metal to catch light in the Kresge Chapel. It is metal, in fact, that unifies his jewelry, chairs, and sculpture. His drawings' linearity is thoroughly consistent with his lifetime of working with wire.

Since 1978 Bertoia's reputation and work have taken unexpected turns. In the 1980s and 1990s, his art was rarely seen in public, because work that thoroughly Modernist was out of step with Postmodernism. His major commissions, however, seemed secure, but that would change. Soon financial pressures left corporations far less concerned about the public relations value of art. Commissions were sold or reinstalled in new and often unrelated sites. The Manufacturers Trust building was sold, renamed "510 Madison Avenue," and the golden screen removed. Fortunately, Bunshaft's building already had historic landmark status, and the screen retroactively received landmark status and was reinstalled. Now that prime place for banking has become retail space. The Philadelphia Civic Center was demolished and its fountain stored for twenty years in a police impoundment lot. In 2016 it was reinstalled a few miles away, in a completely different kind of setting, surrounded by lawn and trees at the Woodmere Art Museum.

Bertoia's works are now reaching new audiences. The younger generation and others tired of the decorativeness of Postmodernism have turned, or returned, to the classics of Modernist design, especially furniture, calling it "Mid-Century Modernism." Mid-Century Modernism has been embraced by a generation that is increasingly mobile, affluent, and desirous of simpler, less-cluttered lives. Bertoia's Diamond Chairs have been consistently popular and are still iconic. His jewelry, shown in 1948 with Calder's in *Modern Jewelry Under Fifty Dollars* at the Walker Art Center, today sells for thousands of dollars and can be found in museum collections. Bertoia earned $75,000 in 1978 for the Richmond, Virginia, Federal Reserve Bank sculpture, covering labor, materials, and overhead. Today a medium-size bush can sell for at least that. Bertoia no doubt would shake his head if he knew; pleased, stunned, slightly amused, and appalled all at once.

Artists often create their own worlds. Bertoia's world included his barn, his workshop, his home, and his storage barn. Bertoia's shop was essential to this world. It was not only where he created his works, but also where he often met dealers and clients. His barn, with its installation of sculptures, was many things to him, and the result of years of intellectual and artistic exploration that brought him as close as he would come to meeting his expressive aims. He was both serious and lively there: talking, doing interviews, and playing sculptures. In many respects, in the barn Bertoia was creating his own ideal world of order, of forms inspired by nature that, in their sounds and motion, were reminders of *chi*. A visit to his Sonambient barn distilled this and created a unique environment and experience of seeing and hearing the world differently. For visitors, it was simultaneously serene and exciting. Sadly, the Sonambient barn has not been preserved. It was his desire that the contents of his barn be preserved. Bertoia wanted it to remain as a collection, as he had arranged it, but that was not to be. Its complete state now exists only in the memories of those who were fortunate to visit it during Bertoia's lifetime and in film, photographs, and his sound recordings, but none captures the full experience.

Bertoia found great pleasure and tranquility in living in the quiet of a small Pennsylvania farm for the last thirty years of his life. The real origin of the works in Bertoia's barn lay in another small farm, the one in rural Italy, where he was fascinated by weather, streams, the growth of plants and animals. His few surviving childhood drawings already had the careful observation, attention to detail, and craftsmanship that would characterize his life's work. His focus and striving for perfection developed when he was a young, non-English-speaking immigrant in Detroit. Wisely mentored, he flourished at Cass Technical High School, making possible the education and experiences of Cranbrook that greatly widened his artistic vision and taught him to collaborate successfully with those in allied fields. His skills and sophistication evolved greatly while working with Eliel and Eero Saarinen, Charles Eames, and others, while his father-in-law, Wilhelm Valentiner, introduced him to recent art and the art world. Associates from Cranbrook were constant factors in his life. He developed a strong sense of order and perfection, as well as the desire to create works embodying those characteristics. Whether he was creating a large commission or something small and seemingly insignificant, he always worked as if it were a piece of fine jewelry.

Bertoia lived for just a year past his sixty-second birthday. Although he was never able to make an aeolian harp, he came near his dream of making a vast outdoor piece with a two-ton gong he made just before he was sixty. Its two circles of bronze, 10 feet (3 m) in diameter, are welded together and hang near both his house and barn. Testing it, he heard it 3 miles (4.8 km) away at his shop. His burial site would be at that gong, and a simple memorial service was held there. His friend Richard Schultz vividly remembered it. Yellow leaves were floating down from the trees behind the gong evoking the reredos of the Kresge Chapel. Nature provided the perfect setting.

ENDNOTES

CHAPTER 1

1 Oral history interview with Harry Bertoia, June 20, 1972, the Archives of American Art, Smithsonian Institution.

2 For discussion of Bertoia's years in Italy, I rely on Celia Bertoia, *The Life and Work of Harry Bertoia. The Man. The Artist. The Visionary.* (Atglen, PA: Schiffer, 2015), passim, and on her interviews with Ave Bertoia di Paolo, October 29 and 30, 2008, and May 21, 2010, Di Paoli farm, Cayley, Alberta, Canada. I am grateful for her assistance and the many materials she has provided. It is curious that, in an undated letter to Hilla Rebay from early 1944, Bertoia indicated his birthplace as "San Lorenzo di Valvasone, Udine, Italy." It is now sometimes referred to as San Lorenzo Pordenone, associating it with the closest large town. Wilbur Springer provided me with a copy of the complete Bertoia-Rebay correspondence, only some of which was published in Joan M. Lukach, *Hilla Rebay: In Search of the Spirit in Art* (New York: George Braziller, 1983).

3 Bertoia, Celia, interviews with Ave Bertoia di Paolo, October 29 and 30, 2008.

4 Oral history interview with Harry Bertoia, June 20, 1972, the Archives of American Art, Smithsonian Institution.

5 Ibid.

6 John Willenbecher, *Harry Bertoia, A monograph* (master's thesis, Brown University, 1958); and Celia Bertoia, *The Life and Work*, 16–18. His entry into the United States through Canada was illegal, it turned out, and delayed his being drafted into military service from Cranbrook. Later it slowed the process of obtaining citizenship. (Oral history interview with Harry Bertoia, June 20, 1972, the Archives of American Art, Smithsonian Institution.)

7 Oral history interview with Harry Bertoia, June 20, 1972, the Archives of American Art, Smithsonian Institution.

8 Armando Delicato, *Italians in Detroit* (Chicago, IL: Arcadia, 2005), 107–18.

9 Celia Bertoia, *The Life and Work*, 18.

10 Adam Gopnik, "What Alexander Calder set in motion," *New Yorker*, December 4, 2017, 73.

CHAPTER 2

Paul Goldberger, "The Cranbrook Vision," *New York Times* magazine, april 8, 1984, 48, nytimes.com/1984/04/08/magazine/the-cran brook-vision.html, accessed April 23, 2015.

1 H. H. Miller, "How Michigan Became the Epicenter of the Modernist Experiment," www.nytimes.com/2018/09/06/t-magazine/michigan-modernist-architecture.html?action=click&module=Well&pgtype=Homepage §ion=T%20Magazine

2 Amy L. Arnold and Brian D. Conway, "Introduction," Amy L. Arnold and Brian D. Conway, eds. *Michigan Modern: Design That Shaped America* (Detroit: Michigan State Historic Preservation Office, and Layton, UT: Gibbs Smith, 2016), passim and 49–52. There is evidence that the region's design activity of the 1940s continues: a 2013 report found that Michigan and California were then the only states "employing more than 3000 industrial designers," 52.

3 Patrick Sisson, "Cranbrook's Golden Age: How a Freewheeling School Changed American Design," *Curbed* (blog), November 17, 2015, www.curbed.com/2015/11/17/9900436/cranbrook-academy-american-modern-design-charles-ray-eames-knoll.

4 Cranbrook Archives, Alumni Records, Richard Raseman to Harry Bertoia, May 5, 1937. See J. David Farmer, "Metalwork and Bookbinding," in Clark et al., *Design in America*, 163n52.

5 Paul Goldberger, "The Cranbrook Vision," *New York Times Magazine*, April 8, 1984, 48, www.nytimes.com/1984/04/08/magazine/the-cran brook-vision.html, accessed January 21, 2017.

6 Oral history interview with Harry Bertoia, June 20, 1972, Archives of American Art, Smithsonian Institute.

7 Gregory Wittkopp, "Cranbrook Academy of Art: Architecture's Cradle of Modernism," in Arnold and Conway, *Michigan Modern*, 84.

8 Ralph Rapson studied architecture at both Cranbrook and the University of Michigan, where George Booth's son, Henry, was pursuing a degree, including taking a course taught by visiting professor Eliel Saarinen.

9 Florence Schust subsequently was a student at the London Architectural Association but left because of the war, completing her studies at the Institute of Design in Chicago, where she worked with Ludwig Mies van der Rohe. In 1941 she would join Hans Knoll's furniture company and establish its Planning Unit in interior architecture, at which time Knoll renamed it Knoll Associates. In 1946 they married.

10 Leslie S. Edwards, "Competition, Collaboration and Connection," in Arnold and Conway, *Michigan Modern*, 165.

11 Edwards, "Competition, Collaboration, and Connection," in Arnold and Conway, *Michigan Modern*, 165–66 and n26; and Benjamin Baldwin, *Benjamin Baldwin: An Autobiography in Design* (New York: Norton, 1995), 22.

12 Robert Judson Clark, "Cranbrook and the Search for Twentieth-Century Form," in Clark et al., *Design in America*, 33; and Craig Miller, "Interior Design and Furniture," in Clark et al., *Design in America*, 110 and n96. I have followed the Eames biography in *Design in America* (269–70), while Arthur Drexler, in *Charles Eames, Furniture from the Design Collection* (New York: Museum of Modern Art, 1973), maintains that Eames went to Cranbrook in 1936 (12).

13 Eric Larrabee and Massimo Vignelli, *Knoll Design* (New York: Harry N. Abrams, 1987), 20.

14 Knoll has undergone many name changes (especially when it has been sold), including "Knoll Furniture" and "Knoll International" and still has divisions known as "Knoll Studio" and "Knoll Textiles."

15 Larrabee and Vignelli, *Knoll Design*, 19

16 Brigitta Valentiner, *The Adventure of Living: The Life of Mrs. Harry Bertoia*, self-published, 1984, 69.

17 Oral history interview with Harry Bertoia, June 20, 1972, the Archives of American Art, Smithsonian Institute.

18 Ibid.

19 Ibid.

20 Shelley Selim, *Bent, Cast & Forged: The Jewelry of Harry Bertoia* (Bloomfield Hills, MI: Cranbrook Museum of Art, 2015), 22. He had also cast a wedding ring for the wife of Edmund Bacon, another Cranbrook classmate. Bacon became a controversial city planner for Philadelphia.

21 Taxco, Mexico, had become a center for the design and production of Modernist silver and copper jewelry and tableware in the 1930s, with the *tallers* (ateliers) of many artists developing in part under the influence of the American designer William Spratling. Georg Jensen had been producing fine items in Denmark since at least 1906, modernizing styles consistent with the times. Both Taxco and Jensen jewelry were very popular in the United States even before the 1940s.

22 The earrings are included in Martine Newby Haspeslagh, *Jewelry by Contemporary Painters and Sculptors @ 50: 1967–2017* (London: Didier, 2017), 24–25, no. 6.

23 Selim, *Bent, Cast & Forged*, 41.

24 Alexander S. C. Rower and Holton Rower, eds, *Calder Jewelry* (New York: Calder Foundation and Yale University Press, 2007), 13.

25 Selim, *Bent, Cast & Forged*, 22.

26 J. David Farmer, "Metalwork and Bookbinding," in Clark et al., *Design in America*, 165–66.

27 Ellen M. Dodington, *Cranbrook Art Museum: 100 Treasures* (Bloomfield Hills, MI: Cranbrook Art Museum, 2004) as quoted in discussion of this piece, cranbrookartmuseum.org/artwork/harry-bertoia-coffee-and-tea-service/.

28 June Kompass Nelson dated these works in the published version of her master's thesis, *Harry Bertoia Sculptor* (Detroit: Wayne State University Press, 1970), plates 4 and 5. She worked closely with Bertoia to establish as much chronology as possible, so it is likely that these are dates he gave her. She owned a copy of *Grape Harvest*.

29 Julie Longacre, "A Moment in Time with Harry Bertoia," unpublished memoir, October 2011, as quoted by Celia Bertoia, *The Life and Work*, 31.

30 Harry Bertoia, in conversation with Sally Fairweather and [unknown] Hoff, tape 1, side B, as quoted by June Kompass Nelson, *Harry Bertoia, Printmaker* (Detroit: Wayne State University Press, 1988), 33. His reference to his "inner self" recalls Kandinsky's emphasis on working from "inner necessity."

31 Joan M. Lukach and S. Ferleger in conversation with Bertoia, May 1978, in Joan M. Lukach, *Hilla Rebay: In Search of the Spirit in Art* (New York: George Braziller, 1983), 149.

32 Julie Longacre, "A Moment in Time with Harry Bertoia," unpublished memoir, October 2011, as quoted by Celia Bertoia, *The Life and Work*, 31.

33 Joan Marten, "Painting and Sculpture," in Clark et al., *Design in America*, 258.

34 Joan Marten, "Painting and Sculpture," in Clark et al., *Design in America*, 260–61; Celia Bertoia, 32, and Susan Joyce McGhee, interview with Harry Bertoia for a master's thesis, Pennsylvania State University, March 28, 1979, 90, as quoted by Celia Bertoia, n4, 246.

35 Holland Cotter, "The Guggenheim's Greatest Hits Come Roaring Back," *New York Times*, March 9, 2017, www.nytimes.com/2017/03/09/arts/design/the-guggenheims-greatest-hits-come-roaring-back.html, accessed March 9, 2017.

36 Guggenheim Museum, "Hilla Rebay," www.guggenheim.org/history/hilla-rebay?utm_medium=Email&utm_source=ExactTarget&utm_campaign=Mktg_InternationalWomens Day_030818, accessed March 12, 2018.

37 Ibid.

38 Hilla Rebay to Harry Bertoia, March 3, 1943. Largely unpublished correspondence between Harry Bertoia and Hilla Rebay, 1943–46, provided by Wilbur Springer and Lesta Bertoia. They assembled this as part of preparing the artist's estate. I am indebted to Wilbur Springer for lending me the very informative letters.

39 Harry Bertoia, letter to Hilla Rebay, June 18, 1943.

40 This exchange between them includes Hilla Rebay's letter to Harry Bertoia, October 23, 1943, as quoted by Lukach, *Hilla Rebay* 149–50. Brigitta Bertoia discussed their friendship with Oskar and Elfriede Fischinger in Valentiner, *The Adventure of Living*, 100–106.

CHAPTER 3

Henry Dreyfuss, "California: World's New Design Center," *Western Advertizing*, June 1947, 60, as quoted by Wendy Kaplan, "Introduction: 'Living in a Modern Way,'" *Living in a Modern Way: California Design 1930-1965*, Wendy Kaplan, ed., Los Angeles Country Museum of Art (Cambridge, MA and London, England: The MIT Press, 2011, 28.

1 Brigitta Valentiner, *The Adventure of Living: The Life of Mrs. Harry Bertoia*, self-published, 1984, 86.

2 Oral history interview with Harry Bertoia, June 20, 1972, the Archives of American Art, Smithsonian Institute.

3 Marilyn Neuhart with John Neuhart, *The Story of Eames Furniture*, vol. 1, (Berlin, Die Gestalten Verlag, 2010), 126; and oral history interview with Harry Bertoia, 20 June, 1972, the Archives of American Art, Smithsonian Institute.

4 John Neuhart and Marilyn Neuhart, with the editorial assistance of Ray Eames, *Eames Design* (New York: Harry N. Abrams, 1989) 27.

5 Wendy Kaplan, "Introduction," and Bobbye Tigerman, "Fusing Old and New: Émigré Designers in California," in Kaplan, *Living in a Modern Way*, 92.

6 Kaplan, *Living in a Modern Way*, 28, 34–35; and Glen Lukens, "The New Handcraftsman," *California Arts & Architecture*, December 1934, 13, quoted by Kaplan, *Living in a Modern Way*, 39.

7 Jeremy Aynsley, "Developing a Language of Vision: Graphic Design in California," in Kaplan, *Living in a Modern Way*, 268.

8 Neuhart and Neuhart, with the editorial assistance of Ray Eames, *Eames Design*, 9–10.

9 Ibid, 43.

10 Ibid, 8–9.

11 Ibid, 28–33.

12 Todd Oldham, "Alexander Girard," in Kaplan, *Living in a Modern Way*, 149.

13 Neuhart with Neuhart, *Story of Eames Furniture*, 124.

14 Oral history interview with Harry Bertoia, June 20, 1972, the Archives of American Art, Smithsonian Institute.

15 Oral history interview with Harry Bertoia, June 20, 1972, the Archives of American Art, Smithsonian Institute.

16 Neuhart and Neuhart, with the editorial assistance of Ray Eames, *Eames Design*, 69–71. Eliot Noyes's essay appeared in the September 1946 issue of *Arts & Architecture*.

17 Oral history interview with Harry Bertoia, June 20, 1972, the Archives of American Art, Smithsonian Institute.

18 Neuhart with Neuhart, *The Story of Eames Furniture*, 125.

19 Marilyn Neuhart interviewed Ray Eames in Venice, California, in 1982, Neuhart with Neuhart, *The Story of Eames Furniture*, 126–27.

20 Hilla Rebay to Harry Bertoia, August 30, 1944, unpublished letter copied by Wilbur Springer for the Harry Bertoia Foundation.

21 "Modern Handmade Jewelry," September 11, 1946, Museum of Modern Art, New York, documents, www.moma.org/documents/moma_press-release_325531.pdf?, accessed December 12, 2017.

22 Valentiner, *Adventure of Living*, 99–106.

23 Frederick A. Sweet and Katharine Kuh, *Abstract and Surrealist American Art. Fifty-eighth Annual Exhibition of American Paintings and Sculpture*, Chicago, Art Institute of Chicago, 1947. www.artic.edu/sites/default/files/libraries/pubs/1948/AIC1948PandS58thAn_comb.pdf, accessed September 12, 2018.

24 Dave Hampton, "John McLaughlin & Harry Bertoia in San Diego," *Culture Lust* (blog), November 29, 2009, and now appears at www.kpbs.org/news/2009/nov/29/mid-century-modern-art-san-diego-culture-lust-seri/, accessed September 14, 2018.

25 Walker Art Center, "Modern Jewelry Under Fifty Dollars," *Everyday Art Quarterly*, no. 7 (Spring 1948): 6. John Lyon of the Walker's library generously provided me with this material.

26 Mrs. David M. Stewart, Foreword, Toni Greenbaum, *Messengers of Modernism: American Studio Jewelry 1940-1960*. Martin Eidelberg. Ed. Montreal Museum of Decorative Arts, Paris and New York: Flammarion, 1996, 11.

27 Greenbaum, *Messengers of Modernism*, 56–60. The earrings are on p. 60.

28 I am indebted to James A. Kallas of Kallas Jewelers in Santa Fe, New Mexico, for insight into their making. Conversation with the author, July 2017.

29 Selim, *Bent, Cast & Forged: The Jewelry of Harry Bertoia*, (Bloomfield Hills, MI: Cranbrook Museum of Art, 2015). Personal correspondence with the author, July 15, 2015.

30 Email from the dealer Kenneth Maffia to John Brien, January 4, 2017, explaining that Ihlenfeld had attributed them to Bertoia.

31 Valentiner, *The Adventure of Living*, 95–97.

32 Lao Tsu, *Tao Te Ching*, trans. Gia-Fu Feng and Jane English (New York: Vintage Books, 1972), Two.

CHAPTER 4

Harry Bertoia, quoted in the *Denver Post*, May 25, 1966, www.gettyimages.com?license/836984282.

1 Brigitta Valentiner, *The Adventure of Living: The Life of Mrs. Harry Bertoia*, self-published, 1984, 119–124.

2 John Brunetti, *Baldwin Kingrey, Midcentury Modern in Chicago 1947-1957* (Chicago: Wright, 2007), 11–84, passim.

3 Richard Schultz, telephone conversation with the author, December 12, 2017. I am indebted to him for his generosity with information and for his insights into the history of modern furniture and sculpture, especially Bertoia's.

4 Bobbye Tigerman, "I Am Not a Decorator: Florence Knoll, the Knoll Planning Unit and the Making of the Modern Office," *Journal of Design History* 20, no. 1 (January 2007): 61–62, www.deepdyve.com/lp/oxford-university-press/i-am-not-a-decorator-florence-knoll-the-knoll-planning-unit-and-the-c6k9HUSi4p?articleList=%2Fsearch%3Fquery%3Di%2Bam%2Bnot%2Ba%2Bdecorator%2Bflorence%2Bknoll%2Bthe%2Bknoll%2Bplanning%26docNotFound%3Dtrue accessed November 28, 2017.

5 Eric Larrabee and Massimo Vignelli, *Knoll Design* (New York: Harry N. Abrams, 1981), 69.

6 Oral history interview with Harry Bertoia, June 20, 1972, the Archives of American Art, Smithsonian Institute.

7 Ibid.

8 Ibid.

9 Larrabee and Vignelli, *Knoll Design*, 50.

10 Richard Schultz, telephone conversation with the author, December 12, 2017.

11 Bill Shea, telephone conversation with the author, December 8, 2017. I appreciate Bill's great historical and technical knowledge, his generosity with them, and his editorial skill. He is a founding partner at Shea+Latone, a design, development, and engineering consulting firm specializing in contract furniture design, seating, and accessories.

12 Oral history interview with Harry Bertoia, June 20, 1972, the Archives of American Art interview, Smithsonian Institute.

13 Ibid.

14 Bobbye Tigerman, transcript of an interview with Richard Schultz, June 29, 2004, in Schultz's office, Palm, Pennsylvania.

15 Larrabee and Vignelli, *Knoll Design*, 68.

16 Richard Schultz, telephone conversation with the author, December 12, 2017.

17 Bobbye Tigerman, transcript of an interview with Richard Schultz, June 29, 2004, in Schultz's office, Palm, Pennsylvania.

18 "Making Bertoia," Knoll (website), knoll.com/knollnewsdetail/bertoia-production?trk_msg=70728MH7NV4 4NAEACF6RVON/UG6trK_contact, accessed June 21, 2017.

19 Oral history interview with Harry Bertoia, June 20, 1972, the Archives of American Art, the Smithsonian Institute.

20 Betty Pepis, "Sculptor Designs Wire-Shell Chairs," *New York Times*, December 10, 1952, 46, timesmachine.nytimes.comtimesmachine/1952/12/10/84377526.html?pageNumber=46.

21 Bill Shea, telephone conversation with the author, December 8, 2017, and subsequent e-mail correspondence.

22 I am indebted to Wilbur Springer for sharing this information with me as well as for having the chair so beautifully photographed.

23 Bill Shea, telephone conversation with the author, December 8, 2017.

24 Bill Shea, telephone conversation with the author, December 8, 2017, and e-mail correspondence, March 16, 2018; Wilbur

Springer, "The Bertoia Chaise Lounge. A Mid-Century Modern Design Masterpiece," draft of an article, March 2018. I appreciate being able to see and use his work in progress.

25 I appreciate Wilbur Springer's generosity in informing me of the existence of these drawings and lending me the images.

26 Bill Shea, telephone conversation with the author, December 8, 2017, and e-mail March 18, 2018.

27 Bill Shea, e-mail to the author, March 8, 2018.

28 Bill Shea, telephone conversation with the author, December 8, 2017.

29 Don Petitt in an interview, September 6, 1994, conducted for the Vitra Design Museum by Alexander von Vegesack. I appreciate Bill Shea providing me with the valuable and interesting material.

30 Richard Schultz, telephone conversation with the author, December 12, 2017.

31 Bill Shea, telephone conversation with the author, December 8, 2017.

32 "Prices in 1954," Fifties Web (website), fiftiesweb.com/pop/prices-1954, accessed November 6, 2017.

33 Bill Shea, telephone conversation with the author, December 8, 2017.

34 Bill Shea, telephone conversation with the author, December 8, 2017.

35 Larrabee and Vignelli, Knoll Design, 69.

36 Hans Knoll in a letter to Harry Bertoia, February 11, 1954, offered to pay him eight dollars an hour plus expenses, including travel to New York to see objects. Papers of Harry Bertoia, the Archives of American Art, Smithsonian Institution, and the Harry Bertoia Foundation.

37 Designed by Zion Breen Richardson Associates, it was a gift to the city from William S. Paley in honor of his father, Samuel.

CHAPTER 5

1 June Kompass Nelson, Harry Bertoia, Sculptor (Detroit: Wayne State University Press, 1970), Plate 17, shows Bertoia's "Study of light and space effects (c.1943), metal painted white, about 13 x 30 x 3 in., photographed in window of his studio."

2 Betty J. Blum, oral history interview with Gordon Bunshaft, April 4 to 7, 1989, Chicago Architects Oral History Project, Department of Architecture, the Art Institute of Chicago, digital-libraries.saic.edu/cdm/ref/collection/caohp/id/18407, accessed December 18, 2017.

3 Jayne Merkel, Eero Saarinen (London: Phaidon Press, 2005), 73.

4 Ibid., 69–73. Much attests to the historical and architectural importance of the complex: it is on the National Register of Historic Places, was named one of the "Most Outstanding Architectural Achievements of its Era" by the American Institute of Architects, and was called "a Versailles of modern industry" by Ada Louise Huxtable.

5 Delf Dodge, "A Look Inside GM Technical Center's Restoration," Smith GM Chevrolet Cadillac Blog. June 16, 2011, smithgm.wordpress.com/2011/06/16/a-look-inside-gm-technical-center's-restoration/, accessed December 20, 2017.

6 Harry Bertoia to Wilhelm Valentiner, September 5, 1951. Wilbur Springer has generously lent me this letter.

7 Harry Bertoia to Wilhelm Valentiner, December 25, 1951. I appreciate Wilbur Springer's generosity in providing me with a copy of this letter.

8 Hans Knoll to Harry Bertoia, February 11, 1954, Harry Bertoia papers, 1917–79, the Archives of American Art, Smithsonian Institution.

9 Ibid.

10 Ibid.

11 Oral history interview with Harry Bertoia, June 20, 1972, the Archives of American Art, Smithsonian Institution.

12 Ada Louise Huxtable, "Banker's showcase," Arts Digest, December 1, 1954, 13, as quoted by Marin Sullivan, "Alloyed Screens: Harry Bertoia and the Manufacturers Hanover Trust Building—510 Fifth Avenue," Sculpture Journal 25, no. 3 (December 2016): 362.

13 Nelson, Harry Bertoia Sculptor, 32.

14 Sullivan, Sculpture Journal 25, no. 3 (December 2016): 361–79.

15 Letter from Harry Bertoia to Wilhelm Valentiner, dated only "1954." Wilbur Springer has generously provided me with a copy of this informative letter.

16 "15,000 Ooh and Ah at Opening of Dazzling, 'Newfangled' Bank," New York Times, October 5, 1954, timesmachine.nytimes.comtimesmachine/1952/10/05, accessed February 9, 2012.

17 On June 29, 1992, Manufacturers Hanover Trust was absorbed by Chemical Bank. JPMorgan Chase in turn would take it over as deregulation reshaped U.S. banking. Most discussion of deregulation was in terms of economics, but a largely overlooked result of the new rules was that banks reduced or abandoned their role as patrons of art, because deregulation and mergers led to intense emphasis on profitability: works of art often were removed and "monetized." Manufacturers Hanover Trust, as a masterpiece of the American International Style, had been awarded landmark status by the New York City Landmarks Preservation Commission in 1977. That status limited alterations to its structure and led to legal action restricting the new owner, Vornado Realty Trust, a development company specializing in retail property, concerning proposed changes to the building. The Bertoia screen was removed in 2010, and a year later the Landmarks Preservation Commission took the unprecedented step of adding the interior, including the screen, to the building's landmark status. Reinstalling and restoring the screen, which is the property of JPMorgan Chase, ensued. Robin Pogrebin, "Settlement Reached on 5th Avenue Landmark," ArtsBeat (blog). New York Times, February 8, 2012, artsbeat.blogs.nytimes.com/2012/02/08/preservationists-win-a-battle-over-former-manufacturers-hanover-trust-building/.

18 Sir David Adjaye discusses Eero Saarinen, October 14, 2016, arts.mit.edudavid-adjaye-discusses-eero-saarinens-mit-chapel, accessed February 14, 2017.

19 Sir David Adjaye at MIT, interview at Eero Saarinen's MIT chapel, www.youtube.com/results?search_query=david+Adjaye+MIT+chapel, accessed January 13, 2018. An African-born architect whose practice is based in London, Adjaye is not only an innovative architect but also an articulate spokesman for his profession.

20 Noah Jeppson, "Dallas Central Library," Unvisited Dallas (blog), March 22, 2011, www.unvisiteddallas.com/archives/236, accessed March 12, 2017; and The Nostalgic Glass (website), nostalgicglass.org/background.php?pn=19, accessed April 15, 2018.

21 Among these were group exhibitions at MoMA, the Art Institute of Chicago, the Museum of Contemporary Crafts in New York, the Walker Art Center (the Third National Exhibition of Contemporary Jewelry), and Cranbrook. In addition, the Smithsonian Institute arranged a traveling exhibition of Bertoia's graphics and sculpture. See the chronology for a more complete list of exhibitions and awards.

CHAPTER 6

Peter van Dijk, in telephone conversation with the author, May 15, 2018.

1 Letter from Harry Bertoia to Mr. Rhodes (no further identification), Harry Bertoia papers, 1917–79, the Archives of American Art, Smithsonian Institution.

2 Correspondence between John M. Garber, architect with Garber, Tweddell & Wheeler, Cincinnati, Ohio, and Harry Bertoia, Harry Bertoia papers, 1917–79, the Archives of American Art, Smithsonian Institution.

3 Unfortunately, there are fake "Bertoia" sprays, many of them unconvincing but some are fairly skillful. The bad approximations, sometimes even kitschy fiberoptic lights, can ultimately interfere with responses to the Bertoia originals, much as cheap souvenirs with images of the Mona Lisa persist in our brains' storehouse of visual images.

4 Peter van Dijk, in telephone conversation with the author, May 15, 2018.

5 Harry Bertoia to F. Gordon Smith, Syracuse University, March 14, 1962. Laura Wellner, registrar of the Syracuse Art Museums, kindly found and provided me with this letter.

6 Celia Bertoia, The Life and Work of Harry Bertoia: The Man. The Artist. The Visionary (Atglen, PA: Schiffer, 2015), 151. She also noted what tedious work was involved in the dandelions' preparation: each of about a thousand of the longer wires and seventy thousand shorter ones had to be cleaned, some of them by her sister, Lesta, before they could be welded.

7 Visions of Man (Richmond, VA: Virginia Museum of Fine Arts, 1963, exhibition brochure); and Visions of Man in Twelve Aluminum Sculptures (Richmond, VA: Reynolds Metals Company, n.d., exhibition booklet). I appreciate Howell Perkin's providing these materials to me.

8 "Aluminum Winners on Exhibit, Richmond-Times Dispatch, October 2, 1966 (xerox copy, unpaginated). I appreciate Howell Perkin's providing these materials to me.

9 Contract between A. P. Myers of the Federal Aviation Authority and Harry Bertoia, September 1, 1962. He had received a telegram the day before informing him that he had been awarded contract FA-3218. Harry Bertoia papers, 1917–79, the Archives of American Art, Smithsonian Institution.

10 Oral history interview with Harry Bertoia, June 20, 1972, the Archives of American Art, Smithsonian Institution.

11 This is the only one of these works that is not familiar to me from seeing Bertoia works or photographs of spill-cast works. The lump at the top may have been a small visual joke, a

"rock" Bertoia formed of bronze to complement real rocks, if indeed this piece ever existed.

12 Wright 20th Century Auctions, note for this piece, lot 234, *Modern Design*. June 9, 2002, Wright20.com.

13 Harry Bertoia, on the occasion of the installation of *Free Interpretation of Plant Forms* at the Philadelphia Civic Center, May 23, 1967, woodmereartmuseum.org/explore-online/collection/free-interpretation-of-plant-forms, accessed April 26, 2018.

CHAPTER 7

Oral history interview with Harry Bertoia, June 20, 1972, the Archives of American Art, Smithsonian Institution.

1 Oral history interview with Harry Bertoia, June 20, 1972, the Archives of American Art, Smithsonian Institution, Part II.

2 Substantive ideas sometimes return to mind in connection with newer experiences or knowledge. Bertoia would have read about Italian Modernist art, particularly the work of the Futurist Luigi Russolo. Russolo's 1913–14 "noise music concerts" have survived as subjects of historical curiosity more than a century later. Many Futurists wrote manifestos, and Russolo produced *L'Arte dei rumori (The Art of Noises)*, the only evidence that survives of his noise-making implements, or *Intonarumori*. It is likely Bertoia knew of Russolo's *Intonarumori*.

3 "Song & Dance Man," *Time*, March 31, 1961, 56, as quoted by C[hristopher] H[atten], "Harry Bertoia, *Wheatfield*, 1960," *Through American Eyes: Two Centuries of American Art from the Huntington Museum of Art* (Huntington, WV: Huntington Museum of Art, 2003).

4 In a letter to the Huntington museum director (June 26, 1970), Bertoia referred to the piece as *Wheatfield* when replying to a request that he attest in writing to having created the work. Bertoia complied, sending a photo of the sculpture attached to information from Staempfli Gallery describing the piece. Bertoia added his signature, verifying that he had made the sculpture. Unfortunately, the conversation or correspondence that explains how the title was assigned is missing. Later, when collectors or institutions wanted him to attest to the authenticity of works, he would provide sketches of them with his signature.

5 Harry Bertoia, in conversation with the author, August 4, 1974, in Bertoia's barn.

6 Ibid.

7 Oral history interview with Harry Bertoia, June 20, 1972, the Archives of American Art, Smithsonian Institution, Part I. Bertoia would, however, soon make gongs of copper that had beautiful sounds.

8 Oral history interview with Harry Bertoia, June 20, 1972, the Archives of American Art, Smithsonian Institution, Part II.

9 Henry Greene was his helpful young friend.

10 John Brien, "Introduction," Complete *Sonambient Collection*, Groveland, MA, Important Records, 2016.

11 Sotheby's, *Bertoia, Featuring Masterworks from the Kaare Berntsen Collection* (November 16, 2016, auction), (New York: Sotheby's, 2016), 10.

12 John Grayson, ed., *Sound Sculpture* (Vancouver: Aesthetic Research Centre of Canada, 1975), passim. Among the pieces included were the "Structures Sonores" of François and Bernard Baschet, as well as works of Von Huene, Reinhold Pieper Marxhausen, and Charles Mattox.

13 Wright 20th Century Auctions, *Harry Bertoia: The Standard Oil Commission* (Chicago: Wright 20th Century Auctions, 2013), 24.

14 In 1994, when the (then) Amoco Building plaza was redesigned, the reflecting pool was divided into two sections, and six sounding pieces were removed. The remaining pieces were placed farther from the waterfall and the trees, and when the building changed hands again, bought by Aon, more pieces left the plaza, this time for Wright 20th Century Auctions, where they were sold in 2013.

15 Wright 20th Century Auctions, *Harry Bertoia: The Standard Oil Commission*, 6. He also lamented that the sculptures had not been sufficiently maintained.

16 Douglas Durden, "Art Is Ready, but Context Isn't," *Richmond Times-Dispatch*, July 7, 1978.

CONCLUSION

1 Jack Burnham, *Beyond Modern Sculpture* (New York: George Braziller, 1968), 100–101.

2 Ibid., 101, 168.

3 The Bertoia Studio and Harry Bertoia Foundation had much to do with fostering its return to life.

MAJOR EVENTS IN HARRY BERTOIA'S
LIFE AND CAREER

1915
Born, San Lorenzo d'Arène, Friuli, Italy.

1930
Arri Bertoia entered the United States through Windsor, Canada, with his father and from then on he used the name Harry. He went to live with his brother, Oreste, in Detroit, Michigan.

1930–36
Attended Detroit public schools, graduating from Cass Technical High School.

1936–37
Studied at the Art School of the Detroit Society of Arts and Crafts on scholarship.

1937–43
Entered the Cranbrook Academy of Art, Bloomfield Hills, Michigan as a scholarship student. In 1939 he became master of the metal shop, teaching metalwork, and he began working at night on woodcuts, then monotypes, in the print shop. Bertoia sold his jewelry at the Detroit Artists Market and in 1941 was awarded two purchase prizes at the Annual Exhibition of Michigan Artists at the Detroit Institute of Arts. In 1941 A. Everett "Chick" Austin Jr., the avant-garde director of the Wadsworth Atheneum Museum of Art, in Hartford, Connecticut, bought twenty-four monotypes for the museum's collection.

1942
The metal shop closed because of wartime shortages of metal, and Bertoia took over the print shop, teaching printmaking and creating monotypes. He participated in the 1942 Cranbrook Faculty Show. He met a student, Brigitta Valentiner, and her parents, Caecelia and Wilhelm Valentiner, director of the Detroit Institute of Arts, an authority on the work of Rembrandt and a collector of German Expressionist paintings and prints. Wilhelm Valentiner would mentor Bertoia, introducing him to Modernist prints and paintings and advising him in his career.

1943
Bertoia married Brigitta Valentiner. Hilla Rebay purchased more than one hundred Bertoia monotypes for the Museum of Non-Objective Painting in New York, later to become the Solomon R. Guggenheim Museum. There was an exhibition and sale of jewelry and monotypes at Cranbrook and a show of his jewelry with that of Alexander Calder and others at Nierendorf Gallery, New York. Charles Eames invited Bertoia to work for him at Evans Products Company, making splints and other objects for the war effort. Harry and Brigitta Bertoia drove to California in the summer of 1943, and in September Harry Bertoia began working for the Eameses. The Eames project was sold, proceeding under the name Evans Products.

1944–46
In 1944 Evans Products paid for Bertoia to learn welding at the Santa Monica City College. That same year, his first child, Mara Lesta, was born. In August 1944, Bertoia monoprints were exhibited at Catholic University, Washington, D.C., and in 1945 he had a solo show of monotypes at the San Francisco Museum of Art. In the summer of 1945, fifty-three monotypes were exhibited at the Phillips Collection, Washington, D.C., five of which the museum purchased. In the fall of 1946, Bertoia and others left the Eames Office as a result of a dispute over the "Eames" chair. Karl Nierendorf continued showing Bertoia works, as did his friend Hilla Rebay. Bertoia received a $200 monthly stipend from Karl Nierendorf until the dealer's death in 1947. In 1946 Bertoia became a U.S. citizen, and his jewelry was included in the exhibition Modern Handmade Jewelry at the Museum of Modern Art (MoMA) in New York.

1947
Bertoia was hired, initially part time, to work as a graphic designer at the U.S. Navy Electronic Laboratory at Point Loma, San Diego, requiring him to move to La Jolla. In early 1947 he had monoprints on exhibit at the Abstract and Surrealist American Art: Fifty-Eighth Annual Exhibition of American Paintings and Sculpture at the Art Institute of Chicago. A monotype was illustrated in the May issue of Arts & Architecture magazine. He had his last solo show at Nierendorf Gallery and Outlines Modern Art Gallery in Pittsburgh began representing his work. He was experimenting with welded sculpture.

1948–49
Bertoia jewelry was included in the Second National Exhibition of Contemporary Jewelry, Walker Art Center, Minneapolis. Bertoia was making large Surrealist jewelry in brass, and becoming increasingly interested in Eastern philosophies. The Bertoias' son, Val, was born in 1949.

1950–52
The Bertoia family moved to Pennsylvania, living initially in New Hope, then Quakertown, as Bertoia established a metal shop for Knoll in Pennsburg. After several moves, Bertoia found a small farm to rent in Barto, near the new Knoll metals plant in Bally. Bertoia would purchase the metal shop, a year later from Knoll. Josef Albers nominated Bertoia to be visiting critic in sculpture at the Yale University School of Art.

1953
Bertoia resigned from Knoll (but consulted for the company for years thereafter) to devote more of his energy to sculpture. Eero Saarinen commissioned him to make a sculptural screen for the cafeteria of the General Motors Technical Center, Warren, Michigan. Bertoia sculpture went on loan to MoMA for exhibition.

1954
Gordon Bunshaft of Skidmore, Owings and Merrill commissioned Bertoia to create a sculpted screen for the Manufacturers Trust Company, 510 Fifth Avenue, New York, as well as a wire cloud to hang above the escalator. The artist was awarded the Gold Medal of the Architectural League of New York for the Manufacturers Trust screen and commissioned by Eero Saarinen to create an altar screen for the Kresge Chapel at the Massachusetts Institute of Technology (MIT), which he was designing. Bertoia sculpture and monotypes were exhibited at MIT, and he completed a commission for a screen for the Cincinnati Public Library, which would provoke some controversy.

1955
Knoll introduced children's Bertoia chairs, and the Bertoias' third child, Celia, was born. Bertoia won numerous awards and commendations for his chairs, including Designer of the Year, USA, and a Certificate of Merit from the American Institute of Architects (AIA). His work was included in the Third National Exhibition of Contemporary Jewelry at the Walker Art Center in Minneapolis. The commission for the Dallas Public Library was completed, and he received a commission from Minoru Yamasaki for a sculptural screen for the Lambert Airport in St. Louis. His friend and former employer Hans Knoll died in an automobile accident.

1956
Bertoia was awarded the Craftsmanship Medal in Metal Design by the AIA. Chicago's Fairweather-Hardin Gallery held its first solo show of Bertoia's works, and his work was included in an exhibition at the Museum of Contemporary Crafts in New York. He also received commissions for sculpture from the Dayton store in the Southdale Shopping Mall, Edina, Minnesota, and works for the U.S. Department of State, a gong sculpture for the U.S. Consulate in Düsseldorf, and a screen for America House in Bremen. The Smithsonian Institution curated a traveling exhibition of Bertoia works that circulated for ten months in U.S. museums.

1957
Bertoia received a fellowship from the Graham Foundation for Advanced Studies in the Fine Arts, which entailed a six-week seminar with board members and other awardees, as well as a $10,000 stipend that allowed him to travel to Italy, his only trip there after leaving in 1930. On that trip he first visited many important historical and art historical sites. He also received the Craftsmanship Medal of the American Institute of Design and commissions for two sculptures for the U.S. Pavilion at Expo 58, a world's fair in Brussels, and one for a fountain for the First National Bank of Tulsa, Oklahoma. His work was exhibited at the Cranbrook Academy of Art, the annual American art exhibition at the Art Institute of Chicago, and an American Federation of Arts traveling show of metal sculpture, Forged in Fire.

1958
Bertoia was commissioned to make a metal screen for the Davies Auditorium at Yale University and exhibited at Galerie Don Hatch in Caracas, Venezuela. His work was in the exhibitions Living Today at the Corcoran Gallery of Art, Washington, D.C.; and Sculpture 1950-1958 at the Allen Memorial Art Museum at Oberlin College in Ohio.

1959
Florence Knoll commissioned Bertoia to create a ten-panel screen for the National Bank of Miami, and Zenith Radio Corporation commissioned a group of wall-hung sculptures. He received a citation for excellence in furniture design from the Philadelphia Museum College of Art, and he was included in MoMA's Recent Sculpture U.S.A. and served on a panel of exhibition jurors at the Virginia Museum of Fine Arts. His Tree for the U.S. Pavilion at Expo 58 was given to the Virginia Museum by a trustee.

1960
The first sounding sculptures of vertical rods were created in 1959–60, and Bertoia was represented in the exhibition American Sculptors at Galerie Claude Bernard, Paris.

1961
Staempfli Gallery, New York, exhibited Bertoia's work for the first time; Staempfli would remain his primary East Coast gallery. He had a second solo show at Fairweather-Hardin Gallery in Chicago, his Midwest representative. His work was included in Drawings USA at the St. Paul Art Center, Minnesota, and in exhibitions at the Museum of Modern Art, Buenos Aires, organized by Knoll, Inc.

His commissions this year included a screen and a dandelion for the Hilton Hotel, Denver, Colorado; a wall screen for St. John's Unitarian Church, Cincinnati, Ohio; a screen for the Albright-Knox Art Gallery, Albany, New York; and a wall-hung sculpture for the Eastman Kodak Company, Rochester, New York. He was also commissioned by Chi Omega sorority, of Syracuse University in New York, for a wall-hung sculpture, and he lectured to the Collectors Circle of the Virginia Museum of Fine Arts, Richmond.

1962
Bertoia received the 1962 Richard S. Reynolds Memorial Award from Reynolds Metals, Richmond, Virginia, and was commissioned to create a wall sculpture for Bankers Trust, New York. Knoll received the Design Center Stuttgart Award for the Bertoia Chair.

1963
Bertoia exhibited works in the Joslyn Art Museum, Omaha, Nebraska, and a traveling Knoll show in Europe. He also exhibited at Sculpture in the Open Air at Battersea Park, London. He had a second solo show at Staempfli Gallery in New York and received commissions for a dandelion sculpture from Perpetual Savings and Loan Association, Beverly Hills, California and a large, spill-cast bronze mural at the Dulles International Airport, Chantilly, Virginia. He was awarded the Fine Arts Medal of the Pennsylvania Association of the AIA.

1964
Bertoia sculptures were in a group show, *Stone, Wood, Metal*, at Staempfli Gallery in New York and his sculpture and chairs were included in Knoll's Amsterdam exhibition. He was commissioned to create *Sunlit Straw* for Northwestern National Life Insurance, Minneapolis; *World* for the Woodrow Wilson School of Public and International Affairs at Princeton University in New Jersey; *Galaxy* for Golden West Financial, Crystal Valley, California; seven gilt dandelions for the Eastman Kodak Pavilion at the New York World's Fair; and a wall sculpture, *Comet*, for W. Hawkins Ferry, Grosse Pointe Shores, Michigan.

1965
Cuyahoga Savings Association, Cleveland, Ohio, commissioned Bertoia to make a large wire hemisphere to suspend from its lobby's ceiling, and he created a hanging sculpture for Southwestern Bell Telephone of Houston. He also traveled to Spain.

1966
Bertoia was again invited to participate in *Drawings USA* at the St. Paul Art Center in Minnesota, and he received a commission for a fountain for River Oaks Center, Calumet City, Illinois. He traveled to Amsterdam and Brussels for Knoll exhibitions of his work.

1967
Bertoia created the Philadelphia Civic Center fountain, *Free Interpretation of Plant Forms*, and received the award of Excellence in Sculpture from the Philadelphia Arts Festival.

1968
Staempfli Gallery and Fairweather-Hardin Gallery each held its third Bertoia solo show, and his work was included at a Knoll International exhibition in Zürich. The artist was commissioned to create three bronze cubes as planters for Rochester Institute of Technology; thirty-six hanging willow sculptures for Seattle First National Bank in Washington, and, by Minoru Yamasaki, to create a huge fountain sculpture for Manufacturers and Traders Trust, Buffalo, New York. He received the Architecture Critic's Medal from the AIA, and Knoll won the AIA Critics' Award for the Bertoia Chair. He began remodeling his barn, which would ultimately hold about one hundred Sonambient sculptures.

1970
Bertoia had a solo show at Mangel Gallery, Bala Cynwyd, Pennsylvania, and his fourth at Staempfli Gallery. He received a commission for a ceiling sculpture for the Genesee Valley Shopping Center, Flint, Michigan. Bertoia's *Sonambient* LP was released privately.

1971
Bertoia was commissioned to create a sculpted screen for Lake Clifton Senior High School, Baltimore, and received an honorary doctorate of fine arts from Muhlenberg College, Allentown, Pennsylvania. Jeffrey and Miriam Eger made the film *Sonambients: The Sound Sculpture of Harry Bertoia*.

1972
Oreste Bertoia died. Bertoia was commissioned to make the *Marshall University Memorial Fountain*, Huntington, West Virginia. He attended his solo show at Galleri Kaare Berntsen/Galleri KB, Oslo, and attended the opening of the Knoll exhibition at the Louvre in Paris.

1973
Bertoia's work was included in the exhibition and catalog *Sound Sculpture* by the Aesthetic Research Center at the Vancouver Art Gallery. His work was exhibited at Court Gallery, Copenhagen, and there was an exhibition of Bertoia's work at Cedarhurst Center, Mount Vernon, Illinois. He lectured at Marshall University, Huntington, West Virginia. Bertoia was awarded the Fine Arts Medal by the AIA for the *Marshall University Memorial Fountain*.

1974
Bertoia sounding sculpture was exhibited at the Wadsworth Atheneum Museum of Art, Hartford, Connecticut. The artist was commissioned for a bronze fountain for Wichita, Kansas, a fountain for the National Bank of Boyertown in Pennsylvania, and a fountain of tonal sculptures for Standard Oil Plaza, Chicago.

1975
Bertoia was awarded the Institute Award and inducted into the American Academy of Arts and Letters. This was the year of his fourth exhibition at Fairweather-Hardin Gallery, Chicago, and his fifth solo show at Staempfli Gallery, New York, and he went to Oslo for a second solo show at Galleri Kaare Berntsen/KB Galleri. He had exhibitions at Olympia Gallery, Glenside, Pennsylvania, and Inkfish Gallery, Denver, Colorado. The Allentown Art Museum in Pennsylvania held a retrospective exhibition. He received a commission for a standing screen from Swann Oil Company, Bala Cynwyd, Pennsylvania, and one for the University of Pennsylvania's Annenberg Center in Philadelphia.

1976
Bertoia traveled to Guatemala and Peru to visit ancient sites, including Machu Picchu, and to Mexico for laetrile treatment. He received a commission from the Colorado National Bank, Denver, for a large tonal sculpture. Other commissions included a gong sculpture for the U.S. Embassy in Oslo; a hanging sculpture for the Allentown-Bethlehem-Easton Airport, Allentown, Pennsylvania; a hanging sculpture for Sun Oil Company Headquarters, Radnor, Pennsylvania; and a sounding sculpture for Bowling Green State University in Ohio. The artist had an exhibition at Ianuzzi Gallery, Scottsdale, Arizona, his sixth solo show at Staempfli Gallery, New York, and an exhibition at the National Academy of Arts and Sciences, Washington, D.C. He was awarded an honorary doctorate of humane letters by Lehigh University, Bethlehem, Pennsylvania.

1977
Bertoia had a solo show at Galleri Kaare Berntsen/Galleri KB in Oslo, and he attended one at Galeria Don Hatch in Caracas, Venezuela, and lectured to students at the University of Venezuela in Caracas. There were solo Bertoia exhibitions at Marshall University, Huntington, West Virginia, and at the Joslyn Art Museum, Omaha, Nebraska. Bertoia works were shown at Ianuzzi Gallery, Scottsdale, Arizona, and he was commissioned to produce a sculptural screen for Sentry Insurance Company World Headquarters, Omaha, Nebraska. A series of fifty sounding sculptures, numbered and initialed, was produced under his supervision.

1978
Bertoia installed his commission for the Federal Reserve Bank of Richmond, Virginia. His seventh solo exhibition at Staempfli Gallery, New York, took place, and he had exhibitions at Ianuzzi Gallery, Scottsdale, Arizona; Pat Moore Gallery, Aspen, Colorado; Mangel Gallery, Bala Cynwyd, Pennsylvania; Hokin Gallery, Palm Beach, Florida; and Carl Schlosberg Fine Arts Gallery, Los Angeles. There was an exhibition of sculpture and monotypes at Grieg Hall, Bergen, Norway, and one at Heinie-Onstad Art Center, Hovikodden, Norway. A fire in Norway destroyed a number of works borrowed for an exhibition Kaare Berntsen was assembling in Oslo. Bertoia died on November 6, 1978. The Sonambient set of ten more record albums was released privately shortly thereafter.

1979
Bertoia's commission for the Cleveland, Ohio, public library was completed and installed by his son, Val.

1980
Bertoia was awarded the Hazlett Memorial Award for Excellence in the Arts in Pennsylvania, accepted by his widow.

2007
Brigitta Bertoia died.

2015
Remastered Sonambient recordings produced by Important Records, Groveland, Massachusetts.

After Bertoia's death, his work continued to be exhibited at venues including Ianuzzi Gallery, Scottsdale, Arizona (1979, 1984, 1992, 1994); Mangel Gallery, Bala Cynwyd, Pennsylvania (1979, 1983, 1985, 1998, 2001); Fairweather-Hardin Gallery, Chicago (1984); Robert Miller Gallery, New York (2000); Kennedy Galleries, New York (2001); and Solway Gallery, Cincinnati, Ohio (2015). In 2001 Wright 20th Century Auctions held its first auction of works only by Bertoia and held others in 2013 and 2014; Sotheby's held its first in 2013.

Cranbrook Museum of Art held solo shows of Bertoia works in 1980, 1986, 2001, and 2015. The latter exhibition, *Bent, Cast & Forged*, featured the artist's jewelry and related monotypes. Many other museums have held shows of his works, including the Detroit Institute of Arts, Allentown Art Museum in Pennsylvania, Reading Art Museum in Pennsylvania, James A. Michener Museum, Doylestown, Pennsylvania; and college and university museums, including those at Cornell University, Lehigh University, Moravian College, Saginaw University, Ursinus College, University of Missouri, and Montana State University.

In 1987 the house in San Lorenzo d'Arène, where Bertoia was born, was opened, and in 2009 the Pordenone Civic Art Museum in Friuli, Italy, held an exhibition of Bertoia's works.

I have relied in large part on the appendices in Celia Bertoia, *The Life and Work of Harry Bertoia* (Atglen, PA: Schiffer, 2015); and June Kompass Nelson, *Harry Bertoia Sculptor* (Detroit: Wayne State University Press, 1970).

BIBLIOGRAPHY

BOOKS

Arnold, Amy L., and Brian D. Conway, eds. *Michigan Modern: Design That Shaped America*. Detroit: Michigan State Historic Preservation Office; Layton, UT: Gibbs Smith, 2016.

Bertoia, Celia. *The Life and Work of Harry Bertoia: The Man, the Artist, the Visionary*. Atglen, PA: Schiffer, 2015.

Bruegmann, Robert. *The Architecture of Harry Weese*. New York: W. W. Norton, 2010.

Brunetti, John. *Baldwin Kingrey: Midcentury Modern in Chicago 1947-1957*. Chicago: Wright, 2007.

Burnham, Jack. *Beyond Modern Sculpture*. New York: George Braziller, 1968.

Delicato, Armando. *Images of America: Italians in Detroit*. Charleston, SC, : Arcadia, 2005.

Egber, Donald Drew. *Social Radicalism and the Arts*. New York: Alfred A. Knopf, 1970.

Ganzer, Gilberto, ed. *Harry Bertoia. Decisi che una sedia non poterva bastarde*. Milan: Silvana Editoriale, 2009.

Graham Foundation for Advanced Studies in the Fine Arts. *Graham Foundation for Advanced Studies in the Fine Arts*. Chicago: Graham Foundation for Advanced Studies in the Fine Arts, n.d.

Grayson, John, ed. *Sound Sculpture*. Vancouver, Aesthetic Research Centre of Canada: A.R.C. Publications, 1975.

Huntington Museum of Art. *Through American Eyes, Two Centuries of American Art from the Huntington Museum of Art*. Huntington, WV: Huntington Museum of Art, 2003.

Lao Tsu. *Tao Te Ching*. Trans. Gai-Fu Feng and Jane English. New York: Vintage Books, 1972.

Larrabee, Eric, and Massimo Vignelli. *Knoll Design*. New York: Harry N. Abrams, 1987.

Lukach, Joan M. *Hilla Rebay: In Search of the Spirit in Art*. New York: George Braziller, 1983.

Lynch, John. *Metal Sculpture: New Forms, New Techniques*. New York: Viking Press, 1957.

Merkel, Jayne. *Eero Saarinen*. London: Phaidon Press, 2005.

Nelson, June Kompass. *Harry Bertoia Sculptor*. Detroit: Wayne State University Press, 1970.

———. *Harry Bertoia Printmaker: Monotypes and Other Monographics*. Detroit: Wayne State University Press, 1988.

Neuhart, John, and Marilyn Neuhart, with the editorial assistance of Ray Eames. *Eames Design*. New York: Harry N. Abrams, 1989.

Neuhart, Marilyn, with John Neuhart. *The Story of Eames Furniture*, vol. 1. Berlin: Die Gestalten Verlag, 2010.

Reynolds Metals Company. *Visions of Man in Twelve Aluminum Sculptures*. Richmond , VA: Reynolds Metals Company, n.d.

Rood, John. *Sculpture with a Torch*. Minneapolis: University of Minnesota Press, 1963.

Rower, Alexander S. C., and Holton Rower, eds. *Calder Jewelry*. New York: Calder Foundation and Yale University Press, 2007.

Schiffer, Nancy N. *Harry Bertoia Monoprints*. Atglen, PA: Schiffer, 2011.

Schiffer, Nancy N., and Val Bertoia. *The World of Bertoia*. Atglen, PA: Schiffer, 2003.

Sterne, Margaret. *The Passionate Eye: The Life of William R. Valentiner*. Detroit: Wayne State University Press, 1980.

Valentiner, Brigitta. *The Adventure of Living: The Life of Mrs. Harry Bertoia*. Pennsylvania: self-published, 1984.

ARTICLES

"Aluminum Winners on Exhibit," *Richmond-Times Dispatch*, October 2, 1966.

Durden, Douglas. "Art is Ready, but Context Isn't." *Richmond-Times Dispatch*, July 7, 1978.

Gopnik, Adam. "What Alexander Calder set in Motion." *New Yorker*, December 4, 2017.

Hall, Lee. "The Passions of Hilla Rebay" [Review of *Hilla Rebay: In Search of the Spirit in Art*]. *New Criterion* 3, no. 2 (October 1984): 76–80.

Leider, Philip. "Kinetic Sculpture at Berkeley." *Artforum* 4, no. 9 (May 1966): 40–43.

Perreault, John. "Craft Is Not Sculpture." *Sculpture*, November–December 1993, 32–35.

Rickey, George, and Donald Judd. "Two Artists Comment [on the Russian Avant-Garde]." *Art Journal* 41, no. 3 (Fall 1981): 248–50.

Sullivan, Marin. "Alloyed Screens: Harry Bertoia and the Manufacturers Hanover Trust Building—510 Fifth Avenue." *Sculpture Journal* 25, no. 3 (2016) 361–80.

Wooster, Ann-Sargent. "Art Sounds: Excursions of 20th-Century Artists into the Domain of Sound Were Evaluated in a Multi-media Show." *Art in America*, February 1982, 116–25.

PRINT ARTICLES RETRIEVED ONLINE AND INTERNET SOURCES

"Dallas Public Library," nostalgicglass.org/background.php?pn=19.

"Public Artworks," Roottulsa.com.

"Tulsa's Bertoia Fountain to get restoration and a new home at Central Library," tulsaworld.com/homepagetest/tulsa-s-bertoia-fountain-to-get-restoration-and-a-new/ article_52bba703-873b-50749238-fcaaafl=170.gtm[4/15/ 2017 4:50PM].

"15,000 Ooh and Ah at Opening of Dazzling 'Newfangled' Bank." *New York Times*, October 5, 1954. www.nytimes.com/1954/10/05/archives/15000-ooh-and-ah-at-opening-of-dazzling-newfangled-bank.html.

Adjaye, Sir David. David Adjaye Discusses Eero Saarinen's MIT Chapel. arts.mit.edudavid-adjaye-discusses-eero-saarinens-mit-chapel/.

Artner, Alan G. "Death Knell." *Chicago Tribune*, August 11, 1994. www.chicagotribune.com/news/ct-xpm-1994-08-11-9408110097-story.html.

Belluschi, Pietro, Harry Bertoia, Reg. Butler, Eduardo Chillida, Jimmy Ernst, Walter Gropius, Le Corbusier, et al. "Views on Art and Architecture: A Conversation." *Dædalus*, 89, no. 1, "The Visual Arts Today" (Winter 1960): 62–73. www.jstor.orgstable/ 20026549.

Bertoia, Harry, "Harry Bertoia Sits in One of His Chairs Near his Sculpture," *Denver Post*, May 26, 1966. Denver Post via Getty Images. www.gettyimages.com/detail/news-photo/harry-bertoia-sits-in-one-of-his-chairs-near-his-sculpture-news-photo/836984282.

Bertoia Chair patents. www.google.com/patents/USD170790 and patents.google.com/patent/USD170790S/.

Beta, Andy. "How Metal Master Harry Bertoia Made Sound from Sculpture." *Wall Street Journal*, May 6, 2016. www.wsj.com/articles how-metal-master-harry-bertoia-made-sound-from-sculpture-1462578270.

Blum, Betty J. Oral history interview with Gordon Bunshaft April 4 to 7, 1989. Chicago Architects Oral History Project, Department of Architecture, the Art Institute of Chicago, rev. ed. 2000. digital-libraries.saic.edu/cdm/ref/collection/caohp/id/18407.

Cotter, Holland. "The Guggenheim's Greatest Hits Come Roaring Back." *New York Times*, March 9, 2017. www.nytimes.com/2017/03/09/arts/design/the-guggenheims-greatest-hits-come-roaring-back.html.

Craig, Gabriel. "Cranbrook Marks Bertoia at 100 with Jewelry Exhibition." *Art Jewelry Forum*, April 29, 2015. artjewelryforum.org/exhibition-reviews/cranbrook-marks-bertoia-at-100-with-jewelry-exhibition.

Cranbrook Art Museum. "Harry Bertoia, *Coffee and Tea Service*, 1940." cranbrookartmuseum.org/artwork/harry-bertoia-coffee-and-tea-service/.

Crimmins, Peter. "A Long Dormant Bertoia Sculpture Transplanted to Chestnut Hill." *NewsWorks*, July 21, 2016. whyy.org/articles/long-dormant-bertoia-sculpture-transplanted-to-chestnut-hill/.

Crosse, John. "Herbert and Mercedes Matter: The California Years with the Eames Office and Arts & Architecture. Reflections on the 'Mercedes Matter Retrospective' at Pepperdine's Weisman Art Museum." *Southern California Architectural History* (blog), March 19, 2010. socalarchhistory.blogspot.com/2010/03/mercedes-and-herbert-matter-california.html.

Dodge, Delf. "A Look Inside GM Technical Center's Restoration." *Smith GM Chevrolet Cadillac Blog*. June 16, 2011. (blog) smithgm.wordpress.com/2011/06/16/a-look-inside-gm-technical-center's-restoration/.

Doyle, Rachel B. "The Iconic Wire Chair, Harry Bertoia, and the Making of America's Living Room," *Curbed* (blog), March 23, 2015. www.curbed.com/2015/3/23/9977780/harry-bertoia-centenary-knoll-design.

Felsenthal, Julia. "Harry Bertoia's First and Last Acts at the Museum of Arts and Design." *Vogue*, May 5, 2016. www.vogue.com/13434305/harry-bertoia-museum-of-arts-and-design/.

Fontanella, Megan M. "Unity in Diversity: Karl Nierendorf and America, 1937–47." *American Art* 24, no. 3 (Fall 2010): 114–25. www.jstor.org/stable/10.1086/658212.

Gebhard, David. "Kem Weber, Moderne Design in California: 1920-1940." *Journal of Decorative and Propaganda Arts* 2 (Summer–Autumn 1986): 20–31. www.doi.org/10.2307/1503922.

Giovanni, Joseph. "Florence Knoll: Form, Not Fashion." *New York Times*, April 7, 1983. www.nytimes.com/1983/04/07/garden/florence-knoll-form-not-fashion.html. No longer available online.

Goldberger, Paul. "The Cranbrook Vision." *New York Times Magazine*, April 8, 1984, 48. www.nytimes.com/1984/04/08/magazine/the-cranbrook-vision.html.

Gopnik, Blake. "Harry Bertoia: Stradivarius of Cacophony." Artnet News, August 25, 2016. news. artnet.com/opinion/harry-bertoia-museum-of-arts-and-design-620930.

Greenbaum, Toni. "Bizarre Bijoux: Surrealism and Jewelry." Journal of Decorative and Propaganda Arts 20 (1994): 196–207, www.jstor.org/stable/1504122.

Guggenheim Museum. "Hilla Rebay." www.guggenheim.org/history/hilla-rebay

Hayes, Bryon. "Harry Bertoia: The Complete Sonambient Collection." Exclaim!, August 30, 2016. exclaim.ca/music/article/harry_bertoia-the_complete_sonambient_collection.

Hine, Thomas. "Old Sculpture, New Wonders: 'Plant Forms' Comes to Woodmere." Philly.com, August 5, 2016. www.philly.com/philly/entertainment/20160807_Old_sculpture__new_home__new_wonders__Plant_Forms__comes_to_Woodmere.html.

Hodges, Michael H. "Jewelry of Harry Bertoia on Display at Cranbrook." Detroit News, April 21, 2015. www.detroitnews.com/story/entertainment/arts/2015/04/21/jewelry-harry-bertoia-display-cranbrook/25938675/.

Huxtable, Ada Louise. "A Landmark Jewel Box Loses Its Biggest Gem." Wall Street Journal, November 4, 2010. www.wsj.com/articles/SB10001424052748703506904575592394173795892.

Jeppson, Noah. "Dallas Central Library." Unvisited Dallas (blog), March 22, 2011. unvisiteddallas.com/archives/236.

Kahn, Eve M. "Retrospectives for Harry Bertoia's Grids and Gongs." New York Times, July 11, 2013. www.nytimes.com/2013/07/12/arts/design/retrospectives-for-harry-bertoias-grids-and-gongs.html?_r=0.

Knoll. "Making Bertoia." October 26, 2017. knoll.com/knollnewsdetail/bertoia-production?trkmsg=70728MH7NV44NAEACF6RVON/UG6trk_contact.

Knoll. "Woodmere Art Museum Welcomes a Hidden Bertoia Sculpture to Its Grounds." January 14, 2018. www.knoll.com/knollnewsdetail/harry-bertoia-at-woodmere-art-museum.

"Les sculptures sonores et bijoux d'Harry Bertoia au MAD." Intramuros, May 30, 2016. intramuros.fr/agenda/les-sculptures-sonores-et-bijoux-d-harry-bertoia-au-mad.

"Modern Handmade Jewelry." September 11, 1946. Museum of Modern Art, New York, documents. www.moma.org/momaorg/shared/pdfs/docs/press_archives/1064/releases/MOMA_1946-1947_0047_1946-09-16_46916-45.pdf?.

Pepsis, Betty. "Sculptor Designs Wire-Shell Chairs." New York Times, December 10, 1952, 46. timesmachine.nytimes.com/timesmachine/1952/12/10/84377526.html?pageNumber=46. www.nytimescom/1952/12/10/archives/sculptor-designs-wireshell-chairs-bertoia-makes-holders-for-rubber.html

———. "Definition Sought for 'Good Design.'" New York Times, June 23, 1954. timesmachine.nytimes.com/timesmachine/1954/06/23/84124364.pdf.

Phillips Collection, Washington, D.C., exhibition history. www.phillipscollection.org/sites/default/files/attachments/the-phillips-collection-exhibition-history.pdf.

Pogrebin, Robin. "Settlement Reached on 5th Avenue Landmark." ArtsBeat (blog). New York Times, February 8, 2012. artsbeat.blogs.nytimes.com/2012/02/08/preservationists-win-a-battle-over-former-manufacturers-hanover-trust-building/.

———. "MoMA's Makeover Rethinks the Presentation of Art." New York Times, June 1, 2017. www.nytimes.com/2017/06/01/arts/design/moma-redesign-art-expansion.html.

Rose, Joel. "Sound Sculptor Harry Bertoia Created Musical Meditative Art." NPR Weekend Edition, March 26, 2016. www.npr.org/2016/03/26/468881945/sound-sculptor-harry-bertoia-created-musical-meditative-art.

Schuster, Angela M. H. "Dandelions and Sonambients: Harry Bertoia's Sculptures Find Their Audience." Blouin ArtInfo, February 28, 2015. www.blouinart info.com/news/story/1108582/dandelions-and-sonambients-harry-bertoias-sculptures-find.

Schwab, Helen. "'All That Sparkles ...' Shows Thought." Charlotte Observer, July 28, 2016. www.charlotteobserver.com/entertainment/arts-culture/article92350027.html.

Sisson, Patrick. "Cranbrook's Golden Age: How a Freewheeling School Changed American Design." Curbed (blog), November 17, 2015. ny.curbed.com/2015/11/17/9899264/how-a-freewheeling-school-changed-american-design.

Tigerman, Bobbye. "I Am Not a Decorator: Florence Knoll, the Knoll Planning Unit and the Making of the Modern Office." Journal of Design History 20, no. 1 (January 2007), doi.org/10.1093/jdh/epl042.

Tourtelot, Madeline. "Metal Sculpture by Harry Bertoia, ca. 1958." Filmed with the cooperation of Fairweather-Hardin Gallery. www.youtube.com/watch?v=Wey_5PXDf9A.

Warren, Virginia Lee. "Woman Who Led an Office Revolution Rules an Empire of Modern Design." New York Times, September 1, 1964. www.nytimes.com/1964/09/01woman-who-led-an-office-revolution-rules-an-empire-of-modern-design.html.

West, Clifford. "Harry Bertoia's Sculpture," 1965 (film) www.youtube.com/watch?v=a9EF_zO5ihs.

EXHIBITION AND AUCTION CATALOGS

Allentown Art Museum. Harry Bertoia: An Exhibition of His Sculpture and Graphics Allentown, PA: Allentown Art Museum, 1975.

Art Gallery, Marshall University. Harry Bertoia. Huntington, WV: Marshall University, 1977.

Clark, Robert Judson, David G. De Long, Martin Eidelberg, J. David Farmer, John Gerard, Neil Harris, Joan Marter, et al. Design in America: The Cranbrook Vision 1925–1950. Edited by Adele Westbrook and Anne Yarowsky. New York: Harry N. Abrams; Detroit: Detroit Institute of Arts; New York: Metropolitan Museum of Art, 1983.

Coir, Mark. In Nature's Embrace: The World of Harry Bertoia. Reading, PA: Reading Public Museum, 2006.

Drexler, Arthur. Charles Eames: Furniture from the Design Collection. New York: MoMA, 1973.

Grayson, John, ed. Sound Sculpture. Vancouver: Aesthetic Research Centre of Canada, 1975.

Greene, Vivien, ed. Italian Futurism 1909–1944: Reconstructing the Universe. New York: Solomon R. Guggenheim Museum, 2014.

Greenbaum, Toni. Messengers of Modernism: American Studio Jewelry 1940–1960. Edited by Martin Eidelberg. Montreal Museum of Decorative Arts; Paris and New York: Flammarion, 1996.

Haspeslagh, Martine Newby. Jewelry by Contemporary Painters and Sculptors @ 50: 1967–2017. London: Didier, 2017.

Kaplan, Wendy, ed. Living in a Modern Way: California Design 1930–1965. Los Angeles: Los Angeles County Museum of Art; Cambridge, MA, and London, England: MIT Press, 2011.

Selim, Shelley. Bent, Cast & Forged: The Jewelry of Harry Bertoia. Bloomfield Hills, MI: Cranbrook Art Museum, 2015.

Sotheby's. Bertoia: Featuring Masterworks from the Kaare Berntsen Collection. New York: Sotheby's, 2016.

Taft Museum. Sounds of Sculpture: B. Baschet, H. Bertoia, F. Baschet. Cincinnati, OH: Taft Museum, 1976.

Wright Auctions. Harry Bertoia: Material and Form. Chicago: Wright Auctions, 2007.

Wright Auctions. Bertoia: The Standard Oil Commission. Chicago: Wright Auctions, 2013.

UNPUBLISHED MATERIALS

Bertoia, Ave di Paolo, interviews by Celia Bertoia, October 29 and 30, 2008, and May 21, 2010, Alberta, Canada.

Bertoia, Harry. Interview by the author, Barto, PA, August 15–16, 1974.

———. Letters to Dr. Wilhelm Valentiner, September 5, 1951; December 25, 1951; and 1954.

———. Letter to F. Gordon Smith, Syracuse University, March 14, 1962.

———. Letter to Mrs. Marjorie C. Freytag, registrar, Munson-Williams-Proctor Institute, Utica, NY, April 21, 1966.

Correspondence between Harry Bertoia and Hilla Rebay, 1943–1952.

Harry Bertoia papers, 1917–1979. Archives of American Art, Smithsonian Institution.

Important Records. Complete Sonambient Collection (11 CDs and book). Groveland, MA: 2016.

Knoll, Hans. Letter to Harry Bertoia, February 11, 1954. Papers of Harry Bertoia, the Archives of American Art, Smithsonian Institution, and the Harry Bertoia Foundation.

Oral history interview with Harry Bertoia, June 20, 1972, the Archives of American Art, Smithsonian Institution.

Papers of Harry Bertoia. Archives of American Art, microfilm reels 3843-3851, Smithsonian Institute.

Pettit, Don. Interview by Alexander von Vegesack, September 6, 1994, for the Vitra Design Museum. Copy provided by Bill Shea.

Schultz, Richard. Manuscript of interview by Bobbye Tigerman, June 29, 2004.

———. Telephone interview by the author, December 12, 2017.

Shea, Bill. Telephone interview by the author, December 8, 2017.

Springer, Wilbur. "The Bertoia Chaise Lounge. A Mid-Century Modern Design Masterpiece." Draft of an article, March 2018.

Van Dijk, Peter. Telephone interview by the author, May 15, 2018.

Willenbecher, John. Harry Bertoia, A Monograph. Master's thesis, Brown University, 1958.

Image pages are in *italics*.

PICTURE CREDITS

Unless otherwise noted, all images are courtesy and copyright © 2019 Estate of Harry Bertoia / Artists Rights Society (ARS), New York.

Front cover: Wright 20th Century Art, Chicago, Design Masterworks, 19 May 2016, Lot 30. Photo: Courtesy of Wright.
Back cover: Photo: Wilbur Springer Collection.
Cover background: Image © imi-surface-design.
Interior images:
P. 19 T: Photo: Courtesy of Amici di Harry Bertoia, San Lorenzo.
P. 19 BL: Photo: Harry Bertoia Foundation.
P. 19 BR: Photo: Courtesy of Amici di Harry Bertoia, San Lorenzo.
P. 44: Photograph by Detroit News Airphoto. Cranbrook Archives, neg. 4403. Photo: Courtesy of Cranbrook Archives.
P. 45 (T & B): © The Estate of Eliel Saarinen. Photo © Cranbrook Center for Collections and Research / James Haefner.
P. 46 T: Photograph by Harvey Croze, September 1948. Cranbrook Archives, neg. AA2354-1. Photo: © Cranbrook Archives.
P. 46 B: © The Estate of Eero Saarinen © The Estate of Charles Eames. Photograph by Soichi Sunami, c. 1940. Eero Saarinen collection, Manuscripts & Archives, Yale University, MS 0593. Photo: Courtesy of Yale University.
P. 47 T: © The Estate of Eliel Saarinen & Eero Saarinen © The Estate of J. Robert F. Swanson. Cranbrook Archives, neg. 2006-02. Photo: Courtesy Cranbrook Archives, Benjamin Baldwin Papers.
P. 47 BL: Photograph by Richard G. Askew. Cranbrook Archives, neg. 4883. Photo: © Cranbrook Archives.
P. 47 BR: Cranbrook Archives, neg. 2006-02. Photo: Courtesy Cranbrook Archives, Benjamin Baldwin Papers.
P. 48 TL: Cranbrook Archives, Acc. No. 1991-03. Photo: © Cranbrook Archives, Margueritte Kimball Papers.
P. 48 TR (upper): Cranbrook Archives, neg. 5832-22. Photo: © Cranbrook Archives.
P. 48 TR (lower): Photograph by Richard G. Askew. Cranbrook Archives, neg. 5290-13. Photo: © Cranbrook Archives.
P. 48 BL: Photograph by Richard P. Raseman. Cranbrook Archives, neg. 5278-3. Photo: © Cranbrook Archives.
P. 48 BR: Photograph by Richard G. Askew. Cranbrook Archives, neg. 5371B. Photo: © Cranbrook Archives.
P. 49: Wright 20th Century Auctions, Chicago, Modern Design, 20 March 2005, Lot 135. Photo: Courtesy of Wright.
P. 50 T: Cranbrook Archives, neg. 5985-1. Photo: © Cranbrook Archives.
P. 50 B: Photograph by Richard G. Askew. Cranbrook Archives, neg, 4879-7. Photo: © Cranbrook Archives.
P. 51: Skinner Auctions, Boston, American and European Works of Art-2704B, 6 February 2004, Lot 656. Photo: Courtesy of Skinner, Inc. www.skinnerinc.com
P. 52 (T & B): Photo: Harry Bertoia Foundation.
P. 53 T: Wright 20th Century Auctions, Chicago, Important Design, 7 June 2012, Lot 168. Photo: Courtesy of Wright.
P. 53 B: Wright 20th Century Auctions, Chicago, Important Design, 7 June 2012, Lot 167. Photo: Courtesy of Wright.
P. 54 TL: Acquired directly from the artist by Ralph Rapson. thence by descent; Wright 20th Century Auctions, Chicago, Modern Design, 31 March 2011, Lot 167. Photo: Courtesy of Wright.
P. 54 TR: Acquired directly from the artist by Ralph Rapson; thence by descent; Wright 20th Century Auctions, Chicago, Modern Design, 23 March 2010, Lot 208. Photo: Courtesy of Wright.
P. 54 BL: Ex Nierendorf Gallery, New York; ex coll Kitty Weese; Wright 20th Century Auctions, Chicago, Masterworks, 25 May 2017, Lot 23. Photo: Courtesy of Wright.

P. 54 BR: Gift from the artist to Kitty Weese, Chicago; thence by descent; Wright 20th Century Auctions, Chicago, Design, 22 October 2015, Lot 258. Photo: Courtesy of Wright.
P. 55 L: L. M. Schon, Natchez, Mississippi. Photo: Beverly H. Twitchell.
P. 55 R: Collection of Celia Bertoia, Washington, Utah. Photo: Harry Bertoia Foundation.
P. 56 & 57 (T & B): Photo © Didier Ltd, London.
P. 58 (T & M): Photo: Michael J. Joniec, courtesy of Moderne Gallery, Philadelphia.
P. 58 B: Wright 20th Century Auctions, Chicago, Design Masterworks, 17 November 2016, Lot 15. Photo: Courtesy of Wright.
P. 59: Wright 20th Century Auctions, Chicago, Important Design, 8 December 2009, Lot 289. Photo: Courtesy of Wright.
P. 60: Cranbrook Archives, neg. 5938-3. Photo: © Cranbrook Archives.
P. 61 T: Detroit Institute of Arts, Bequest of Mrs. George Kamperman, Acc. No. V2015.10. Photo: Detroit Institute of Arts, USA / Bridgeman Images.
P. 61 B: Cranbrook Art Museum, Gift of Mrs. Joan R. Graham, Inv. No. CAM 1986.34. Photo: R. H. Hensleigh and Tim Thayer, courtesy of Cranbrook Art Museum.
P. 62: Detroit Institute of Arts, Bequest of Hal H. Smith, Acc. No. 41.123.1-d2. Photo: Detroit Institute of Arts, USA / Bridgeman Images.
P. 63: Detroit Institute of Arts, Bequest of Hal H. Smith, Acc. No. 45.196.3-2. Photo: Detroit Institute of Arts, USA / Bridgeman Images.
P. 64 T: Wadsworth Atheneum Museum of Art, Hartford, Connecticut. The Ella Gallup Sumner and Mary Catlin Sumner Collection Fund, Obj. No. 1942.337.9. Photo: Wadsworth Atheneum Museum of Art.
P. 64 B: Wadsworth Atheneum Museum of Art, Hartford, Connecticut. The Ella Gallup Sumner and Mary Catlin Sumner Collection Fund, Obj. No. 1942.337.1. Photo: Wadsworth Atheneum Museum of Art.
P. 65 T: Wadsworth Atheneum Museum of Art, Hartford, Connecticut. The Ella Gallup Sumner and Mary Catlin Sumner Collection Fund, Obj. No. 1942.337.12. Photo: Wadsworth Atheneum Museum of Art.
P. 65 B: Wadsworth Atheneum Museum of Art, Hartford, Connecticut. The Ella Gallup Sumner and Mary Catlin Sumner Collection Fund, Obj. No. 1942.337.18. Photo: Wadsworth Atheneum Museum of Art.
P. 66: Wright 20th Century Auctions, Chicago, Modernist Design, 19 October 2003, Lot 389. Photo: Courtesy of Wright.
P. 67: The Phillips Collection, Washington, D.C. Acquired 1945. Photo: The Phillips Collection, Washington, D.C.
P. 68 & 69 T: Solway Gallery, Cincinnati. Photo: Courtesy of Solway Gallery and the Harry Bertoia Foundation.
P. 69 B: Photo: Beverly H. Twitchell.
P. 84 & 85 T: Photo © 2018 Eames Office, LLC (eamesoffice.com).
P. 85 B: Photo: Harry Bertoia Foundation.
P. 86: Wright 20th Century Auctions, Chicago, Harry Bertoia: Material and Form, 22 May 2007, Lot 841. Photo: Courtesy of Wright.
P. 87: Private Collection. Photo: Beverly H. Twitchell.
P. 88 & 89: Photo: Harry Bertoia Foundation.
P. 90: Gift of the artist to Ardelle and Arthur Smilowitz; Wright 20th Century Auctions, Chicago, Design, 8 December 2016, Lot 109. Photo: Courtesy of Wright.
P. 91: Photo: Wilbur Springer Collection.
P. 92 T: © The Estate of Charles Eames. Photo: Rolphe Dauphin for Walker Art Center.
P. 92 B: Photo: Beverly H. Twitchell.
P. 93 T: Philadelphia Museum of Art, Gift of Frances Elliot Storey and Gay Elliot Scott, 2014, Acc. No. 2014-10-3. Photo © 2019. The Philadelphia Museum of Art / Art Resource / Scala, Florence.
P. 93 B: Philadelphia Museum of Art, Gift of Frances Elliot Storey and Gay Elliot Scott, 2014, Acc. No. 2014-10-2. Photo © 2019. The Philadelphia Museum of Art / Art Resource / Scala, Florence.
P. 107 (T & B): Photo: Courtesy of Knoll, Inc.

P. 108: Photo: Harry Bertoia Foundation.
P. 109: Photo: Herbert Matter, Courtesy of Knoll, Inc.
P. 110: Photo: Harry Bertoia Foundation.
P. 111: Wright 20th Century Auctions Designs, Chicago, Design, 24 March 2016, Lot 139. Photo: Courtesy of Wright.
P. 112 (T & B): Photo: Wilbur Springer Collection.
P. 113 (T & B): Wright 20th Century Auctions, Chicago, Modernist 20th Century, 6 June 2004, Lot 349. Photo: Courtesy of Wright.
P. 114, 115, 116 (T & B), 117 & 118: Photo: Courtesy of Knoll, Inc.
P. 120 & 121: Photo: Courtesy of Knoll, Inc.
P. 122 T: Photo: Herbert Matter, Courtesy of Knoll, Inc.
P. 122 B: Photo: Harry Bertoia Foundation.
P. 123: Photo: Herbert Matter, Courtesy of Knoll, Inc.
P. 124: © The Estate of George Nelson © The Estate of Edward Wormley © The Estate of Eero Saarinen © The Estate of Charles Eames © The Estate of Jens Risom. Photo © Marvin Koner.
P. 125: Photo: Courtesy of Knoll, Inc.
P. 126 (T & B): Photo: Wilbur Springer Collection.
P. 127 (T & B): Photo: Wilbur Springer Collection.
P. 145 T: Wright 20th Century Auction, Chicago, Modernist 20th Century, 5 December 2004, Lot 361. Photo: Herbert Matter, Courtesy of Wright.
P. 145 B: Photo: Harry Bertoia Foundation.
P. 146: Wright 20th Century Auctions, Chicago, Modern Design, 6 October 2009, Lot 220. Photo: Courtesy of Wright.
P. 147 (T & B): Private Collection. Photo: Beverly H. Twitchell.
P. 148: Wright 20th Century Auctions, Chicago, Important Design, 14 December 2010, Lot 239. Photo: Courtesy of Wright.
P. 149 T: Wright 20th Century Auctions, Chicago, Important Design, 11 December 2008, Lot 591. Photo: Courtesy of Wright.
P. 149 B: Wright 20th Century Auctions, Chicago, Design, 12 December 2013, Lot 309. Photo: Courtesy of Wright.
P. 150 & 151: Photo: Harry Bertoia Foundation.
P. 152: Photo: Harry Bertoia Foundation / Art Resource, NY.
P. 153: Collection Albright-Knox Art Gallery, Buffalo, New York, Gift of Mr. and Mrs. Gordon Bunshaft, 1964, Inv. No. RCA1964:4.3. Photo © 2019. Albright Knox Art Gallery / Art Resource, NY / Scala, Florence.
P. 154: Wright 20th Century Auctions, Chicago, Important Design, 11 December 2014, Lot 124. Photo: Courtesy of Wright.
P. 155 T: Photo: Herbert Matter, Courtesy of Knoll, Inc.
P. 155 B: Photo: Courtesy of Knoll, Inc.
P. 156: Wright 20th Century Auctions, Chicago, Art + Design, 12 January 2018, Lot 338. Photo: Courtesy of Wright.
P. 157 T: Wright 20th Century Auctions, Chicago, Modern Design, 28 March 2013, Lot 174. Photo: Courtesy of Wright.
P. 157 B: Photo: Harry Bertoia Foundation.
P. 158 & 159: Photo © Ezra Stoller / Esto.
P. 160: Harry Bertoia to Edward Flanagan; Wilbur Springer. Photo: Wilbur Springer Collection.
P. 161: Skinner Auctions, Marlborough, Auction 2704B, 7 February 2014, Lot 656. Photo: Courtesy of Skinner, Inc. www.skinnerinc.com
P. 162 TL: Wright 20th Century Auctions, Chicago, Design Masterworks, 19 May 2015, Lot 1. Photo: Courtesy of Wright.
P. 162 TR: Photo: Randy Duchaine / Alamy Stock Photo.
P. 162 B: Aerial photograph by Balthazar Korab, 1950-55. Photo: Library of Congress, Prints & Photographs Division, Balthazar Korab Archive at the Library of Congress, Reproduction Number LC-DIG-krb-00238.
P. 163: Photo: Robert Proctor / Alamy Stock Photo.
P. 164: Wright 20th Century Auctions, Chicago, Important Design Session 2, 11 December 2007, Lot 582. Photo: Courtesy of Wright.
P. 165 (T & B): Photo: Collections of the Dallas History & Archives Division, Dallas Public Library.
P. 166: Wright 20th Century Auctions, Chicago, Important Design, 11 December 2014, Lot 122.

Photo: Courtesy of Wright.

P. 167 T: Wright 20th Century Auctions, Chicago, Harry Bertoia: Material and Form, 22 May 2007, Lot 834. Photo: Courtesy of Wright.

P. 167 B: Harry Bertoia to Edward Flanagan; Wilbur Springer; Harry Bertoia Foundation. Photo: Wilbur Springer Collection.

P. 168: Wright 20th Century Auctions, Chicago, Important Design Session 2, 11 December 2007, Lot 589. Photo: Courtesy of Wright.

P. 169: Photo: Minnesota Historical Society.

P. 170 T: Harry Bertoia to Edward Flanagan; Wilbur Springer; Harry Bertoia Foundation. Photo: Wilbur Springer Collection.

P. 170 B: Photo: Harry Bertoia Foundation.

P. 171 T: Private Collection. Lent and exhibited at the Virginia Museum of Fine Arts (Exhibition Title: "Collectors' Choice", Exhibition Date: 16 April – 14 May 1961, Exhibition Description: The second annual exhibition of art objects acquired by members of the VMFA's Collectors' Circle). VMFA Photo Archives. Photo © Virginia Museum of Fine Arts.

P. 171 BL: VMFA Photo Archives. Photo © Virginia Museum of Fine Arts.

P. 171 BR: Virginia Museum of Fine Arts, Richmond, Gift of a Trustee, Obj. No. 58.51. Photo: Travis Fullerton © Virginia Museum of Fine Arts.

P. 187 T: Wright 20th Century Auctions, Chicago, Design, 9 June 2016, Lot 189. Photo: Courtesy of Wright.

P. 187 B: Private Collection. Photo: Beverly H. Twitchell.

P. 188: Gift of the artist to Edward Durrell Stone, New York; thence by descent; Wright 20th Century Auctions, Chicago, Design, 20 October 2016, Lot 391. Photo: Courtesy of Wright.

P. 189 (T & B): Estate of Harry Bertoia; gift of Brigitta Bertoia to the present owner. Private Collection. Photo: Beverly H. Twitchell.

P. 190: Wright 20th Century Auctions, Chicago, Important Design, 13 December 2012, Lot 259. Photo: Courtesy of Wright.

P. 191: Wright 20th Century Art, Chicago, Important Design, 6 June 2013, Lot 101. Photo: Courtesy of Wright.

P. 192: Wright 20th Century Auctions, Chicago, Modernist 20th Century, 18 May 2003, Lot 345. Photo: Courtesy of Wright.

P. 193 T: Wright 20th Century Auctions, Chicago, 20th Century Art, 27 April 2017, Lot 7. Photo: Courtesy of Wright.

P. 193 B: Acquired in 1962 by Robert Muir; acquired from Muir c. 1990; Wright 20th Century Auctions, Chicago, Design, 8 December 2016, Lot 138. Photo: Courtesy of Wright.

P. 194: Wright 20th Century Auctions, Chicago, Modern Design, 6 October 2011, Lot 106. Photo: Courtesy of Wright.

P. 195 T: Collection of the artist; John R. Eckel, Jr., Houston; Wright 20th Century Auctions, Chicago, Masterworks, 25 May 2017, Lot 19. Photo: Courtesy of Wright.

P. 195 B: Wright 20th Century Auctions, Chicago, Design, 14 December 2017, Lot 145. Photo: Courtesy of Wright.

P. 196 T: Knoll showroom, Paris; Wright 20th Century Auctions, Chicago, Century Art + Design, 10 June 2001, lot 368; private collection; Wright 20th Century Auctions, Chicago, Design, 11 June 2015, Lot 139. Photo: Courtesy of Wright.

P. 196 B: Wright 20th Century Auctions, Chicago, 20th Century Art, 27 April 2017, Lot 8. Photo: Courtesy of Wright.

P. 197 T: Syracuse University Art Galleries, Gift of the Chi Omega Sorority, Upsilon Alpha Chapter, Inv. No. 1961.01. Photo: Courtesy of the Syracuse University Art Collection.

P. 197 B: Private Collection. Photo: Josh Nefsky, courtesy of Jonathan Boos Gallery, New York.

P. 198: Cuyahoga Savings Association, Cleveland; Manchester Realty, Cleveland; Wright 20th Century Auctions, Chicago, Important Design, 11 December 2007, Lot 590. Photo: Courtesy of Wright.

P. 199: Cuyahoga Savings Association, Cleveland; Manchester Realty, Cleveland; Wright 20th Century Auctions, Chicago, Important Design, 11

December 2007, Lot 590. Photo: Courtesy of Wright.

P. 200: Harry Bertoia to Edward Flanagan to Wilbur Springer. Photo: Wilbur Springer Collection.

P. 201 TR: Estate of E. H. Bennett, Lake Forest, IL; Wright 20th Century Auctions, Design, 24 March 2016, Lot 134. Photo: Courtesy of Wright.

P. 201 L: Collection of the artist; private collection; Wright 20th Century Auctions, Modern Design, 3 October 2004, Lot 394. Photo: Courtesy of Wright.

P. 201 BR: Wright 20th Century Auctions, Chicago, Important Design, 8 December 2009, Lot 287. Photo: Courtesy of Wright.

P. 202: Photo: Bill Cotter of worldsfairphotos.com.

P. 203 T: Staempfli Gallery, New York; Wright 20th Century Auctions, Chicago, Living Contemporary, 27 September 2012, Lot 138. Photo: Courtesy of Wright.

P. 203 B: Wright 20th Century Auctions, Chicago, Important Design, 2 June 2009, Lot 427. Photo: Courtesy of Wright.

P. 204 T: Virginia Museum of Fine Arts, Richmond, Gift of Richard S. Reynolds, Obj. No. 62.24. Photo: Troy Wilkinson © Virginia Museum of Fine Arts.

P. 204 B: Virginia Museum of Fine Arts, Richmond, Gift of the Reynolds Metals Company, Obj. No. 86.93. Photo: Travis Fullerton © Virginia Museum of Fine Arts.

P. 205 T: Federal Aviation Administration for Dulles International Airport, Chantilly, Virginia. Photo: courtesy of the Metropolitan Washington Airports Authority.

P. 205 B: Harry Bertoia to Ed Flanagan to Wilbur Springer. Photo: Wilbur Springer Collection.

P. 206 T: Fairweather-Hardin Gallery, Chicago; Private Collection; Wright 20th Century Auctions, Chicago, Design, 23 March 2017, Lot 113. Photo: Courtesy of Wright.

P. 206 B: Acquired from Knoll International, France in 1969; Private Collection, Metz, France; Private collection, Chicago; Wright 20th Century Auctions, Chicago, Design, 24 March 2016, Lot 135. Photo: Courtesy of Wright.

P. 207 (T & B): Private Collection. Photo: Beverly H. Twitchell

P. 208 T: Acquired directly from the artist; Wright 20th Century Auctions, Chicago, Important Design, 9 June 2011, Lot 101. Photo: Courtesy of Wright.

P. 208 B: Wright 20th Century Auctions, Chicago, Living Contemporary, 26 April 2012, Lot 178. Photo: Courtesy of Wright.

P. 209 T: Wright 20th Century Auctions, Chicago, Modern Design, 18 October 2012, Lot 138. Photo: Courtesy of Wright.

P. 209 B: Wright 20th Century Auctions, Chicago, Modern + Contemporary Design, 28 March 2006, Lot 145. Photo: Courtesy of Wright.

P. 210 T: Wright 20th Century Auctions, Chicago, Art & Design, 23 February 2014, Lot 108. Photo: Courtesy of Wright.

P. 210 B: Wright 20th Century Auctions, Chicago, Art & Design, 26 February 2015, Lot 204. Photo: Courtesy of Wright.

P. 211: Woodrow Wilson School of Public and International Affairs, Princeton University and Princeton University Art Museum, Inv. No. PP518. Photo © 2019. Princeton University Art Museum / Art Resource NY / Scala, Florence.

P. 212 (T & B): Private Collection. Photo: Tim Thayer, courtesy of Jonathan Boos Gallery, New York.

P. 213: Wright 20th Century Auctions, Chicago, Important Design, 15 December 2011, Lot 157. Photo: Courtesy of Wright.

P. 214: Wright 20th Century Auctions, Chicago, Art + Design, 23 September 2014, Lot 124. Photo: Courtesy of Wright.

P. 215: Huntington Museum of Art, Huntington, West Virginia, in memory of Dorothy Lewis Polan and Lake Polan, Jr. Photo: Huntington Museum of Art.

P. 216: Wright 20th Century Auctions, Design, 22 March 2018, Lot 160. Photo: Courtesy of Wright.

P. 217 (T & B): Wright 20th Century Auctions, Chicago, Important Design, 8 June 2010, Lot 610. Photo: Courtesy of Wright.

P. 218 (TL & TR & BL & BR): Photo: Richard Schultz,

courtesy of Harry Bertoia Foundation.

P. 219: Wright 20th Century Auctions, Chicago, Modern Design, 16 March 2003, Lot 292. Photo: Courtesy of Wright.

P. 220: Photo: Rick Haye, Marshall University Office of Communications.

P. 221 T: Photo: Beverly H. Twitchell.

P. 221 B: Wright 20th Century Auctions, Chicago, Modern Design, 24 March 2009, Lot 269. Photo: Courtesy of Wright.

P. 237: Photo: Beverly H. Twitchell.

P. 238: Wright 20th Century Auctions, Chicago, Modern Design, 30 March 2008, Lot 210. Photo: Courtesy of Wright.

P. 239: Huntington Museum of Art, Huntington, West Virginia, Funds provided by the National Endowment for the Arts with partial funds by Mr. Alex E. Booth, Jr. Photo: Huntington Museum of Art.

P. 240: Harry Bertoia Monoprints, Nancy N. Schiffer, Schiffer Publishing Ltd., 2011. Photo: Courtesy of Schiffer Publishing Ltd.

P. 241 (L & R): Photo: Harry Bertoia Foundation.

P. 242 (T & B): Photo: Harry Bertoia Foundation.

P. 243 (L & R): Photo: Harry Bertoia Foundation.

P. 244: Photo: Beverly H. Twitchell.

P. 245 (TL, TR, BL & BR): Photo: Beverly H. Twitchell.

P. 246 T: Wright 20th Century Auctions, Chicago, Important Design, 15 December 2011, Lot 126. Photo: Courtesy of Wright.

P. 246 b: Wright 20th Century Auctions, Chicago, Design, 10 December 2015, Lot 119. Photo: Courtesy of Wright.

P. 247: Acquired from the Bertoia family; Private collection, New York; Wright 20 Century Auctions, Chicago, Important 20th Century Design, 3 December 2006, lot 347; Private Collection; Wright 20th Century Auctions, Chicago, Masterworks, 21 November 2017, Lot 16. Photo: Courtesy of Wright.

P. 248 T: Wright 20th Century Auctions, Chicago, Important Design, 8 June 2010, Lot 613. Photo: Courtesy of Wright.

P. 248 B: Wright 20th Century Auctions, Chicago, Important Design, 15 December 2011, Lot 166. Photo: Courtesy of Wright.

P. 249 (T & B): Harry Bertoia Monoprints, Nancy N. Schiffer, Schiffer Publishing Ltd., 2011. Photo: Courtesy of Schiffer Publishing Ltd.

P. 250 (T & B): Exhibited at Payne Gallery, Bethlehem, PA in The Bertoia Legacy, 1990, and published in the catalogue under a title supplied by Val Bertoia, Circular Motion. Photo: Harry Bertoia Foundation.

P. 251 (L & R): Photo: Harry Bertoia Foundation.

P. 252 (TL, TR & B): Photo: Harry Bertoia Foundation.

P. 253: Photo: Harry Bertoia Foundation.

P. 254 T: Wright 20th Century Auctions, Chicago, Harry Bertoia: Material and Form, 22 May 2007, Lot 858. Photo: Courtesy of Wright.

P. 254 B: Wright 20th Century Auctions, Chicago, Harry Bertoia: Material and Form, 22 May 2007, Lot 859. Photo: Courtesy of Wright.

P. 255 T: Estate of Harry Bertoia; Private collection; Wright 20th Century Auctions, Chicago, Harry Bertoia: Material and Form, 22 May 2007, Lot 848. Photo: Courtesy of Wright.

P. 255 B: Harry Bertoia Monoprints, Nancy N. Schiffer, Schiffer Publishing Ltd., 2011. Photo: Courtesy of Schiffer Publishing Ltd.

P. 256 (T & B): Harry Bertoia Monoprints, Nancy N. Schiffer, Schiffer Publishing Ltd., 2011. Photo: Courtesy of Schiffer Publishing Ltd.

P. 257: Photo © Bill Smith.

P. 258: Photo: Beverly H. Twitchell.

P. 259 (T & B): Photo: Beverly H. Twitchell.

P. 260: Photo: Harry Bertoia Foundation.

P. 261: Wright 20th Century Art, Chicago, Design Masterworks, 19 May 2016, Lot 30. Photo: Courtesy of Wright.

Every reasonable effort has been made to acknowledge the ownership of copyright for photographs included in this volume. Any errors that may have occurred are inadvertent, and will be corrected in subsequent editions provided notification is sent in writing to the publisher.

AUTHOR BIOGRAPHY

Beverly H. Twitchell, Ph.D., is Professor Emerita of Art History at Marshall University, having previously taught at Virginia Tech and La Salle University. She received degrees in Art History from Randolph-Macon Woman's College, Virginia Commonwealth University, and a doctorate from Binghamton University. She is a trustee of the Wheelwright Museum of the American Indian in Santa Fe and is the author of a variety of articles as well as *Cézanne and Formalism in Bloomsbury*. As the only art historian who knew and worked with Harry Bertoia in his last years, who interviewed him at length and who amassed a considerable archive of photographs of his works, she is uniquely placed to offer real insight into Bertoia's work and world.

ACKNOWLEDGMENTS

Many people have been generous with their knowledge, images, and energy as I have worked on this book, beginning in the 1970s. Most people expressed great admiration for Harry Bertoia's work and were pleased to discover that this book was in progress. Their generosity was because of my wonderful subject.

Among those who were helpful are Robert Aibel, Moderne Gallery, Philadelphia; Ceylan Akturk, Wayne State University Press, Detroit, Michigan; Amy Arnold, Michigan State Historic Preservation Office; Angelo Bertani, San Lorenzo, Italy; Elena Bertoia, San Lorenzo, Italy; the Harry Bertoia Foundation, Washington, Utah; Lesta Bertoia, Maui, Hawaii; Val Bertoia, Barto, Pennsylvania; Laura Calderon, New Mexico State Library; Renny Cave, Richmond, Virginia; Brian Collins, Dallas Public Library; Nat DeBruin, Marshall University Archives; Lisa Delgado, Hercules, California; Michele De Shazo, the Phillips Collection, Washington, D.C.; Al and Kim Eiber, Miami; Michael Frost, Yale University Library, Manuscripts and Archives, New Haven, Connecticut; Mary Jo Giudice, Dallas Public Library; Martine Haspeslagh, Didier Ltd., London; Rick Haye, Marshall University, Office of University Communications, Huntington, West Virginia; Julia Hasting, Phaidon Press, London; Josué Hurtado, Temple University Research Collections Center, Philadelphia; Important Records, Groveland, Massachusetts; James Kallas, Kallas Jewelers, Santa Fe, New Mexico; Carolyn Karr, Huntington, West Virginia; Kelly Kerney, The Valentine museum, Richmond, Virginia; Amy Kilkenny, Wadsworth Atheneum Museum of Art, Hartford, Connecticut; Jacob Lie, Skidmore, Owings and Merrill, New York; John Lyon, Walker Art Center, Minneapolis; Barbara J. Messer, Santa Fe Public Library; Erin Monroe, Wadsworth Atheneum Museum of Art, Hartford, Connecticut; Darryl Moran Photography, Philadelphia; Brandon Murray, Dallas History and Archives Division, Dallas Public Library; Francesco Orlando, San Lorenzo, Italy; Howell Perkins, Virginia Museum of Fine Arts; Angelika Pirkl, London; Clare Rogan, Detroit Institute of Arts; Richard Schultz, Skillman, New Jersey; Penina Seigel, Skinner, Marlborough, Massachusetts; Bill Shea, Barto, Pennsylvania; Richard Sieber, Philadelphia Museum of Art; Emilie Sims, Wright 20th Century Auctions, Chicago; Michael Solway, Cincinnati, Ohio; Stacey Stachow, Wadsworth Atheneum Museum of Art, Hartford, Connecticut; Valerie Stanos, Jonathan Boos Gallery, New York; James Stephenson, Hove, East Sussex, England; Gina Tecos, Cranbrook Academy Archives, Bloomfield Hills, Michigan; Laura J. Wellner, Syracuse University Art Galleries; Nord Wennerstrom, the Cultural Landscape Foundation, Washington, D.C.; Keith Wilkinson, Wilkinson & Co. Santa Fe, New Mexico; Gregory Wittkopp, Cranbrook Center for Collections and Research, Bloomfield Hills, Michigan; Richard Wright, Wright 20th Century Auctions, Chicago.

Above all, Celia Bertoia, John Brien, Sophie Hodgkin, Emilia Terragni, and Wilbur Springer were especially generous with their time, knowledge, and images, and my in-home editor, research assistant, and husband, Kenneth Marchant, was extremely helpful. I deeply appreciate what all of you have done for me and for Harry Bertoia.

Phaidon Press Limited
Regent's Wharf
All Saints Street
London N1 9PA

Phaidon Press Inc.
65 Bleecker Street
New York, NY 10012

phaidon.com

First published 2019
© 2019 Phaidon Press Limited

ISBN 978 0 7148 7807 2

A CIP catalogue record for this book is
available from the British Library and the
Library of Congress.

Commissioning Editor: Emilia Terragni
Project Editor: Sophie Hodgkin
Production Controller: Adela Cory
Typesetter: Luísa Martelo
Design: Julia Hasting

The publisher would also like to thank
Celia Bertoia for her time and generosity,
and Clare Churly, Lisa Delgado, Isobel
McLean, and Angelika Pirkl for their
contributions to the book.

Printed in China